Winfried Baumann Kathedralen für den Müll — Cathedrals for Garbage

Winfried Baumann

KATHEDRALEN FÜR DEN MÜLL

CATHEDRALS FOR GARBAGE

HIRMER

GOTT ALS MÜLLGIFT

GOD AS TOXIC WASTE

Bazon Brock

Kathedralen für die neue Wirklichkeit

Cathedrals for the New Reality

Es gibt zwei prinzipielle Haltungen von Künstlern gegenüber ihrer Zeit. Sie können ihre kulturelle Produktion als Gegenbild zum Zustand und den Erscheinungsformen der Gesellschaft konzipieren, in der sie leben, oder aber mit ihrer kulturellen Produktion in diesen Zustand eingreifen, damit es den Zeitgenossen möglichst schwerfällt, diesen Zustand zu verdrängen. Winfried Baumann gehört zum letzteren Typ, wobei die Radikalität seiner Haltung und hoffentlich auch die Wirkung seiner Arbeit von der Formkraft getragen werden, über die er als professioneller Künstler, Bildhauer und Architekt in so großem Maße verfügt.

Als Zeitgenossen ist Baumann klar, dass die entscheidenden Probleme der Konsumgesellschaft durch unsere Unfähigkeit

There are two principal attitudes artists adopt towards their times. They can see their cultural production as a counterpoint to the condition and manifestations of the society in which they live, or alternatively they can intervene in this state of affairs with their creative production, thus making it as difficult as possible for their contemporaries to suppress any awareness of what is going on. Winfried Baumann is one of the latter type, whereby the radical nature of his attitude and, hopefully, also the impact of his work is founded on the formal potential that he wields to such a degree as a professional artist, sculptor and architect.

As a contemporary, it is very clear to Baumann that the decisive problems of the consumer society result from our inability to

entstehen, mit dem Abfall und den zerstörerischen Konsequenzen von Produktion und Konsum fertig zu werden.

Gerade das aber, womit wir nicht fertig werden und was sich unseren Wünschen nicht fügt, definiert unsere Wirklichkeit. Womit wir nicht fertig werden, das macht uns Angst, und was uns Angst macht und als übermächtige Wirklichkeit unser Schicksal jenseits aller individuellen Anstrengungen bestimmt, das müssen wir rituell zu bannen versuchen.

Solche Ritualformen entwickelte die Kultur auf unterschiedlichen Ebenen; am bedeutsamsten war diejenige, die als Sakralarchitektur den Gott, die Götter, die Geister und die Ideen ins Gehäuse, in den begrenzten Bezirk zu zwingen versuchte. Der Dämon unserer Zeit scheint sich nirgends so übermächtig und so wirklichkeitsbestimmend zu zeigen wie in der Verwandlung der Welt in eine lebensfeindliche, unkontrollierbare, mondtote Giftmülldeponie.

Diesem Dämon, also unserer aller Besessenheit, baut Baumann Kathedralen, damit der Geist, der uns vermüllt, sich vielleicht doch noch zwingen lässt, einen Teil seiner Macht an uns abzutreten, und wir im Gegenzug uns bereitfinden, den Müll und das Gift als unsere Schicksalsmacht anzuerkennen und ihnen die höchste Aufmerksamkeit zu widmen. Anbetung war schon immer höchste Form der Selbstvergewisserung des Menschen über sein Schicksal. In dieser Hinsicht unterschieden sich für den Künstler Gott und Müll nicht.

Das Überzeugende an Baumanns formalen Konzeptionen (seien es die Vorschläge für die Gestaltung der Abfallbeseitigungsanlage Atzenhof oder die für die architektonische Neuformulierung des Regierungsviertels in Bonn, seien es die für die Gestaltung eines Altars in einer ruinösen (!) gotischen Kathedrale oder die von *Restauranttischen für schwermetallvergiftete Fresser*) liegt in der Synthese von technischer Funktionstüchtigkeit und psychodynamischer Symbolbildung. Dabei hat Baumann zum Beispiel für den Entwurf der Abfallkathedrale nicht nur tradierte Formensprachen ägyptischer Pyramiden und Flugzeughangars addiert. Der Anklang an diese Formen ist gewollt und wünschenswert (monumentale Sakralbauten waren immer auch von neuen technischen Meisterleistungen abhängig); meines Wissens aber hat bisher kein anderer Künstler zu solchen

deal adequately with the waste and destructive outcomes of production and consumerism.

But it is precisely those things that we cannot deal with, those that do not comply with our wishes, which define our reality. Things we are unable to deal with make us afraid, and things that make us afraid and define our destiny beyond all individual effort, as an overwhelming reality, these things we must seek to exorcise through ritual.

Culture develops such ritual forms at different levels; the most significant being those that attempted, in the shape of religious architecture, to force God, the gods, spirits and ideas into a container, into a delimited area. Nowhere does the demon of our age appear to show itself as so overwhelming and so defining of reality quite as much as in the transformation of the world into an uncontrollable, dead, lunar toxic waste dump, hostile to life.

Baumann constructs cathedrals to this demon, that is, to the obsession we all share, so that the spirit overwhelming us with garbage can perhaps still be compelled to hand over a part of its power to us and we, in exchange, can become ready to acknowledge the refuse and the toxins as our vital force and to devote our greatest attention to them. Worship has always been man's highest form of self-assurance with respect to his destiny. In this regard, there is no distinction for the artist between God and garbage.

The truly convincing aspect of Baumann's formal conceptions (whether his suggestions for the design of the waste disposal site Atzenhof, those for the architectural re-composition of the government district in Bonn, whether for the design of an altar in a ruinous (!) Gothic cathedral, or *restaurant tables for gourmands poisoned by heavy metals*) lies in their synthesis of technical functionality and a psychodynamic creation of symbols. In this context, Baumann not only combined the traditional formal languages of Egyptian pyramids and aircraft hangars, for example, in the case of his design for the garbage cathedrals. The echo of such forms is intended and desirable (monumental religious buildings have always also been dependent on masterly, new technical achievements); but to my knowledge, to date no other artist apart from Baumann has found architectural

Architekturkonzepten wie Baumann gefunden. Zweifellos sind diese Konzepte aus seiner Arbeit als Bildhauer entstanden, sie sind aber keineswegs nur monumentalisierte Skulpturen. Von ihrer Symbol- und Formkraft sind sie eigenständig projektierte Visionen, die meiner Ansicht nach zum ersten Mal die Heiligkeit des unser Menschenschicksal bestimmenden Mülls, des Gifts und der Strahlung erfahrbar werden lassen.

Mit Hinweis auf Baumanns Konzepte für die Kathedralen des Abfalls können wir uns endlich auf unsere entscheidende Kulturproduktion, nämlich die von Tod und Verderben in unseren Städten einlassen; wir brauchen den tödlichen und deswegen anbetungswürdigen Dreck nicht mehr in lebensfernen Gegenden unter die Erde zu verbannen oder durch allgegenwärtige Verteilung zu minimieren, das heißt zu versuchen, ihn unsichtbar werden zu lassen. Je schneller wir uns aber zu der tödlichen, schicksalbestimmenden Wendung unserer eigenen Werke gegen uns selbst bekennen, indem wir den selbsterzeugten Tod in Kathedralen bannen, desto begründeter wird die Hoffnung, dass sich die strafenden Götter noch einmal besänftigen lassen.

concepts for them. Without doubt, these concepts have evolved from his work as a sculptor, but they are by no means simply monumentalised sculptures. In terms of their symbolic and formal power they are independently projected visions, which in my opinion enable us, for the first time, to experience the holiness of the garbage, toxins and radiation that are defining the fate of humanity.

In the context of Baumann's concepts for cathedrals of garbage, we can at last engage with our decisive cultural production, that is, the production of death and decay in our cities; we no longer need to banish the deadly and thus worship-worthy filth to areas far from life and underground, or to minimise it through omnipresent distribution, that is, to attempt to make it become invisible. The quicker we can acknowledge the deadly, fateful turning of our own works against us, by banishing this self-produced death into cathedrals, the more foundation there will be for hope that these punishing gods will allow themselves to be placated once more.

ÜBER DEN ZUSTAND DER GESELLSCHAFT

ON THE CONDITION OF SOCIETY

Winfried Baumanns Werke aus, über und für den Müll

Winfried Baumann's works with, about and for garbage

Harriet Zilch

Im November 1985 schreibt Winfried Baumann an Manfred Schneckenburger, den künstlerischen Leiter der documenta 8: „Schon seit einiger Zeit beschäftige ich mich als Bildhauer mit der in heutiger Zeit zusehends zu einer Überlebensfrage der zivilisierten Menschheit avancierten ökologischen Problematik. Diese Thematik in dieser Globalität ist sicherlich gerade im Bereich der Kunst nicht neu. Meines Erachtens reicht es jedoch nicht, diesbezüglich Kunst und die künstlerische Auseinandersetzung mit diesen Problemen in Museen und Ausstellungen durch entsprechende, der räumlichen Begrenztheit dieser Räume unterworfene Werke, darzustellen, da die räumliche Enge es dort nicht zulässt, eine der Größe und dem Gewicht der Problematik entsprechende Aussage darzustellen. Kunst und Kunstwerke müssen dort entstehen, wo die hierdurch angespro-

In November 1985 Winfried Baumann wrote to Manfred Schneckenburger, the artistic director of documenta 8: "For some time now, as a sculptor I have been concerned with the ecological issues that are becoming more and more a question of survival for civilised humanity today. These themes in this globality are nothing new, certainly, particularly in the field of art. In my opinion, however, in this regard it is not enough to present art and an artistic discussion of this set of problems in museums and exhibitions, using works subordinated to the spatial restrictions of such places; the lack of space there prevents us from making a corresponding statement about the problem's size and importance. Art and artworks need to be produced in the places where the problems they address exist, that is, in the open landscape, in natural surroundings in general, and not inside a narrow space."

chenen Probleme bestehen, nämlich in der freien Landschaft, in der Natur ganz allgemein und nicht in einem engen Raum."

Von dieser Prämisse ausgehend, legt Winfried Baumann das Konzept zu einer Großplastik[1] dar, die „als bleibendes Mahnmal für die Erde und deren Ausbeutung" errichtet und „in deren Innern dann Giftmüll" eingelagert werden soll. Die geplante Skulptur, die in ihrer Form an eine langgezogene Dreieckspyramide erinnert, könne eine ökologische Problematik visualisieren, die ansonsten „unsichtbar unter der Erde" vergraben aus dem Blickfeld und Gedächtnis der Bevölkerung verschwinden würde.[2] In seinem Antwortschreiben beurteilt Manfred Schneckenburger das Projekt als „außerordentlich interessant" und attestiert, es könne „einer Problematik unserer Gegenwart eine fast mythische Form geben". Für die documenta 8 sei die Planung jedoch „zu umfassend und expansiv".[3]

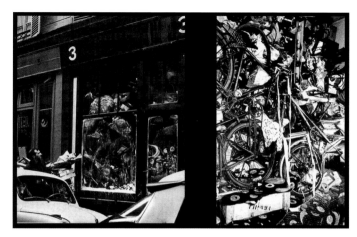

Arman, *Le Plein*, Galerie Iris Clert, Paris 1960
Arman, *Le Plein*, Gallery Iris Clert, Paris 1960

„Eine Hochkultur ist zunächst einmal eine Kultur, die eine Müllkippe hat."[4]

Seit den 1960er-Jahren führt die wirtschaftliche Prosperität der Wohlstandsgesellschaften zu einem immensen Anstieg der Müllproduktion. In diesem Kontext formuliert der französische Psychoanalytiker und Publizist Jacques Lacan die These, das Verhältnis einer Gesellschaft zum selbst produzierten Abfall sei ein Gradmesser zivilisatorischer Entwicklung. Auch ließe sich der Entwicklungsstand einer Gemeinschaft über das definieren, was sie als wertlos empfindet und wegwirft. Die kontinuierlich anwachsenden Abfallvolumina provozieren generelle Fragen zum Umgang mit dem Müll: Was empfindet eine Gesellschaft als Abfall? Wie sehen der industriegesellschaftliche Umgang mit und die Kommunikation über den Müll aus? Wie verändern sich Wertigkeiten und Verwendungsketten? Was erzählt der Zeitpunkt der Abwertung eines Objektes über die Alltagskultur?

Auch die künstlerische Kritik richtet sich in den 1960er-Jahren gegen einen unreflektiert steigenden Warenkonsum. Müll als materielles Überbleibsel des Überflusses wird in diesem Kontext verstärkt zum künstlerischen Werkstoff: Unter dem Titel *Le Plein* schichtet Arman, Objektkünstler und Mitbegründer des Nouveau Réalisme, im Oktober 1960 zusammengesammelten Sperrmüll bis unter die Decke der Pariser Galerie von Iris Clert.

Starting out from this premise, Winfried Baumann presented the concept for a large-scale sculpture[1] to be constructed "as a lasting monument to the earth and its exploitation" and, "inside which poisonous refuse" was to be stored. The planned sculpture, reminiscent in its form of an elongated triangular pyramid, could visualise a set of ecological problems that would otherwise be buried "invisibly beneath the earth", made to disappear from the population's view and their memories.[2] In his answering letter Manfred Schneckenburger judged the project to be "extraordinarily interesting" and attests that it could "lend an almost mythical form to a contemporary problem". For documenta 8, however, the project was "too all-encompassing and expansive".[3]

"A high culture is primarily a culture with a waste dump."[4]

Since the 1960s the economic prosperity of wealthy societies has led to an immense rise in the production of waste. In this context French psychoanalyst and publicist Jacques Lacan formulated the thesis that a society's relationship to the waste it produces is a measure of civilisatory development. A community's state of development, he contended, can also be defined by what it regards as worthless and therefore throws away. The constantly increasing volumes of waste prompt universal questions about our handling of garbage: What does a society regard as

Die Künstlerin Louise Nevelson trägt 1959/60 auf den Straßen von New York Abfall zusammen, den sie in goldene Farbe taucht und zu Altargemälden und Altarwänden zusammenfügt. Die „armen" Materialien, der Sperrmüll und die Fundstücke, werden auf diesem Weg überhöht und in einen neuen gedanklichen Kontext gestellt.[5]

Die Kunst der Umwidmung

In einem Prozess künstlerischer Umwidmung kann aus dem Abstoßenden etwas Anziehendes, aus dem Bedeutungslosen etwas Außerordentliches, aus dem Schäbigen etwas Wertvolles werden. Strategien der künstlerischen Transformation zeigen sich bereits zu Beginn des 20. Jahrhunderts: Künstler beschäftigen sich mit den Hinterlassenschaften der Gesellschaft und nutzen diese mit disparaten Aussagen als Ausgangsmaterial für Kunstwerke. So verwendet Marcel Duchamp 1917 für seine Arbeit *Fountain*[6] ein Pissoir-Becken, das er mit dem fiktiven Künstlernamen „R. Mutt" signiert und zur Jahresausstellung der Society of Independent Artists in New York einreicht. Die Geste des Signierens und die Loslösung von seiner eigentlichen Funktion verleihen dem Pissoir eine neue Bedeutung. Durch die künstlerische Umwidmung erhält der industriell produzierte Gebrauchsgegenstand eine neue Wertigkeit.

Drei Jahre später, 1920, verwendet Kurt Schwitters Lumpenfetzen, Straßenbahnbillets, Deckel von Konservendosen und andere wertlose Materialien für seine *Merzbilder*.[7] Als einer der ersten Künstler „recycelt" er für diese Materialmontagen ausrangierte und verbrauchte Überbleibsel der Industriegesellschaft. Schwitters selbst spricht von einem Prozess der „Entnutzung"[8], da er die Gegenstände von ihrer ursprünglichen Funktion loslöst und in einen gänzlich neuen Kontext stellt. Dennoch thematisieren die *Merzbilder* immer auch die Gebrauchsgeschichte der umgewidmeten Alltagsmaterialien, da ihr Charakter als „authentische Bruchstücke des täglichen Lebens"[9] erhalten bleibt.

Diese frühen Werke stehen im Kontext einer weitreichenden Umwertung des tradierten Materialbegriffs: Um 1900 löst sich die künstlerische Avantgarde von den etablierten Werkstoffen, und das Spektrum der im Kunstkontext verwendeten Materialien wird in den folgenden Jahrzehnten nahezu unüberschaubar.

garbage? What is the handling of garbage and communication about garbage like in industrial societies? How do values and chains of usage change? What does the moment of an object's devaluation tell us about everyday culture in a society?

Artistic criticism was also directed towards the unreflected increase in consumerism in the 1960s. Garbage, as the material remains of affluence, became an art material more and more frequently in this context: in October 1960 – in a work entitled *Le Plein*, Arman, object artist and co-founder of Nouveau Réalisme, collected piles of bulky refuse in the Parisian gallery belonging to Iris Clert until it almost came up to the ceiling. Artist Louise Nevelson gathered garbage from the streets of New York in 1959/60, which she then dipped into gold paint and assembled to create altar paintings and altar panels. In this way the "poor" materials, the bulky refuse and found objects, are glorified and placed in a fresh intellectual context.[5]

The Art of Re-Dedication

In a process of artistic re-dedication, something repugnant can be turned into an attractive object, something meaningless can become unusual and something shabby can be made valuable. Strategies of artistic transformation already appeared in the early 20th century: artists were concerned with the remains society left behind, and used them as the starting materials for works of art with extremely different messages. Thus, for example, in 1917 Marcel Duchamp used a urinal basin for his work *Fountain*[6], signing it with the fictive artist's name "R. Mutt" and submitting it to the annual exhibition of the Society of Independent Artists in New York. The gesture of signing and separating the object from its true function lent fresh meaning to the urinal. By means of this artistic re-dedication the industrially produced, functional object is given a new value.

Three years later, in 1920, Kurt Schwitters used scraps of rags, tram tickets, lids of food tins and other worthless materials for his *Merz Pictures*[7]. He was one of the first artists to "recycle" discarded, consumed remains of industrial society for these montages of materials. Schwitters himself spoke of a process of "de-utilisation"[8], as he robbed the objects of their original function and set them into an entirely new context. Nevertheless, the

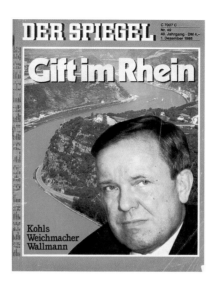

Titel DER SPIEGEL,
49/1986
Cover DER SPIEGEL,
49/1986

theme of the *Merz Pictures* is always the history of usage behind re-dedicated everyday materials, as their character as "authentic fragments of daily life"[9] is retained.

These early works can be seen in the context of a far-reaching re-evaluation of the traditional concept of material: around 1900 the artistic avant-garde moved away from the established materials of art and the range of materials used in the art context became immense in the decades that followed. Artists directed their interest towards materials explicitly representing the contemporary world they lived in. The attraction was that as yet, no traditional aesthetics and predefined canon of motifs existed for the use of such new materials. Besides materials like plastic, neon tubing or the so-called *raw materials*[10], garbage, found objects and pre-used objects were now utilised. The aim was to integrate life into art: each thing found, every *objet trouvé*, not only expunged the notion of the artist as a creator but also transposed a story of its own, as a kind of store – the history of its production, its function and its usage.

Deep Silence and other Residues

Since the mid 1980s Winfried Baumann has been employing garbage, slag, used oil and other waste products of consumer society as material for his sculptural work: in the installation *Deep Silence* (1986) he tipped 16 cubic metres of slag from a waste incineration plant into a basin filled with 800 litres of waste oil. The grey mountain of slag rises with majesty from a deep black lake. *Deep Silence* develops an unusual optical charm through its reduced formal language, which seems to cite works of Minimal Art, and the reflecting surface of the waste oil. However, the material aesthetics remain ambivalent, as they are counteracted by the accompanying olfactory phenomena and our knowledge of the industrial waste materials involved. A sense of uncertainty is triggered, perhaps comparable with the discovery of a pool of oil on the road. The light separates the oil into the full spectrum, making it shimmer in all the colours of the rainbow. The iridescent play of colours unfolds a strange beauty until the moment when the human processes of perception and recognition begin to grasp the puddle as stinking, environmentally damaging pollution.

Künstler richten ihr Interesse auf Werkstoffe, die explizit ihre Gegenwart repräsentieren. Der Reiz liegt darin, dass für die Verwendung der neuen Werkstoffe noch keine tradierte Ästhetik und kein definierter Motivkanon existieren. Neben Materialien wie Kunststoff, Neonröhren oder den sogenannten *raw materials*[10] werden auch Abfall, Gefundenes und Benutztes verwendet. Ziel ist es, das Leben in die Kunst zu integrieren, denn jedes gefundene Ding, jedes *objet trouvé*, durchkreuzt nicht nur die Vorstellung vom Künstler als Schöpfer, sondern transportiert als eine Art Speicher auch seine eigene Geschichte, die Geschichte seiner Herstellung, seiner Funktion und seines Benutztwerdens.

Deep Silence und andere Hinterlassenschaften

Seit Mitte der 1980er-Jahren verwendet Winfried Baumann Müll, Schlacke, Altöl und andere Abfallprodukte der Konsumgesellschaft als Werkstoff für seine bildhauerische Arbeit: Für seine Installation *Deep Silence* (1986) schüttet er 16 Kubikmeter Schlacke aus einer Müllverbrennungsanlage in ein Becken aus 800 Liter Altöl. Hoheitlich erhebt sich der graue Schlackeberg aus tiefschwarzer See. In seiner reduzierten Formsprache, die Werke der Minimal Art zu zitieren scheint, und mit der spiegelnden Oberfläche des Altöls entwickelt *Deep Silence* einen außergewöhnlichen optischen Reiz. Die Materialästhetik bleibt

jedoch ambivalent, da sie durch die olfaktorischen Begleiter-scheinungen und die Kenntnis über die industriellen Reststoffe konterkariert wird. Es stellt sich ein Gefühl der Verunsicherung ein, vielleicht vergleichbar mit dem Entdecken einer Ölpfütze auf dem Asphalt. Spektral zerlegt das Licht das Öl und lässt es in allen Farben des Regenbogens schimmern. Das changieren-de Farbspiel entfaltet eine eigenwillige Schönheit bis hin zu dem Moment, in dem der menschliche Wahrnehmungs- und Erkenntnisprozess in der Pfütze eine stinkende und umwelt-schädigende Verunreinigung erkennt.

Nicht zufällig entsteht *Deep Silence* im Jahr 1986: Im April ereignet sich die Nuklearkatastrophe von Tschernobyl; im No-vember fließt – nach einem Großbrand in einer Lagerhalle des Schweizer Chemieunternehmens Sandoz in Basel – hochgifti-ges Löschwasser in den Rhein und löst ein gigantisches Fisch-sterben aus. Neben diesen Umweltkatastrophen ist für Winfried Baumann die Auseinandersetzung mit dem Bühnenstück *Totenfloß* zentral, welches er 1986 am Staatstheater Stuttgart[11] sieht. Das Stück des deutschen Dramatikers Harald Mueller entwirft ein bedrückendes Endzeitszenario in einem atomar wie chemisch verseuchten Deutschland des Jahres 2050.[12]

Winfried Baumann wählt in der Folgezeit wiederholt Schla-cke als Werkstoff für seine bildhauerische Arbeit. In einem kreativen Prozess der Neukonnotation gewinnt das eigentlich abstoßende Abfallprodukt eine spezifische Ästhetik. Dies mani-festiert sich beispielsweise in der Installation *Ohne Regung ruht das Meer*, die Baumann 1989 im Nürnberger Kunsthaus präsen-tiert: In mit Altöl angefüllten, auf dem Boden stehenden Stahl-becken streut er Felder aus Schlacke. Die formale Präzision und atmosphärische Dichte des Arrangements, aber auch der poe-tische Werktitel, der Assoziationen mit Landschaftsgemälden von Caspar David Friedrich weckt, erzeugen eine Erwartung, die durch die Verwendung der industriellen Reststoffe konterkariert wird. Mit der Geste leiser und zugleich subversiver Provokation fordert Baumann ein sinnliches Erleben heraus, welches jedoch durch das Erkennen des Materials torpediert wird. Das ebenso kluge wie komplexe Täuschungsmanöver löst einen Prozess der Auseinandersetzung aus.

It was no coincidence that *Deep Silence* was made in 1986: in April the Chernobyl nuclear catastrophe occurred; in November – after a major fire in a warehouse belonging to the Swiss chem-ical company Sandoz in Basel – highly poisonous fire-fighting water flowed into the Rhine and triggered the death of fish on a gigantic scale. Besides these environmental catastrophes, discussion of the stage play *Totenfloß* was highly significant for Winfried Baumann, who saw it at the Staatstheater Stuttgart in 1986.[11] This play by German dramatist Harald Mueller projects an impressive apocalyptic scenario into a Germany polluted by chemicals and nuclear waste in the year 2050.[12]

In the following period Winfried Baumann repeatedly chose slag as a material for his sculptural work. In a creative process of re-connotation the actually repugnant waste product developed specific aesthetics of its own. This was manifest, for example, in the installation *Ohne Regung ruht das Meer*, which Baumann presented at the Kunsthaus Nuremberg in 1989: here, he distributed piles of slag in steel basins full of waste oil standing on the gallery floor. The formal precision and atmospheric concentration of the arrangement as well as the poetic title of the work (Motionless, the sea reposes), which awakens associa-tions with landscape paintings by Caspar David Friedrich, create an expectation that is counteracted by the use of the industrial waste materials. Through the gesture of quiet but also subver-sive provocation, Baumann triggers a sensual experience, which is then torpedoed, however, by our recognition of the materials. This deceptive manoeuvre, both clever and complex, prompts a process of debate.

The Aesthetics of Disorder

In 1883 Vincent van Gogh described a visit to the municipal refuse tip with great euphoria in a letter to his friend and fellow painter Anthon van Rappard: "Today I was in the place where the bin men take the refuse. Golly, it was beautiful [...]. It would be something for one of Andersen's fairy-tales, this collection of abandoned buckets, baskets, kettles, army cooking pots, oil cans, wire, street lamps, stove pipes [...]. I will probably dream about it tonight."[13] In this letter Van Gogh is manifestly enthusiastic about the disorder, the chaotic accumulation of objects whose

Zur Ästhetik des Ungeordneten

Vincent van Gogh beschreibt 1883 in einem Brief an seinen Freund und Malerkollegen Anthon van Rappard den Besuch der städtischen Müllhalde äußerst euphorisch: „Heute bin ich auf dem Fleck gewesen, wo die Aschemänner Müll hinbringen. Donnerwetter war das schön [...]. Das wäre was für ein Andersensches Märchen, diese Sammlung ausgedienter Eimer, Körbe, Kessel, Soldatenkochgeschirre, Ölkannen, Draht, Straßenlaternen, Ofenrohre [...]. Heute Nacht werde ich wahrscheinlich davon träumen."[13] Van Gogh zeigt sich in diesem Schreiben begeistert von der Ästhetik des Ungeordneten, der chaotischen Ansammlung von Objekten, über deren endgültige Unbrauchbarkeit noch nicht entschieden wurde. Denn im Gegensatz zu den heutigen Mülldeponien aus zerhäckseltem und amalgamiertem Abfall präsentiert sich der öffentlich entsorgte Müll zu van Goghs Zeiten noch als eine Ansammlung individueller Dinge. Durch ihre spezifische Historizität werden die abgenutzten und entsorgten Objekte zu Vanitassymbolen der Moderne. Für zahlreiche künstlerische Arbeiten – wie zum Beispiel für Armans beschriebene Installation *Le Plein* – ist dieser Aspekt zentral: Die verwendeten Objekte erzählen als *objet trouvés* auch stets ihre individuelle Geschichte.

Diese Motiv- wie Materialtradition greift Winfried Baumann in seinen Werken auf, radikalisiert sie jedoch zugleich, da es sich bei der vielfach verwendeten Schlacke nicht um irgendein Abfallprodukt handelt. Schlacke ist kein individuelles Fundstück, das sich künstlerisch recyceln ließe. Die von ihm verwendete Schlacke ist die Abfallmasse, die bei der Müllverbrennung zurückbleibt. Somit ist sie ein Konzentrat und das ultimative Ende der Abfallkette. Sie erzählt keine spezifische Geschichte, sondern ist ein kollektives, anonymes Sekret. Schlacke repräsentiert wie kaum ein anderer Stoff explizit unsere Gegenwart: Als ein Vanitassymbol der Gegenwart erzählt sie von Konsum, Überfluss und menschlicher Hybris.

Das Schäbige und das Allerheiligste

Seine Werke präsentiert Winfried Baumann vielfach in Kirchenräumen oder in sakralem Umfeld. Dabei entwickelt er ein vielschichtiges Spiel mit religiöser Ikonografie: Im Kontext seiner

ultimate uselessness has not been defined yet. By contrast to today's refuse dumps comprising shredded and amalgamated waste, in van Gogh's time the publicly disposed-of waste still appeared as a collection of individual objects. Due to their specific historicity, the worn and discarded objects become the vanitas symbols of the modern age. This is a central aspect for numerous artistic works – like Arman's installation *Le Plein* described above: the objects used, as *objet trouvés*, always tell their individual stories as well.

Winfried Baumann takes up this tradition of motifs and materials in his works, but immediately radicalises it further: in the case of the frequently used slag, this is not just about some random waste product. Slag is not an individual found object, which could be recycled artistically. The slag used by him is the mass of waste material left behind when refuse is incinerated. This means that it is a concentrate, and the final link in the refuse chain. It narrates no specific story but is a collective, anonymous secretion. Like very few other materials, slag represents our contemporary world explicitly: as a vanitas symbol of the present day, it tells of consumerism, superfluity and human hybris.

Meanness and the Holiest of Holies

In many cases Winfried Baumann presents his works in churches or within a religious environment. Here, he develops a complex play with religious iconography: in the context of his installation *Die Hinterlassenschaft als Gabe* (The Legacy as a Gift), which Baumann presented in the ruins of St. Catherine's Church[14] in Nuremberg in 1987, he heaped slag as a "sacrificial offering" on a table covered in lead, reminiscent of an altar in its appearance and position. Water dyed red with pigment flows into a channel, associated with the blood of a sacrifice.

In this work – and also in the series of works *Requiem* (1996) and the pieces *Sanctus* (1999) or *Erntedank* (Harvest Festival 2000) – the mean and shabby is confronted with the holiest of holies. The slag is implemented in a process of making sacred and ennobling within the church space. Here, however, the industrial waste product always remains visible. It is piled on an altar, directed into a basin, or presented in glass display cabinets. The series of works *Reliquienschrein*[15] (Reliquary Casket,

Installation *Die Hinterlassenschaft als Gabe*, die Baumann 1987 in der Nürnberger Katharinenruine[14] präsentiert, häuft er Schlacke als eine „Opfergabe" auf einem bleiummantelten Tisch auf, der in seiner Erscheinung und Position an einen Altar erinnert. In einer Rinne fließt mit Farbpigmenten rot gefärbtes Wasser, welches sich mit Opferblut assoziiert.

In dieser Arbeit – wie auch in der Werkserie *Requiem* (1996) und den Arbeiten *Sanctus* (1999) oder *Erntedank* (2000) – wird das Schäbige mit dem Allerheiligsten konfrontiert. In einem Prozess der Sakralisierung und Nobilitierung wird die Schlacke in den Kirchenraum implementiert. Dabei bleibt das industrielle Abfallprodukt stets sichtbar. Es wird auf einem Altar aufgehäuft, in Becken eingelassen oder in gläsernen Vitrinen präsentiert. Die Werkserie *Reliquienschrein* (2006) zeigt es in mit Blattgold überzogenen Schreinen[15] und die *Erratischen Blöcke*, die an grob behauene, archaische Opfersteine erinnern, tragen ein Herz aus Schlacke in ihrem Inneren. Schmale Einschnitte im Muschelkalk, durch Panzerglas versiegelt, ermöglichen den Blick auf dieses schwarze Herz.

In der allgemeinen Wahrnehmung ist Abfall eine Belanglosigkeit, die es zu entsorgen gilt und die explizit in Vergessenheit geraten soll. Gegensätzliches will Religion und Kunst, die für sich einen Ewigkeitsanspruch formulieren. Winfried Baumann nutzt diesen Anspruch: Seine Werke aus, über und für den Müll sind Speicher, die den Abfall präsent halten. Die Ausscheidungen der Konsumgesellschaft werden nicht nivelliert, sondern archiviert.[16] Dieser zentrale Aspekt ist bereits in dem eingangs zitierten Schreiben an Manfred Schneckenburger formuliert. Hier fordert Winfried Baumann eine „Totenstätte für den Giftmüll", die ein Übersehen unmöglich und die Konfrontation unausweichlich macht.[17]

Let's shop till we drop: Kathedralen für den Müll

Durch die Präsentation seiner Werke im sakralen Kontext thematisiert Winfried Baumann den gesellschaftlichen Überkonsum, repräsentiert durch seine materiellen Hinterlassenschaften, auch als eine moderne Ersatzreligion. Schon seit den 1960er-Jahren geht das allgemeine Konsumniveau der Industrienationen weit über die Erfüllung profaner Grundbedürfnisse hinaus. Der Konsum erscheint vielmehr als eine neue Gottheit,

Winfried Baumann, *Die Wächter von Fukushima*, 2011
Winfried Baumann, *The Guardians of Fukushima*, 2011

2006) displays it in gold-covered caskets and the *Erratischen Blöcke* (Erratic Boulders), which are reminiscent of roughly hewn, archaic sacrificial stones, conceal a heart of slag within. Narrow cuts in the shell limestone, sealed with bullet-proof glass, allow us to view their black hearts.

Garbage is universally perceived as an irrelevance that needs to be disposed of: our explicit intention is to forget about it. Religion and art seek the exact opposite, each formulating its own claim to eternity. Winfried Baumann uses this claim: his works made from, about and for garbage are stores that keep refuse available. The excretions of the consumer society are not smoothed over but archived.[16] This central aspect was formulated already in the letter to Manfred Schneckenburger quoted at the beginning. There, Winfried Baumann demands a "grave for poisonous waste", which would make it impossible to overlook and make confrontation unavoidable.[17]

Let's shop till we drop: Cathedrals for garbage

By presenting his works in a sacred context Winfried Baumann also thematises society's excess consumerism – represented by its material waste products – as a modern replacement religion. Even since the 1960s the general level of consumption in the

als Sinnstifter und als Hauptzweck aller Lebensanstrengungen. So finden Menschen heute auch zumeist in sehr weltlichen Konsumtempeln zusammen.

Von dieser generellen Beobachtung ausgehend, erscheint es konsequent, dem materiellen Erbe dieser Ersatzreligion eine Kathedrale zu errichten. Winfried Baumann beginnt 1986 mit seiner konzeptuellen Arbeit an den *Kathedralen für den Müll*: Ausgehend von den Proportionsschemata sakraler Bauwerke entwirft er komplexe Mülldeponien und Entsorgungsanlagen, die als monumentale Kultorte erscheinen. Das Spektrum der Bezugnahme umfasst den Kölner Dom und die Aachener Pfalzkapelle ebenso wie die Hagia Sophia, das Taj Mahal, die Pyramiden von Gizeh oder die Omar Bin al Khattab Moschee in Doha. Andere Entwürfe für Sondermülldeponien zitieren den Jing'an Tempel in Shanghai oder den Himmelstempel in Peking. Winfried Baumann zeichnet Konstruktionspläne und baut Modelle aus Eisen, Beton, Gips und Holz. Diese Modelle sind autonome bildhauerische Arbeiten und zugleich dienen sie als Entwürfe für Monumentalplastiken. Maßgeblich ist für Baumann stets die technische Funktionsfähigkeit seiner Entsorgungsanlagen. Die Entwürfe und die geplanten Wände mit einer Mauerstärke von 12 Metern berücksichtigen bestehende Sicherheitsfragen und reflektieren zugleich kultische Aspekte.

Die *Kathedralen für den Müll* formulieren Fragen, die den Installationen mit Altöl und Schlacke ebenso inhärent sind. Auch im Kontext der Müllarchitektur ist die Sichtbarkeit und konfrontative Präsentation entscheidend: Müll ist heute viel weniger greifbar als noch vor hundert Jahren. Längst erscheint er als diffuse Bedrohung, zugleich überall und nirgends. Für konkret nicht greifbare und damit nicht kontrollierbare Autoritäten hat der Mensch schon immer Orte geschaffen, an dem sich diese diffuse Macht lokalisiert. Warum also nicht auch dem Giftmüll eine Kathedrale bauen? Bereits die schiere Größe der geplanten Architekturen, die an archaische Grabkammern erinnern, würde ein Übersehen der Problematik unmöglich machen. Der Abfall und der Giftmüll würden eine konkrete Verortung erhalten. Sie wären nicht vergraben in unterirdischen Salzstöcken, sondern in „Kathedralen" archiviert, die sichtbare Narben in der Landschaft darstellen würden.

industrial nations has far exceeded the meeting of basic needs. Consumerism is now appearing far more as a new deity, creating meaning and even the main purpose of every effort in life. And so today, people come together mainly in very secularised temples to consumerism.

Starting out from this general observation, it seems logical to build a cathedral for the material residues of our replacement religion. Winfried Baumann began his conceptual work on the *Cathedrals for Garbage* in 1986: starting out from the proportional schemata of sacred buildings, he designed complex refuse dumps and disposal units that resemble monumental cult sites. The range of references here encompasses Cologne cathedral and the Palatinate Chapel in Aachen as well as the Hagia Sophia, the Taj Mahal, the Pyramids of Gizeh and the Omar Bin al Khattab Mosque in Doha. Other designs for hazardous waste depots cite the Jing'an Temple in Shanghai or the Heavenly Temple in Peking. Winfried Baumann draws construction plans and builds models from iron, concrete, plaster and wood. These models are autonomous sculptural works while simultaneously functioning as designs for monumental scultures. The definitive aspect for Baumann is always the technical workability of his disposal systems. The designs and the projected walls with a thickness of 12 metres take into account existing safety issues and reflect cult aspects at the same time.

The *Cathedrals for Garbage* formulate the same questions as those inherent in the installations using waste oil and slag. In the case of the garbage architecture, visibility and confrontational presentation are also decisive: today, refuse is much less tangible than it was even one hundred years ago. For a long time now, it has appeared as a diffuse threat, simultaneously everywhere and nowhere. Man has always found settings for intangible, impossible-to-control authorities, where this diffuse power is situated. So why not build a cathedral for poisonous waste, as well? The sheer size of the planned architecture, which is reminiscent of archaic grave chambers, would already make it impossible to overlook the problems involved. Our garbage and poisonous waste would be give a concrete location. It would not be buried in underground salt mines, but archived in "cathedrals", which would appear as visible scars in the landscape.

Innerhalb dieses Werkkomplexes erscheint das *Urban Mining Project* (2003) zentral. Hier entwirft Winfried Baumann Anlagen zur Rohstoffrückgewinnung nach den Proportionsschemata gotischer Kathedralen. Für die Konzeption ist die geografische Nähe zu einer Metropole zentral, die Baumann in dem eingangs zitierten Brief bereits vorweggenommen hat: „Durch die Wahl des Standorts für die Plastik in der unmittelbaren Nähe einer Stadt soll eine ständige Korrespondenz mit der verbrauchenden und immer mehr Abfall und Giftmüll produzierenden Bevölkerung hergestellt werden, soll der Müll enthaltende ‚stählerne Sarg' Teil des Lebens in der Stadt und ihrer Umgebung werden. Es ist dadurch nicht mehr mit der anonymen Beseitigung des Abfalls und des Giftmülls getan, sondern es entsteht eine peinliche Berührungssituation."[18]

Winfried Baumanns *Kathedralen für den Müll* konfrontieren ebenso wie seine Werke aus industriellen Reststoffen mit der Tatsache, dass die Gesellschaft kontinuierlich mehr Müll produziert. Denn die kapitalistische Wirtschaftsdynamik beruht auf einem stetigen Absatz von Gütern, und wirtschaftliches Wachstum ist an eine massenhafte Objektproduktion wie eine beschleunigte Zirkulation gekoppelt.[19]

Grundsätzlich ändert sich daran nichts, auch wenn in den vergangenen Jahren Modelle des Recyclings, der Wiederverwertung und Umnutzung in den Fokus gerückt sind und sich der Begriff der „Nachhaltigkeit" im Kontext der Produktentwicklung zu einem omnipräsenten Terminus entwickelt hat. Der Konsum erscheint dennoch als neues Opium des Volks und materieller Besitz ist zum bestimmenden Parameter des Daseins geworden. Dieser selbstzerstörerischen Ersatzreligion setzt Winfried Baumann mit seinen Werken aus, über und für den Müll ein verstörendes Mahnmal.

The *Urban Mining Project* (2003) seems to adopt a central position within this complex of work. Here, Winfried Baumann designs complexes for the recycling of raw materials based on the proportions of Gothic cathedrals. Geographic proximity to a metropolis is central to the concept, which Baumann anticipated already in the letter cited at the beginning of this essay: "The intention in selecting the location for the sculpture in direct proximity to a city is to create permanent correspondence with the consumer population, which is also producing more and more refuse and hazardous waste, and for the 'steel coffin' containing waste to become part of life in the city and its surroundings. In this way the issue is not closed with the anonymous removal of garbage and hazardous waste; an embarassing state of contact emerges instead."[18]

Winfried Baumann's *Cathedrals for Garbage*, like his works made from industrial waste materials, confront us with society's production of a continually increasing mass of waste. For the economic dynamics of capitalism are based on the constant marketing of goods, and economic growth is coupled with the mass production of objects and their accelerated circulation.[19] There has been no fundamental change here, although in recent years the focus has moved towards models of recycling, reutilisation and alternative usage, and "sustainability" has become an omnipresent concept in product development. Nevertheless, consumerism manifests as a new opium for the people, and material possessions have become a defining existential parameter. Winfried Baumann erects a disturbing monument to this self-destructive, replacement religion with his works with, about and for garbage.

1 Geplant ist eine ungefähre Größe von „70 mtr Höhe, 70 mtr Breite und 200 mtr Länge".

2 Alle Zitate nach einem Schreiben von Winfried Baumann an Manfred Schneckenburger, datiert auf den 4. November 1985.

3 Alle Zitate nach einem Schreiben von Manfred Schneckenburger an Winfried Baumann, datiert auf den 12. Dezember 1985.

4 Jacques Lacan: „Meine Lehre, ihre Beschaffenheit und ihre Zwecke", in: Jacques Lacan: *Meine Lehre*, übersetzt von Hans-Dieter Gondek, Wien 2008, S. 67–100, hier: S. 73f. [Das Zitat stammt ursprünglich aus dem Vortrag *Mon enseignement, sa nature et ses fins*, den Jacques Lacan am 20. April 1967 in der psychiatrischen Klinik Charles Perrens in Bordeaux hielt.].

5 Louise Nevelson wurde 1899 in Kiew geboren und wanderte mit ihrer Familie 1905 nach Amerika aus. In ihrer Werkserie *Royal Tide* visualisiert sie auch die Vorstellung ihrer Heimat, in Amerika seien die Straßen mit Gold gepflastert.

6 Marcel Duchamp: *Fountain*, 1917, Porzellan, 36 x 48 x 61 cm.

7 vgl. z. B.: Kurt Schwitters: *Merzzeichnung* 141 *Lumpenwurf*, 1920, Collage, Gouache, Linoleum, Stoff, Blech, Gaze, Papier auf Papier, 9,8 x 7,4 cm / 14 x 11,6 cm, Kurt und Ernst Schwitters Stiftung, Hannover.

8 Vgl.: Andrea El-Danasouri: *Kunststoff und Müll. Das Material bei Naum Gabo und Kurt Schwitters*, München 1992, Kap. 5.

9 Walter Benjamin: „Der Autor als Produzent", in: *Gesammelte Schriften in 5 Bänden*, hrsg. von Rolf Tiedemann und Hermann Schweppenhäuser, Frankfurt a. M. 1972–1982, Bd. 2, S. 692.

10 Das Museum für Konkrete Kunst Ingolstadt widmete den *raw materials* eine thematische Gruppenausstellung: *Raw Materials – Vom Baumarkt ins Museum* (26. Mai bis 15. September 2012).

11 Winfried Baumann im Gespräch mit der Autorin am 9. Dezember 2015.

12 Die Umwelt ist vergiftet und die verbliebene Bevölkerung lebt in zu Festungen ausgebauten diktatorisch regierten Städten. Vier Todgeweihte treiben mit einem Floß den Rhein flussabwärts nach Xanten, wo sie sich eine Möglichkeit des Überlebens erhoffen. Die Premiere des Stücks am 5. Oktober 1984 am Theater Oberhausen blieb ohne überregionale Resonanz. Eine Neufassung wurde 1986, nach der Nuklearkatastrophe von Tschernobyl, in Basel, Düsseldorf und Stuttgart aufgeführt. Es folgten Inszenierungen auf über 40 weiteren Bühnen. Auch ein Hörspiel wie ein Fernsehfilm entstanden nach der Bühnenvorlage.

13 Vincent van Gogh: *Sämtliche Briefe*, hrsg. von Fritz Erpel, Bd. 5, Zürich 1968, S. 174.

14 Die Klosterkirche St. Katharina wurde 1945 bei Luftangriffen zerstört und ist als Ruine erhalten. Sie wird heute zumeist für Open-Air-Konzerte und andere Kulturveranstaltungen genutzt.

15 Gold gilt epochen-, kultur-, länder- und religionsübergreifend als das Metall mit dem höchsten ideellen wie realen Wert. Baumann verbindet hier somit gänzlich Konträres, quasi die „Gold- und Pechmarie der Materialikonografie".

16 Ganz anders in der bundesdeutschen Realität: Schlackeberge werden heute meist rekultiviert und zu Naherholungsbieten und Freizeitflächen umgewidmet. Im Ruhrgebiet gehören diese künstlichen Berge inzwischen zu den höchsten Erhebungen der Region. Für den sogenannten „Atzenhofer Hügel" bei Fürth, inzwischen ebenfalls begrünt, hat Baumann bereits in den 1980er-Jahren ein Mahnmal entwickelt. Die *Fürther Nachrichten* fragen in diesem Kontext am 12. Juli 1989: „Brutale Wachhaltung der Müllproblematik oder schön gestaltete Harmonisierung?".

17 Vgl. Anm. 2.

18 Vgl. Anm. 2.

19 Vgl. Reiner Keller: *Müll – Die gesellschaftliche Konstruktion des Wertvollen. Die öffentliche Diskussion über Abfall in Deutschland und Frankreich*, Wiesbaden 2009, S. 21f.

1 The plan was for the following approximate dimensions; "70 m high, 70 m wide and 200 m long".

2 All quotations originate from a letter written by Winfried Baumann to Manfred Schneckenburger dated 4th November 1985.

3 All quotations originate from a letter by Manfred Schneckenburger to Winfried Baumann dated 12th December 1985.

4 Jacques Lacan: "Meine Lehre, ihre Beschaffenheit und ihre Zwecke", in: Jacques Lacan: *Meine Lehre*, translated by Hans-Dieter Gondek, Vienna 2008, pp. 67–100, here: p. 73f. [The quotation originally came from the lecture, *Mon enseignement, sa nature et ses fins*, which Jacques Lacan gave at the psychiatric clinic Charles Perrens in Bordeaux on 20 April 1967].

5 Louise Nevelson was born in Kiev in 1899 and emigrated to America with her family in 1905. In her series of works *Royal Tide* she also visualises the idea in her home country that the streets in America are paved with gold.

6 Marcel Duchamp: *Fountain*, 1917, porcelain, 36 x 48 x 61 cm.

7 Cf., for example, Kurt Schwitters: *Merzzeichnung* 141 Lumpenwurf, 1920, collage, gouache, linoleum, fabric, tin, gauze, paper on paper, 9.8 x 7.4 cm / 14 x 11.6 cm, Kurt and Ernst Schwitters Foundation, Hanover.

8 Cf.: Andrea El-Danasouri: *Kunststoff und Müll. Das Material bei Naum Gabo und Kurt Schwitters*, Munich 1992, Chap. 5.

9 Walter Benjamin: "Der Autor als Produzent", in: *Gesammelte Schriften in 5 Bänden*, ed. by Rolf Tiedemann and Hermann Schweppenhäuser, Frankfurt am Main 1972–1982, vol. 2, p. 692.

10 The Museum für Konkrete Kunst Ingolstadt devoted a thematic group exhibition to raw materials: *Raw Materials – Vom Baumarkt ins Museum* (26 May to 15 September 2012).

11 Winfried Baumann in conversation with the author on 9 December 2015.

12 The environment is poisoned and the remaining population live in fortress-like cities ruled by dictators. Four people condemned to death drift down the Rhine on a raft to Xanten, where they hope there will be a chance of survival. The premiere of the play on 5 October 1984 at the Theater Oberhausen met with no echo beyond the region. A new version was performed in Basel, Düsseldorf and Stuttgart in 1986, after the nuclear catastrophe of Chernobyl. This was followed by productions at more than 40 other theatres. An audio drama as well as a television film were made later, based on the stage version.

13 Vincent van Gogh: *Sämtliche Briefe*, ed. by Fritz Erpel, Vol. 5, Zurich 1968, p. 174.

14 The abbey church of St. Katharina was destroyed in air raids in 1945 and has survived as a ruin. Today, it is used mainly for open-air concerts and other cultural events.

15 Gold is regarded across epochs, cultures, countries and religions as the metal with the greatest ideal as well as real value. Here, therefore, Baumann is combining entirely contrary things: the "Gold Marie and Pitch Marie of material iconography", so to speak.

16 This is very different in Federal German reality: today, slag heaps are usually re-cultivated and rededicated as recreation areas and leisure parks. In the Ruhr area these artificial hills are now among the highest peaks in the region. Baumann already developed a memorial in the 1980s for the so-called "Atzenhofer Hill" near Fürth, also covered in greenery now. In this context, the *Fürther Nachrichten* asked on 12 July 1989: "Brutal reminder of the garbage problem, or charmingly designed harmonisation?"

17 Cf. Note 2.

18 Cf. Note 2.

19 Cf. Reiner Keller: *Müll – Die gesellschaftliche Konstruktion des Wertvollen. Die öffentliche Diskussion über Abfall in Deutschland und Frankreich*, Wiesbaden 2009, p. 21f.

1.1

ANBETUNG UND VEREHRUNG
WORSHIP AND REVERENCE

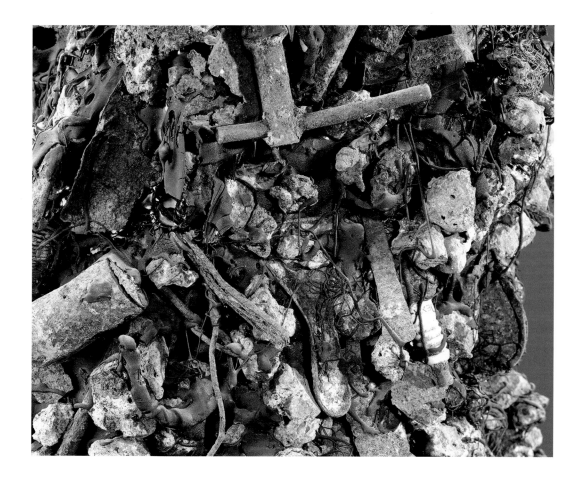

Jahr — Year	2004 / 2014
Maße — Measurements	158 x 52 x 34 cm
Material — Material	Teer, Gips, Schlacke aus der Müllverbrennung
	Tar, plaster, slag from garbage incineration

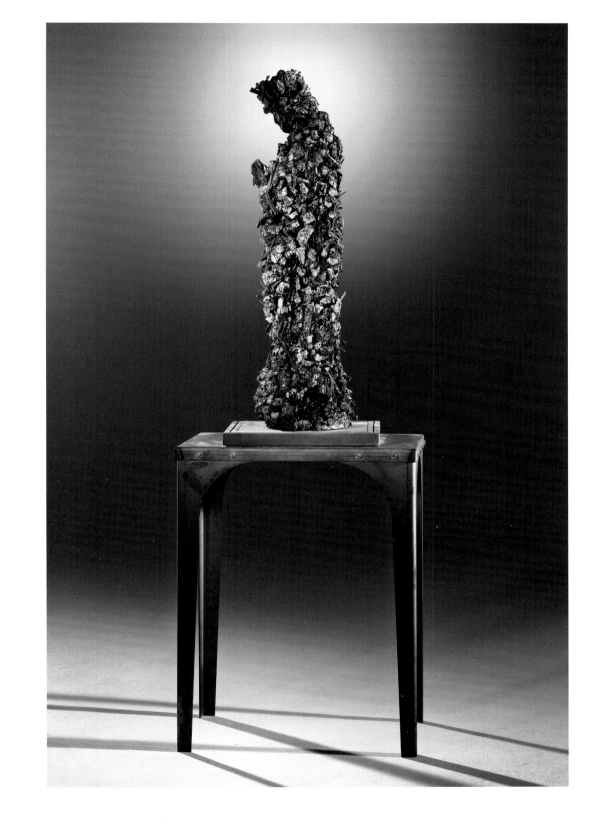

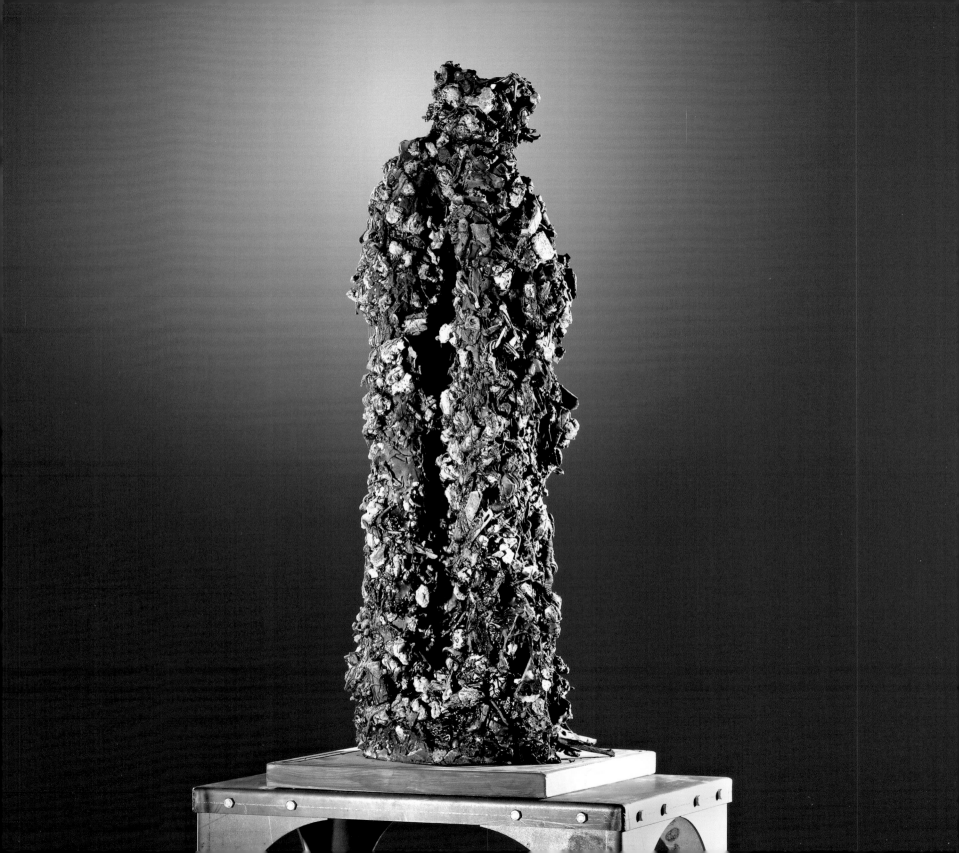

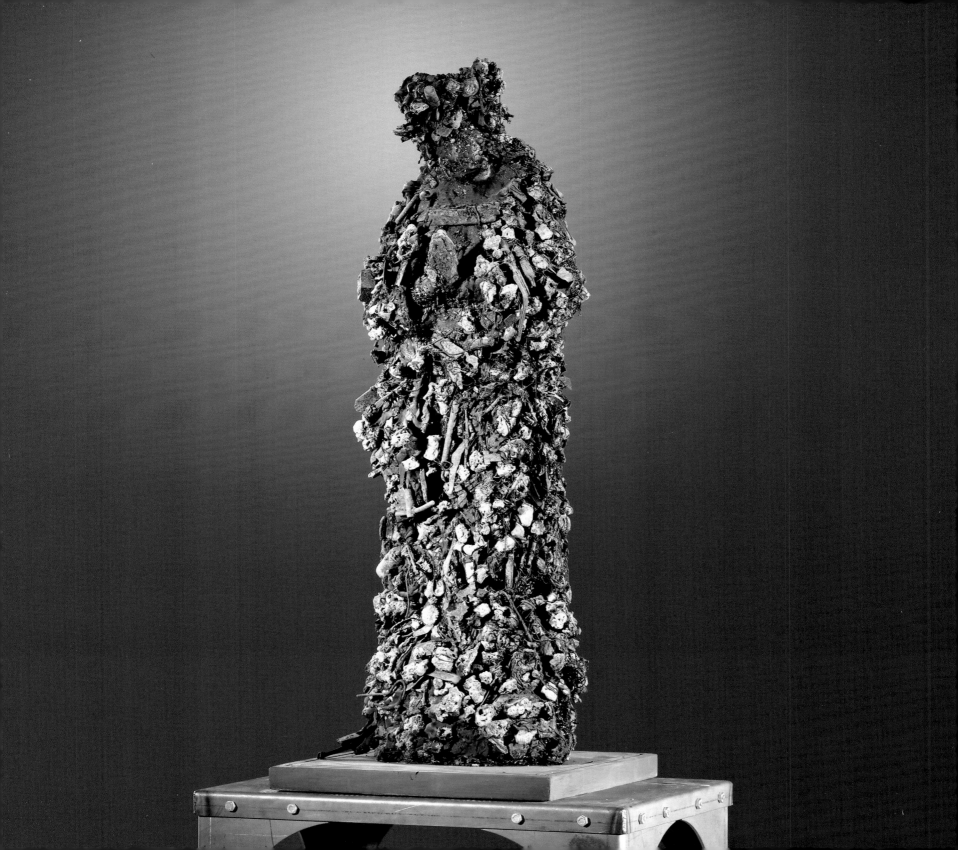

Jahr — Year	2014
Maße — Measurements	122 x 127 x 62 cm
Material — Material	Schlacke aus der Müllverbrennung, Keramik, Messing, Blattgold
	Slag from garbage incineration, ceramics, brass, gold leaf

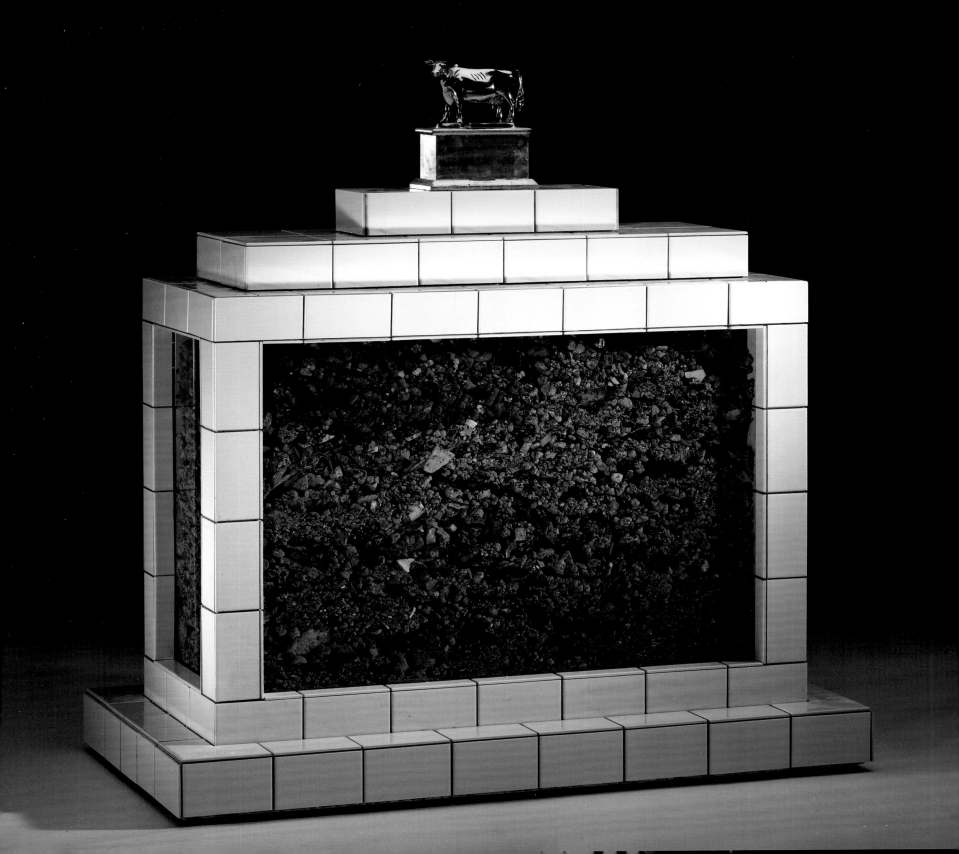

Jahr — Year	2012
Maße — Measurements	120 x 56 x 48 cm
Material — Material	Schlacke aus der Müllverbrennung, Muschelkalk
	Slag from garbage incineration, shell lime

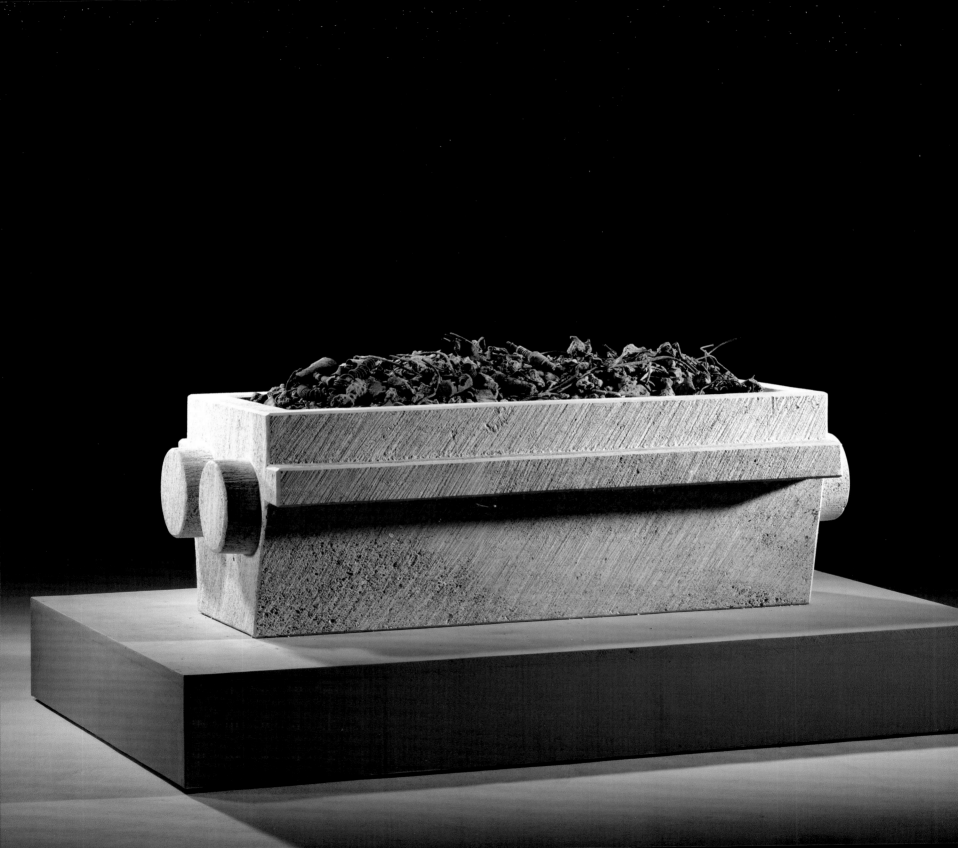

Jahr — Year	2012
Maße — Measurements	74 x 38 x 97 cm
Material — Material	Schlacke aus der Müllverbrennung, Muschelkalk, Eisen
	Slag from garbage incineration, shell lime, iron

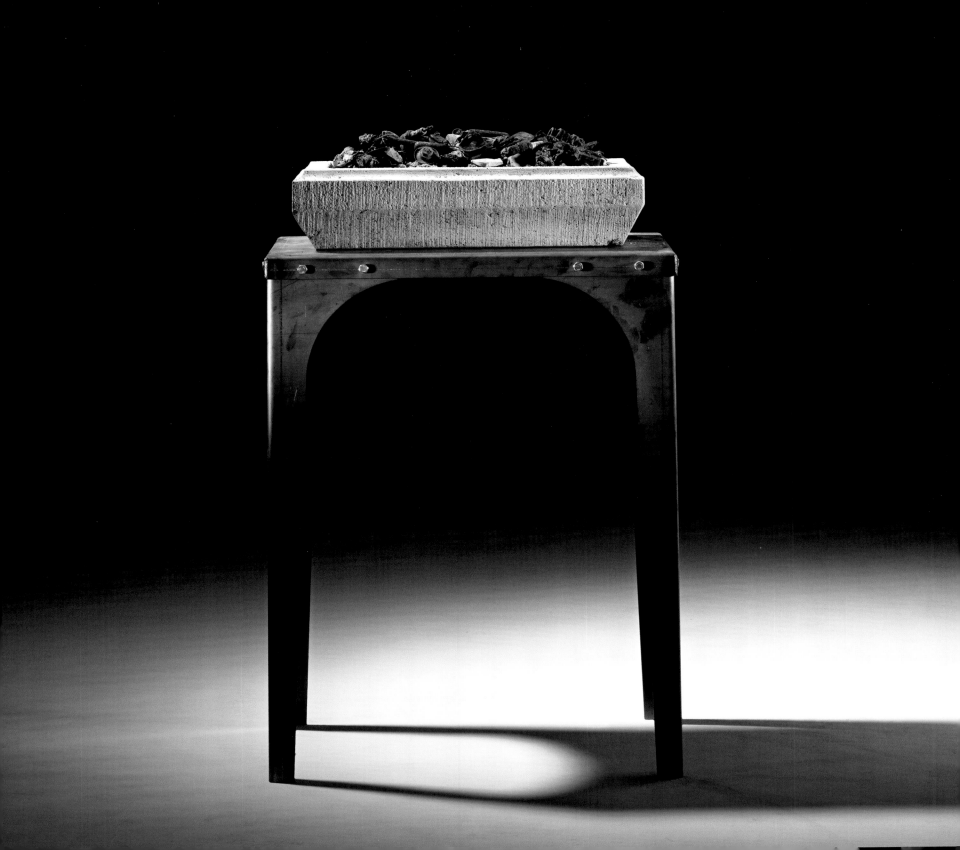

Jahr — Year	2010
Maße — Measurements	88 x 64 x 102 cm
Material — Material	Schlacke aus der Müllverbrennung, Messing, Eisen
	Slag from garbage incineration, brass, gold leaf

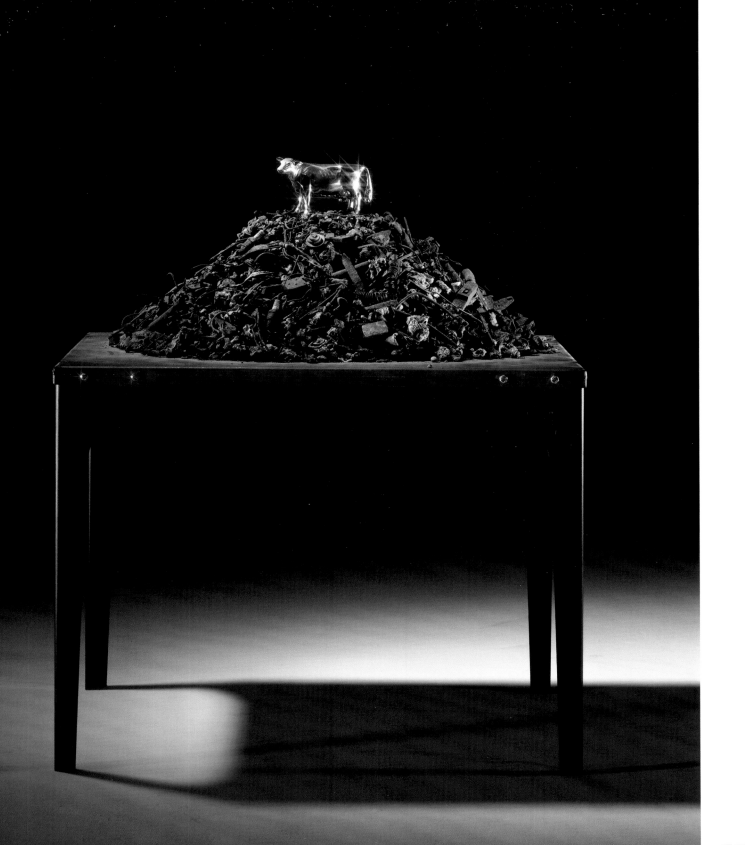

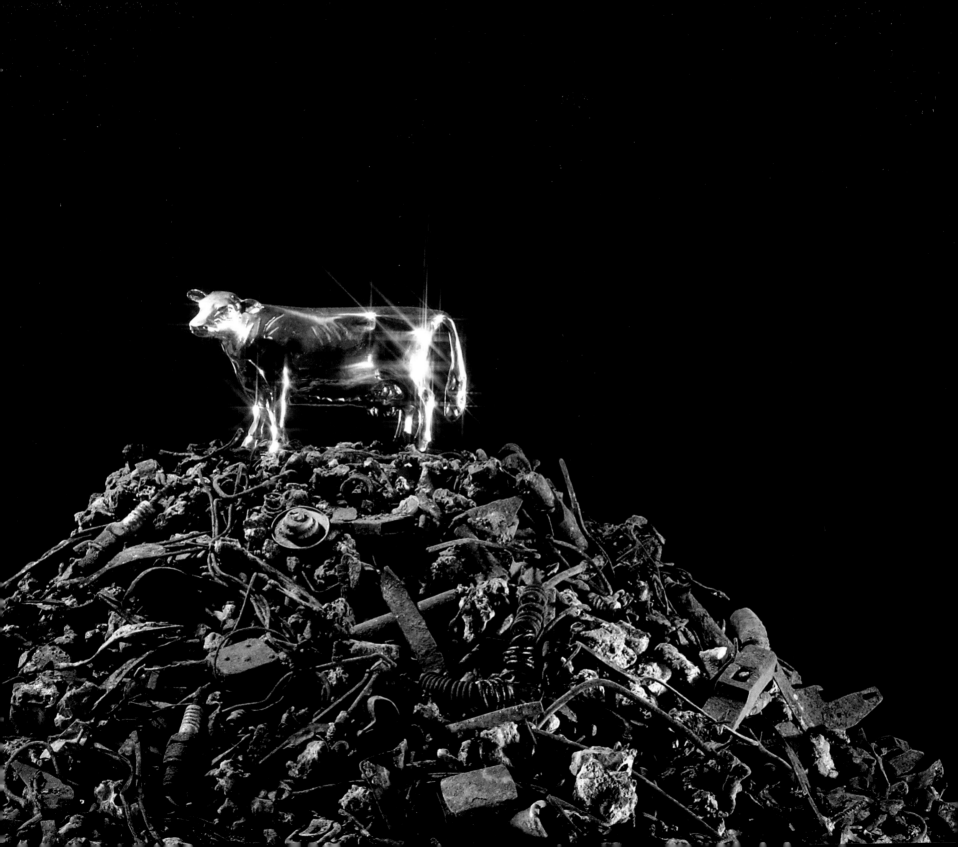

Standort — Location	Integral Kulturstiftung Maxhütte Haidhof, DEU
Jahr — Year	2006
Maße — Measurements	58 x 62 x 24 cm
Material — Material	Blattgold, Schlacke aus der Müllverbrennung
	Gold leaf, slag from garbage incineration

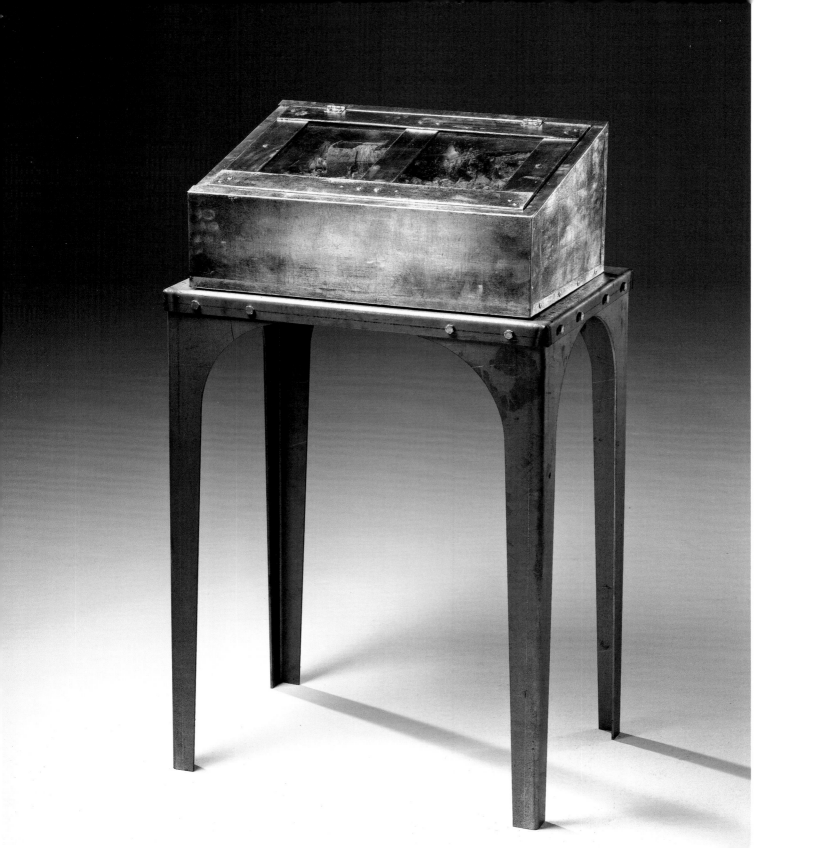

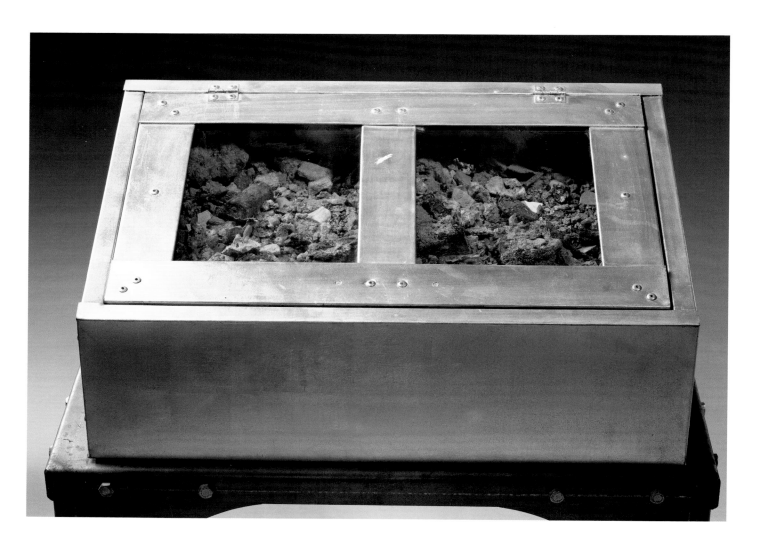

Jahr — Year 2006
Maße — Measurements 58 x 62 x 24 cm
Material — Material Blattgold, Schlacke aus der Müllverbrennung
Gold leaf, slag from garbage incineration

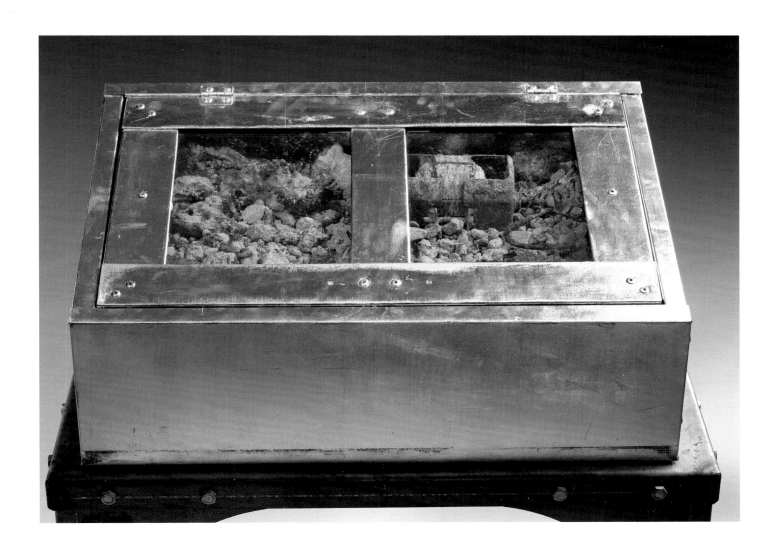

Jahr — Year	2006
Maße — Measurements	58 x 62 x 24 cm
Material — Material	Blattgold, Schlacke aus der Müllverbrennung
	Gold leaf, slag from garbage incineration

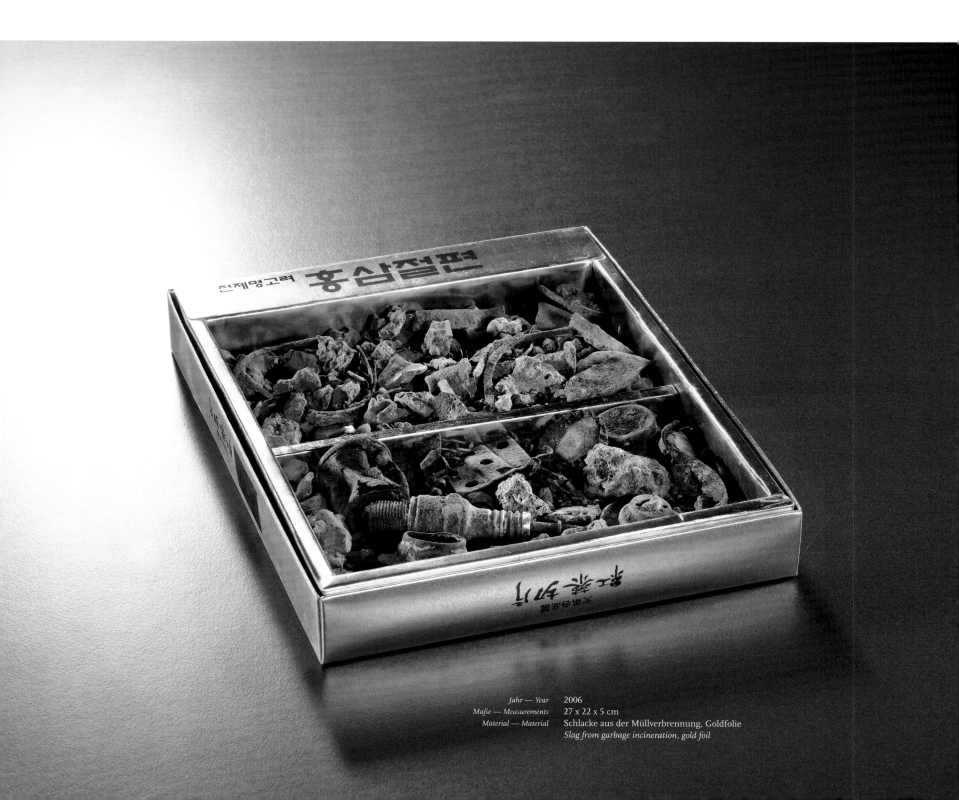

Jahr — Year	2006
Maße — Measurements	27 x 22 x 5 cm
Material — Material	Schlacke aus der Müllverbrennung, Goldfolie
	Slag from garbage incineration, gold foil

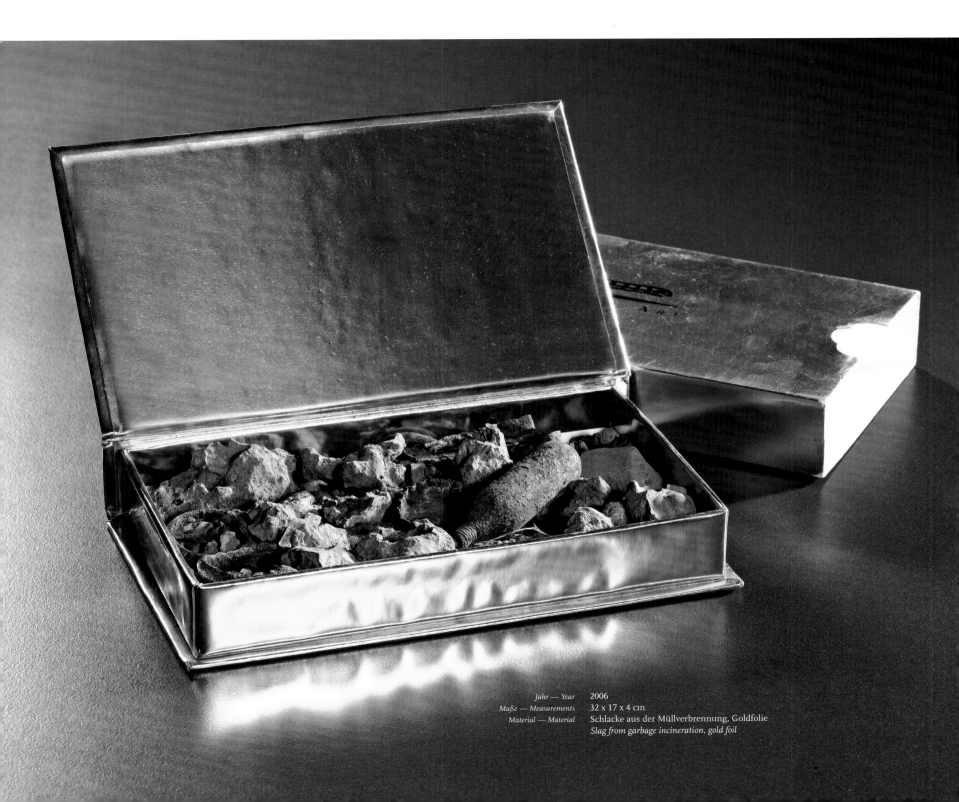

Jahr — Year	2006
Maße — Measurements	32 x 17 x 4 cm
Material — Material	Schlacke aus der Müllverbrennung, Goldfolie
	Slag from garbage incineration, gold foil

Standort — Location	Han Gallery, Hwacheon, KOR
Jahr — Year	2002
Maße — Measurements	380 x 230 x 65 cm
Material — Material	Altöl, Holz, Keramik
	Waste oil, wood, ceramics

In Zusammenarbeit mit Ji Won Hahn
In collaboration with Ji Won Hahn

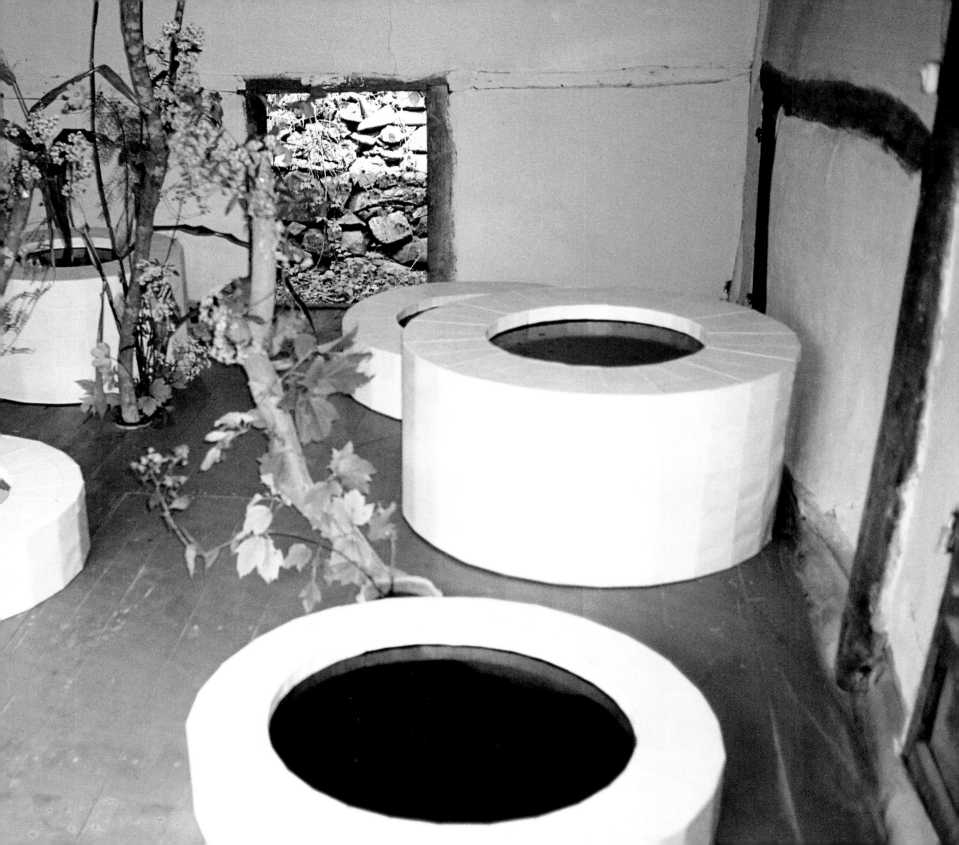

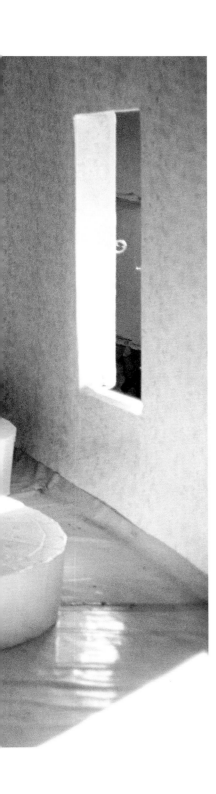

Standort — Location	Han Gallery, Hwacheon, KOR
Jahr — Year	2002
Maße — Measurements	280 x 190 x 65 cm
Material — Material	Altöl, Holz, Keramik
	Waste oil, wood, ceramics

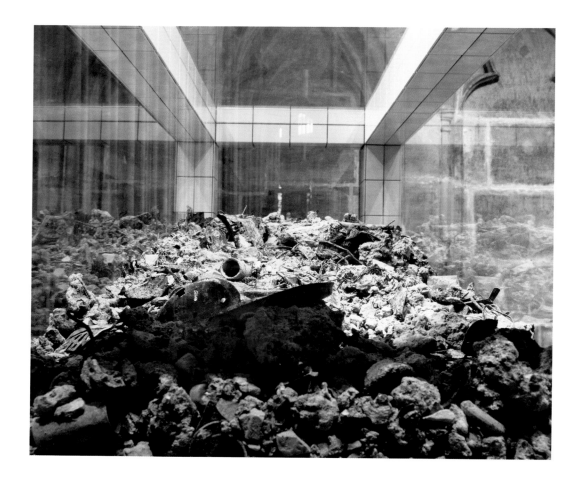

Standort — Location	St. Lorenz, Nürnberg, DEU
Jahr — Year	2000
Maße — Measurements	228 x 198 x 107 cm
Material — Material	Schlacke aus der Müllverbrennung, Keramik
	Slag from garbage incineration, ceramics

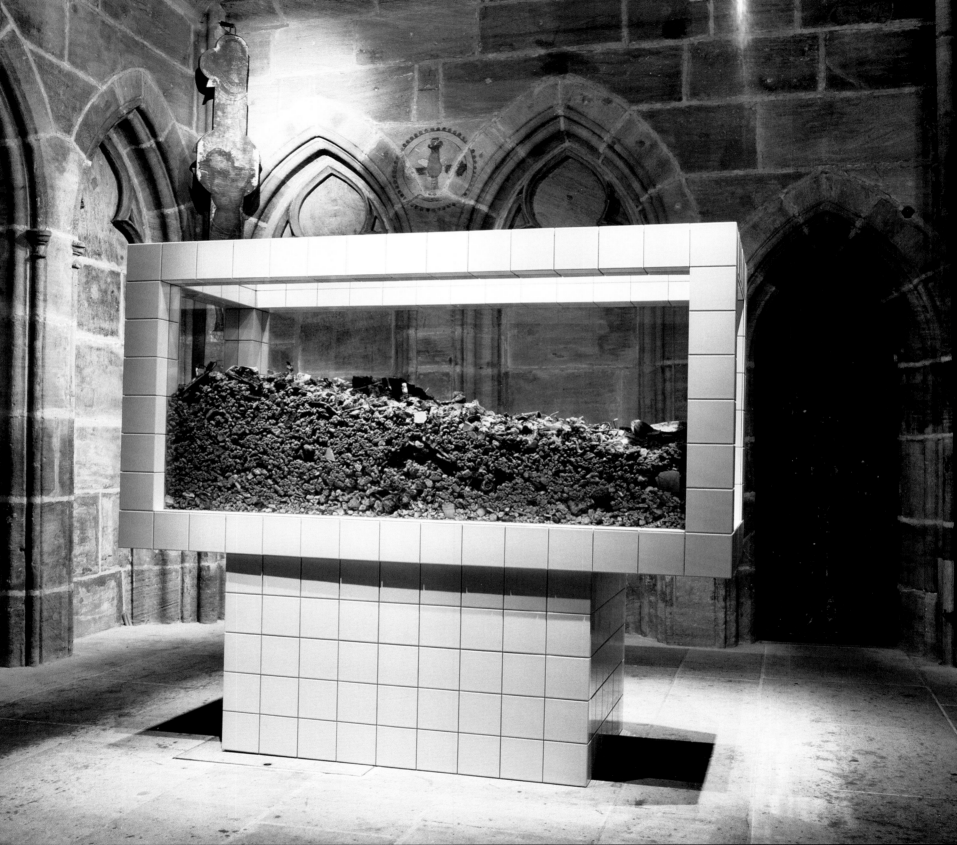

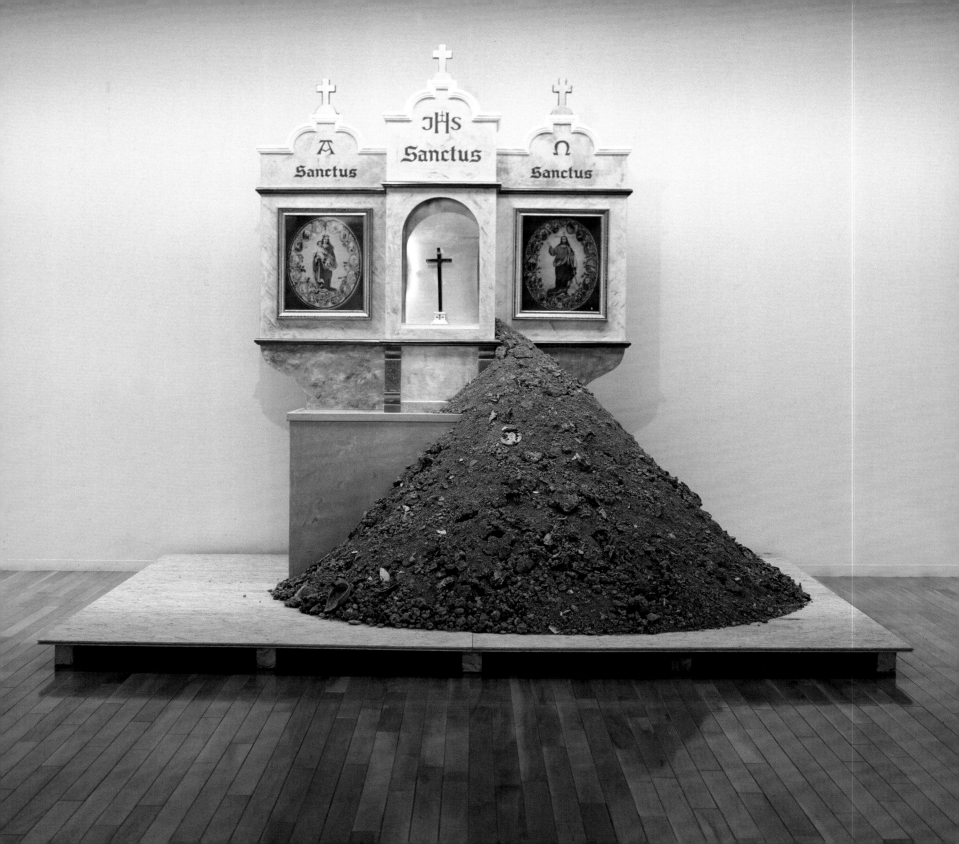

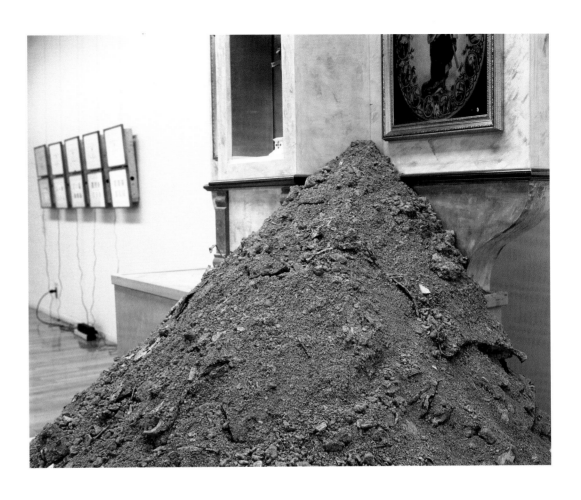

Standort — Location	Kumamoto Prefectural Museum of Art, Kummamoto, JPN
Jahr — Year	1999
Maße — Measurements	390 x 270 x 290 cm
Material — Material	Schlacke aus der Müllverbrennung, Fassmalerei
	Slag from garbage incineration, polychroming

Standort — Location	Halle K3, Kampnagel, Hamburg, DEU
Jahr — Year	1997
Maße — Measurements	640 x 380 x 230 cm
Material — Material	Altöl, Keramik, Stahlblech
	Waste oil, ceramics, steel plate

In Zusammenarbeit mit Anna Bien
In collaboration with Anna Bien

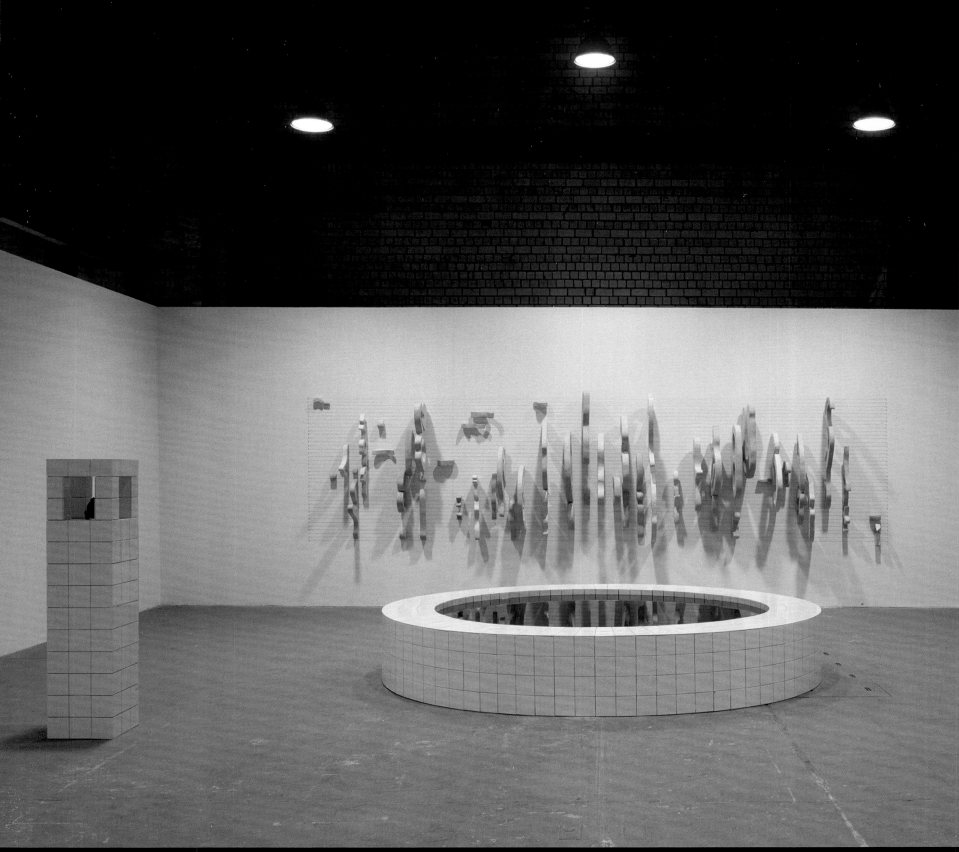

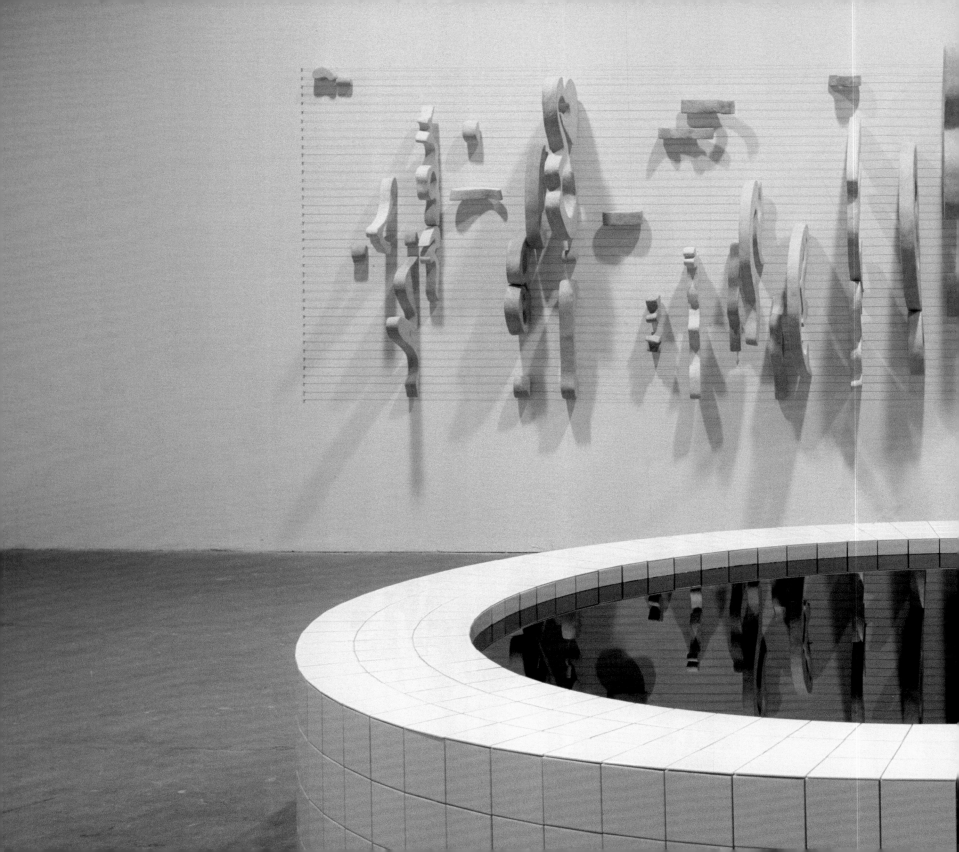

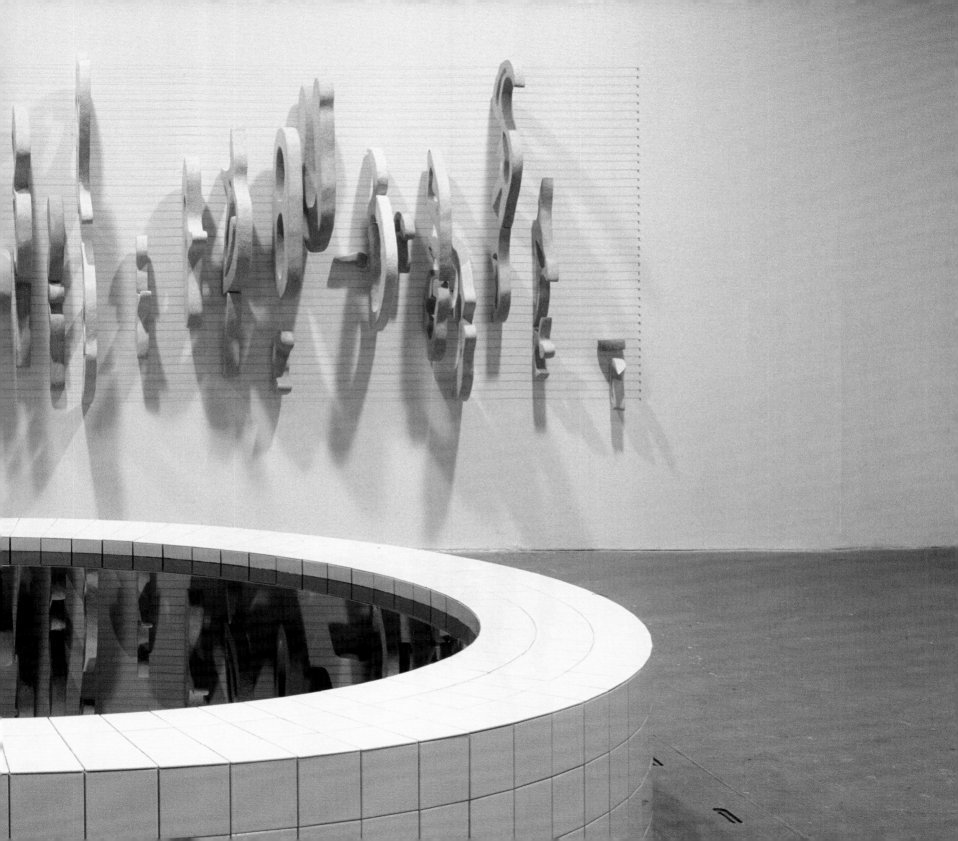

Standort — Location	Hl. Kreuz, Buch, DEU
Jahr — Year	1996
Maße — Measurements	205 x 205 x 92 cm
Material — Material	Altöl, Schlacke aus der Müllverbrennung, Keramik
	Waste oil, slag from garbage incineration, ceramics

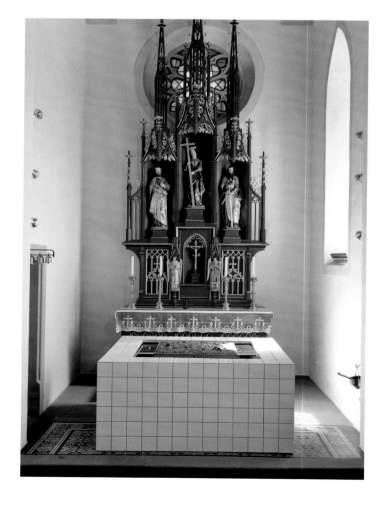

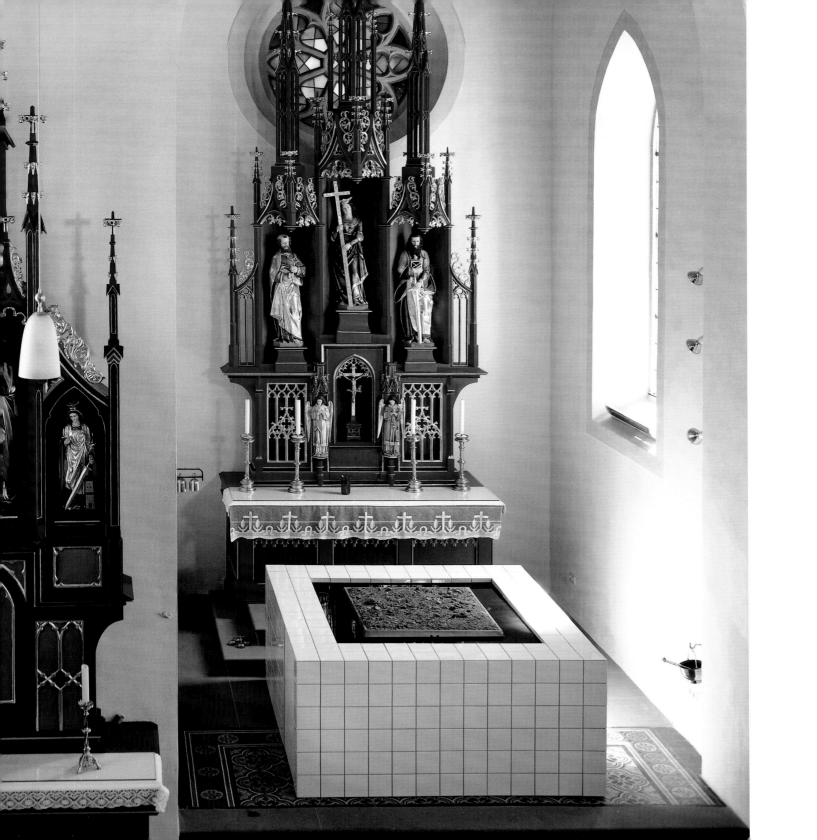

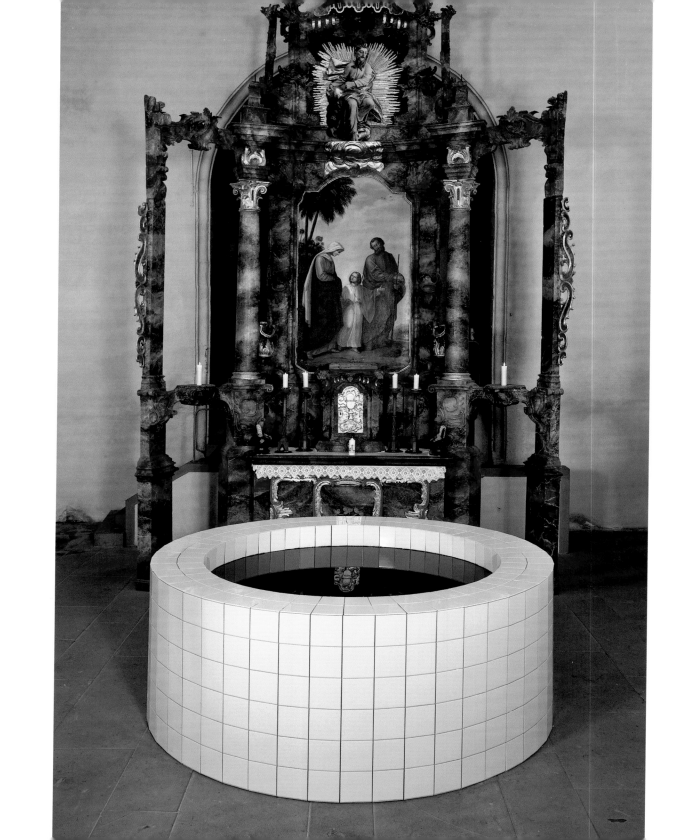

Standort — Location	Kunigundenkapelle, Buch, DEU
Jahr — Year	1996
Maße — Measurements	Durchmesser/*Diameter* 340 cm, Höhe/*Height* 92 cm
Material — Material	Altöl, Schlacke aus der Müllverbrennung, Keramik
	Waste oil, slag from garbage incineration, ceramics

Standort — Location	Kunigundenkapelle, Buch, DEU
Jahr — Year	1996
Maße — Measurements	122 x 41 x 90 cm
Material — Material	Altöl, Keramik, Stahlblech
	Waste oil, ceramics, steel plate

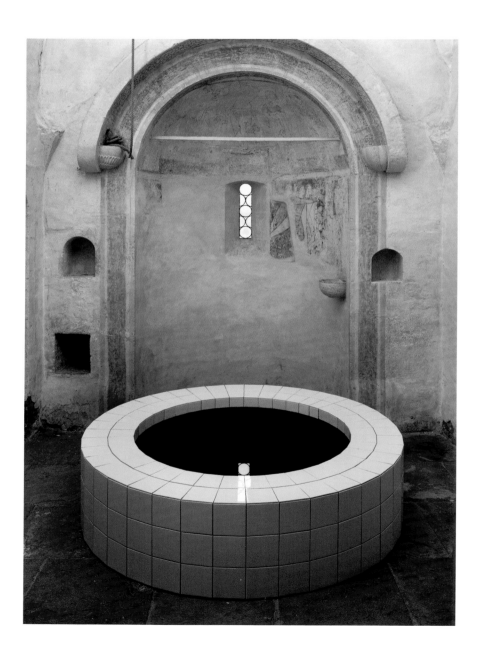

Standort — Location	Kunigundenkapelle, Buch, DEU
Jahr — Year	1996
Maße — Measurements	Durchmesser/*Diameter* 180 cm, Höhe/*Height* 42 cm
Material — Material	Altöl, Keramik, Stahlblech
	Waste oil, ceramics, steel plate

Standort — Location	Kunigundenkapelle, Buch, DEU
Jahr — Year	1996
Maße — Measurements	212 x 136 x 91 cm
Material — Material	Altöl, Keramik, Stahlblech
	Waste oil, ceramics, steel plate

Standort — Location Kunigundenkapelle, Buch, DEU
Jahr — Year 1996
Maße — Measurements 212 x 136 x 91 cm
Material — Material Altöl, Keramik, Stahlblech
 Waste oil, ceramics, steel plate

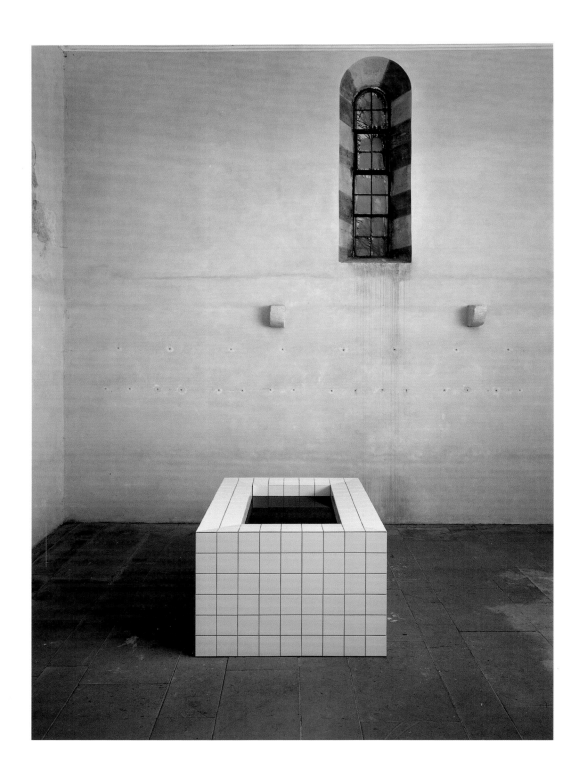

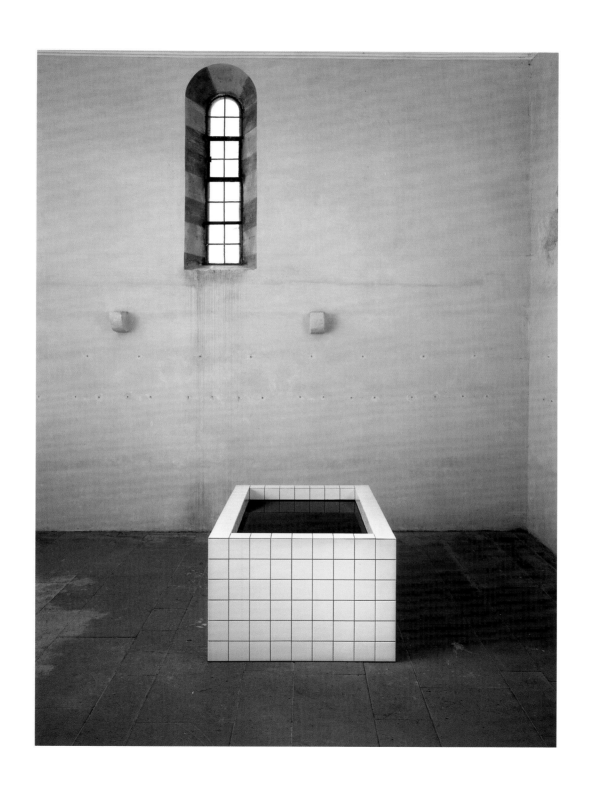

Standort — Location	Kunsthaus, Nürnberg, DEU
Jahr — Year	1993
Maße — Measurements	1400 x 600 x 70 cm
Material — Material	Altöl, Granit, Säulenbasalt, elektrische Heizfolien, Stahlblech
	Waste oil, granite, basaltic column, electric heating foils, steel plate

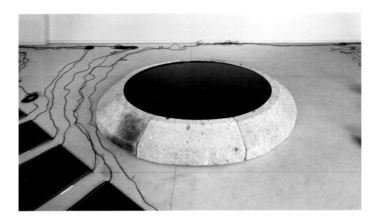

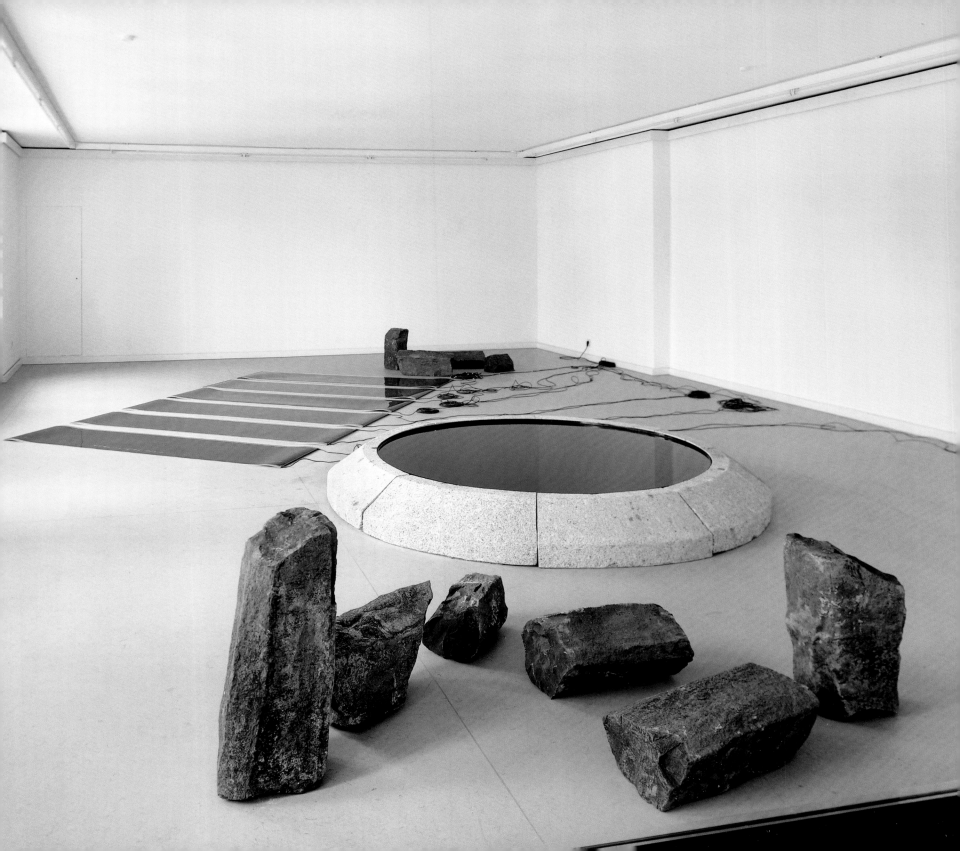

Standort — Location	Kunsthaus, Nürnberg, DEU
Jahr — Year	1993
Maße — Measurements	1400 x 600 x 70 cm
Material — Material	Altöl, Granit, Säulenbasalt, elektrische Heizfolien, Stahlblech
	Waste oil, granite, basaltic column, electric heating foils, steel plate

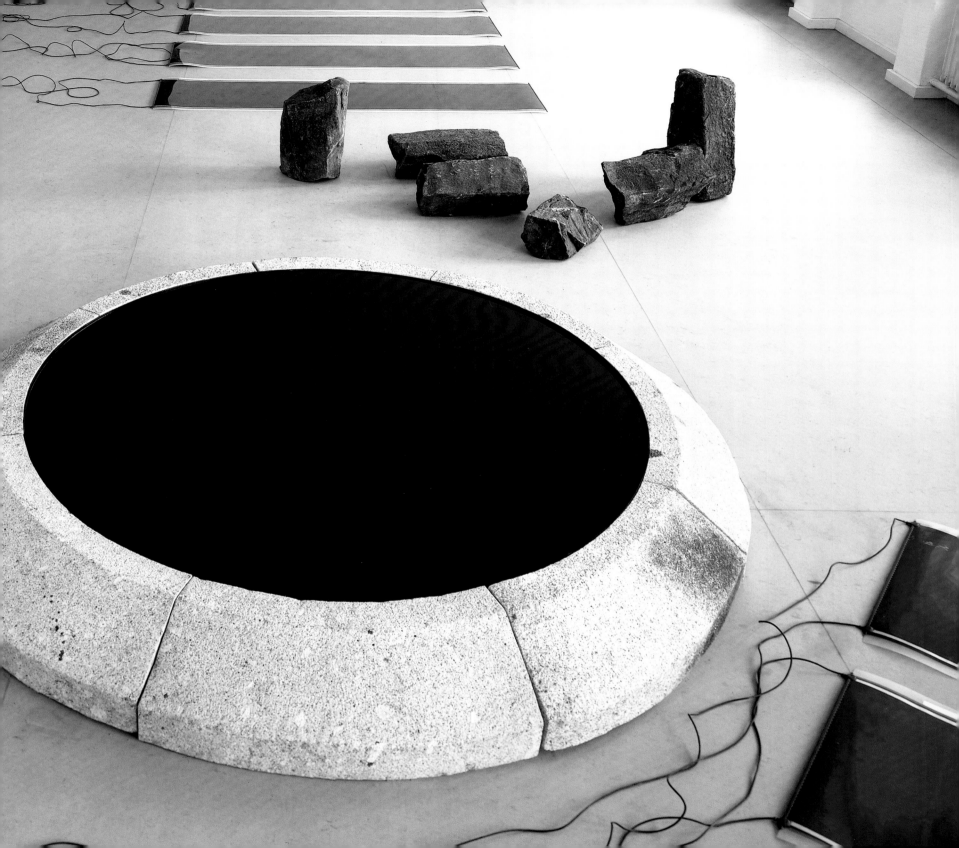

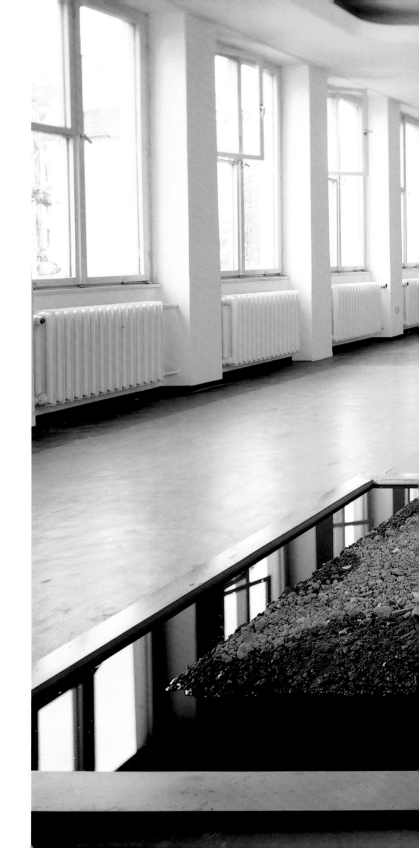

Standort — Location	Kunsthaus, Nürnberg, DEU
Jahr — Year	1989
Maße — Measurements	1400 x 290 x 22 cm
Material — Material	Schlacke aus der Müllverbrennung, Altöl, Stahlwannen
	Slag from garbage incineration, waste oil, steel tanks

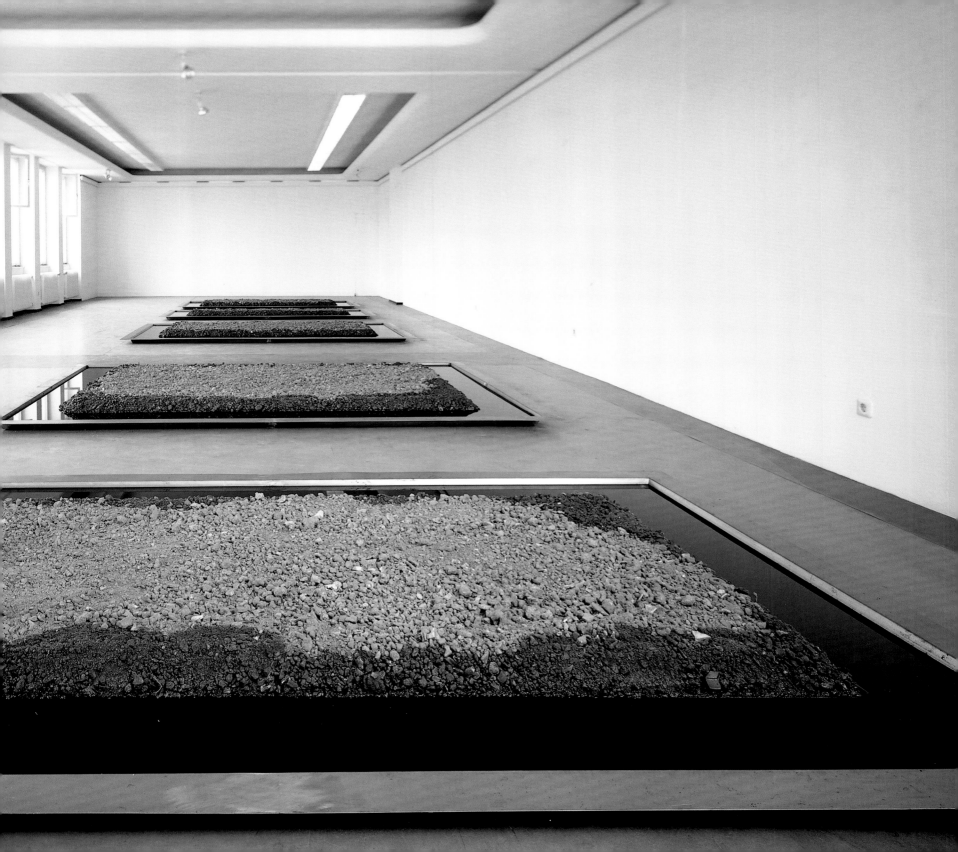

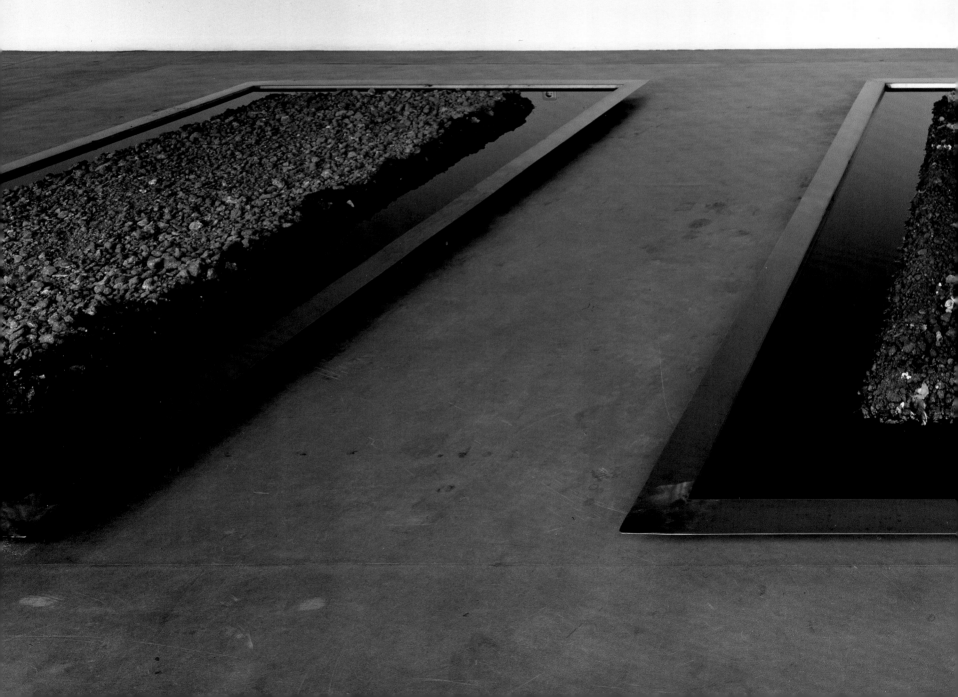

Standort — Location	Rathaus, Wolffscher Bau, Nürnberg, DEU
Jahr — Year	1988
Maße — Measurements	240 x 90 x 60 cm
Material — Material	Schlacke aus der Müllverbrennung, Holz
	Slag from garbage incineration, wood

Jahr — Year	1988
Maße — Measurements	160 x 90 x 140 cm
Material — Material	Schlacke aus der Müllverbrennung, Holz
	Slag from garbage incineration, wood

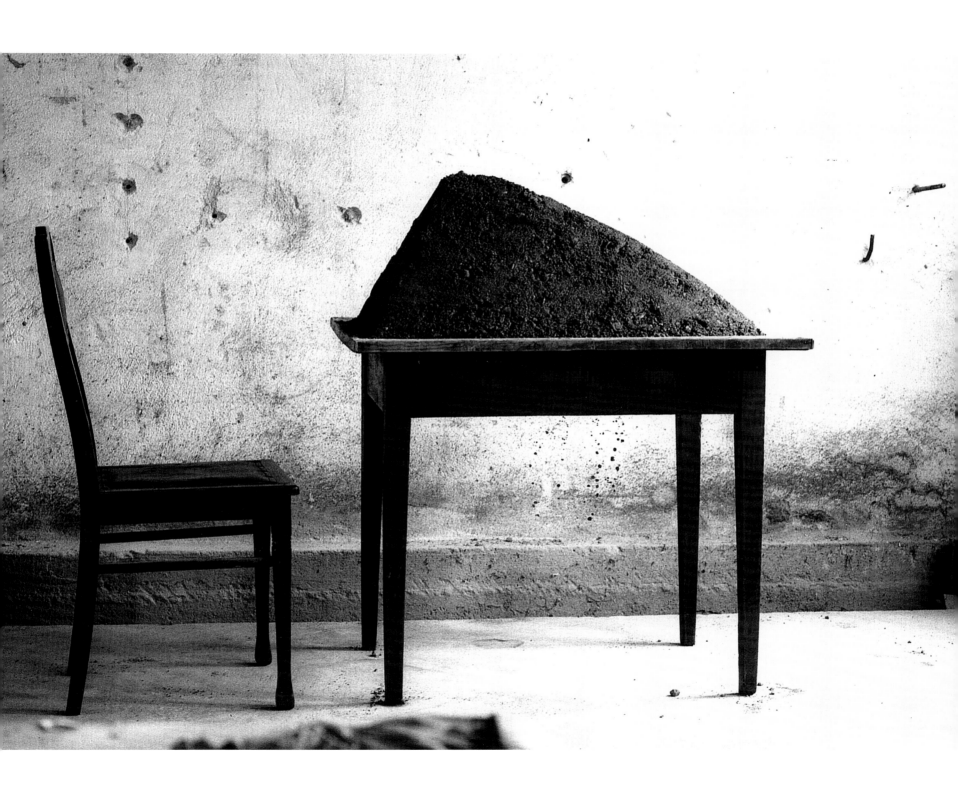

Standort — Location Galerie Traude Näke, St. Katharina, Nürnberg, DEU
Jahr — Year 1987
Maße — Measurements 1100 x 220 x 190 cm
Material — Material Schlacke aus der Müllverbrennung, Blei, Farbpigmente
Slag from garbage incineration, lead, colour pigments

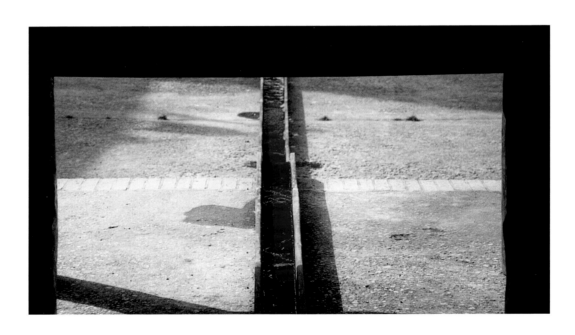

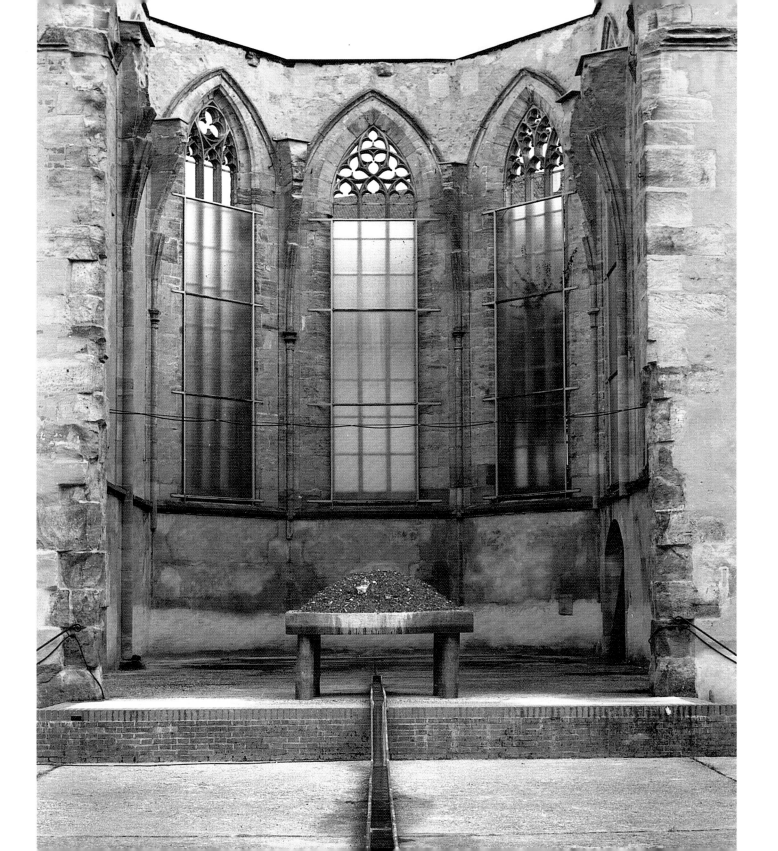

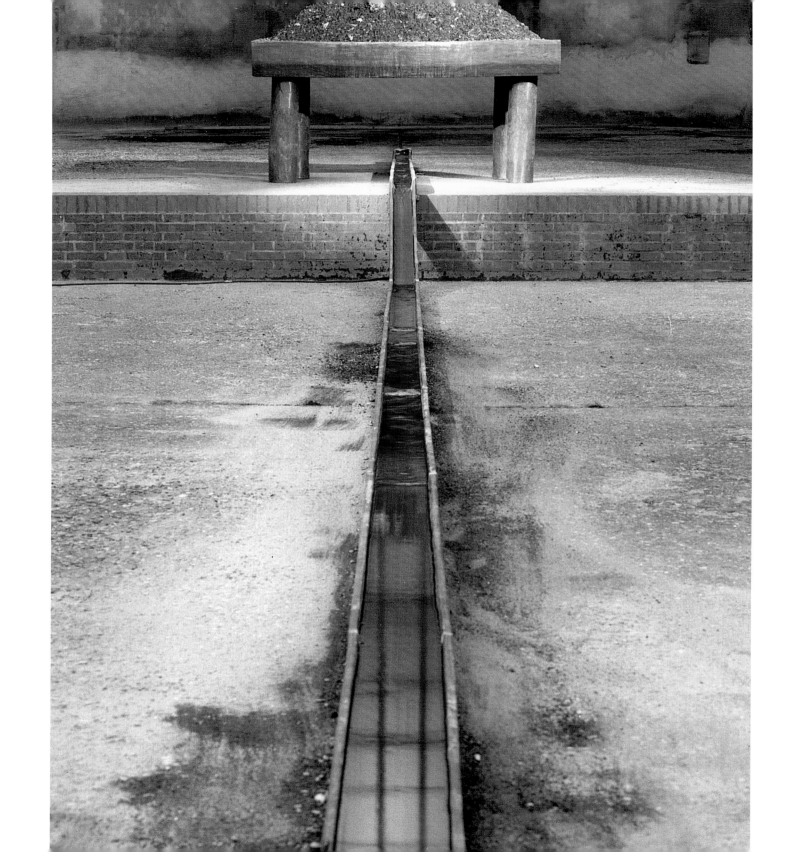

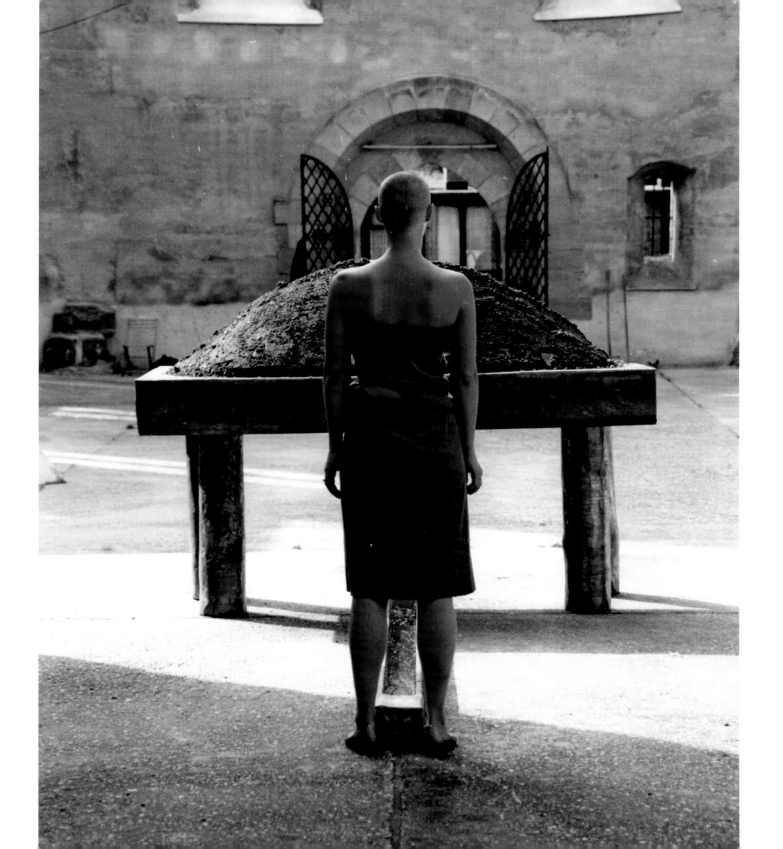

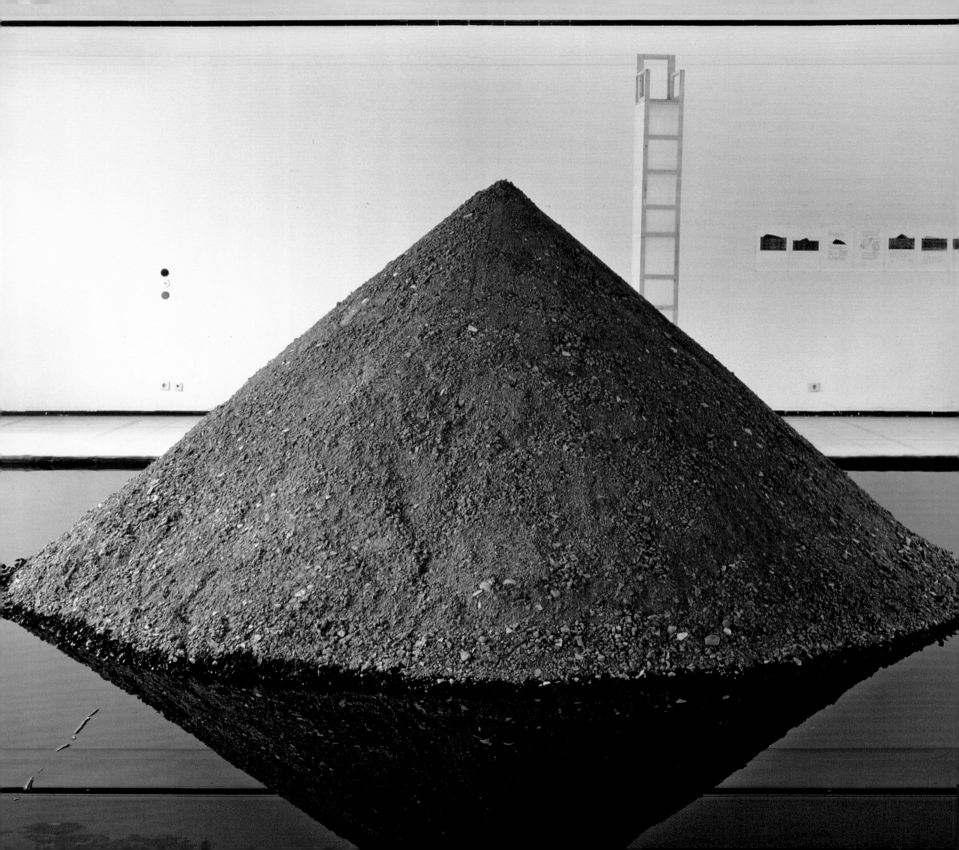

Standort — Location	Kabelmetallfabrik, Nürnberg, DEU
Jahr — Year	1986
Maße — Measurements	600 x 600 x 190 cm
Material — Material	800 Liter Altöl, 16 m³ Schlacke aus der Müllverbrennung
	800 litres waste oil, 16 m³ slag from garbage incineration

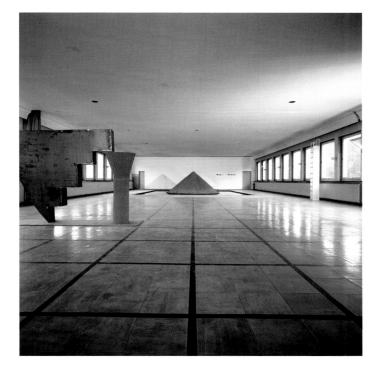

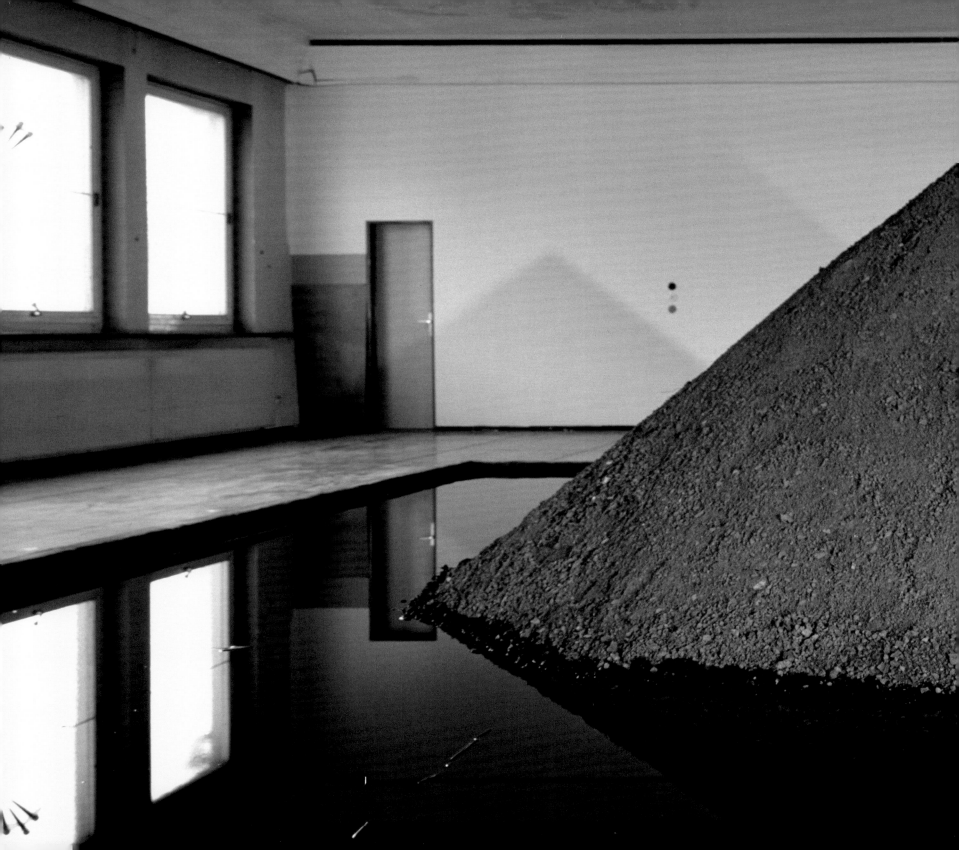

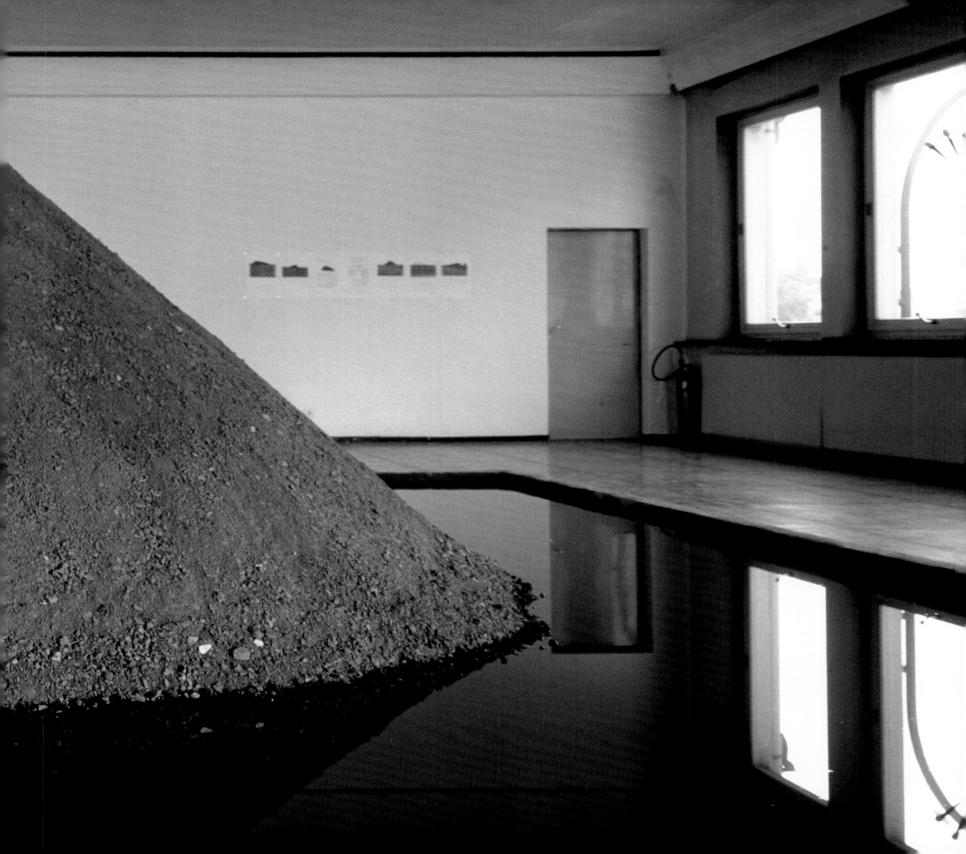

1.2

SELBSTORGANISIERTE KRITIZITÄT
SELF-ORGANISED CRITICALITY

Jahr — Year 2004
Maße — Measurements 260 x 140 x 170 cm
Material — Material Bronze, Holz
Bronze, wood

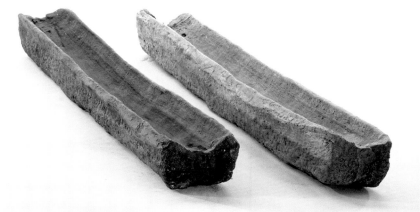

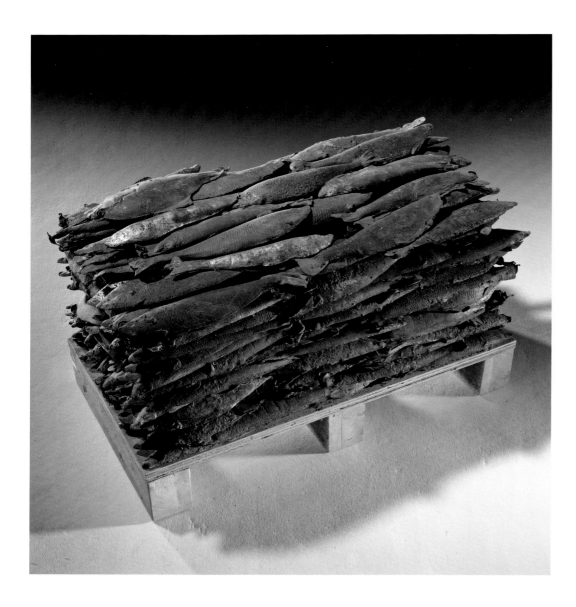

Jahr — Year	1998
Maße — Measurements	85 x 63 x 48 cm
Material — Material	Blei, Holz
	Lead, wood

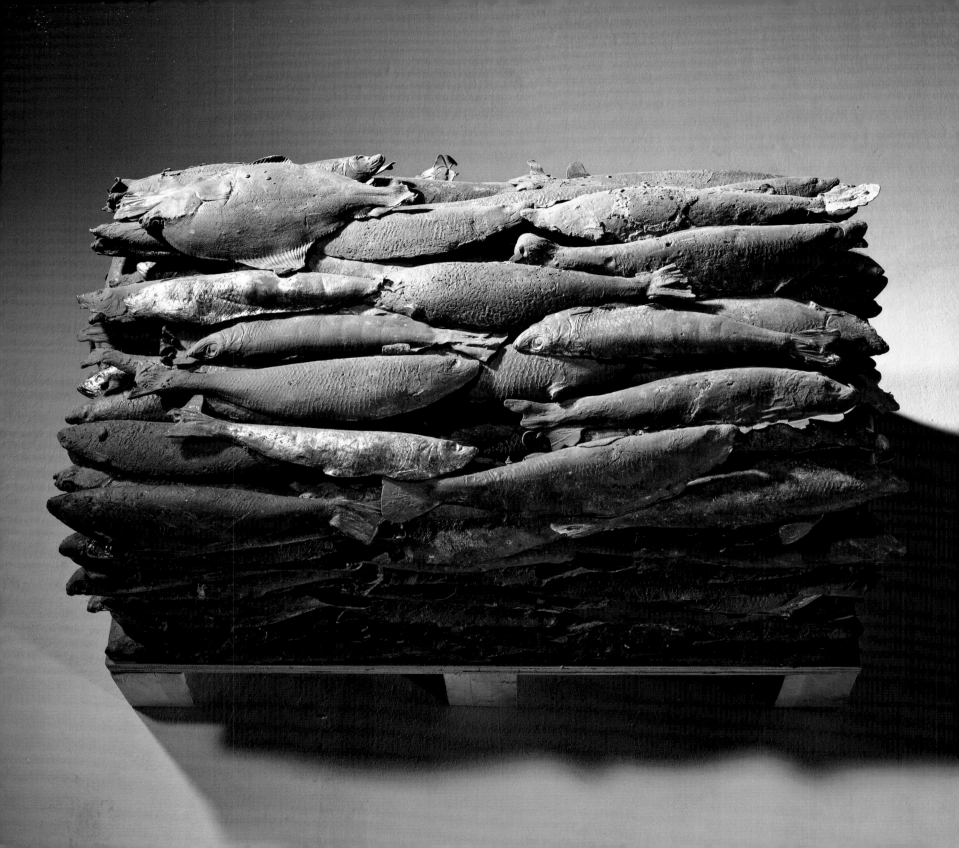

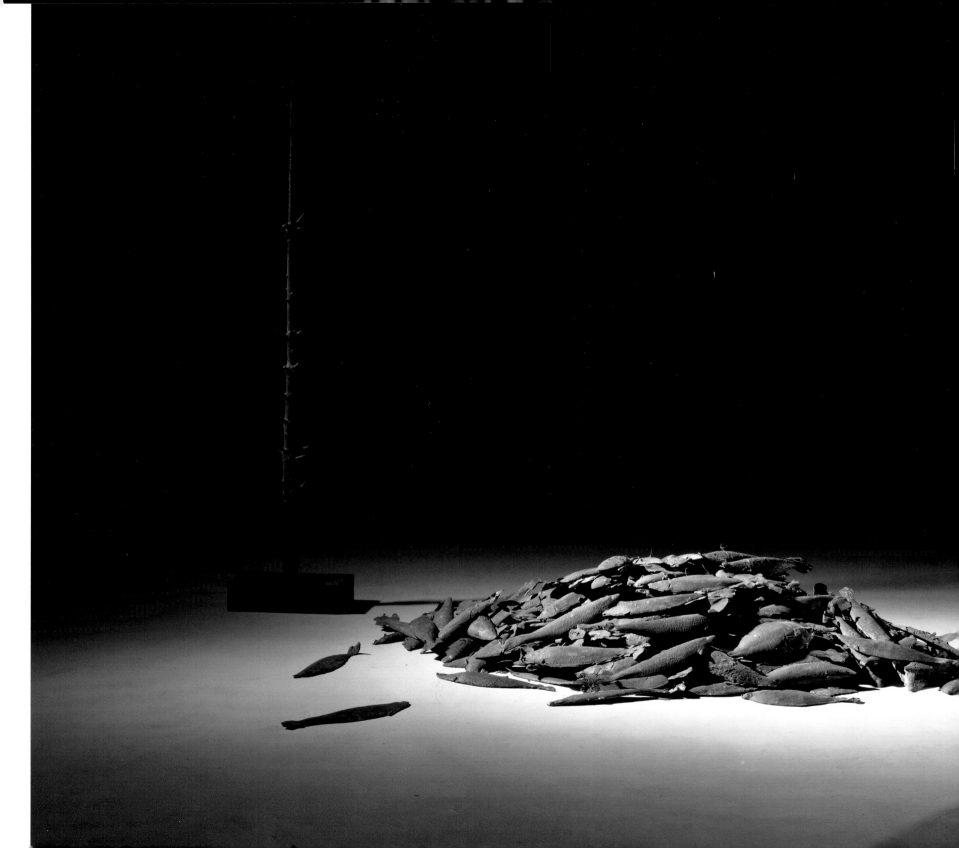

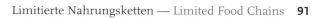

Jahr — Year	1999
Maße — Measurements	ca. 240 x 200 x 170 cm
Material — Material	Bronze, Blei
	Bronze, lead

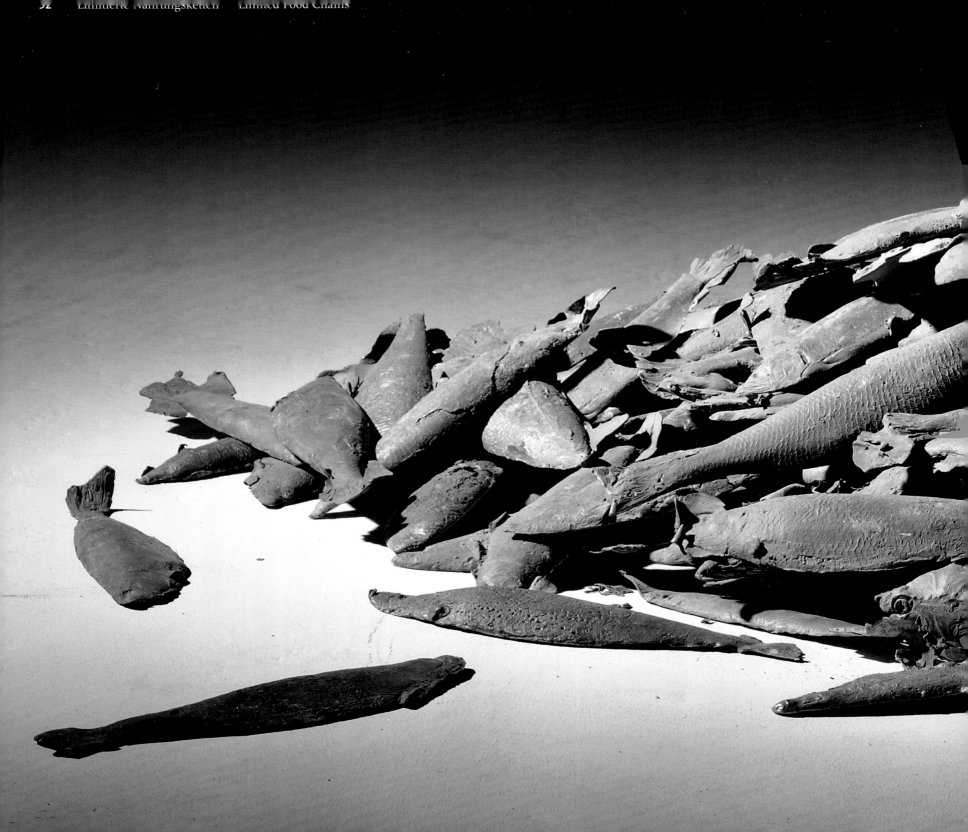

Jahr — Year	2014
Maße — Measurements	210 x 64 x 115 cm
Material — Material	Gips, Holz
	Plaster, wood

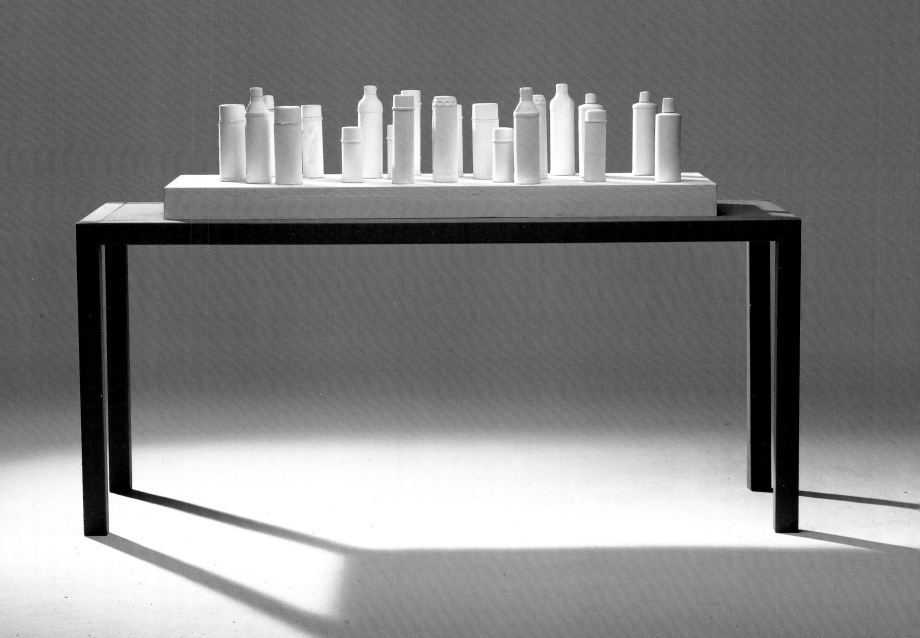

Jahr — Year 2014
Maße — Measurements 32 x 24 x 24 cm
Material — Material Gips, Eisen
Plaster, iron

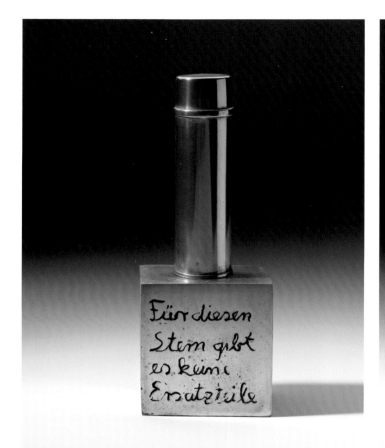
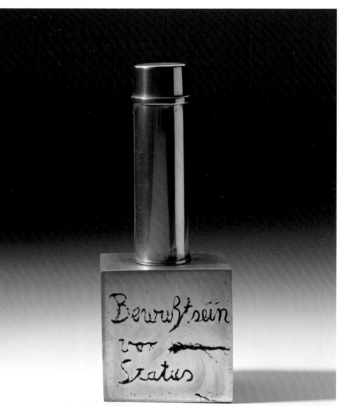

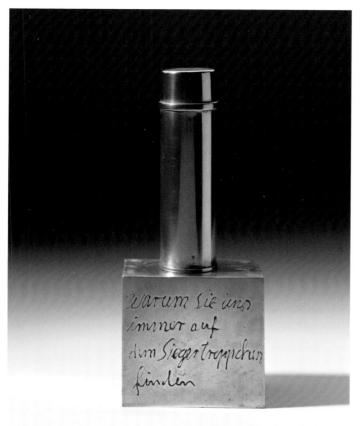 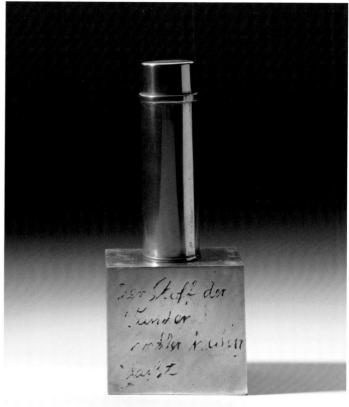

Für diesen Stern gibt es keine Ersatzteile
There are no spare parts for this planet

Bewußtsein vor Status
Awareness before Status

Warum Sie uns immer auf dem Siegertreppchen finden
Why you always find us on the victory podium

Der Stoff der Wunder wahr werden läßt
The stuff of dreams come true

Jahr — Year	2000
Maße — Measurements	16 x 37 x 8 cm
Material — Material	Aluminium poliert
	Aluminium, polished

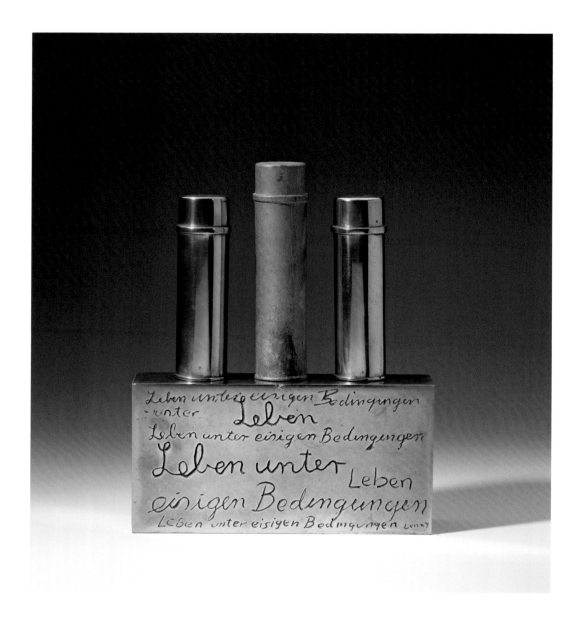

Jahr — Year	2001
Maße — Measurements	32 x 37 x 8 cm
Material — Material	Aluminium poliert
	Aluminium, polished

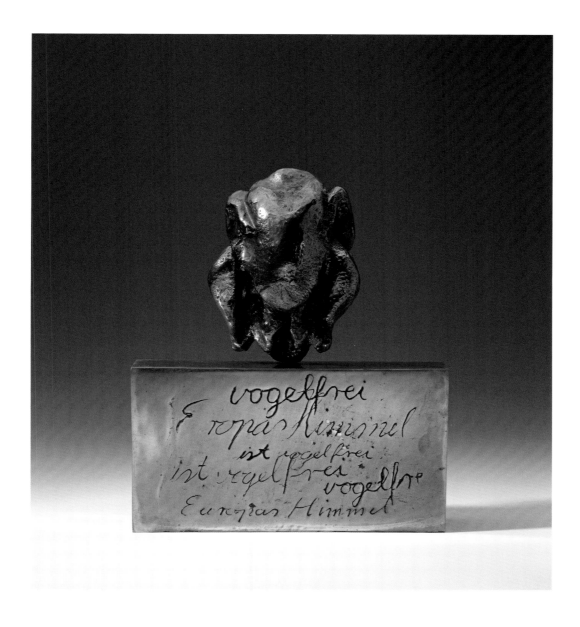

Jahr — Year	2001
Maße — Measurements	32 x 35 x 8 cm
Material — Material	Aluminium poliert, Bronze
	Aluminium polished, Bronze

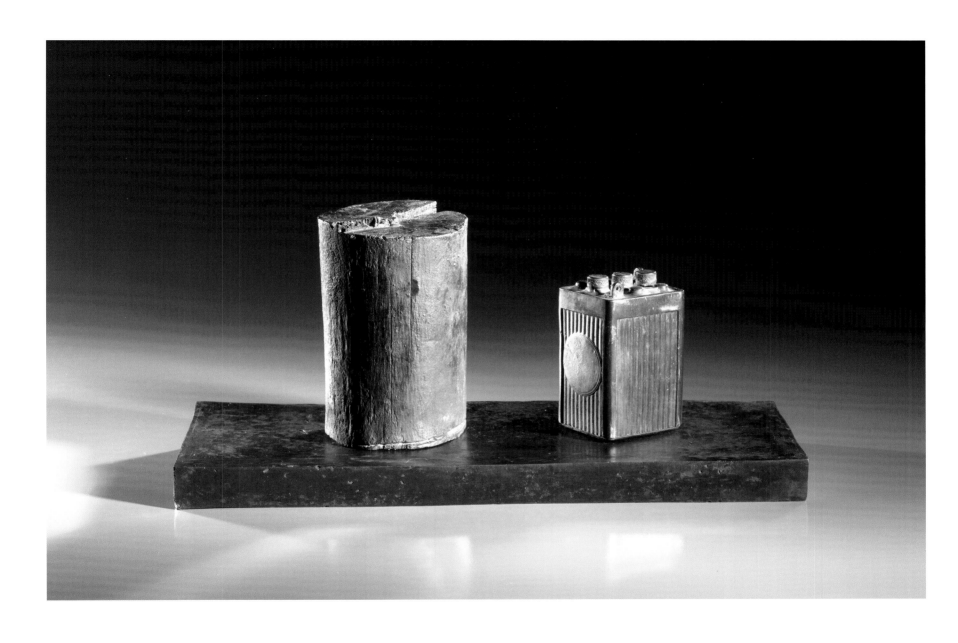

Jahr — Year	2002
Maße — Measurements	47 x 24 x 32 cm
Material — Material	Bronze
	Bronze

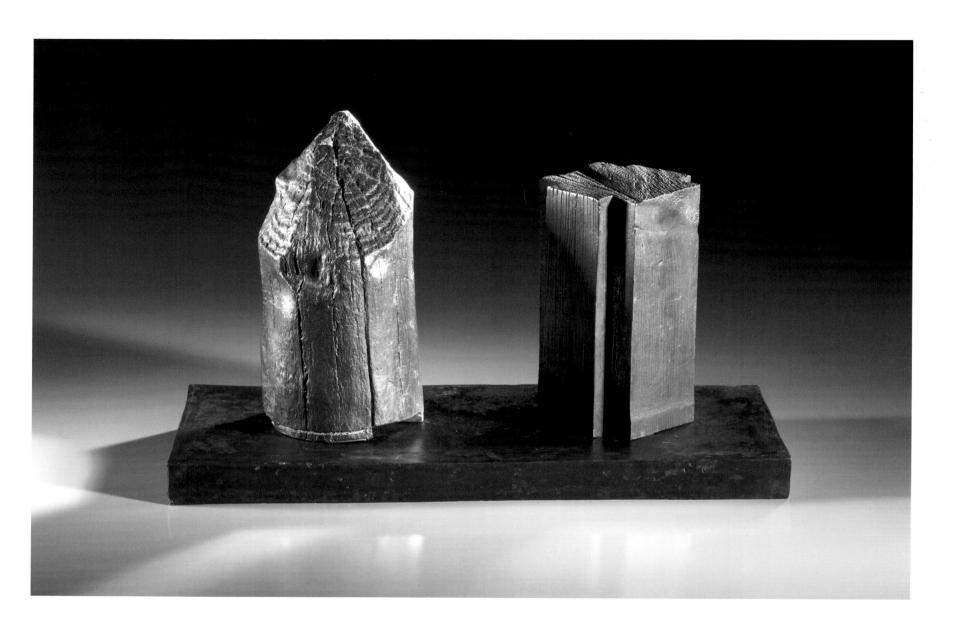

Jahr — Year	2002
Maße — Measurements	47 x 24 x 36 cm
Material — Material	Bronze
	Bronze

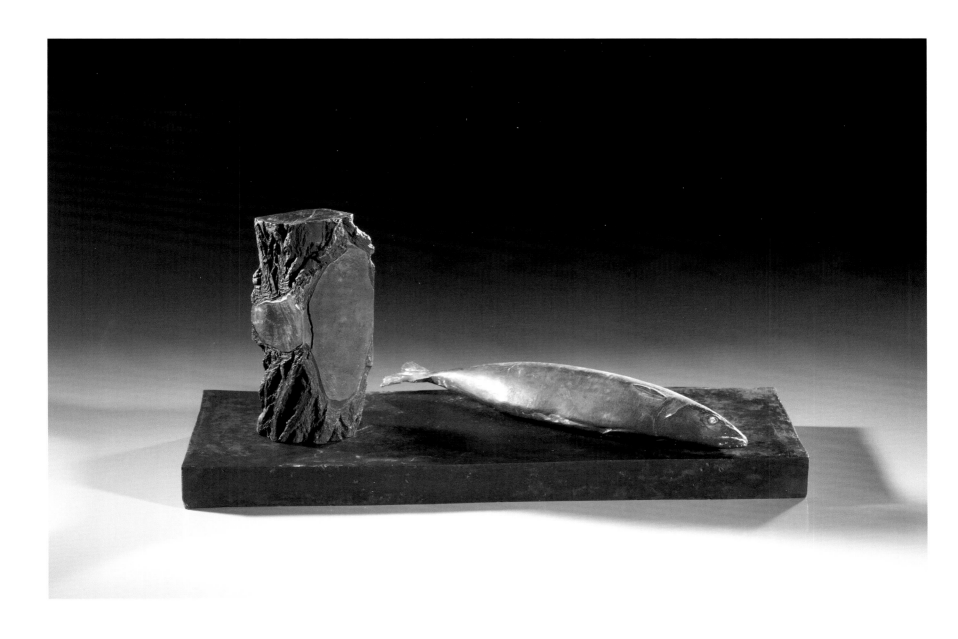

Jahr — Year	2002
Maße — Measurements	47 x 24 x 28 cm
Material — Material	Bronze
	Bronze

Standort — Location	Kunstverein Kohlenhof, Nürnberg, DEU
Jahr — Year	1993
Maße — Measurements	950 x 480 x 70 cm
Material — Material	Glas, Blei, Bronze
	Glass, lead, bronze

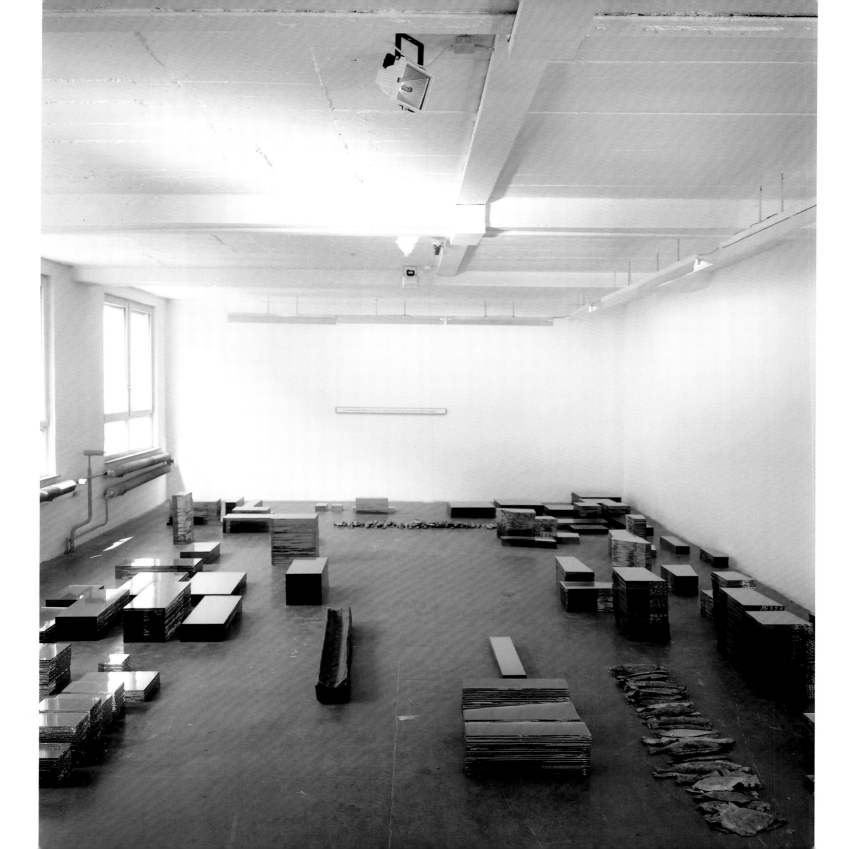

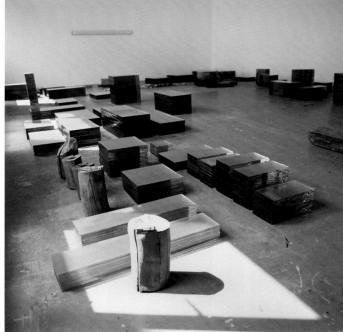
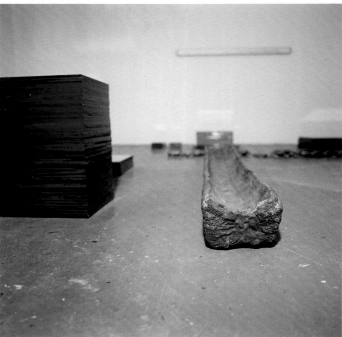

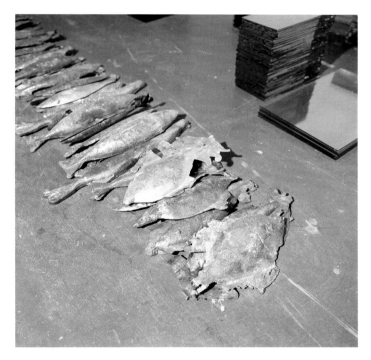
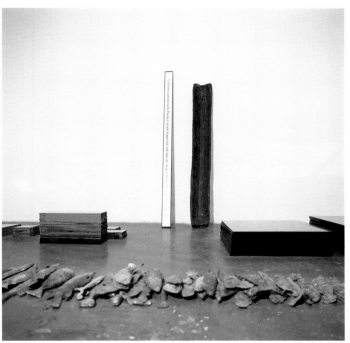
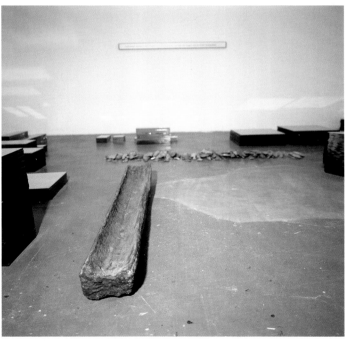
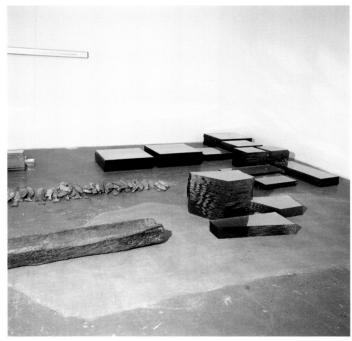

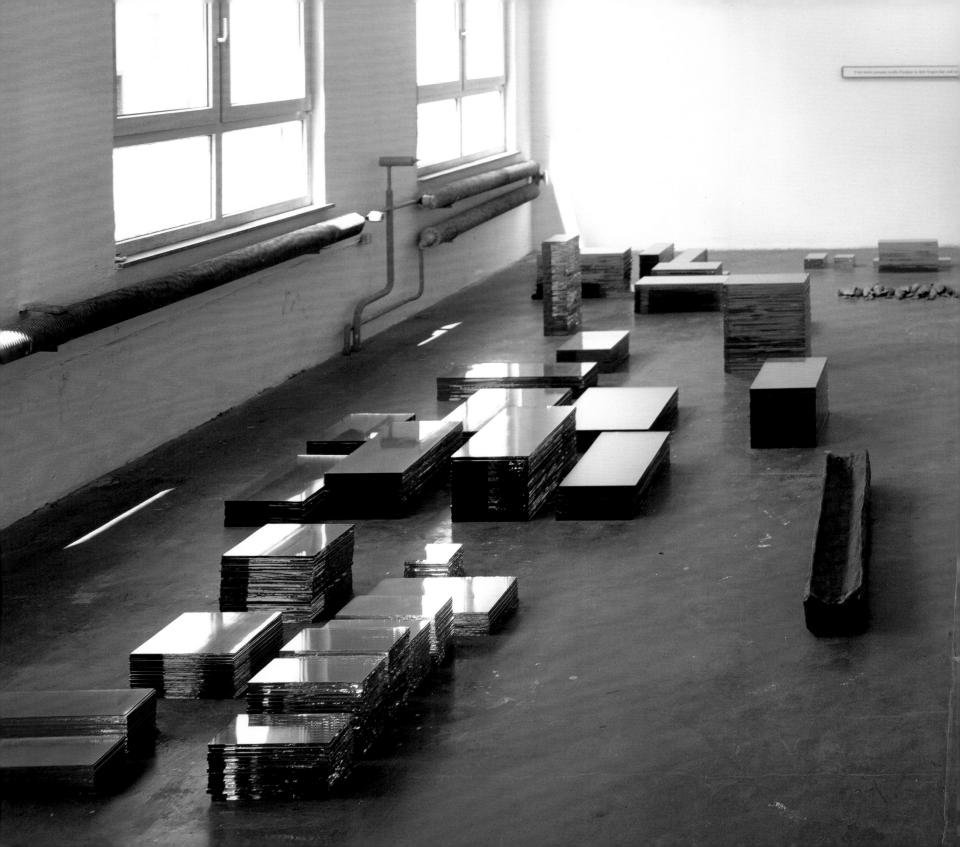

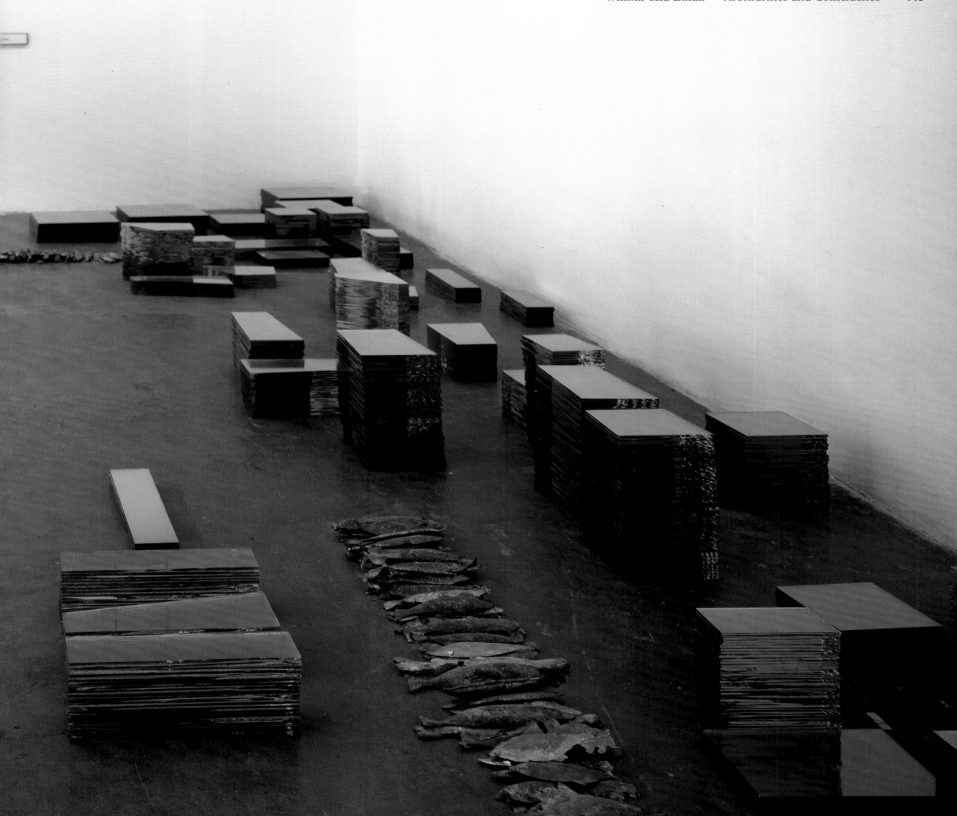

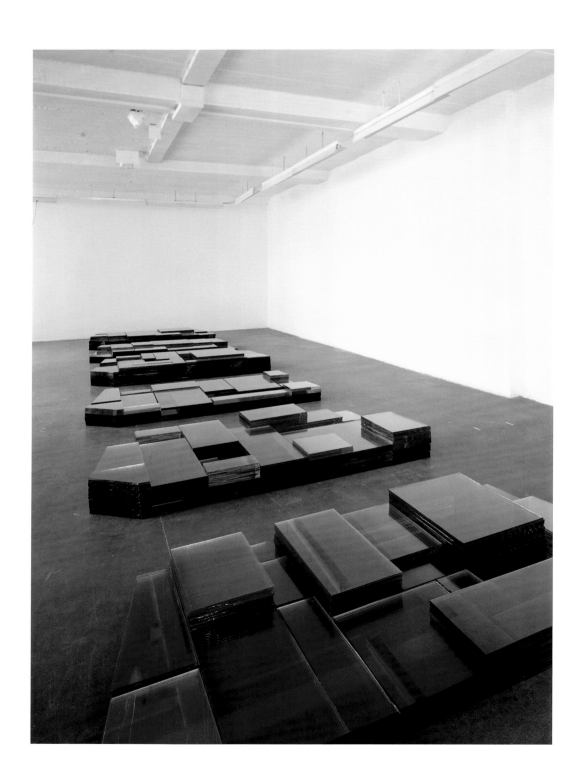

<table>
<tr><td>Standort — Location</td><td>Jelenia Góra, POL</td></tr>
<tr><td>Jahr — Year</td><td>1993</td></tr>
<tr><td>Maße — Measurements</td><td>215 x 110 x 95 cm</td></tr>
<tr><td>Material — Material</td><td>Glas, Blei, Bronze
Glass, lead, bronze</td></tr>
</table>

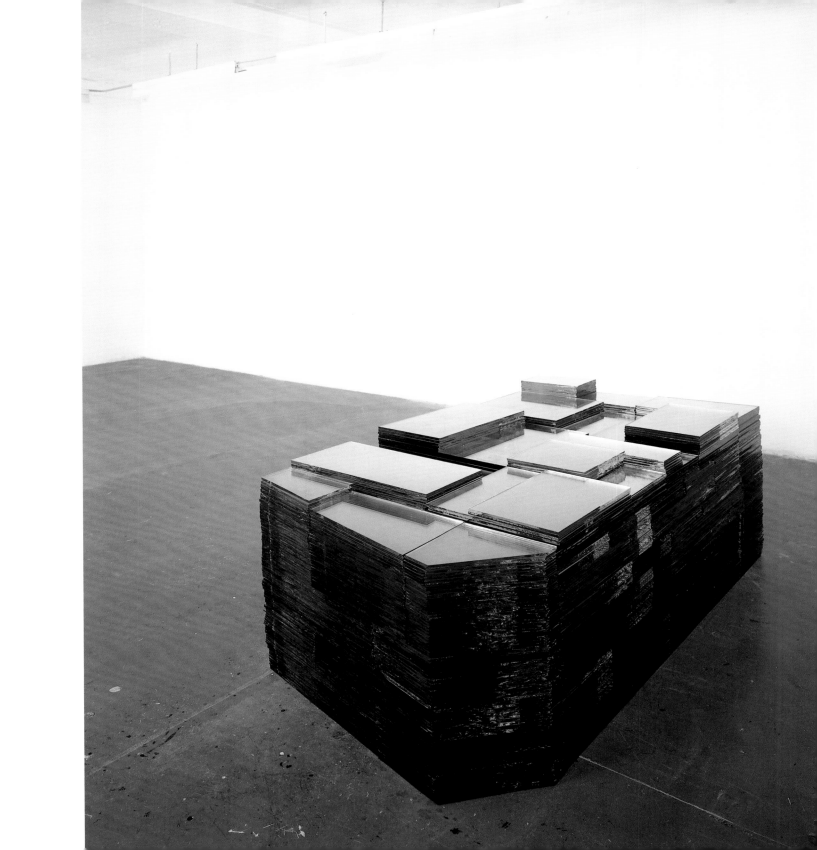

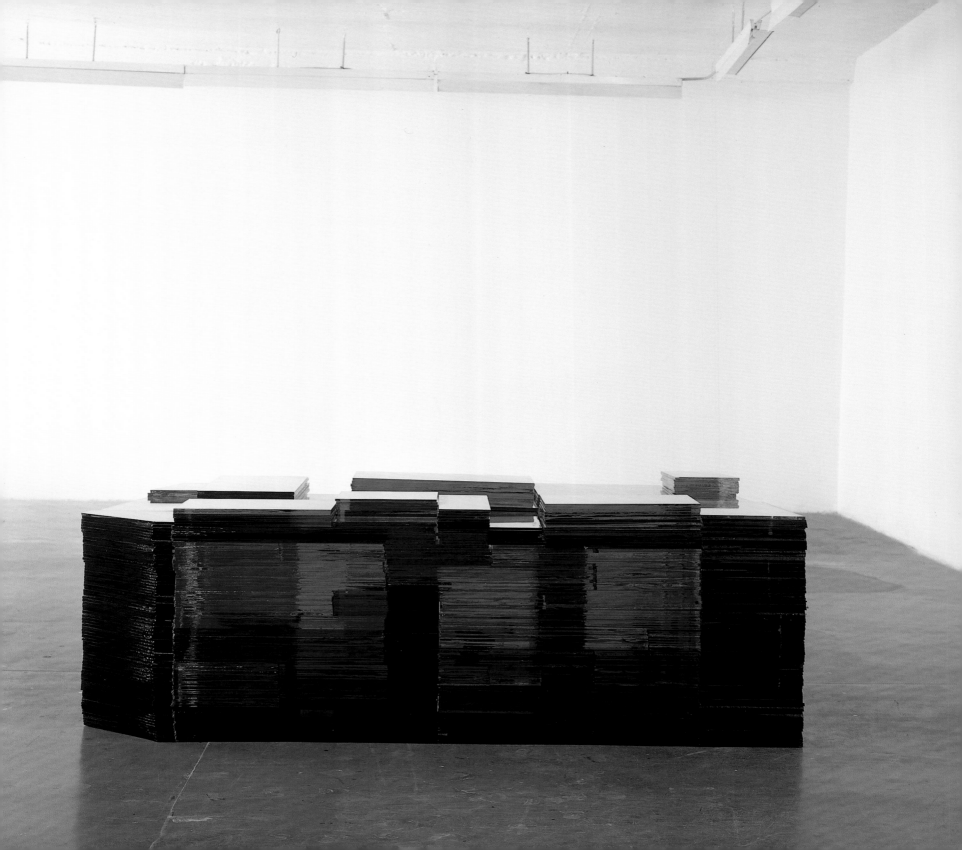

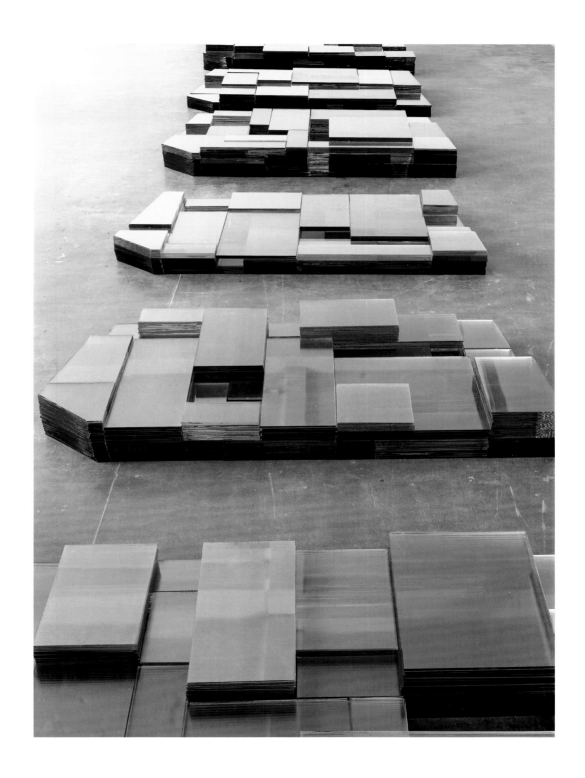

Standort — Location	Jelenia Góra, POL
Jahr — Year	1993
Maße — Measurements	215 x 110 x 95 cm
Material — Material	Glas, Blei, Bronze
	Glass, lead, bronze

Standort — Location	Königsplatz, Schwabach, DEU
Jahr — Year	1990
Maße — Measurements	16 x 4 x 2,5 m
Material — Material	Schlacke aus der Müllverbrennung, Stahlblech
	Slag from garbage incineration, steel plate

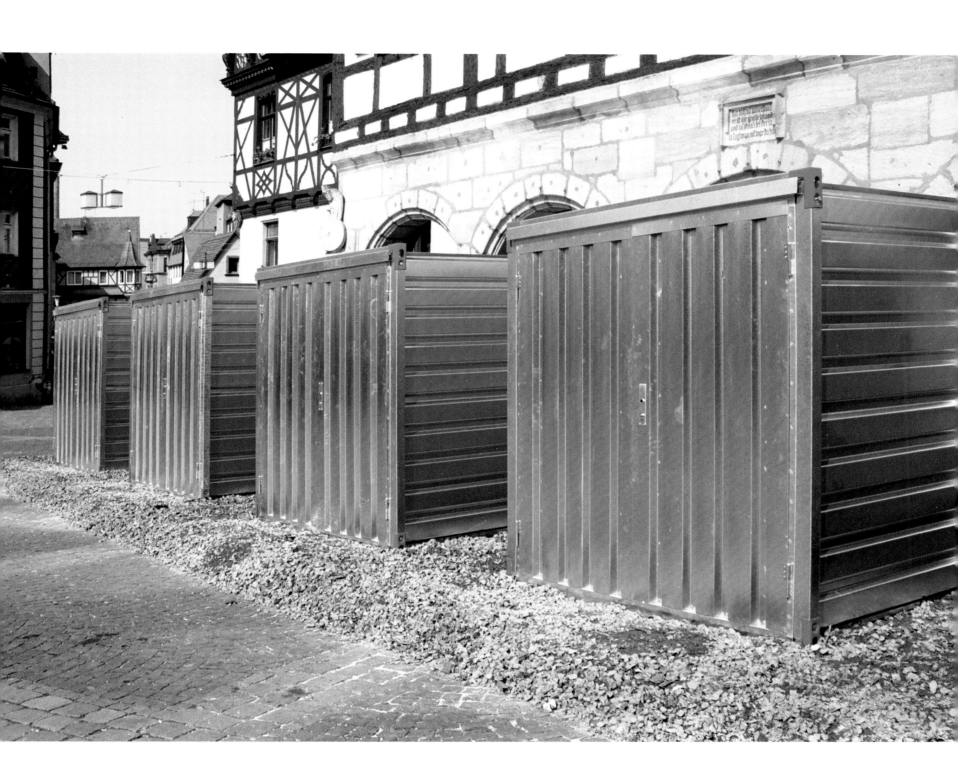

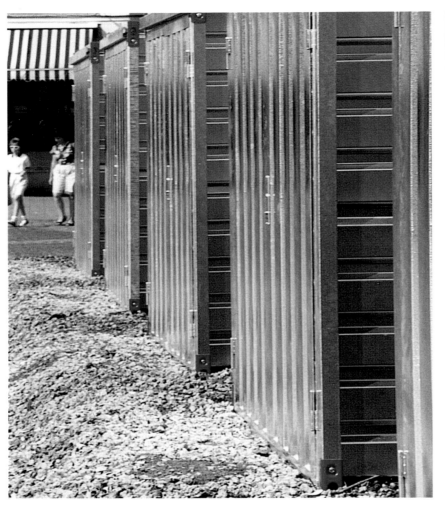

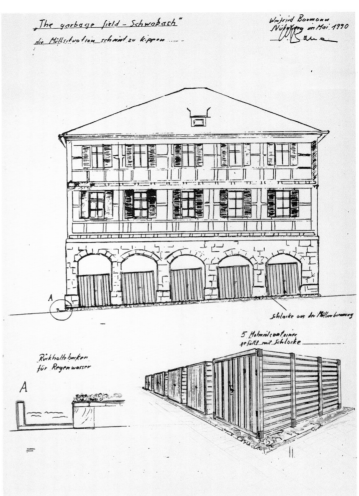

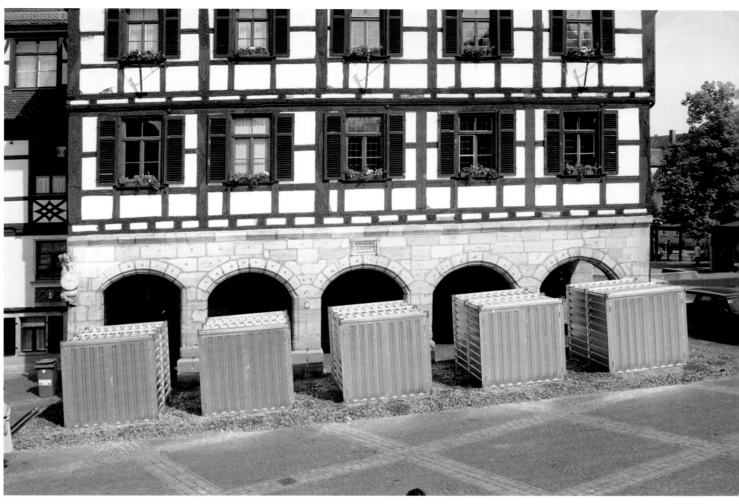

Standort — Location	Königsplatz, Schwabach, DEU
Jahr — Year	1990
Maße — Measurements	16 x 4 x 2,5 m
Material — Material	Schlacke aus der Müllverbrennung, Stahlblech
	Slag from garbage incineration, steel plate

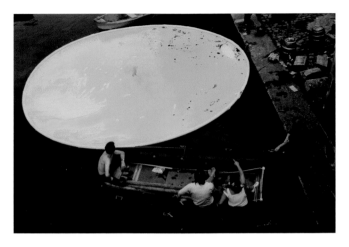

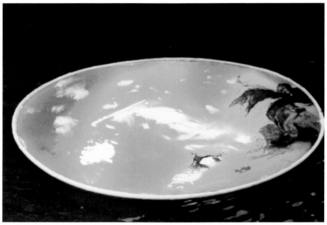

Standort — Location	Kreis im Fluss, Pegnitz, Nürnberg, DEU
Jahr — Year	1987
Maße — Measurements	Durchmesser/*Diameter* 6,5 m
Material — Material	Folienbecken, Farbstoff Uranin grob kristallin
	Foil trough, dye uranin, coarse crystalline

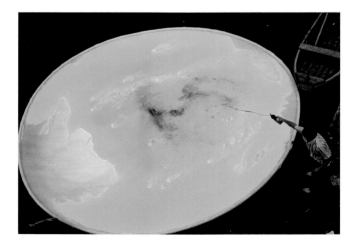

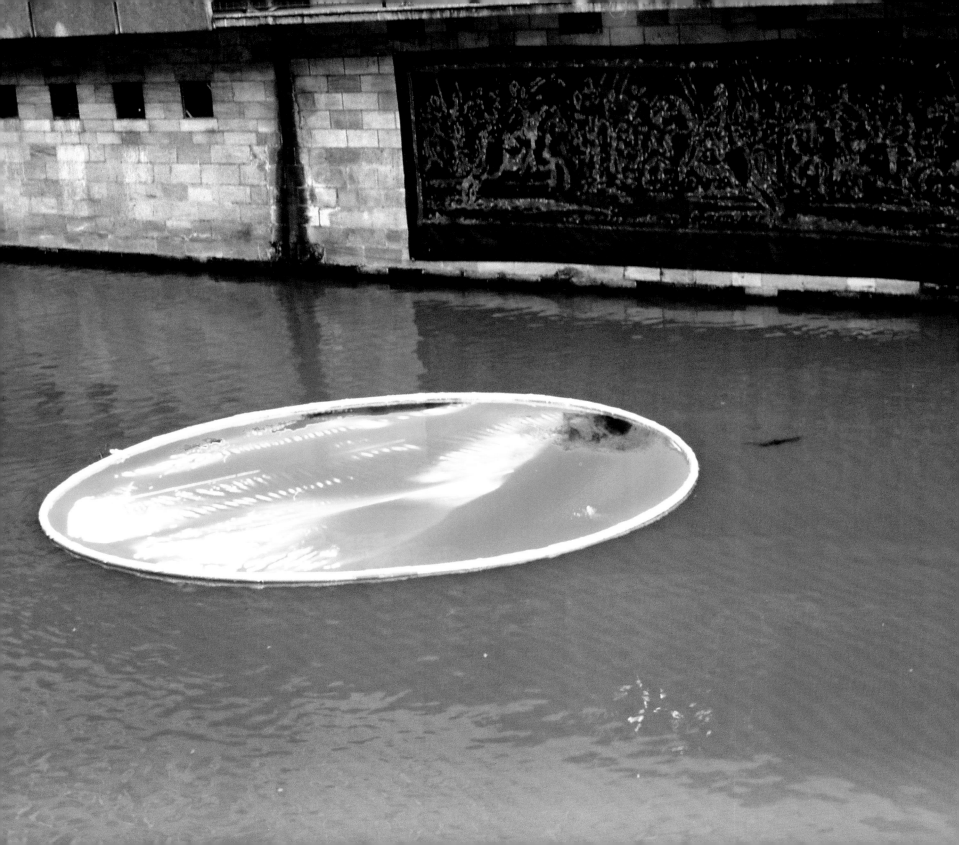

1.3

ERRATISCHE BLÖCKE
ERRATIC BOULDERS

Standort — Location	Hauptmarkt, Nürnberg, DEU
Jahr — Year	1990
Maße — Measurements	290 x 130 x 115 cm
Material — Material	Schlacke aus der Müllverbrennung, Muschelkalk, Blei
	Slag from garbage incineration, shell lime, lead

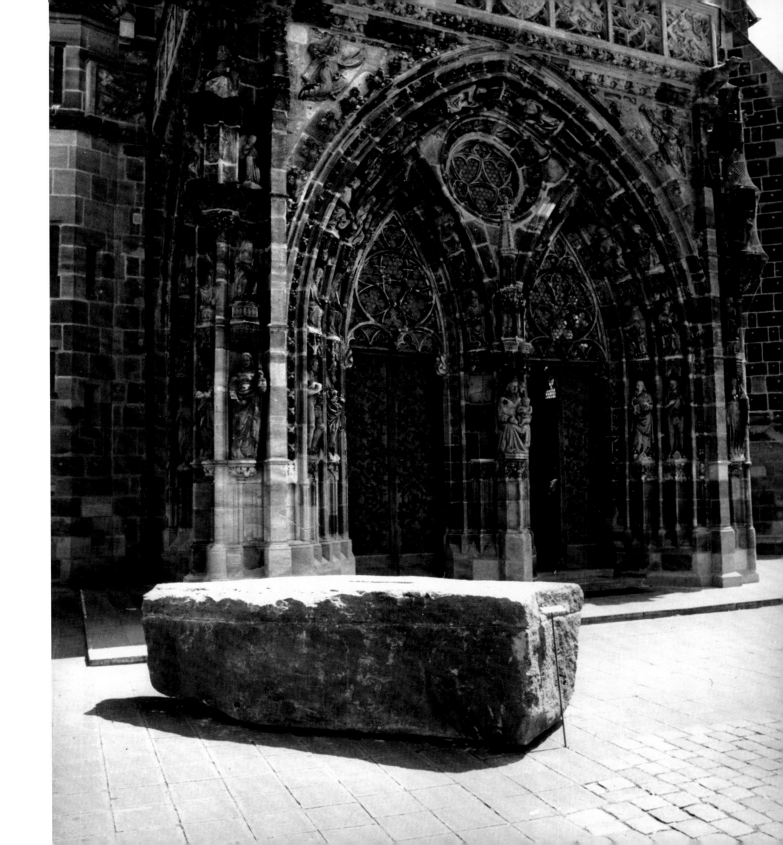

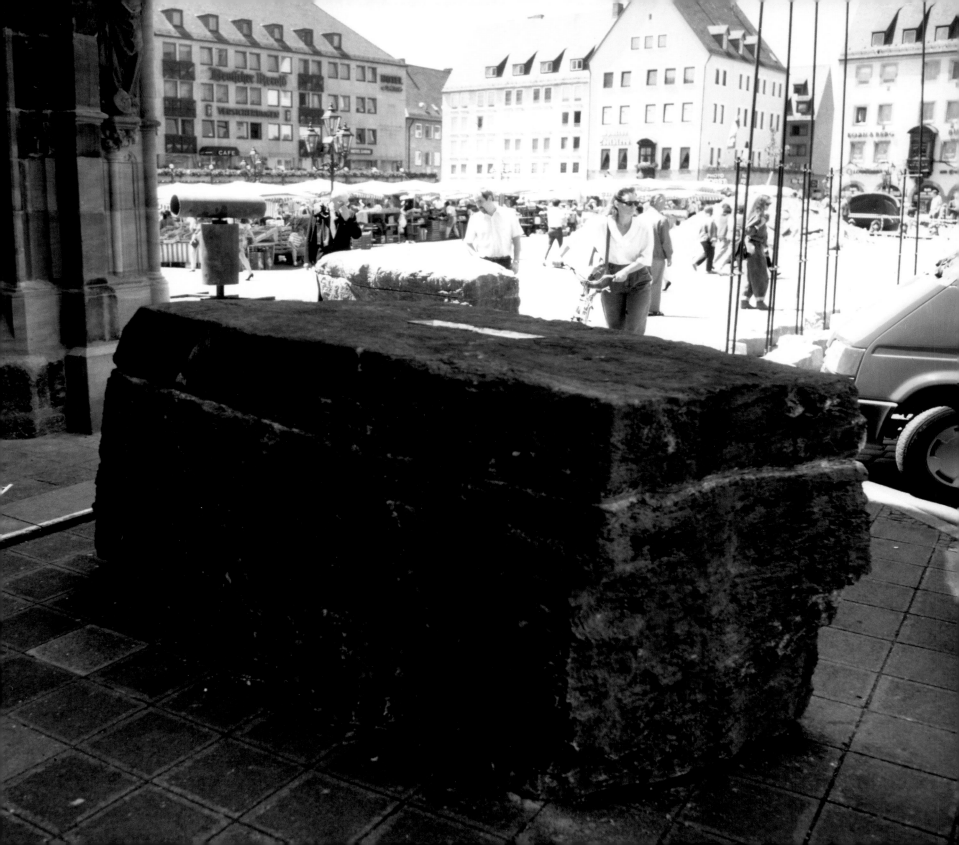

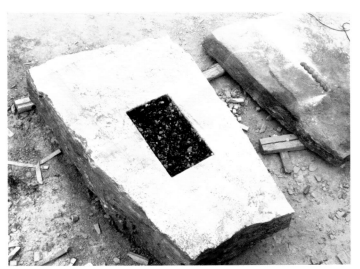

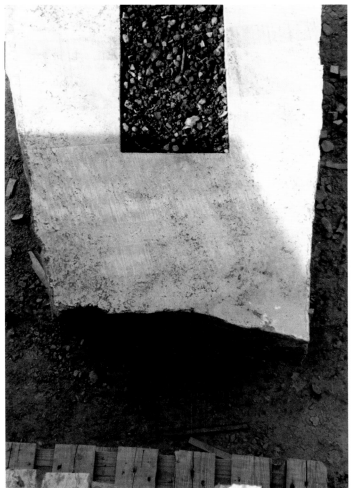

Standort — Location	Hauptmarkt, Nürnberg, DEU
Jahr — Year	1990
Maße — Measurements	220 x 125 x 130 cm
Material — Material	Schlacke aus der Müllverbrennung, Muschelkalk, Blei
	Slag from garbage incineration, shell lime, lead

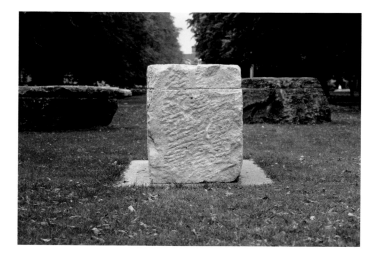

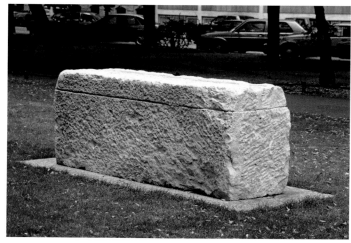

Standort — Location	Hornschuchpromenade, Fürth, DEU
Jahr — Year	1992
Maße — Measurements	290 x 95 x 115 cm
Material — Material	Schlacke aus der Müllverbrennung, Donaukalk
	Slag from garbage incineration, Danube lime

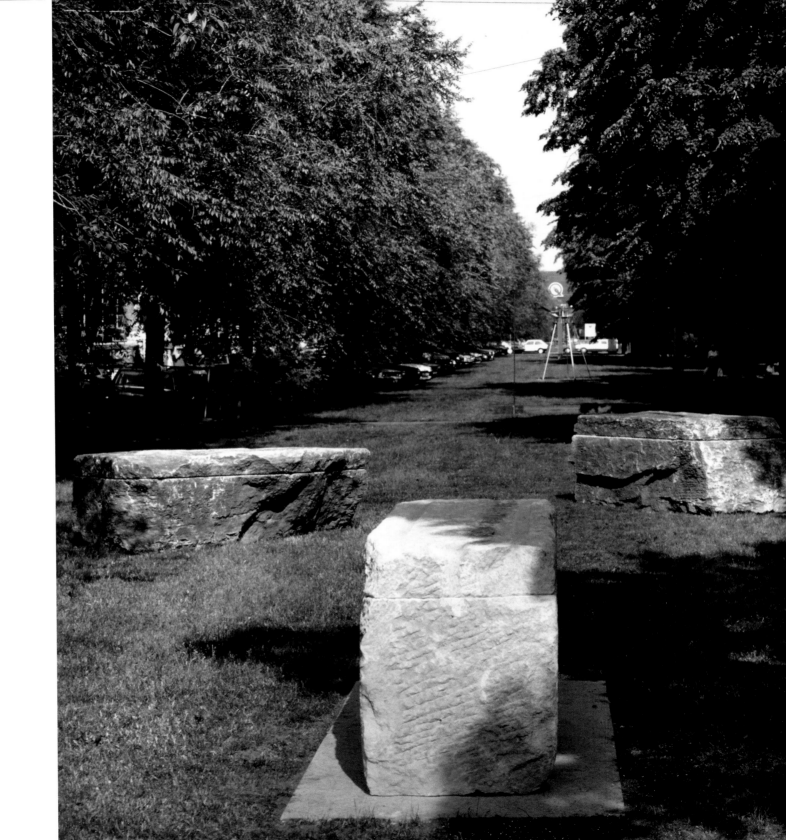

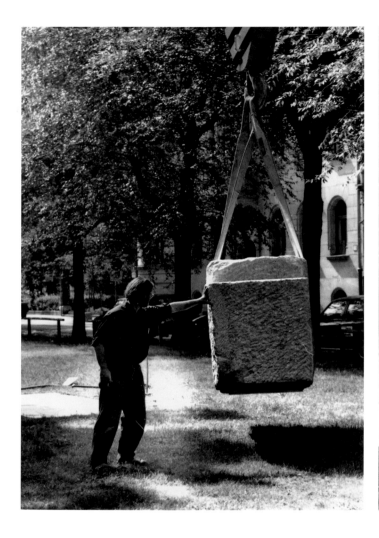
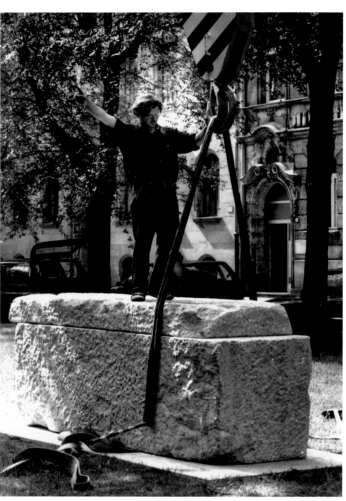

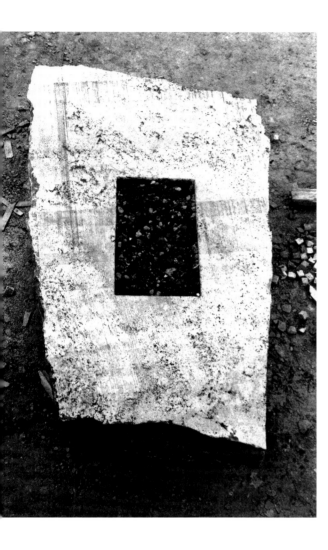

Erratische Blöcke, Hornschuchpromenade, Fürth

Verschattet vom nahen Laub der Alleebäume wird der Platz, den Winfried Baumann für diese Arbeit wählt, zum Ort. Die planvolle Aufstellung der drei Sarkophage bezieht den Betrachter in den wortlosen Dialog ein: die Wahrnehmung von Zeit. Gleichwohl erschließt sich die Arbeit nicht spontan, sie ist widerständig und fordert „zur langsamen Vertiefung von Gedanken" heraus.

Winfried Baumann ist Bildhauer. Trotzdem erinnern die graubraunen hieratischen Grabmale an Findlinge aus Muschelkalkbänken eines fernen Erdzeitalters, durch Austrocknung gerissen, Zeitverletzungen preisgebend. Tiefe, schmale Einschnitte in den beiden schmucklosen Sarkophagdeckeln sind von eingelassenem Panzerglas bedeckt. Sie gewähren Einblicke auf das darin Bewahrte: schwarze Schlacke aus der Müllverbrennungsanlage; als das Geschiedene vom täglichen Gebrauch, an das nicht mehr Benötigte; als Referenz an das Verbrauchte der Welt, an den Grundstoff.

Der mittig dazugesetzte dritte Stein schimmert in ungewöhnlicher Helligkeit. Aus der Grasfläche hervorgehoben von einer ebenso hellen Marmorplatte, die ihm unterlegt ist, zeigt er präzise dieselben Abmessungen der beiden grauen Sarkophage. Er scheint ohne Verletzungen, aus der Jetzt-Zeit. Neben der rundumlaufenden, glattpolierten Rinne des Grabdeckels, die weiß glänzend die Einschlüsse fossiler Relikte zeigt, findet sich eine frischrote Spur. Sie macht den Sarkophag zum Opfertisch für ein unbekanntes Ritual.

Erratic Boulders, Hornschuchpromenade, Fürth

Shaded by the nearby foliage of the trees in the avenue, the site that Winfried Baumann selected for this work became a true location. The deliberate arrangement of the three sarcophagi draws the viewer into a wordless dialogue: on the perception of time. Nonetheless, the work cannot be grasped spontaneously; it resists and challenges us "to gradually think more deeply".

Winfried Baumann is a sculptor. Nonetheless, the grey-brown, hieratic grave monuments are reminiscent of erratic boulders from the shell lime banks of a distant age, cracked by desiccation, exposed to the injuries of time. Deep, narrow cuts in the two simple sarcophagi lids are covered by fortified glass inserts. They allow us to look in and see what is kept there: black slag from the refuse incineration plant; the deposits of daily usage, as things no longer required; a reference to the used and exhausted things of this world, to the raw materials.

The additional third stone standing in the centre shimmers with unusual brightness. Raised from the grass area by an equally light slab of marble laid beneath it, its measurements are precisely the same as those of the two grey sarcophagi. It seems to be without damage, dating from the present time. Beside the smooth-polished channel running all around the grave covering, which reveals embedded, white-gleaming fossil relics, we find a fresh track of red. It makes the sarcophagus into the sacrificial altar for an unknown ritual.

Barbara Rothe

Standort — Location	Georg Simon Ohm Hochschule, Nürnberg, DEU
Jahr — Year	1997
Maße — Measurements	240 x 260 x 115 cm
Material — Material	Schlacke aus der Müllverbrennung, Muschelkalk, Blei
	Slag from garbage incineration, shell lime, lead

Spent natural resources inside
Spent natural resources inside

Standort — Location	Georg Simon Ohm Hochschule, Nürnberg, DEU
Jahr — Year	1997
Maße — Measurements	32 x 32 x 5 cm
Material — Material	Edelstahl, Schlacke aus der Müllverbrennung, Muschelkalk
	Stainless steel, slag from garbage incineration, shell lime

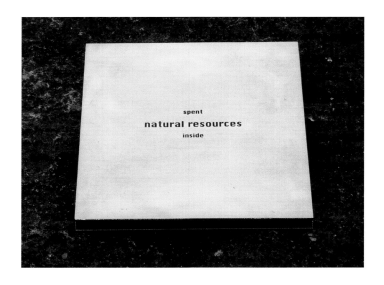

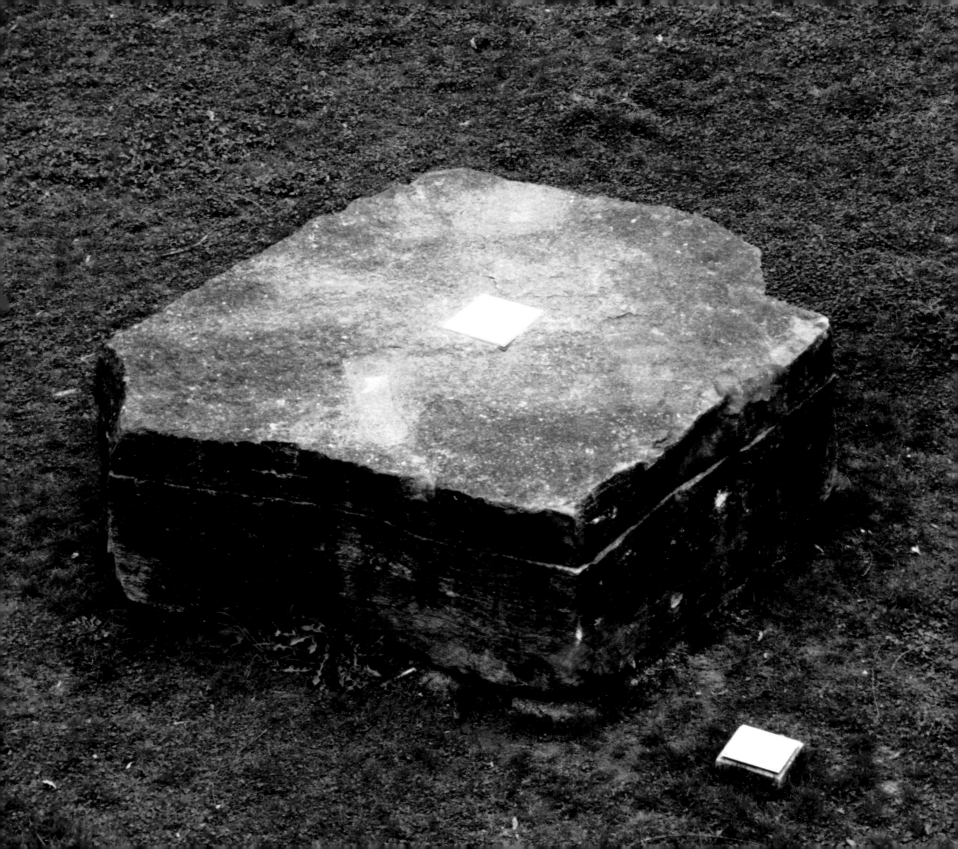

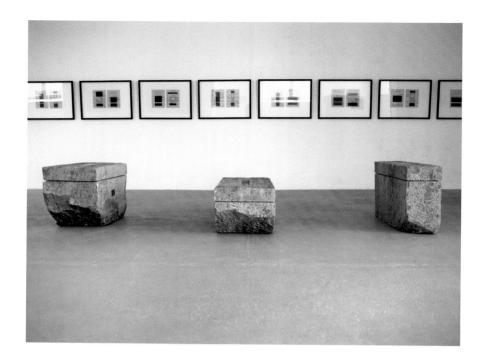

Standort — Location	Galerie ars videndi, Pfaffenhofen, DEU
Jahr — Year	1997
Maße — Measurements	120 x 80 x 45 cm
Material — Material	Schlacke aus der Müllverbrennung, Muschelkalk, Blei
	Slag from garbage incineration, shell lime, lead

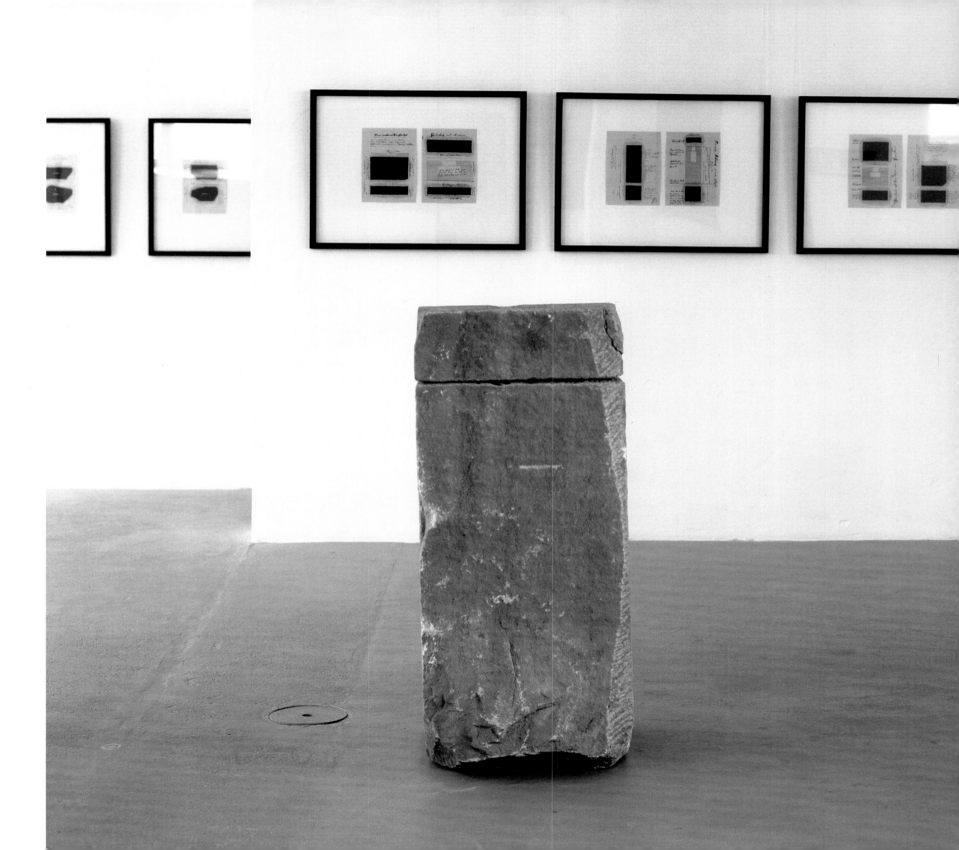

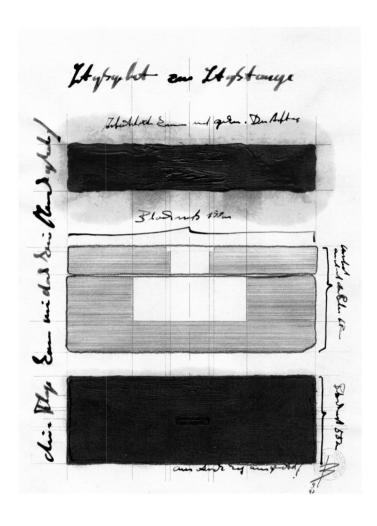

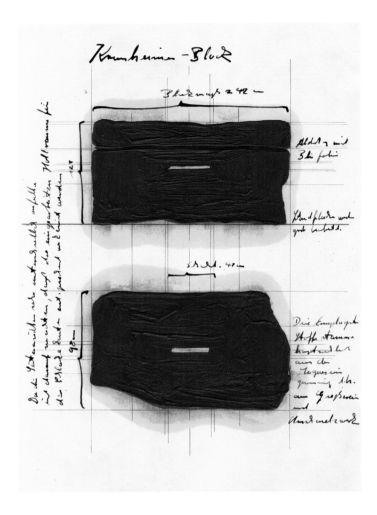

Standort — Location	Privatbesitz, Nürnberg, DEU
Jahr — Year	1997
Maße — Measurements	21 x 30 cm
Material — Material	Caput mortuum, Tusche, Papier
	Caput mortuum, India ink, paper

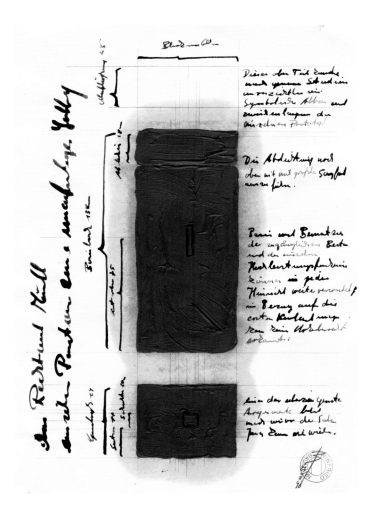

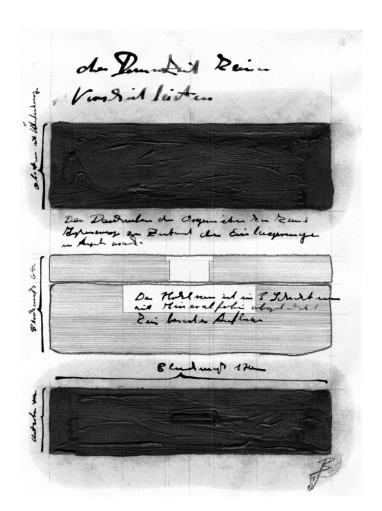

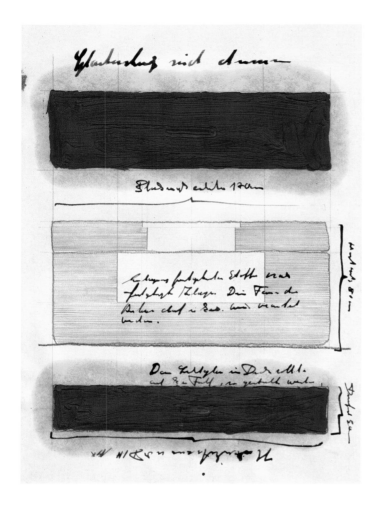

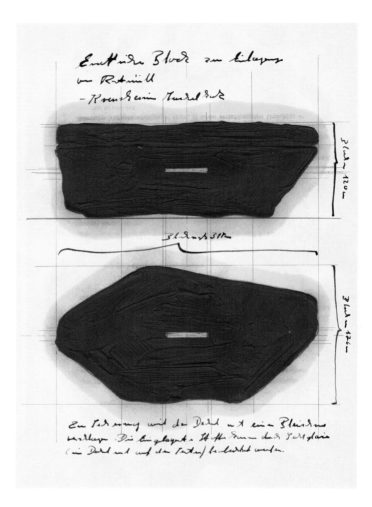

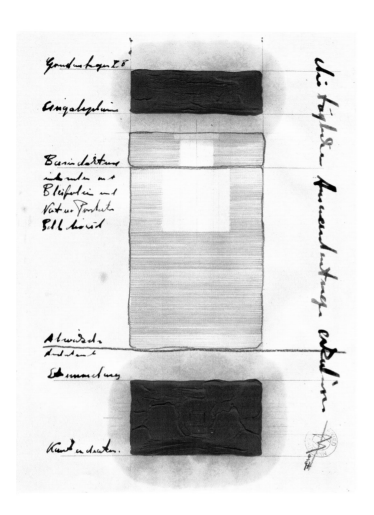

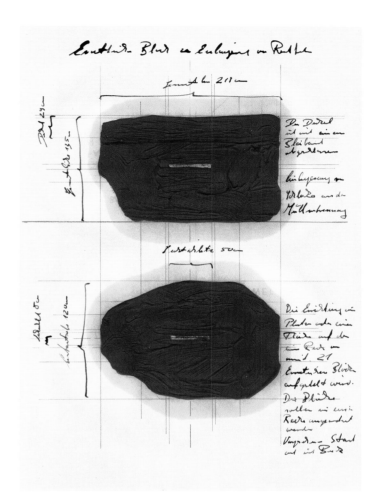

Kathedralen für den Müll
Cathedrals for Garbage

Müllarchitektur
Waste Architecture

Urban Mining Mülldeponien
Urban Mining Waste Dumps

Megadeponien
Mega-Dumbs

Runddeponien
Hazardous Waste Dumbs

Detroit is Everywhere
Detroit is Everywhere

Nuklear-Katastrophen
Nuclear Disasters

2.1

KATHEDRALEN FÜR DEN MÜLL

CATHEDRALS FOR GARBAGE

Konzeption von Mülldeponien
nach dem Proportionsschema gotischer Kathedralen
und anderer sakraler Bauwerke

Concept of waste dumps according to
the schemes of proportion behind Gothic cathedrals
and other religious buildings

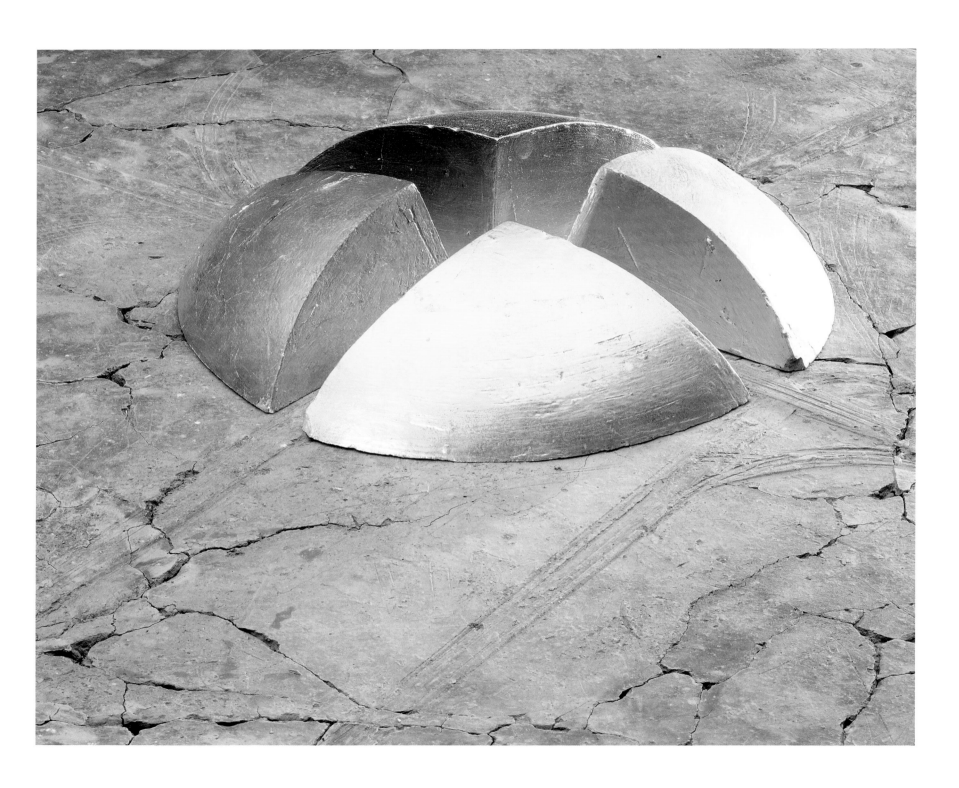

Proportionierungsgrundlage — Basis for Proportioning	Omar Bin al Khattab Moschee, Doha, QAT
	Mosque Omar Bin al Khattab, Doha, QAT
Jahr — Year	2013
Maße — Measurements	115 x 65 x 14 cm
Material — Material	Blattgold, Holz, Tonerde
	Gold leaf, wood, clay

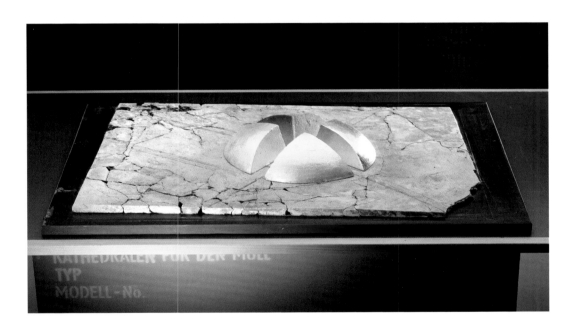

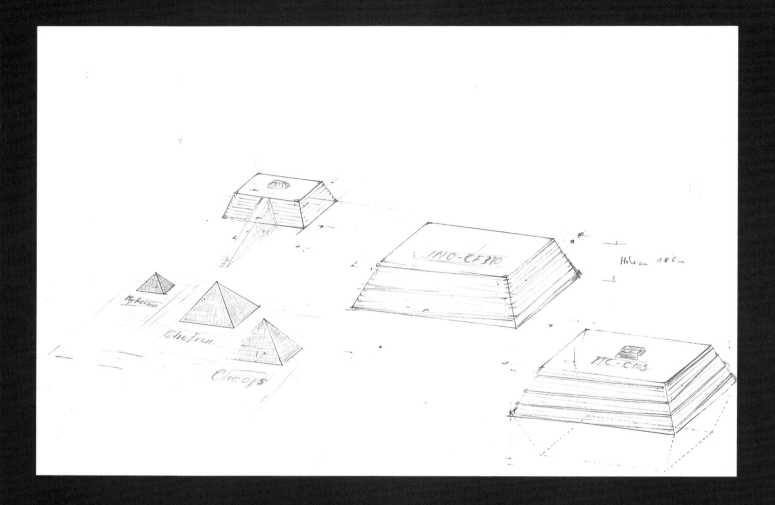

Proportionierungsgrundlage — Basis for Proportioning Pyramiden von Gizeh, EGY
Pyramids of Giza, EGY

Jahr — Year 2013
Maße — Measurements 30 x 21 cm
Material — Material Zeichnungen auf Papier
Drawings on paper

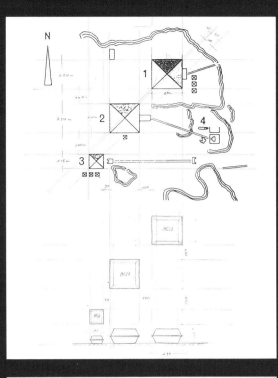

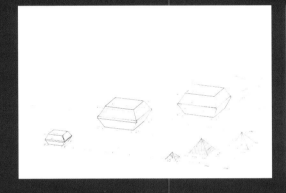

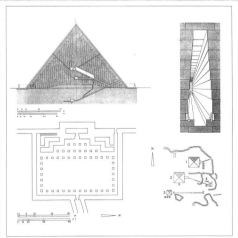

Pyramide de Chéops à Giza, édifiée vers 2600 avant notre ère. Haute de 146,5 m pour une base carrée de 230 m de côté, cette construction, la plus énorme de l'histoire, dépasse 2,5 millions de m³. Coupe 1:3000, plan du temple haut 1:750, coupe axonométrique de la grande galerie en encorbellement et plan masse du site de Giza 1:30000. 1) Chéops, 2) Chéphren, 3) Mykérinos, 4) Sphinx.

Gise, Cheops-Pyramide, um 2600 v. Chr. Dieses gewaltigste Bauwerk der Geschichte hat bei einer Höhe von 146,5 m über einer quadratischen Basis von 230 m Seitenlänge einen Rauminhalt von über 2,5 Millionen Kubikmeter. Schnitt 1:3000; Grundriß des Totentempels 1:750; axonometrischer Schnitt durch die große Galerie mit Kraggewölbe; Lageplan von Gise 1:30000: 1) Cheops, 2) Chefren, 3) Mykerinos, 4) Sphinx.

Cheops pyramid, Giza, built c. 2600 B.C. Rising to a height of 146.5 m. on a base measuring 230 m. square, this building, the largest in history, occupies more than 2.5 million m³. Section 1:3000; plan of the raised temple 1:750; axonometric section of the great corbelled gallery and plan of the Giza site 1:30,000. 1) Cheops, 2) Chephren, 3) Mycerinus, 4) Sphinx.

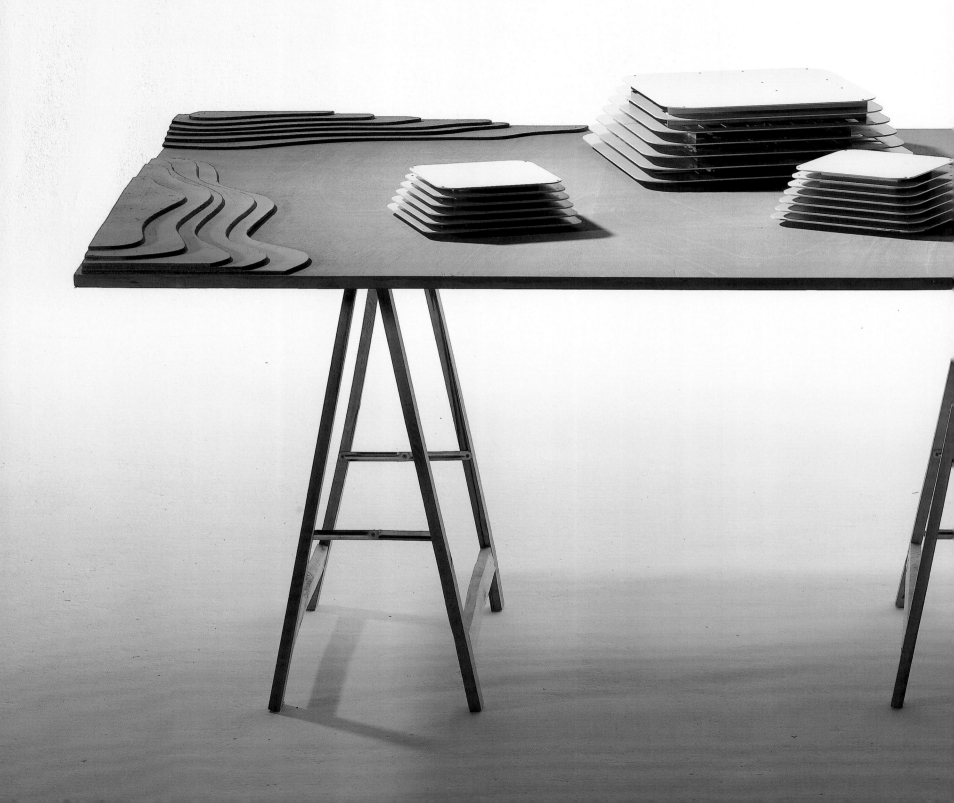

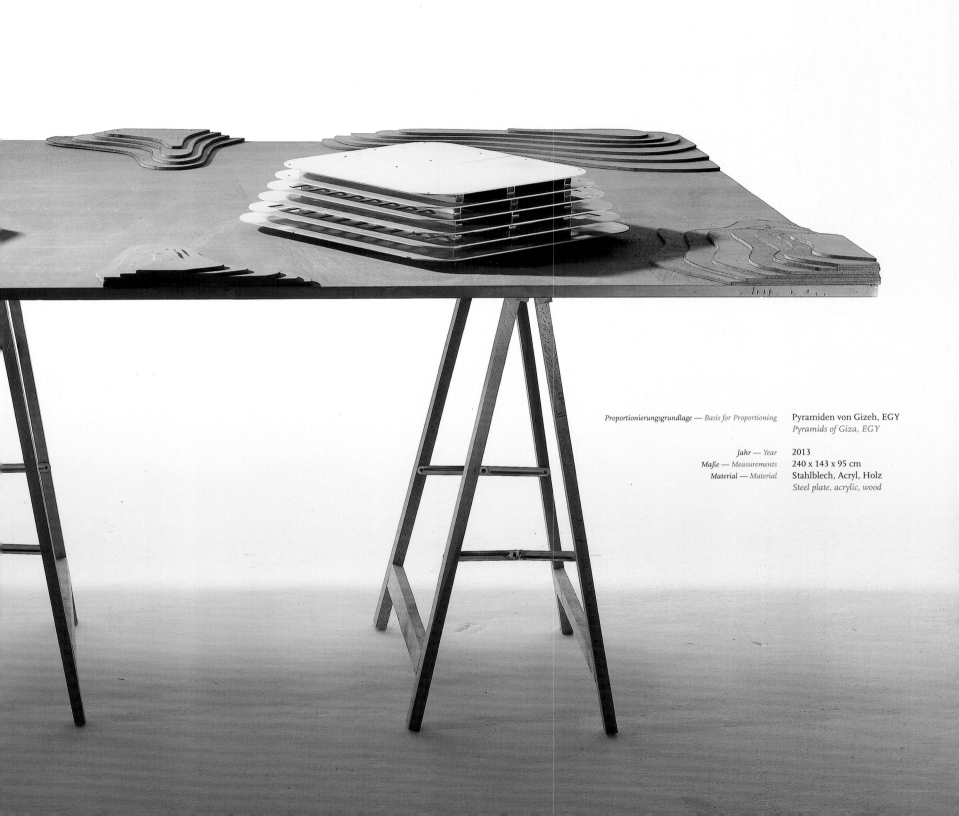

Proportionierungsgrundlage — Basis for Proportioning Pyramiden von Gizeh, EGY
Pyramids of Giza, EGY

Jahr — Year 2013
Maße — Measurements 240 x 143 x 95 cm
Material — Material Stahlblech, Acryl, Holz
Steel plate, acrylic, wood

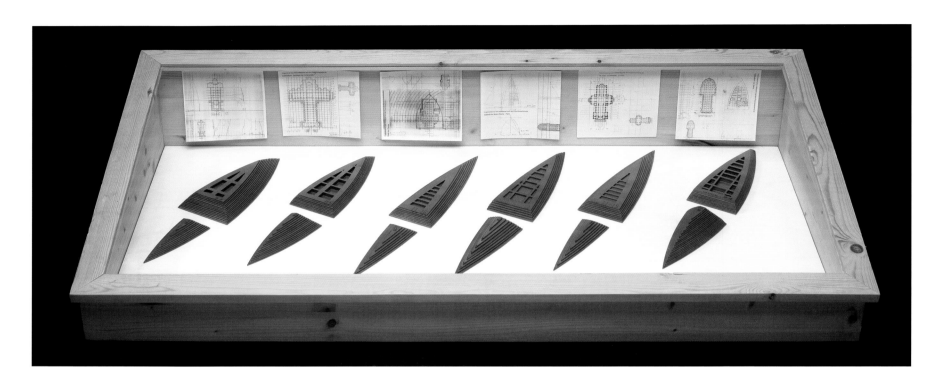

Proportionierungsgrundlage — Basis for Proportioning Basilika St. Peter, Vatikanstadt, VAT
St Peter's Basilica, Vatican City, VAT

Jahr — Year 2013
Maße — Measurements 125 x 60 x 25 cm
Material — Material Holz, Eisen, Glas
Wood, iron, glass

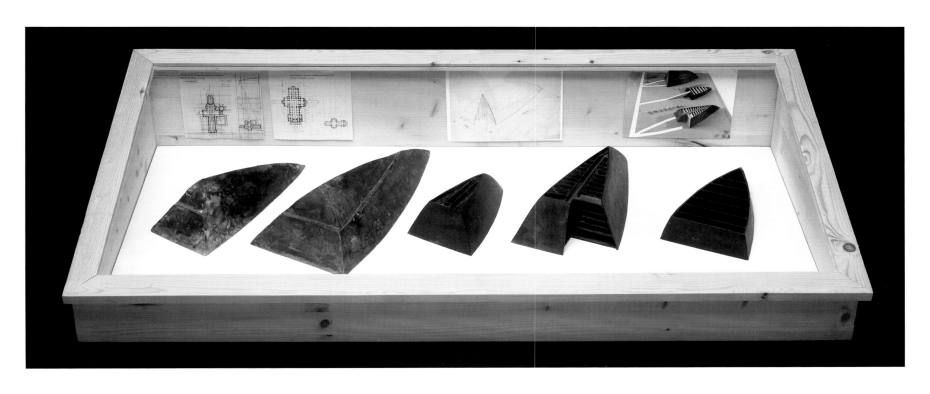

Proportionierungsgrundlage — Basis for Proportioning	Sixtinische Kapelle, Vatikanstadt, VAT *Sixtine Chapel, Vatican City, VAT*
Jahr — Year	2013
Maße — Measurements	125 x 60 x 25 cm
Material — Material	Holz, Eisen, Glas *Wood, iron, glass*

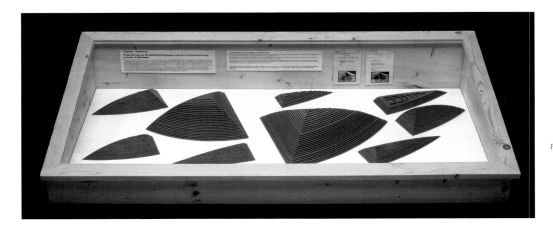

Proportionierungsgrundlage — Basis for Proportioning	Vatikanische Gärten, Vatikanstadt, VAT *Vatican Gardens, Vatican City, VAT*
Jahr — Year	2013
Maße — Measurements	125 x 60 x 25 cm
Material — Material	Holz, Eisen, Glas *Wood, iron, glass*

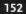

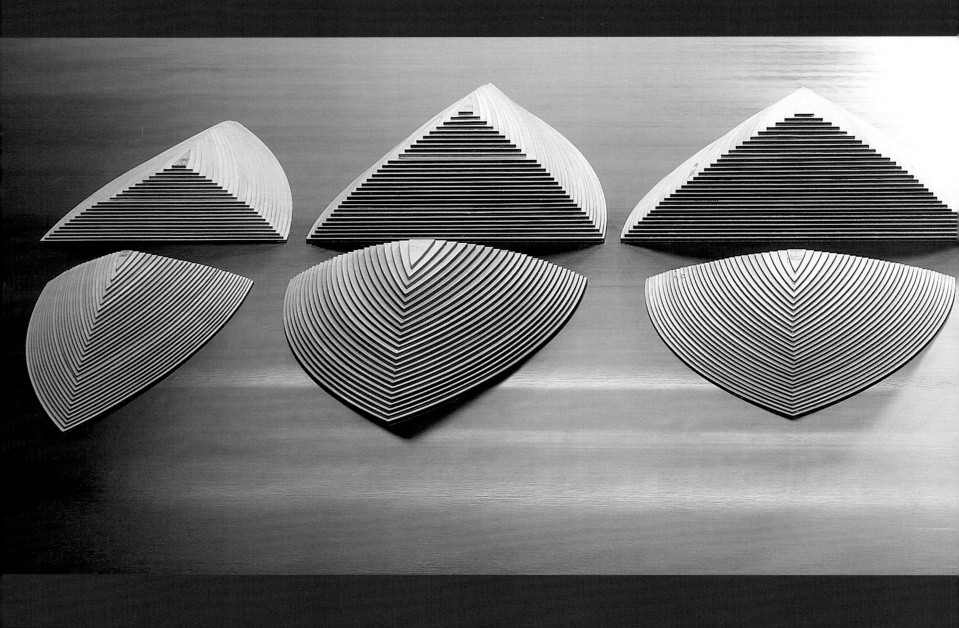

Proportionierungsgrundlage — Basis for Proportioning	Palace of Westminster, London, GBR
Jahr — Year	2013
Maße — Measurements	190 x 115 x 22 cm
Material — Material	Holz, Eisen
	Wood, iron

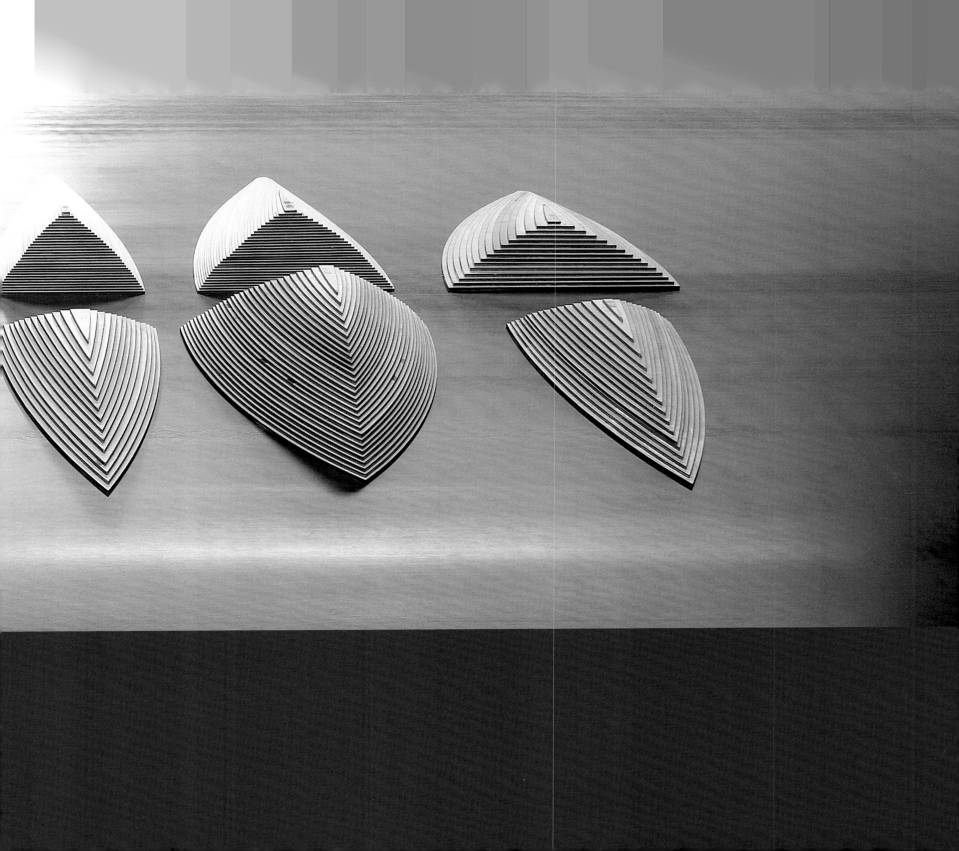

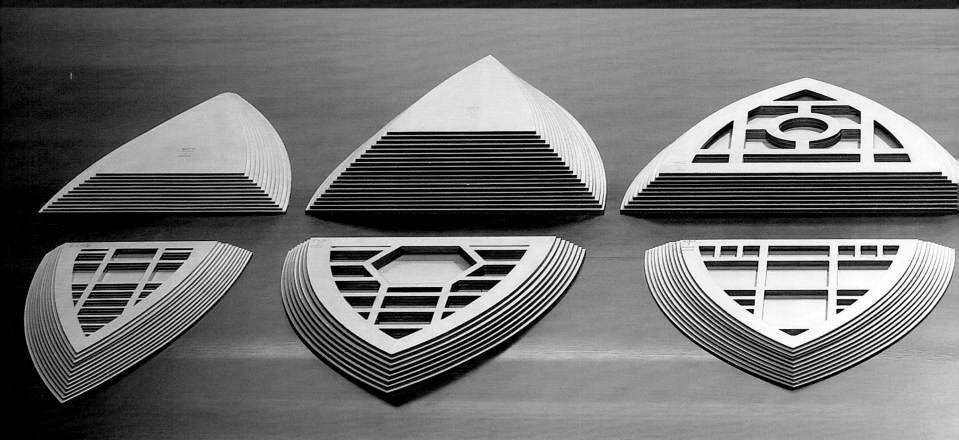

Proportionierungsgrundlage — Basis for Proportioning Palace of Westminster, London, GBR

Jahr — Year 2013
Maße — Measurements 190 x 115 x 22 cm
Material — Material Holz, Eisen
Wood, iron

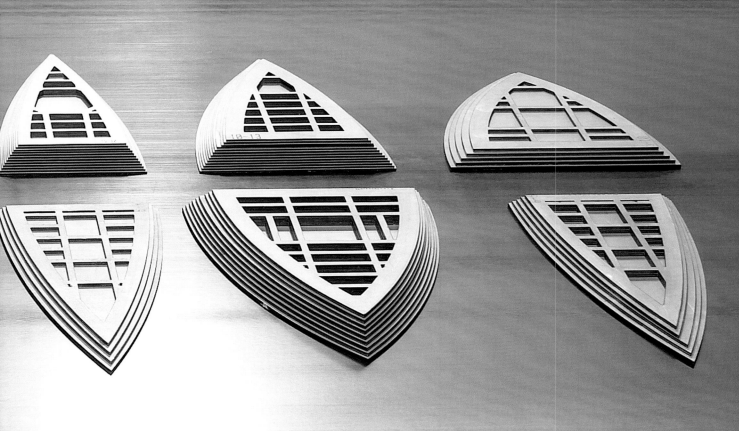

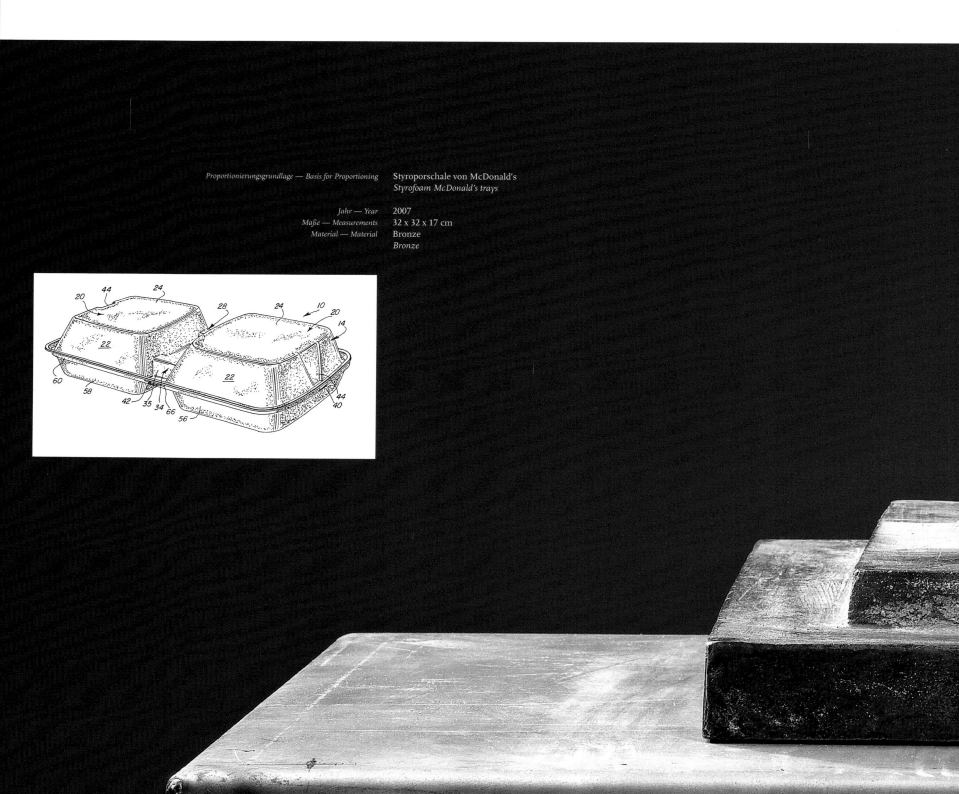

Proportionierungsgrundlage — Basis for Proportioning Styroporschale von McDonald's
Styrofoam McDonald's trays

Jahr — Year 2007
Maße — Measurements 32 x 32 x 17 cm
Material — Material Bronze
Bronze

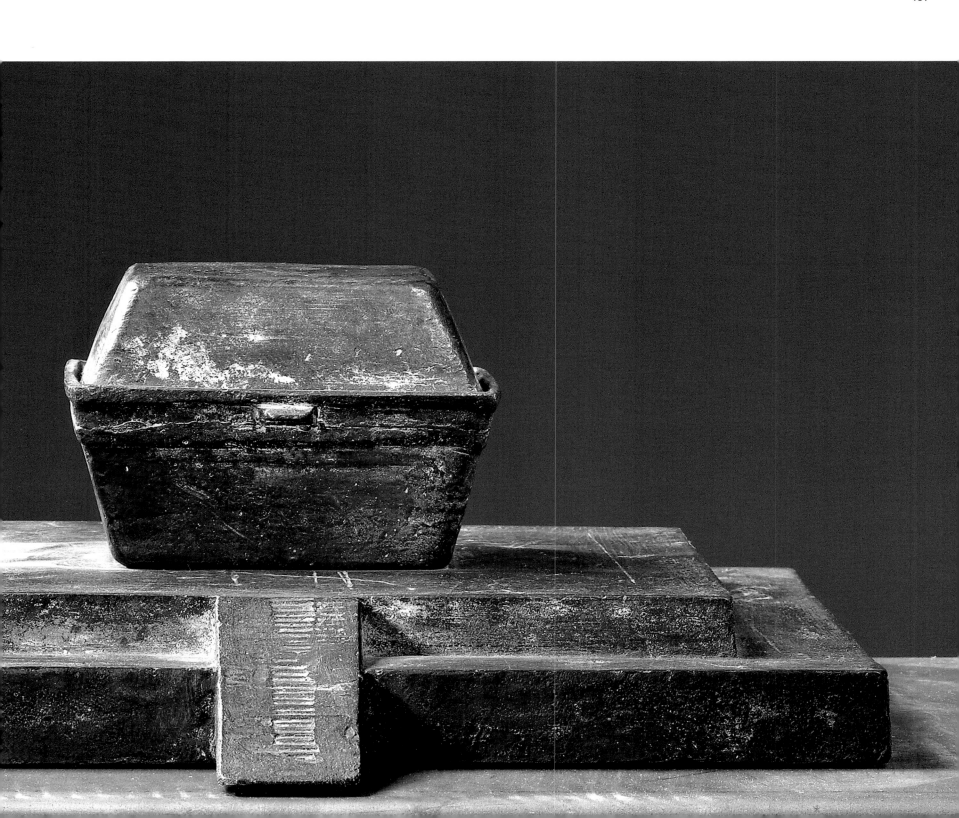

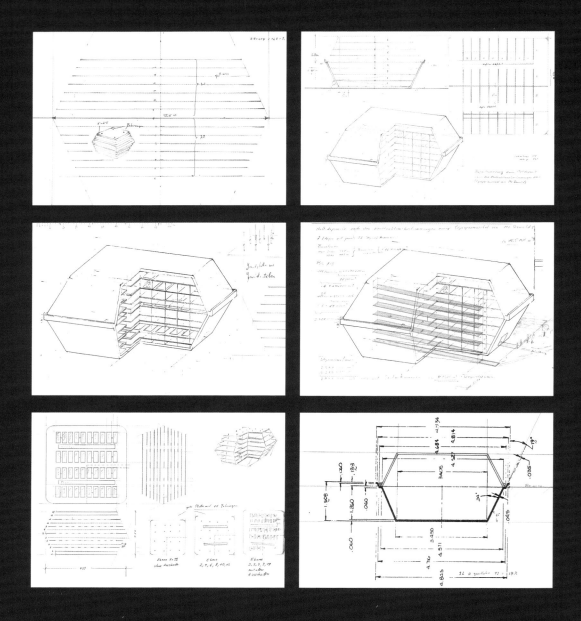

Proportionierungsgrundlage — Basis for Proportioning Styroporschale von McDonald's
Styrofoam McDonald's trays

Jahr — Year 2007
Maße — Measurements 21 x 23 x 17 cm
Material — Material Zeichnung
Drawing

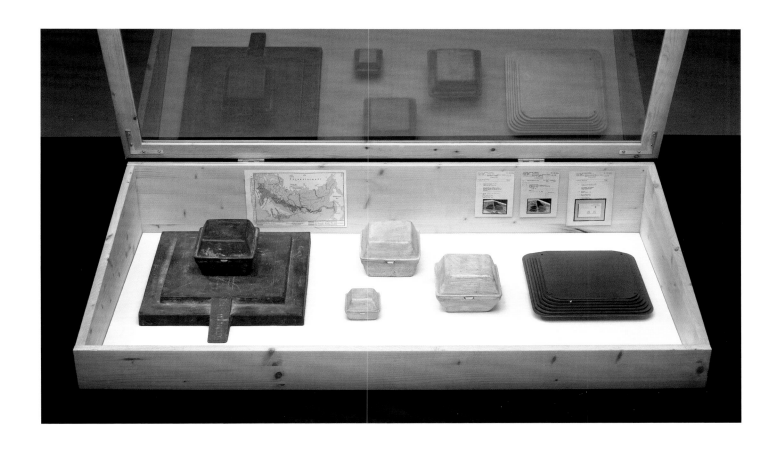

Proportionierungsgrundlage — Basis for Proportioning Styroporschale von McDonald's
Styrofoam McDonald's trays

Jahr — Year 2007
Maße — Measurements 125 x 52 x 22 cm
Material — Material Holz, Bronze, Gips
Wood, bronze, plaster

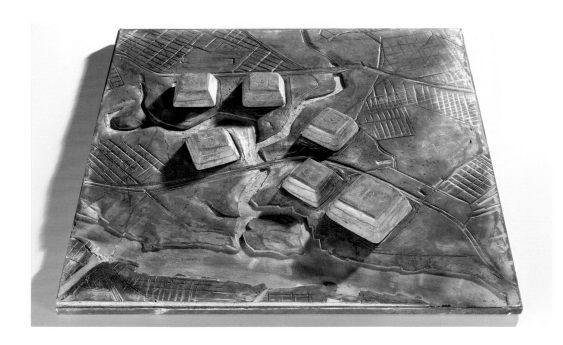

Proportionierungsgrundlage — Basis for Proportioning	Styroporschale von McDonald's *Styrofoam McDonald's trays*
Jahr — Year	2007
Maße — Measurements	97 x 72 x 8 cm
Material — Material	Beton *Concrete*

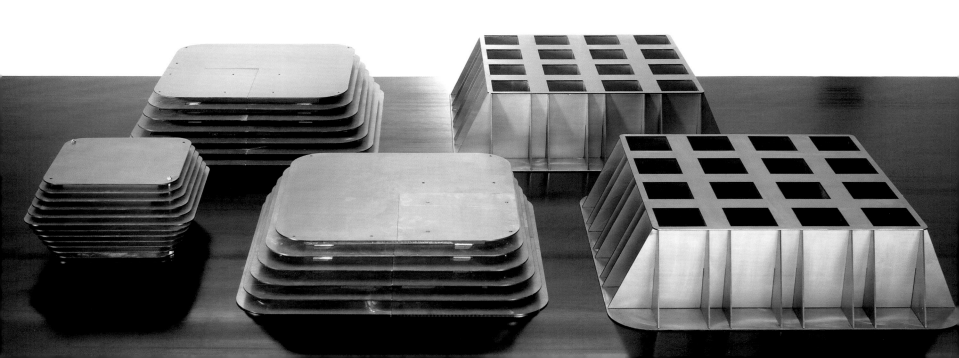

Abbildung 1. Ein Vergleich zwischen der Sonnenpyramide in Teotihuacán in Mexiko (links) und der Fresh-Kills-Deponie auf Staten Island in New York (rechts). Die Sonnenpyramide mißt auf jeder Seite ungefähr 245 Meter; das Gitternetz von Fresh Kills umfaßt insgesamt eine Fläche von etwa 4,5 mal 6 Kilometer. Die Bodenerhebungen wurden der Klarheit wegen überzeichnet, doch das Verhältnis der Volumina zueinander stimmt genau. *Quelle:* Masakazu Tani, Das Müllprojekt.

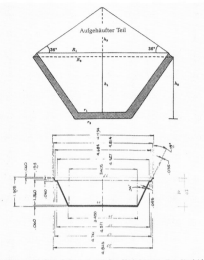

Abbildung 15. Querschnitt einer typischen Uruk-Schüssel. Zum Vergleich darunter ein Detail der ursprünglichen Konstruktionsbestimmungen für die untere Hälfte der Styropormuschel von McDonald's, maßstabsgetreu wiedergegeben.
Quelle: Thomas Wight Beale, »Bevelled Rim Bowls and Their Implications for Change and Economic Organization in the Later Fourth Millennium B. C.«, in: *Journal of Near Eastern Studies,* Oktober 1978; Mc Donald's

Proportionierungsgrundlage — Basis for Proportioning	Styroporschale von McDonald's *Styrofoam McDonald's trays*
Jahr — Year	2007
Maße — Measurements	21 x 30 cm
Material — Material	Fotodruck *Photo print*

Proportionierungsgrundlage — Basis for Proportioning	Styroporschale von McDonald's *Styrofoam McDonald's trays*
Jahr — Year	2007
Maße — Measurements	250 x 52 x 22 cm
Material — Material	Eisen *Iron*

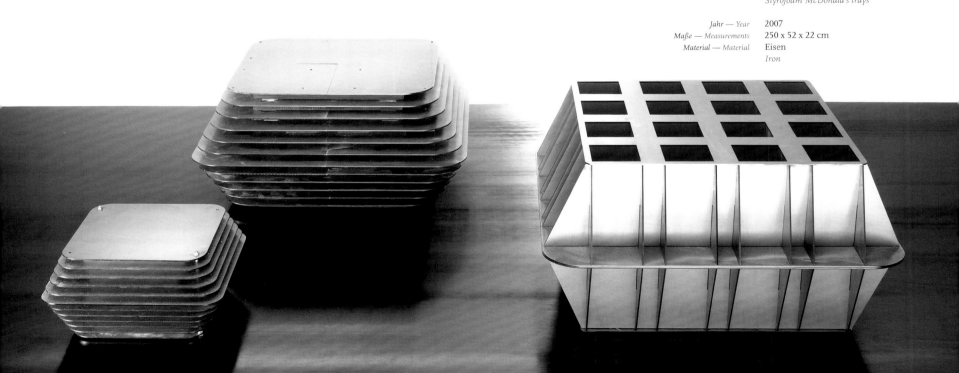

Proportionierungsgrundlage — Basis for Proportioning Jing'an Tempel, Shanghai, CHN
Jing'an Temple, Shanghai, CHN

Jahr — Year 2007
Maße — Measurements 85 x 63 x 42 cm
Material — Material Faserbeton, Eisen, Holz
Fibre concrete, iron, wood

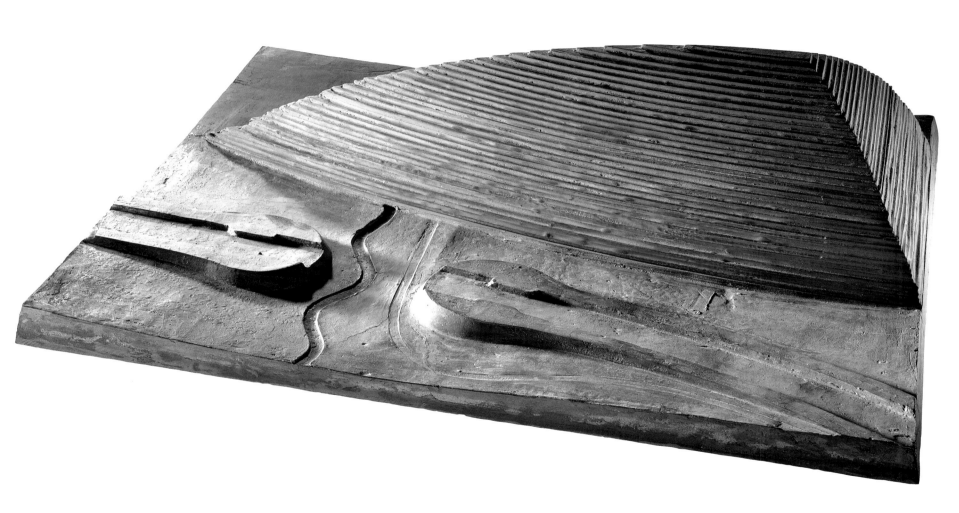

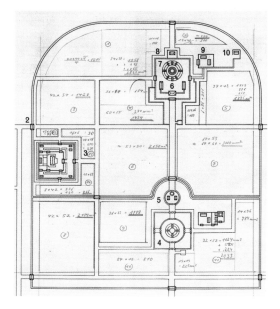

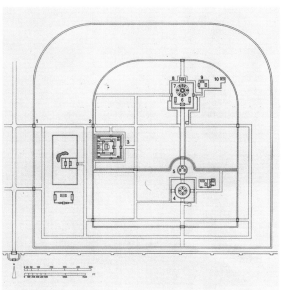

Proportionierungsgrundlage — Basis for Proportioning	Tempel des Himmels, Beijing, CHN
	Temple of Heaven, Beijing, CHN
Jahr — Year	2005
Maße — Measurements	21 x 27 cm
Material — Material	Zeichnung
	Sketch

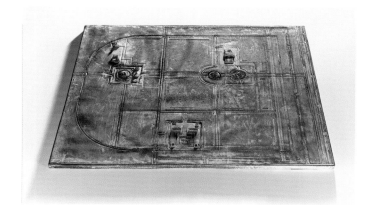

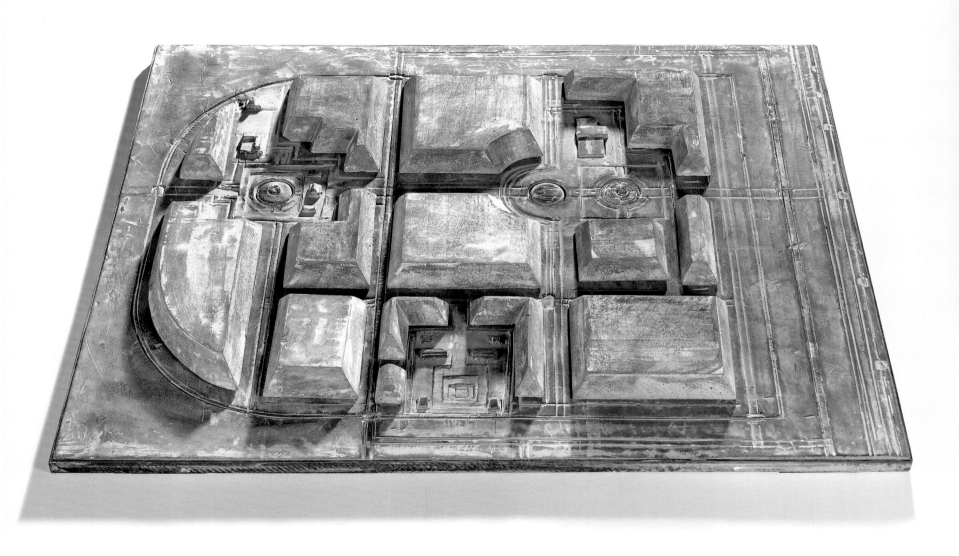

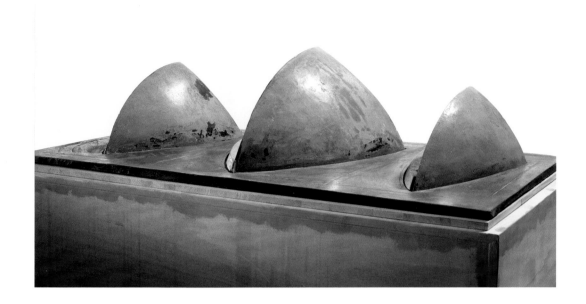

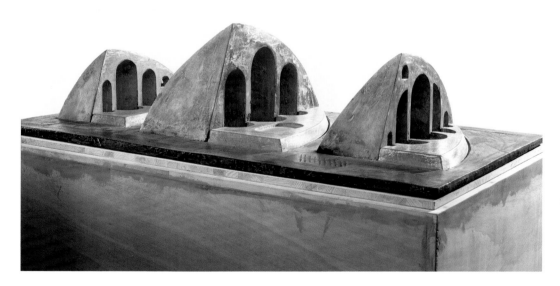

Proportionierungsgrundlage — Basis for Proportioning	al-Aqsa-Moschee, Jerusalem, ISR
	al-Aqsa-Mosque, Jerusalem, ISR
Jahr — Year	2004
Maße — Measurements	115 x 74 x 42 cm
Material — Material	Beton, Eisen, Holz
	Concrete, iron, wood

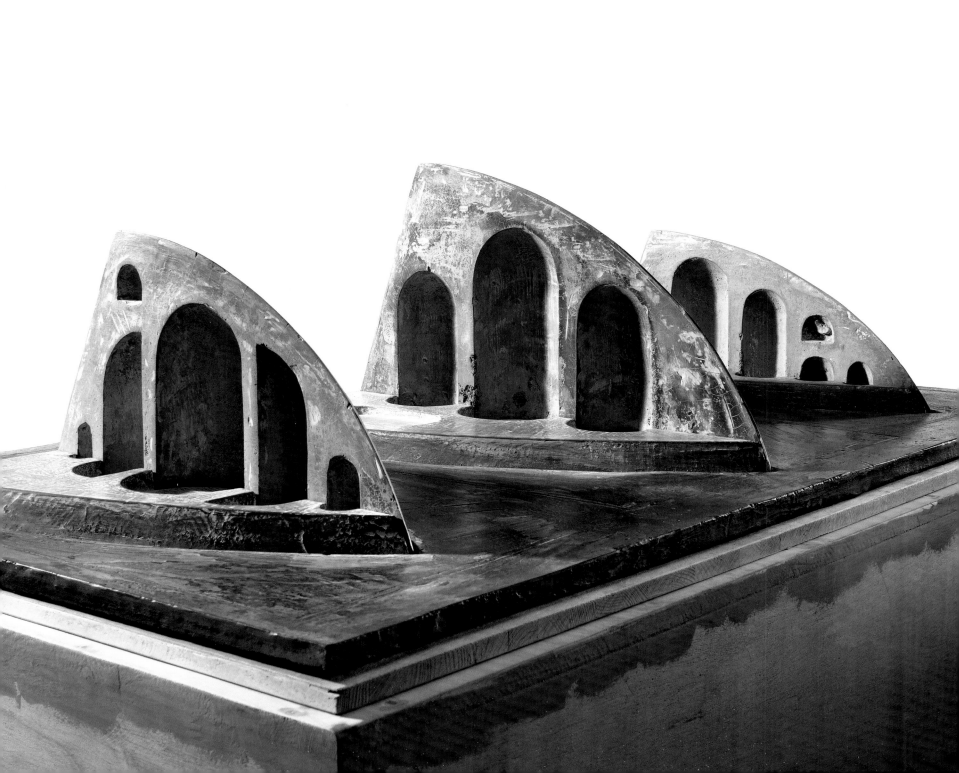

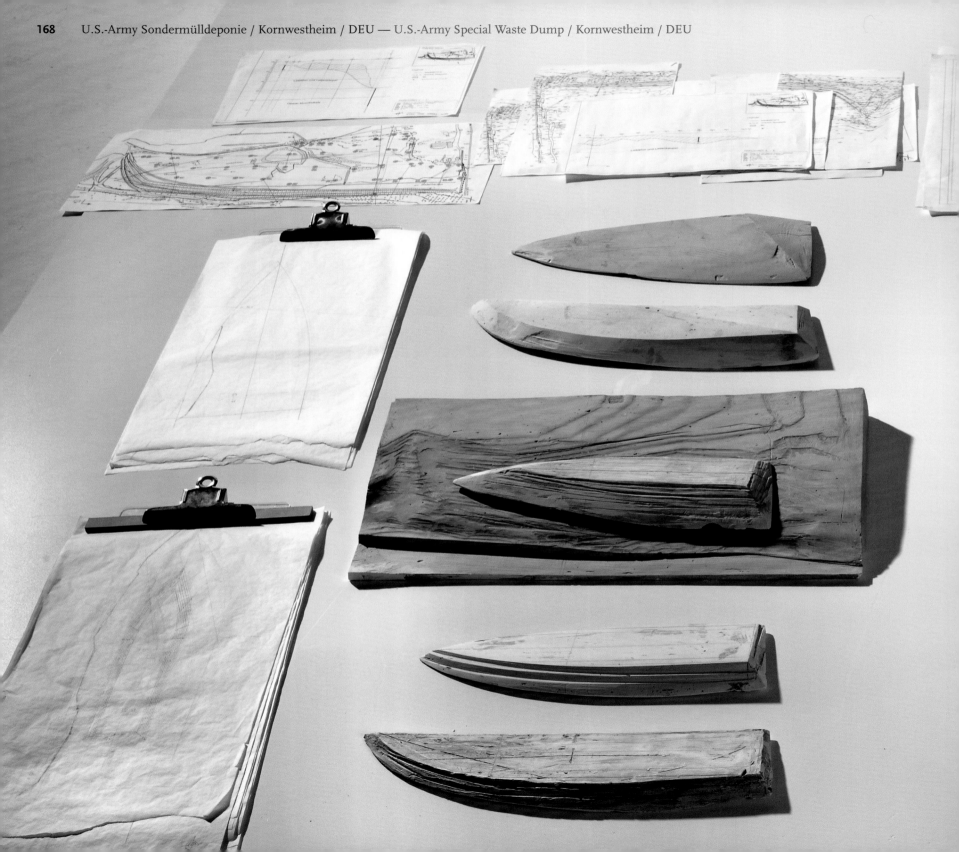

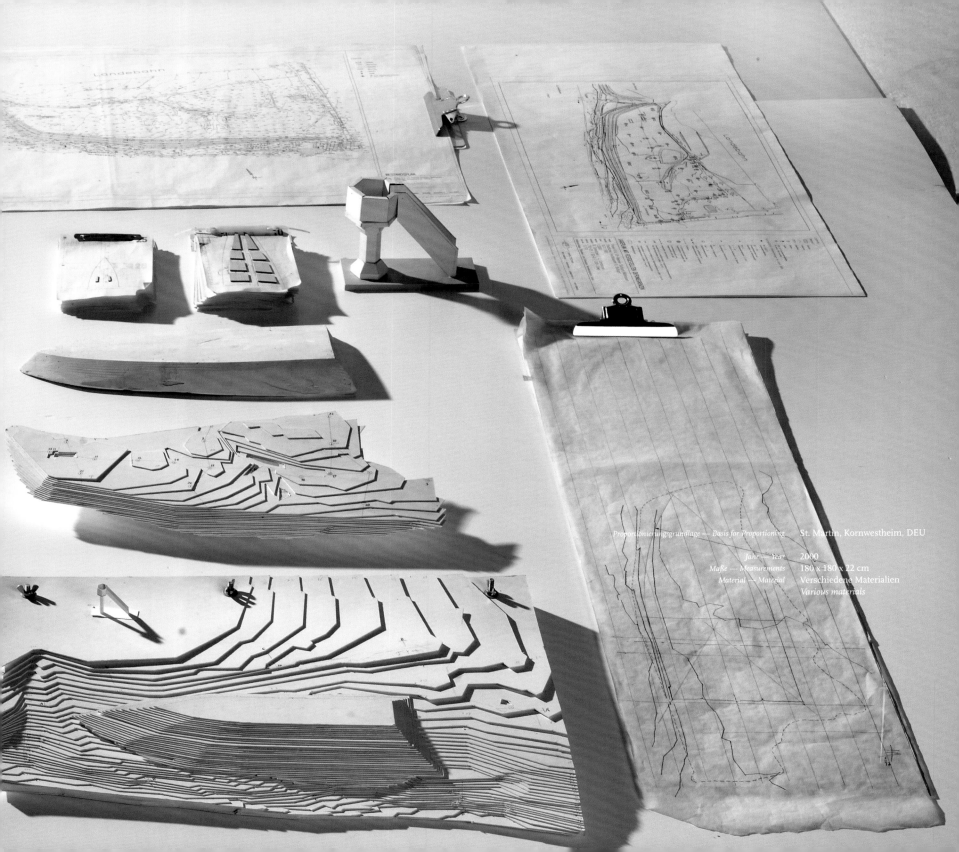

Proportionierungsgrundlage — *Basis for Proportioning* St. Martin, Kornwestheim, DEU

Jahr — Year 2000
Maße — Measurements 180 x 180 x 22 cm
Material — Material Verschiedene Materialien
 Various materials

Seit Langem ist klar, dass nicht mehr die Produktion, sondern die Entsorgung des Produzierten und Konsumierten zum zentralen Problem unserer Gesellschaft geworden ist. So ist es folgerichtig, dass der Standort der neuen Müllverbrennungsanlage St. Leonhard in Nürnberg nahe am Stadtzentrum liegt. Denn nur allzu oft werden die Abfälle fernab ihrer Entstehung und ihrer Herkunft an anonymen Orten entsorgt.

Der Bereich der Müllverbrennungsanlage teilt sich in zwei wesentliche Bezirke auf. Der innere Bezirk mit der zentralen Rostfeuerung und dem Müllbunker, der nur für Spezialisten zugänglich ist. Hier findet im übertragenen Sinn die Zeremonie des Brandopfers statt. Der äußere Bezirk, der ringförmig um die Zentralhalle angelegt ist, ist für die Öffentlichkeit zugänglich. Von diesem äußeren Bezirk können die Besucher den Akt der Müllverbrennung begleiten.

Der Besucher hat die Möglichkeit, sich von unterschiedlichen Standpunkten aus dem Phänomen der Abfallentsorgung zu nähern. An sechs Standorten besteht die Möglichkeit, sich über Verfahrensabläufe zu informieren und Reststoffen in unterschiedlicher Konsistenz zu begegnen.

Es entsteht ein Parcours, der durch die auffordernde Begegnung mit Abfall und Abfallentsorgung das Bewusstsein für Ressourcen schärft.

For some time now, it has been clear that it is no longer the production, but the disposal of manufactured and consumer goods that is a central problem in our society. And so it is logical that the location of the new garbage incineration plant St. Leonhard in Nuremberg should be close to the city centre: refuse is all too often dumped in anonymous places far away from its generation and origins.

The overall area of the garbage incineration plant is divided into two key sectors. There is the inner sector with the central stoker-fired furnace and garbage bunker, which is only accessible to specialists. It is here, in a metaphorical sense, that the ceremony of the burnt offering takes place. The outer sector, laid out in a ring around the central hall, is accessible to the public. From this outer sector it is possible for visitors to follow the act of garbage incineration. They have a chance to approach the phenomenon of garbage disposal from various standpoints. There are six locations providing an opportunity to get information about the various stages of the process and to encounter the waste materials and slag in different forms. A course-like tour emerges, sharpening the visitor's awareness of resources through an encounter with refuse and garbage disposal.

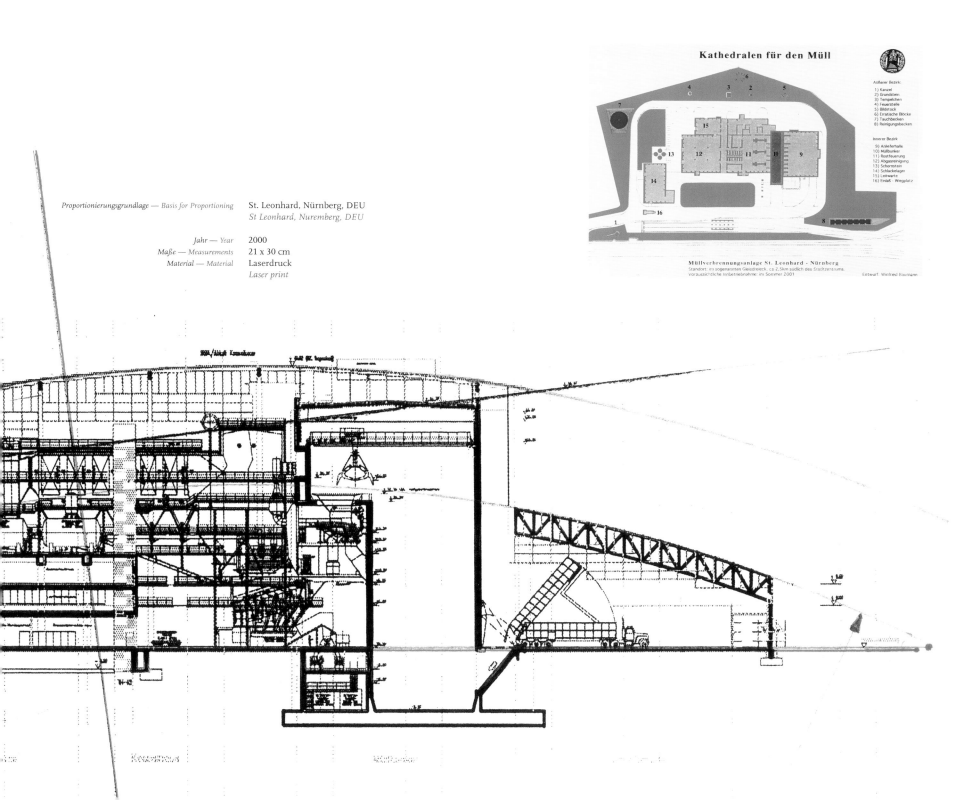

Kathedralen für den Müll

Äußerer Bezirk:
1) Kanzel
2) Grundstein
3) Tempelchen
4) Feuerstelle
5) Bildstock
6) Erratische Blöcke
7) Tauchbecken
8) Reinigungsbecken

Innerer Bezirk
9) Anlieferhalle
10) Müllbunker
11) Rostfeuerung
12) Abgasreinigung
13) Schornstein
14) Schlackelager
15) Leitwarte
16) Einlaß - Wiegplatz

Müllverbrennungsanlage St. Leonhard - Nürnberg
Standort: im sogenannten Gleisdreieck, ca 2,5km südlich des Stadtzentrums.
Voraussichtliche Inbetriebnahme: im Sommer 2001
Entwurf: Winfried Baumann

Proportionierungsgrundlage — Basis for Proportioning St. Leonhard, Nürnberg, DEU
St Leonhard, Nuremberg, DEU

Jahr — Year 2000
Maße — Measurements 21 x 30 cm
Material — Material Laserdruck
Laser print

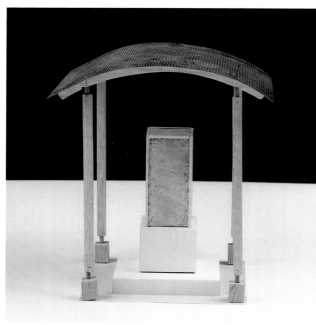

3

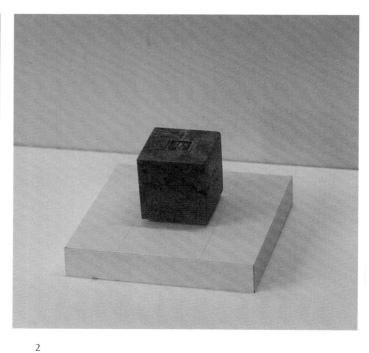

2

Proportionierungsgrundlage — Basis for Proportioning	St. Leonhard, Nürnberg, DEU
	St Leonhard, Nuremberg, DEU
Jahr — Year	2000
Maße — Measurements	210 x 122 x 32 cm
Material — Material	verschiedene Materialien
	Various materials

1

6

Standort 1 — *Location 1*
Kanzel — *Chancel*

Standort 2 — *Location 2*
Grundstein — *Foundation stone*

Standort 3 — *Location 3*
Schlacketempel — *Slag temple*

Standort 4 — *Location 4*
Feuerstelle — *Fire place*

Standort 5 — *Location 5*
Bildstock — *Shrine*

Standort 6 — *Location 6*
Erratische Blöcke — *Erratic boulders*

Standort 7 — *Location 7*
Tauchbecken — *Diving pool*

Standort 8 — *Location 8*
Reinigungsbecken — *Cleaning basin*

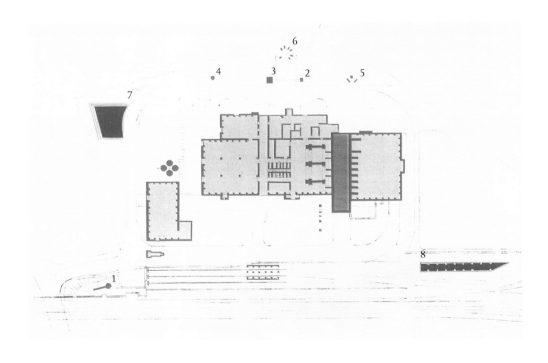

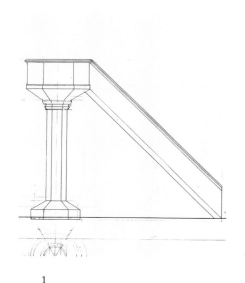

1

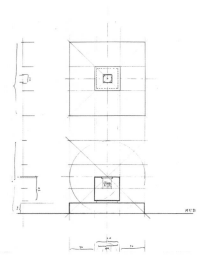

2

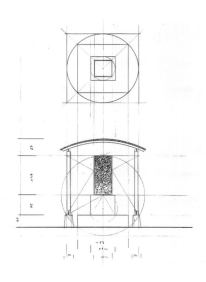

3

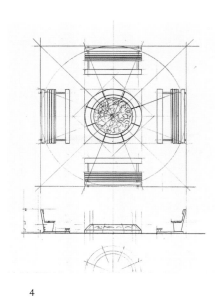

4

Standort 1 — *Location 1*
Kanzel — *Pulpit*
Aussichtsplattform am Haupteingang zur Müllver-
brennungsanlage — *Viewing platform at the main
entrance to the garbage incineration plant*

Material: Beton mit Blattgold belegt, Höhe: ca. 7 m.
Proportionierung der Kanzel nach dem Propor-
tionsschema der alten Kanzel aus der Kirche St.
Leonhard.
Besucher können von dieser Kanzel aus das Be-
triebsgelände der Müllverbrennungsanlage einsehen
und sich anhand von Informationstafeln über
Verfahrensabläufe informieren.
*Material: Gold-plated concrete, height: ca. 7 m. Propor-
tions of the pulpit based on the proportional plan of the
old pulpit from St. Leonhard's Church. From this pulpit,
visitors can look into the operating area of the waste in-
cineration plant and information boards tell them about
the processes going on.*

Standort 2 — *Location 2*
Grundstein — *Foundation stone*
Jubiläumsschlacke aus der neuen Müllverbren-
nungsanlage — *Slag from the new incineration plant*

Natursteinquader aus Rosso Verona (1,1 x 1,2 x
1,2 m), Sockel aus Sichtbeton.
In den Steinquader ist eine Kassette mit der Schlacke
aus der ersten Feuerung eingelassen. Die Kassette
ist mit Panzerglas abgedeckt, so dass man den Inhalt
einsehen kann.
*Natural stone block from Rosso Verona (1.1 x 1.2 x
1.2 m), pedestal made from exposed concrete. A casket
containing slag from the first burning is incorporated
into the stone block. The casket is covered by bullet-proof
glass, so that we can see the contents.*

Standort 3 — *Location 3*
Schlacketempel — *Slag temple*
Tempel zur Verehrung des Mülls — *Temple for the
veneration of garbage*

Quadratischer Grundriss im geometrischen Kon-
struktionsverfahren entwickelt. Stufen und Sockel
aus Sichtbeton. Vitrine mit Stahlrahmen aus Panzer-
glas. Die Vitrine ist gefüllt mit Schlacke aus der
Müllverbrennung.
In dieser Arbeit wird sichtbar, was vom Rest übrig
bleibt. Eine Reverenz an das Geschiedene vom
täglichen Gebrauch. Eine Reverenz an die von einer
Konsumgesellschaft verbrauchten Grundstoffe.
*Square ground plan developed using a geometric
construction process. Steps and pedestal made from
exposed concrete. Bullet-proof glass display case with
steel frame. The display case is filled with slag from waste
incineration. In this work, what remains of the scrap
is visualised. It pays reverence to what is extracted in
daily use, reverence to the raw materials expended by a
consumer society.*

Standort 4 — *Location 4*
Feuerstelle — *Fire place*
Opferstätte für kleinere Müllverbrennungen —
Fire place for small-scale garbage incineration

Rondell aus Naturstein (Durchmesser ca. 2,5 m).
Das Rondell wird auf einem Ringfundament
aufgebaut und zur Hälfte mit Sand aufgefüllt.
Ringsum stehen vier Sitzgarnituren. In Anbetracht
der Besonderheit des Ortes sind die Sitzbänke im
gesamten Bereich der Müllverbrennungsanlage
den Kirchenbänken aus der Kirche St. Leonhard
nachempfunden.
*Roundel made from natural stone (diameter approx.
2.5 m) The roundel is constructed on a ring foundation
and half-filled with sand. There are four lots of seating
around it. In view of the special character of this setting,
the seating in the entire waste incineration plant is based
on pews from St. Leonhard's Church.*

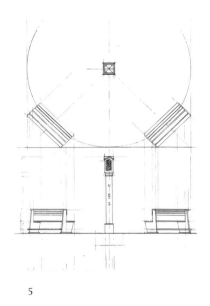

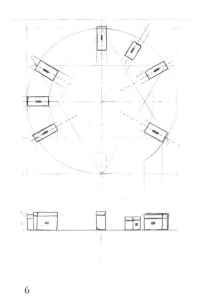

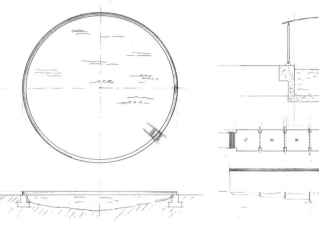

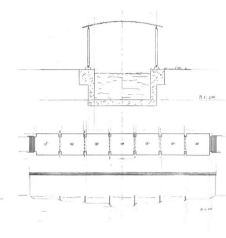

5

6

7

8

Standort 5 — *Location 5*
Bildstock — *Shrine*
Andachtshäuschen mit Flugasche — *Meditation room with fly-ash*

Stele mit Tabernakelaufsatz aus Beton gegossen. Höhe ca. 3 m.
Im oberen Teil ist eine Vitrine mit Flugasche aus der Müllverbrennung eingelassen. Auf den vier Seiten der Stehle sind Texte zum Thema zu lesen. Im Winkel von 45 Grad zum Bildstock sind die Sitzgarnituren (Gebetsstühle) aufgestellt.
Stele cast in concrete with a shrine on the top. Height approx. 3 m. A display case with ashes from waste incineration is inset into the upper part. Texts about the subject can be read on the four sides of the stele. The seating (church kneelers) is erected at an angle of 45 degrees to the column shrine.

Standort 6 — *Location 6*
Erratische Blöcke — *Erratic boulders*
Steinquader mit Schlacke aus der Müll-verbrennung — *Stone blocks, filled with slag from garbage incineration*

Sieben Natursteinquader aus Muschelkalk, kreis-förmig aufgestellt. Die Deckel der Blöcke sind abgetrennt. Aus den Restquadern sind Vertiefungen herausgearbeitet und mit Schlacke aus den Partner-städten von Nürnberg (Krakau, Glasgow, Nizza, Ve-nedig, Prag, Antalia und Herada) aufgefüllt. Schmale Einschnitte in den Deckeln der Blöcke gewähren Einblicke auf das darin Bewahrte.
Seven natural stone blocks made from shell limestone, erected in a circle. The tops of the blocks have been removed like lids. Indentations have been worked into the rest of the blocks and filled with slag from Nuremberg's partner cities (Cracow, Glasgow, Nice, Venice, Prague, Antalya and Herada). Narrow slits in the "lids" reveal what is kept inside.

Standort 7 — *Location 7*
Tauchbecken — *Diving pool*
Rundes Regenwasserrückhaltebecken — *Round rainwater storage reservoir*

Gemauertes Rundbecken, Durchmesser ca. 18 m. Der Rand hat eine Höhe von 60 cm, eine Stärke von 45 cm und ist mit Keramikfliesen verkleidet. Das Becken dient als Sickerbecken, kann von den Mitarbeitern der Müllverbrennungsanlage aber auch als Schwimmbecken genutzt werden.
Round masonry basin, diameter approx. 18 m. The edge is 60 cm high and 45 cm wide and is clad in ceramic tiles. The basin functions as an infiltration basin, can also be used as a swimming pool by the staff of the waste incineration plant.

Standort 8 — *Location 8*
Reinigungsbecken — *Cleaning basin*
Becken zur Reinigung und Desinfektion — *Basin for cleaning and decontamination*

Aneinanderreihung von sieben gleichgroßen, quadratischen Becken. Sie dienen zur Reinigung und auch zur Dekontamination nach Unfällen. Die überdachten Becken haben eine Seitenlänge von 10 m und unterschiedliche Tiefen, wobei das mittlere Becken als Tauchbecken am tiefsten angelegt ist.
A series of seven square pools, all the same size. These are used for cleaning and also for decontamination after accidents. The roofed-over pools have a side length of 10 m and different depths, whereby the one in the middle – as a diving pool – is the deepest.

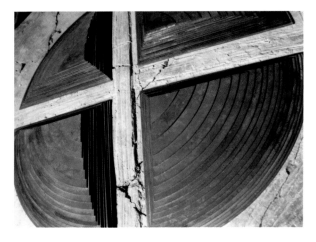

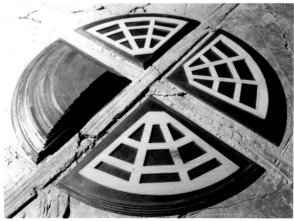

Proportionierungsgrundlage — Basis for Proportioning	Faruq-Moschee, Khartoum, SDN
	Faruq-Mosque, Khartoum, SDN
Jahr — Year	1989
Maße — Measurements	110 x 78 x 14 cm
Material — Material	Tonerde, Eisen, Balsaholz
	Clay, iron, balsa wood

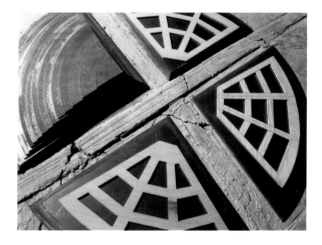

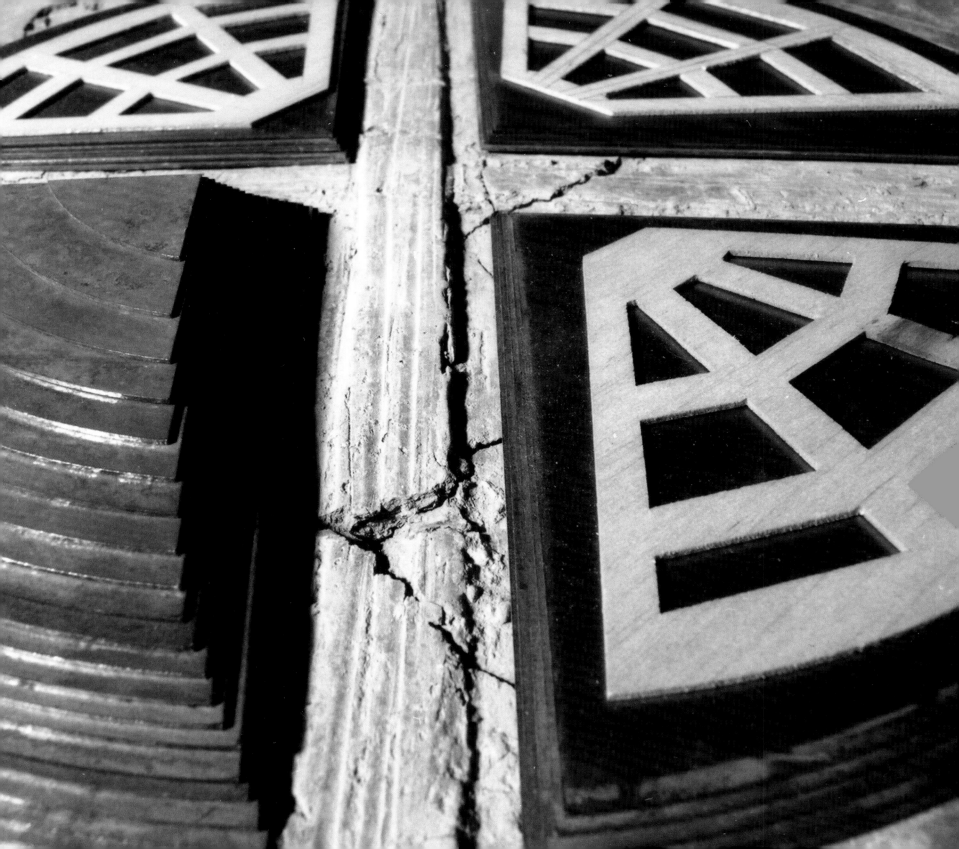

Proportionierungsgrundlage — Basis for Proportioning Iglesia de San Francisco, Lima, PER

Jahr — Year 1998
Maße — Measurements 110 x 80 x 12 cm
Material — Material Tonerde, Eisen, Holz
Clay, iron, wood

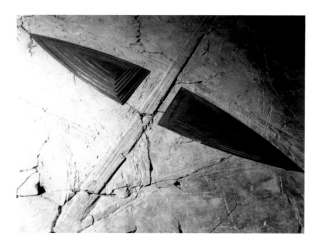

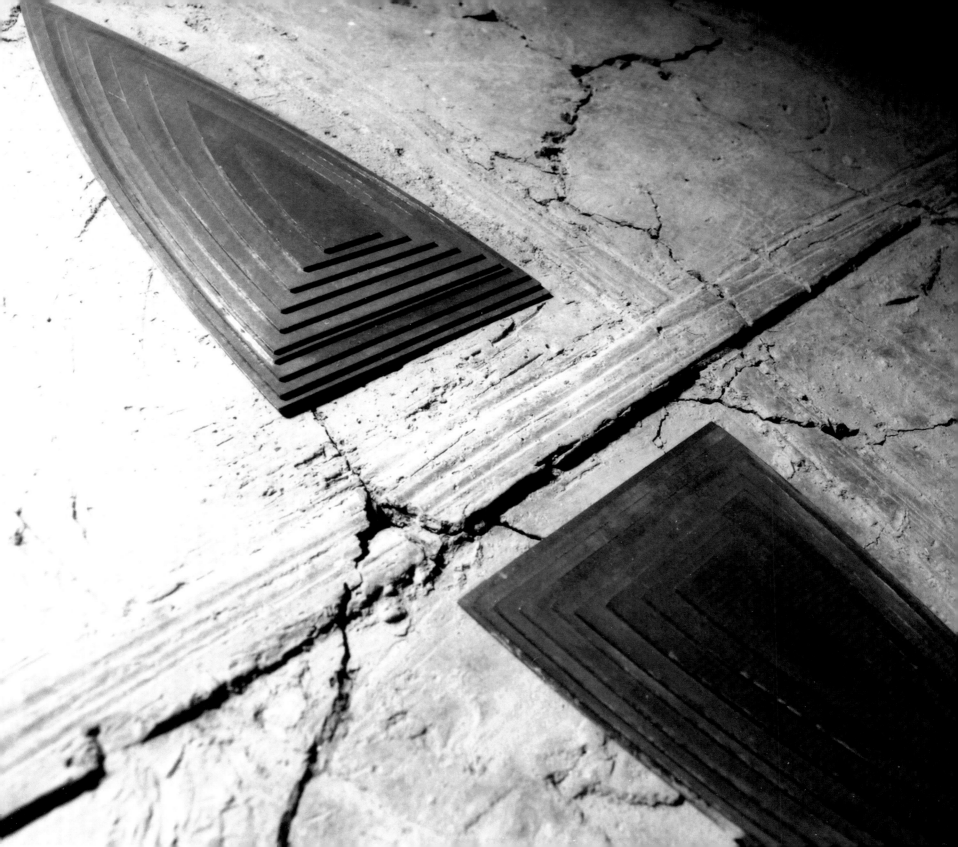

Proportionierungsgrundlage — Basis for Proportioning	Westminster Abbey, London, GBR
Jahr — Year	1991
Maße — Measurements	95 x 70 x 22 cm
Material — Material	Tonerde, Gips, Holz
	Clay, plaster, wood

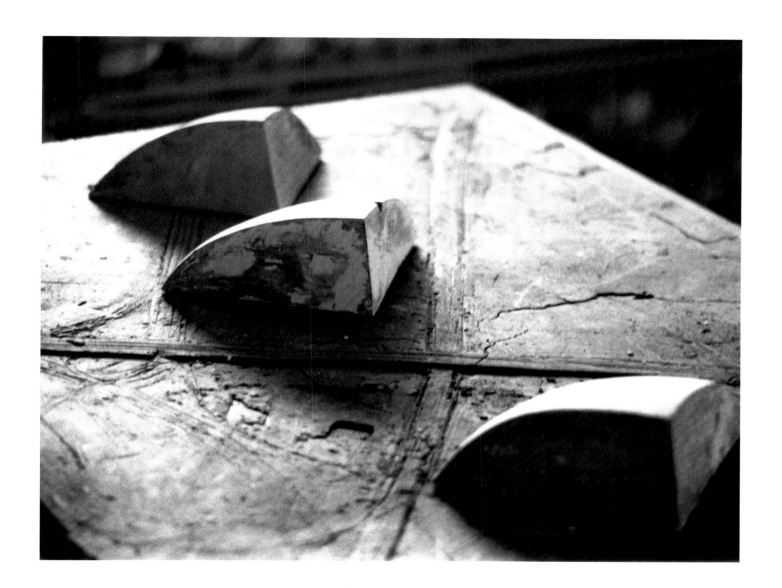

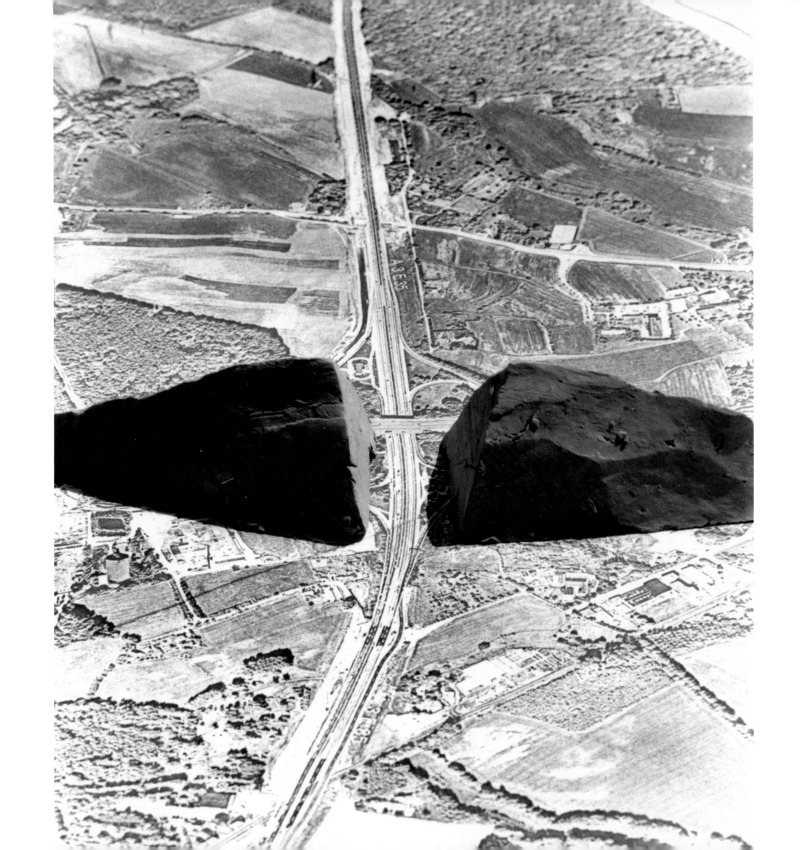

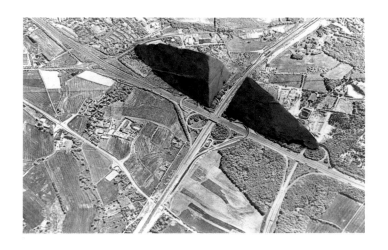

Proportionierungsgrundlage — Basis for Proportioning	Stevenskerk, Nijmegen, NLD
Jahr — Year	1989
Maße — Measurements	120 x 80 x 14 cm
Material — Material	Faserbeton, Laserdruck
	Fibre concrete, laser print

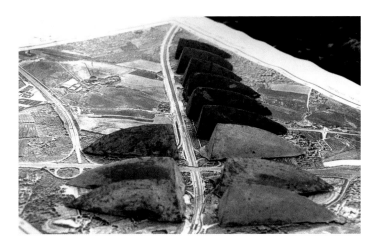

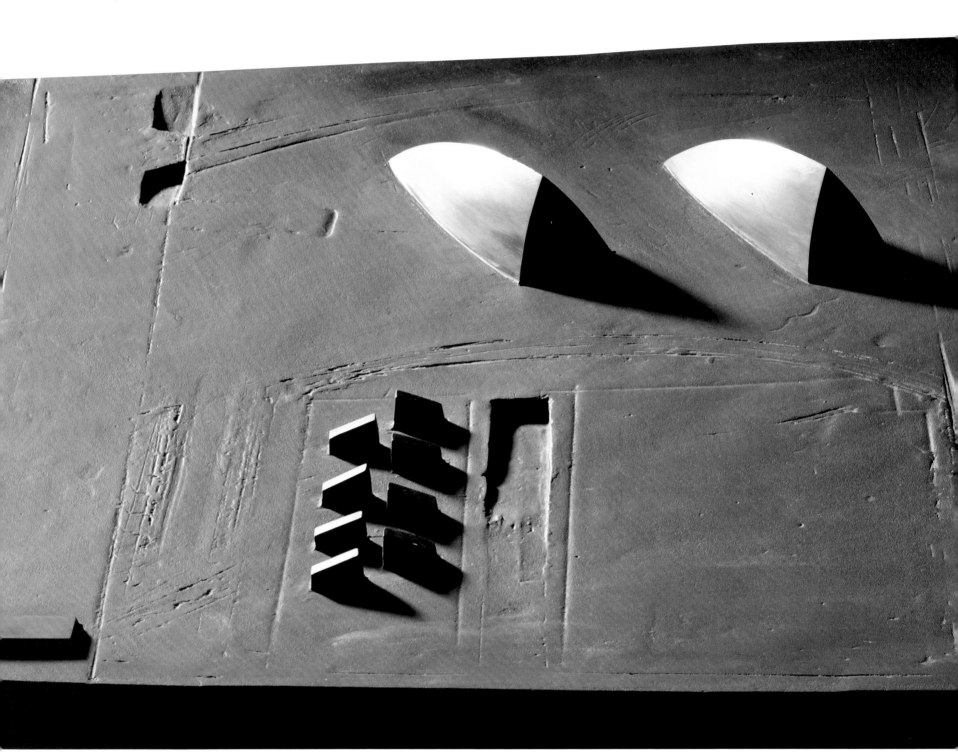

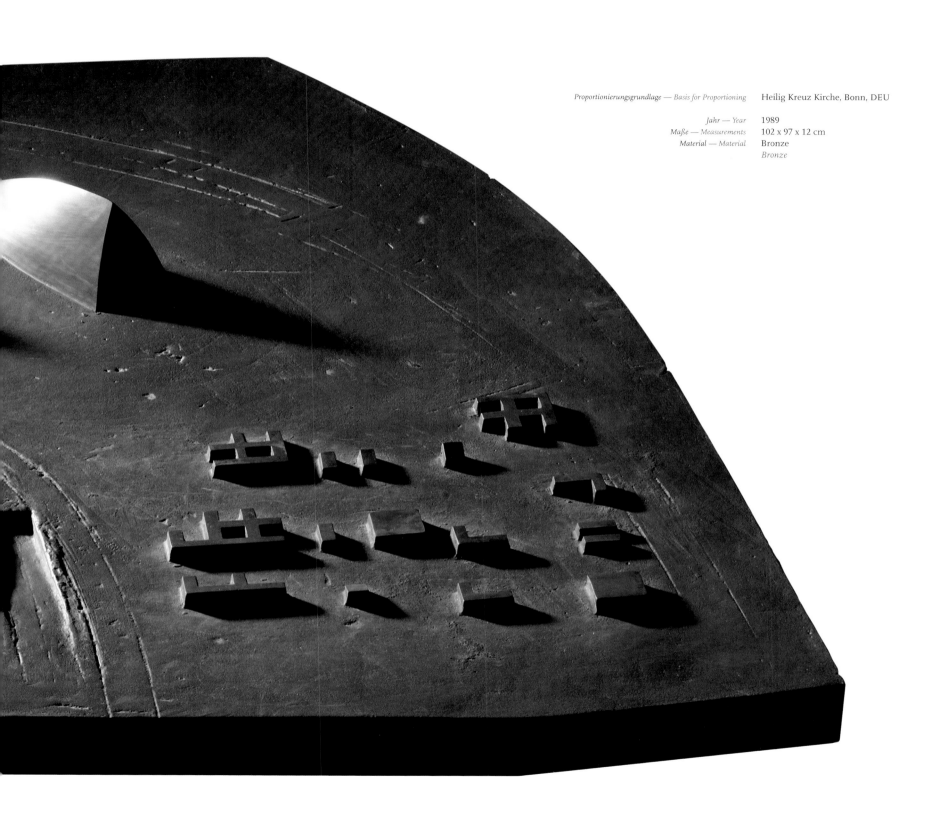

Proportionierungsgrundlage — Basis for Proportioning Heilig Kreuz Kirche, Bonn, DEU

Jahr — Year 1989
Maße — Measurements 102 x 97 x 12 cm
Material — Material Bronze
 Bronze

Proportionierungsgrundlage — Basis for Proportioning	Domkirche St. Salvator, Fulda, DEU
	Cathedral Church of St. Salvator, Fulda, DEU
Jahr — Year	1989
Maße — Measurements	23 x 31 cm
Material — Material	Tusche, Fotoabzug
	Ink, photo print

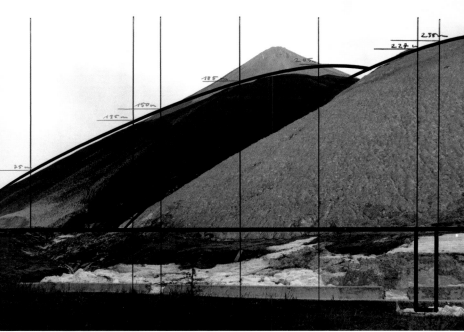

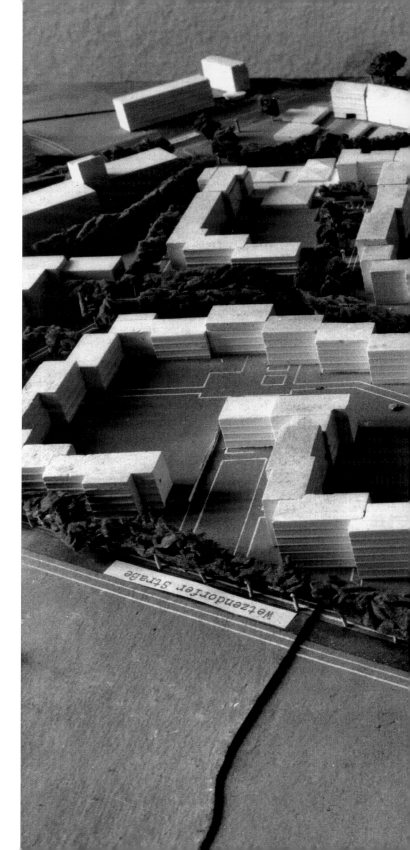

Proportionierungsgrundlage — Basis for Proportioning	St. Hedwigs-Kathedrale, Berlin, DEU *St. Hedwigs' Cathedral, Berlin, DEU*
Jahr — Year	1990
Maße — Measurements	110 x 74 x 27 cm
Material — Material	Gips, Holz *Plaster, wood*

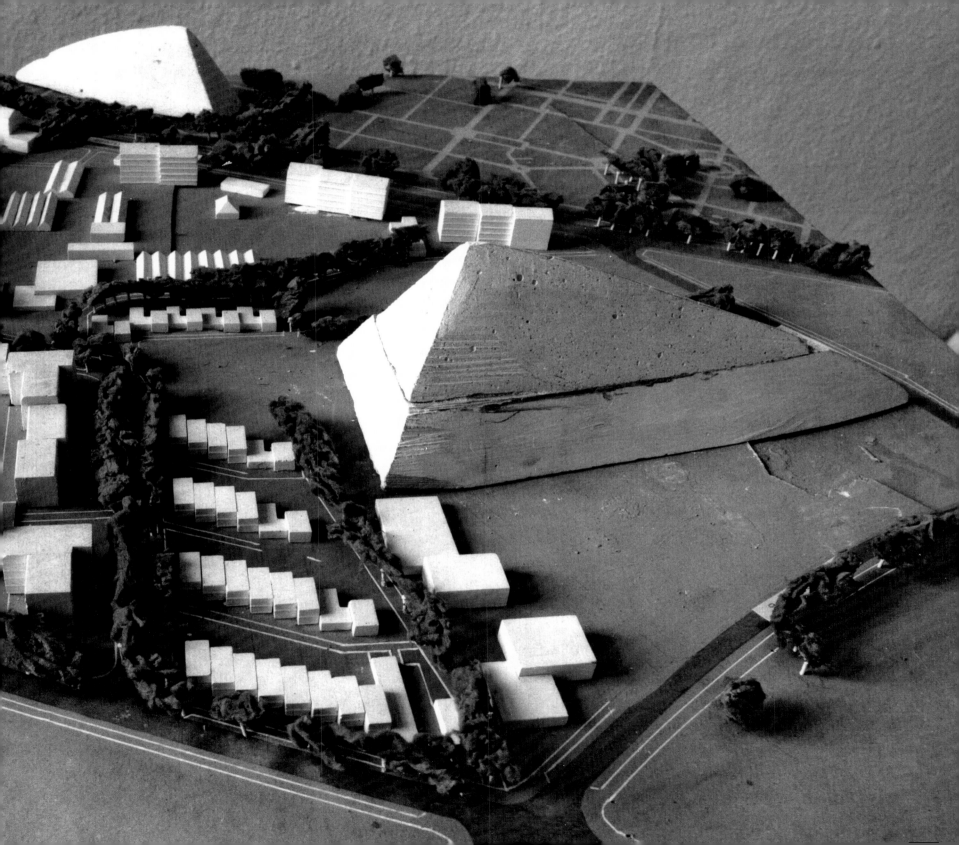

Proportionierungsgrundlage — Basis for Proportioning	Tempelanlage, Labrang Trashi Khyil, CHN
	Labrang Trashi Khyil Temple Complex, CHN
Jahr — Year	1989
Maße — Measurements	120 x 85 x 14 cm
Material — Material	Bronze
	Bronze

Proportionierungsgrundlage — Basis for Proportioning	Tempelanlage, Labrang Trashi Khyil, CHN
	Labrang Trashi Khyil Temple Complex, CHN
Jahr — Year	1989
Maße — Measurements	84 x 31 x 12 cm
Material — Material	Bronze
	Bronze

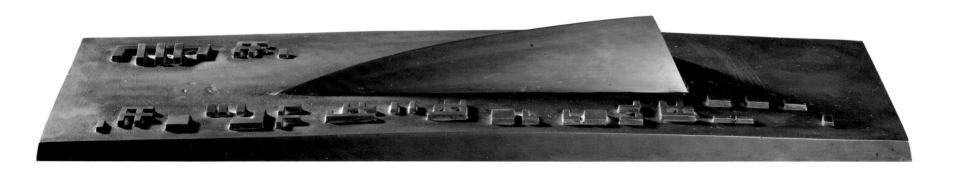

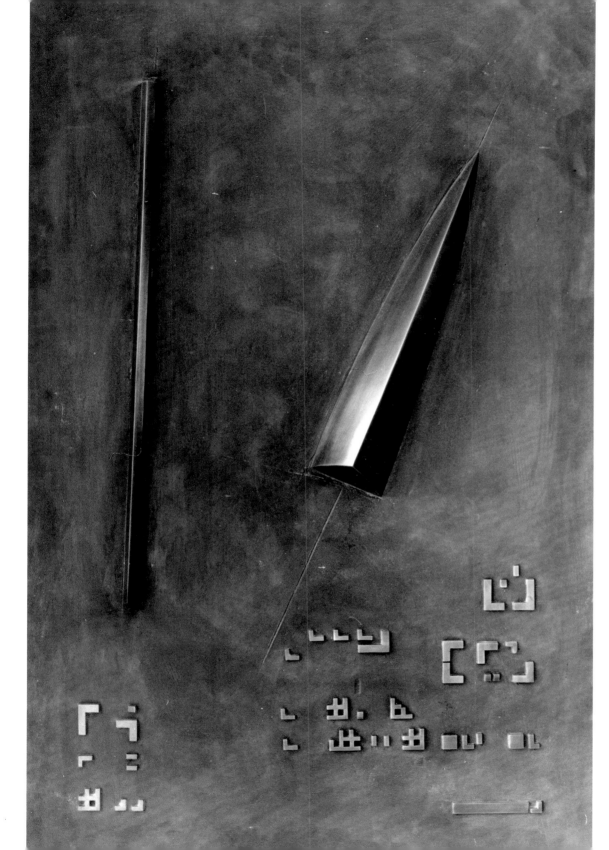

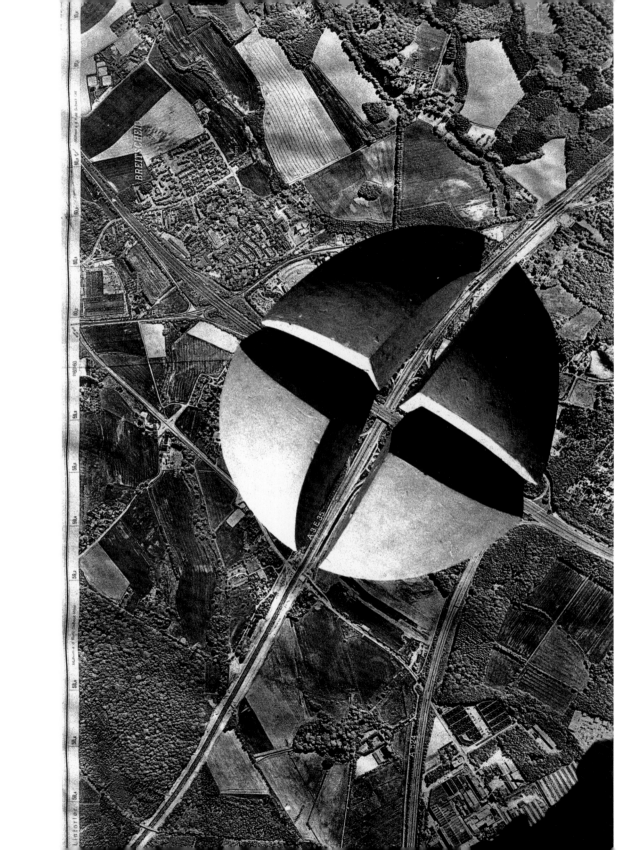

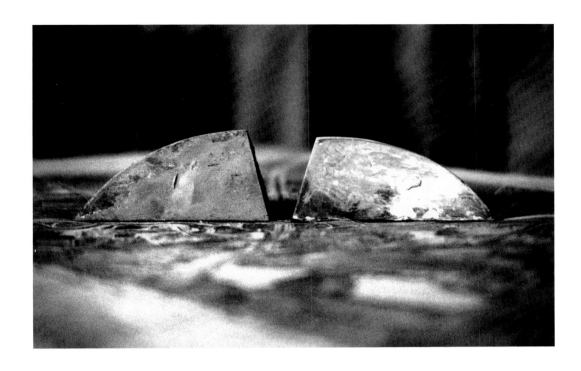

Proportionierungsgrundlage — Basis for Proportioning	Pfalzkapelle, Aachen, DEU
Jahr — Year	1989
Maße — Measurements	90 x 70 x 14 cm
Material — Material	Beton, Laserdruck
	Concrete, laser print

 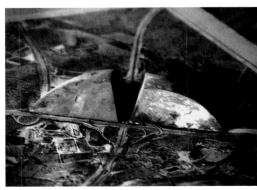

Jefferson Deponieanlage — *Jefferson Garbage Dump*

South Bronx Mülldeponie — *South Bronx Waste Dump*

West-Side Deponieanlage — *West-Side Garbage Dump*

Midtown Zentraldeponie — *Midtown Central Dump*

Broadway Mülldepot — *Broadway Trash Dump*

Celsea Deponieanlage — *Celsea Garbage Dump*

Battery Mülldeponie — *Battery Waste Dump*

COMPETITION FOR THE NEW YORK WATERFRONT

SPONSORED BY THE MUNICIPAL ART SOCIETY: 1987
457 MADISON AVENUE, NEW YORK, NEW YORK 10022

CONTENTS OF COMPETITION PROGRAM KIT

1 AERIAL PHOTO OF WATERFRONT, SITE LOCATION MAP
2 HISTORICAL IMAGES OF SITE, OTHER PROPOSALS
3 CURRENT IMAGES OF SITE
4 ELEVATION PHOTO LOOKING INLAND FROM PIERS
5 AERIAL PHOTO (LOWER MANHATTAN, BATTERY PARK CITY)
6 AERIAL PHOTO (TRIBECA, GREENWICH VILLAGE)
7 AERIAL PHOTO (WHOLESALE MEAT MARKET, CHELSEA)
8 AERIAL PHOTO (MIDTOWN MANHATTAN, CONVENTION CE
9 BASE MAP (LOWER MANHATTAN, BATTERY PARK CITY)
10 BASE MAP (TRIBECA, GREENWICH VILLAGE)
11 BASE MAP (WHOLESALE MEAT MARKET, CHELSEA)
12 BASE MAP (MIDTOWN MANHATTAN, CONVENTION CENTE
 RULES AND REGULATIONS, ENTRY FORM
 FOUR-COLOR POSTER ANNOUNCING COMPETITION

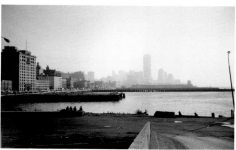

Morton Street, Pier 51

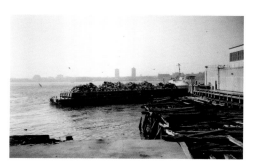

Sanitation Department, Pier 53

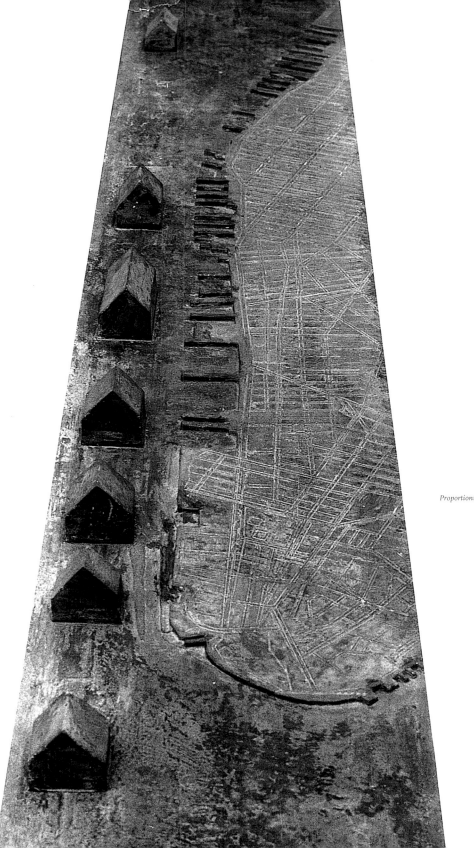

Proportionierungsgrundlage — Basis for Proportioning	St. Patrick's Cathedral, New York, USA
Jahr — Year	1988
Maße — Measurements	218 x 35 x 9 cm
Material — Material	Beton, Eisen
	Concrete, iron

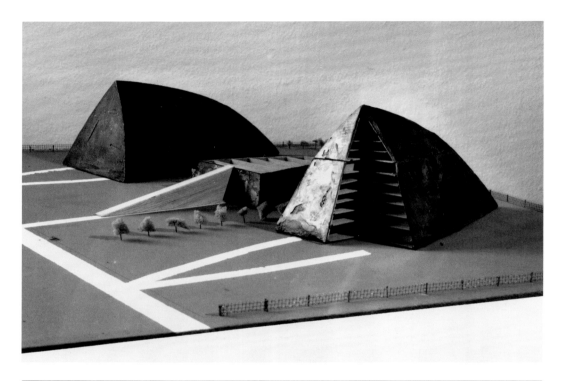

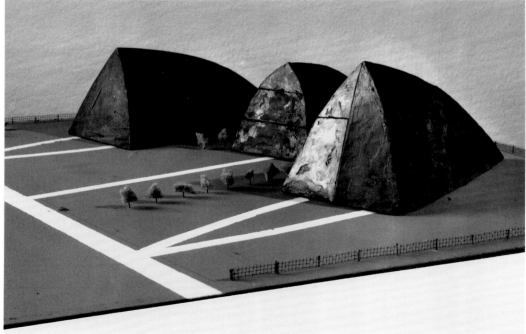

Proportionierungsgrundlage — Basis for Proportioning	Hohe Domkirche St. Petrus, Köln, DEU
	Cologne Cathedral St. Petrus, Cologne, DEU
Jahr — Year	1988
Maße — Measurements	92 x 74 x 22 cm
Material — Material	Bienenwachs, Balsaholz
	Beeswax, balsa wood

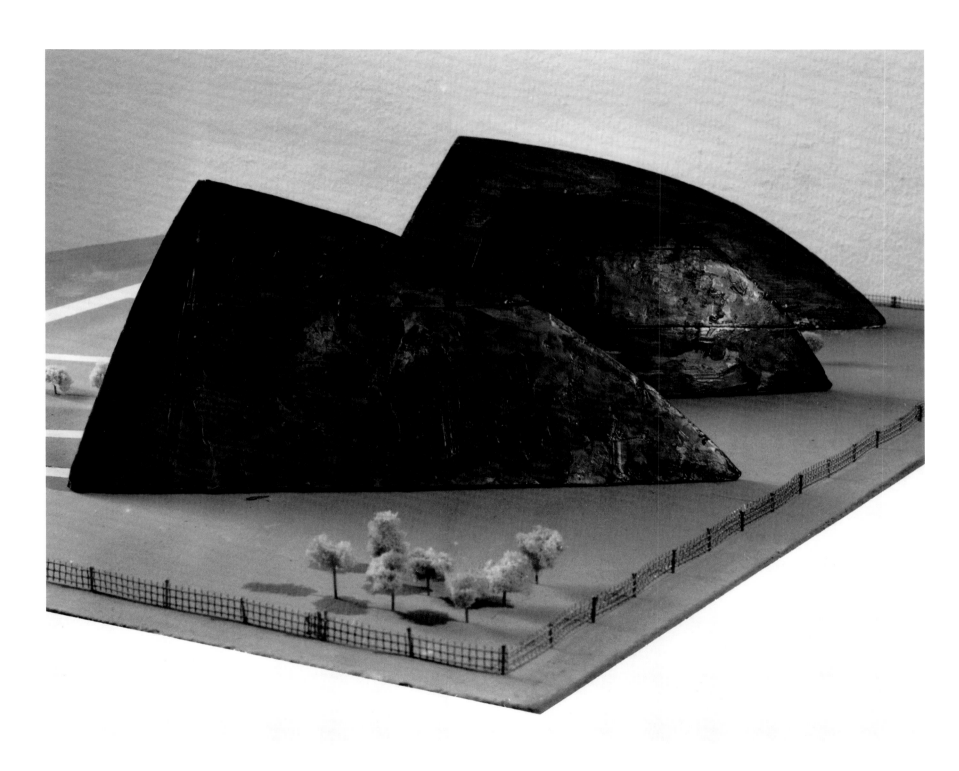

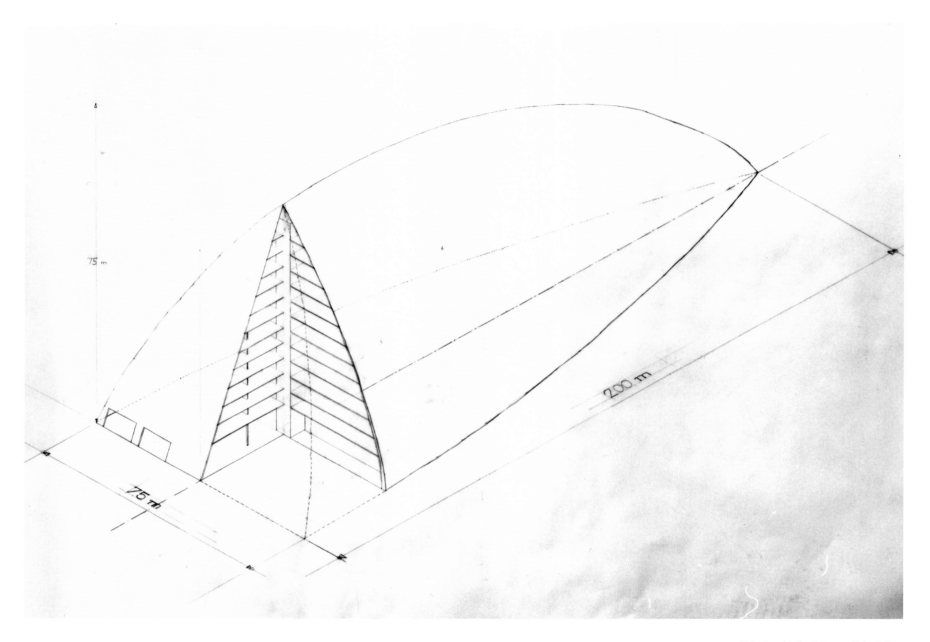

Proportionierungsgrundlage — Basis for Proportioning	Hohe Domkirche St. Petrus, Köln, DEU
	Cologne Cathedral St. Petrus, Cologne, DEU
Jahr — Year	1988
Maße — Measurements	118,8 x 84 cm
Material — Material	Bleistift auf Pergament
	Pencil on parchment

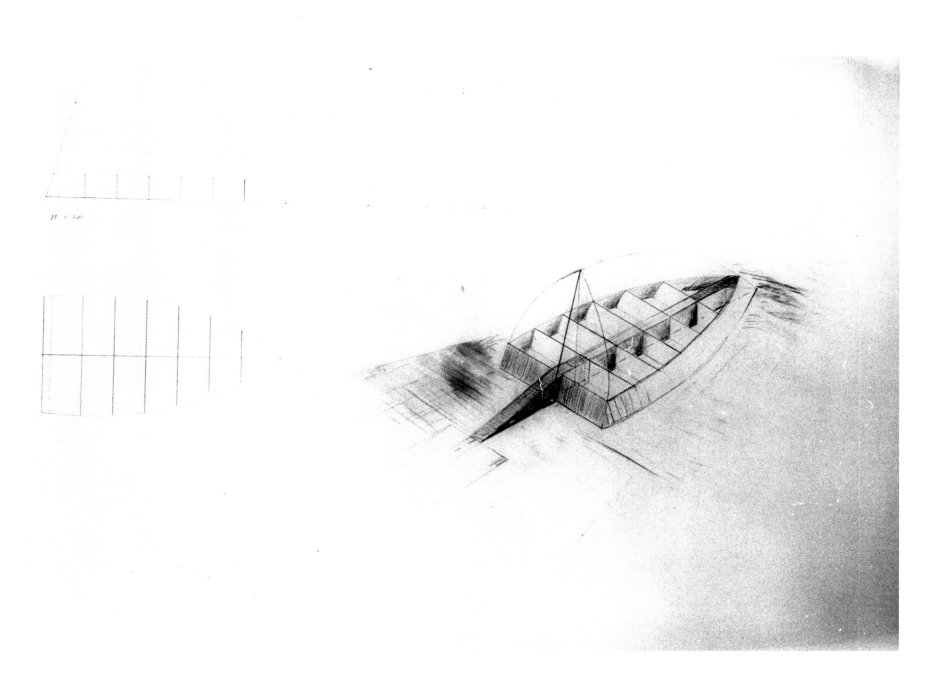

M : 500

Die Abfallbeseitigungsanlage Atzenhof liegt im nördlichen Stadtgebiet von Fürth. Sie umfasst eine Fläche von ca. 10,5 ha. Der Standort ist aus hydrogeologischer Sicht problematisch, weil er unmittelbar an einen die Pegnitz begleitenden Grundwasserstrom angrenzt. Die Deponie dient der Lagerung von Haus-, Gewerbe- und Sperrmüll sowie von Klärschlamm. Bis in die Siebzigerjahre wurden die Anlieferungen nicht kontrolliert. Die Grundfläche der Deponie entspricht annähernd der eines Quadrates. Der wachsende Müllberg wird in seinem Endzustand die Form einer verschobenen Pyramide haben, bei der die Nordseite des Deponiekörpers, zur Stadelner Straße hin, sehr steil abfällt. Die Seite nach Süden läuft dagegen flach aus und ist entsprechen der Erdkrümmung – symbolisch – leicht gewölbt. Die strenge Form des Müllberges sitzt wie ein Stachel auf der Erde.

Die Mantelflächen des Deponiekörpers werden aus Stahlbeton erstellt. Nach Abschluss der Arbeiten bildet der Müllberg einen hermetisch abgeschlossenen Raumkörper, der gewährleistet, dass kein Sickerwasser entsteht und verhindert, dass Deponiegas unkontrolliert ausströmen kann. Das anfallende Deponiegas wird über bereits installierte bzw. über neue Leitungssysteme kontrolliert abgeleitet und bei entsprechender Druckregulierung in die städtische Gasversorgung eingespeist. Die geometrische Form der Pyramide und die wenig Raum beanspruchende Oberflächenabdichtung vergrößert das Auffüllvolumen um ca. 220 000 m3.

The Atzenhof waste disposal site lies in the northern urban area of Fürth. It encompasses a surface area of ca. 10.5 hectares. The location is problematic from a hydro-geological standpoint because it borders directly onto a groundwater current conducting the Pegnitz. The dump serves as storage for domestic, commercial and bulky waste, as well as sewage sludge. Until into the 1970s, deliveries were not checked.

The surface area of the dump corresponds roughly to a square. The growing mountain of refuse will, in its final state, take the form of a distorted pyramid, whereby the north side of the dumping mass, facing onto Stadelner Straße, falls down a very steep slope. By contrast, the side to the south creates a gentle slope and is slightly curved, corresponding to the curve of the earth – symbolically. The stringent form of the refuse mountain squats on the earth like a thorn.

The surface shell of the storage unit is made from reinforced concrete. After completion of the works, the refuse mountain will form a hermetically sealed spatial volume, which guarantees that no leakage will occur and prevents the uncontrolled seeping out of dumping gas. The dumping gas that develops will be discharged in a controlled way via already installed or new pipe systems and then fed into the municipal gas supplies following a corresponding regulation of pressure. The geometric form of the pyramid and the space-consuming surface sealing will increase the site's filling volume by ca. 220,000 m³.

Proportionierungsgrundlage — Basis for Proportioning	St. Michael, Fürth, DEU
Jahr — Year	1988
Maße — Measurements	74 x 76 x 82 cm
Material — Material	Bronze
	Bronze

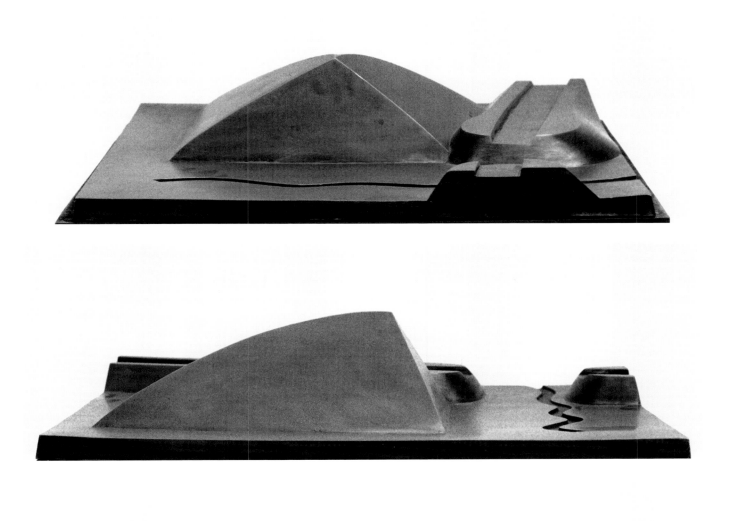

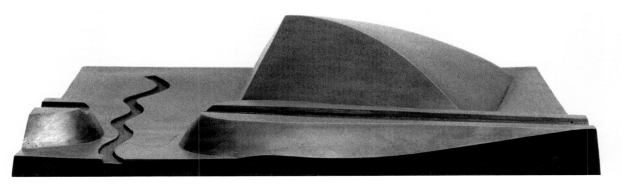

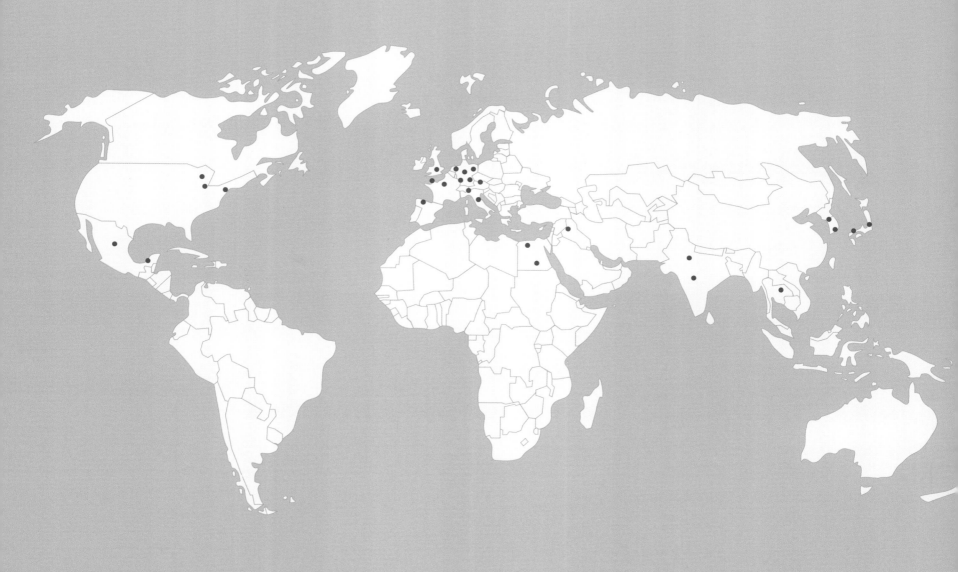

Kathedralen für den Müll	Müllarchitektur	Urban Mining Mülldeponien	Megadeponien	Runddeponien	Detroit is Everywhere	Nuklear-Katastrophen
Cathedrals for Garbage	*Waste Architecture*	*Urban Mining Waste Dumps*	*Mega-Dumbs*	*Hazardous Waste Dumbs*	*Detroit is Everywhere*	*Nuclear Disasters*

2.2

MÜLLARCHITEKTUR
WASTE ARCHITECTURE

Entwürfe für Mülldeponien
und Entsorgungsanlagen

Designs for refuse dumps
and waste disposal plants

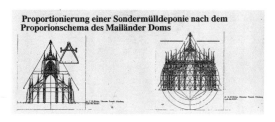
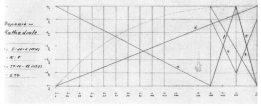
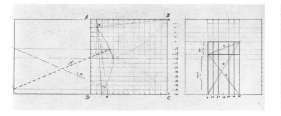
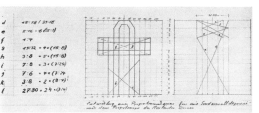

Proportionierungsgrundlage — Basis for Proportioning	Mailänder Dom, Mailand, ITA
	Milan Cathedral, Milan, ITA
Jahr — Year	1989
Maße — Measurements	54 x 54 x 18 cm
Material — Material	Beton, Holz, MDF-Platten
	Concrete, wood, MDF panels

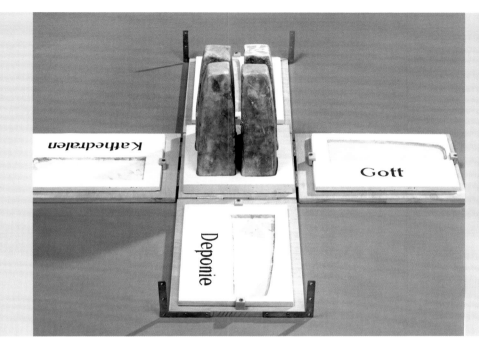

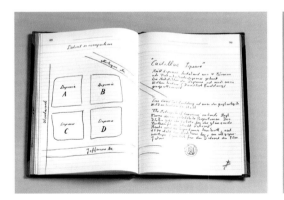

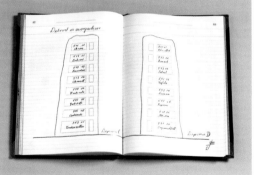

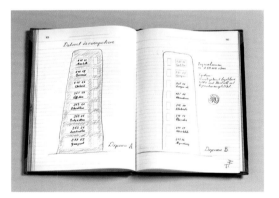

Proportionierungsgrundlage — Basis for Proportioning	Basilika St. Peter, Rom, VAT
	St. Peter's Basilica, Rome, VAT
Jahr — Year	1989
Maße — Measurements	24 x 24 x 36 cm
Material — Material	Gips, Holz
	Plaster, wood

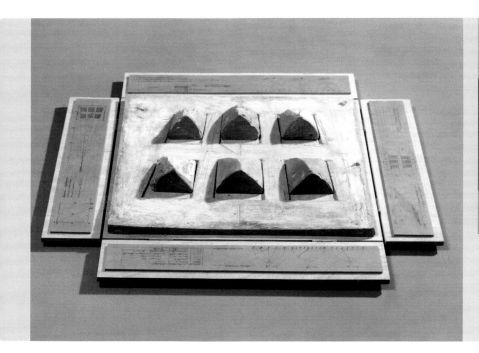
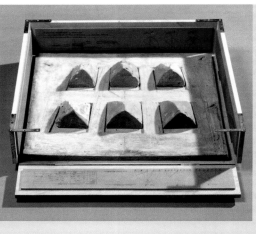

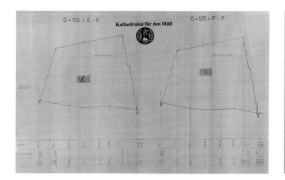
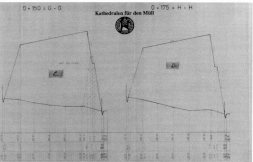
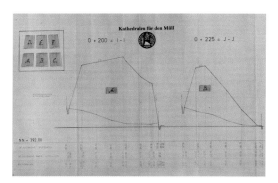

Proportionierungsgrundlage — *Basis for Proportioning*	Tempelanlage Minakshi, IND
	Minakshi Temple Complex, IND
Jahr — *Year*	1989
Maße — *Measurements*	42 x 42 x 15 cm
Material — *Material*	Beton, Holz, MDF-Platten
	Concrete, wood, MDF panels

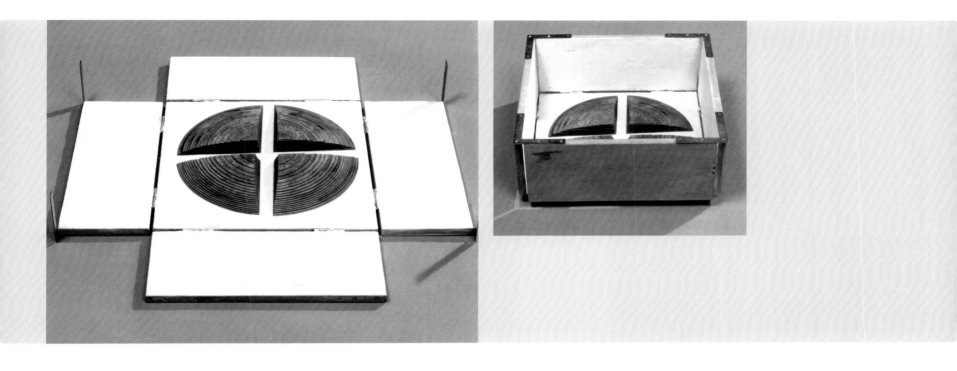

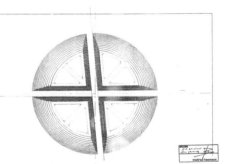

Proportionierungsgrundlage — Basis for Proportioning	Grabmoschee Taj Mahal, Agra, IND
	Taj Mahal Burial Mosque, Agra, IND
Jahr — Year	1989
Maße — Measurements	42 x 42 x 15 cm
Material — Material	Gips, Holz
	Plaster, wood

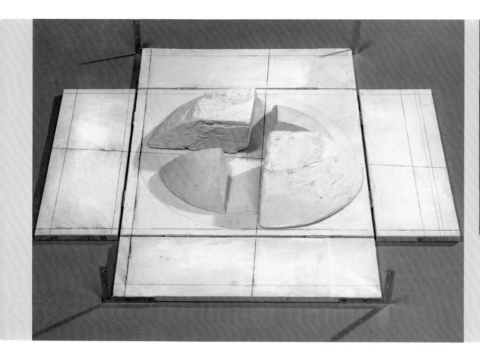
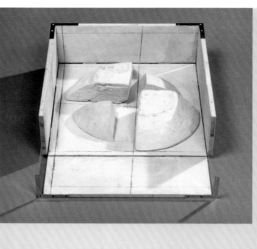

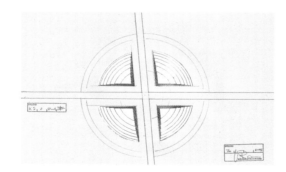
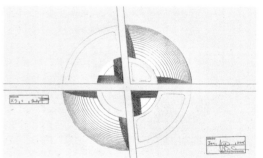

Proportionierungsgrundlage — Basis for Proportioning Ise-jingu-Schrein, Ise, JPN
Ise-jingu-Shrine, Ise, JPN

Jahr — Year 1991
Maße — Measurements 42 x 42 x 15 cm
Material — Material Gips, Holz
Plaster, wood

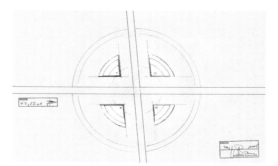
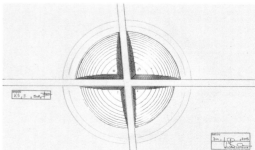

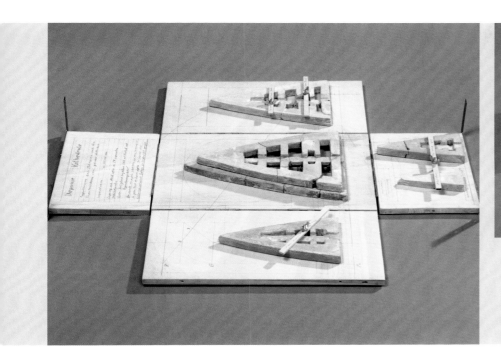
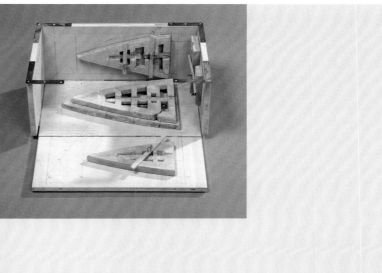

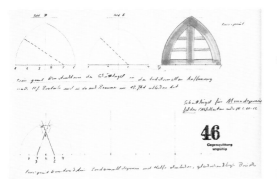
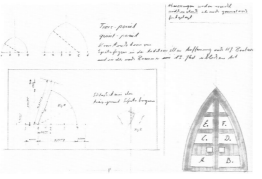
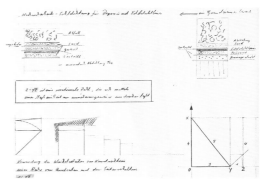

Proportionierungsgrundlage — Basis for Proportioning	Kathedrale, Santiago de Compostela, ESP
	Cathedral, Santiago de Compostela, ESP
Jahr — Year	1989
Maße — Measurements	42 x 34 x 21 cm
Material — Material	Beton, Holz, Eisen
	Concrete, wood, iron

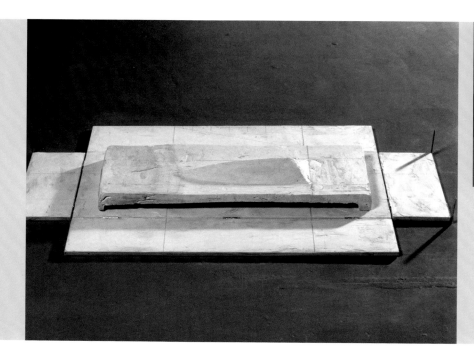
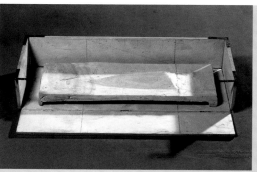

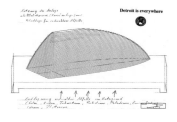
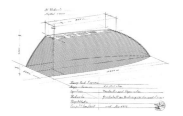
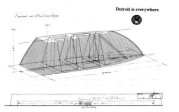

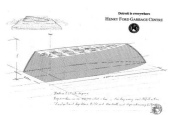
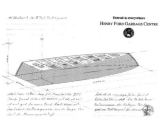
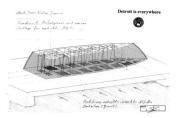

Proportionierungsgrundlage — Basis for Proportioning	General Motors Building, Detroit, USA
Jahr — Year	1989
Maße — Measurements	62 x 32 x 17 cm
Material — Material	Gips, Holz
	Plaster, wood

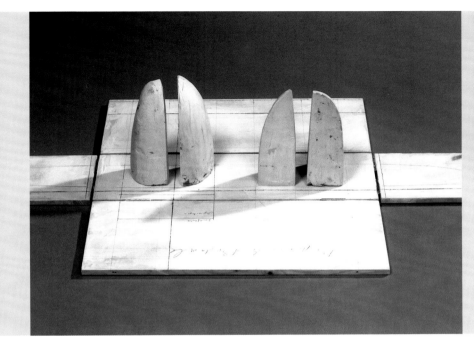
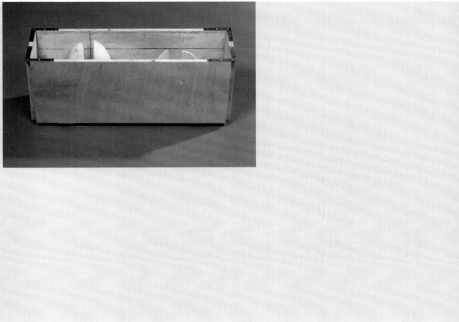

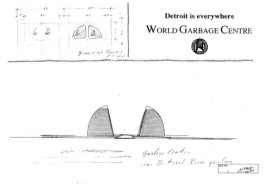
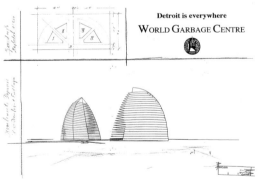
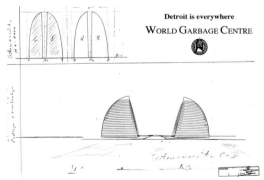

Detroit is everywhere
WORLD GARBAGE CENTRE

Detroit is everywhere
WORLD GARBAGE CENTRE

Detroit is everywhere
WORLD GARBAGE CENTRE

Proportionierungsgrundlage — Basis for Proportioning	Ford Motor Company Building, Chicago, USA
Jahr — Year	1989
Maße — Measurements	54 x 34 x 23 cm
Material — Material	Gips, Holz
	Plaster, wood

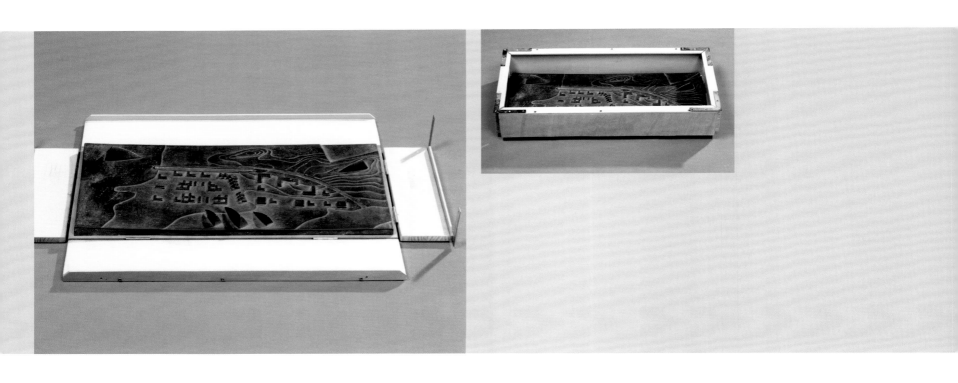

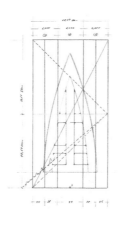
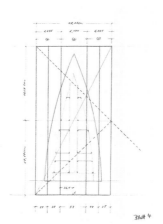
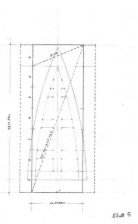

Proportionierungsgrundlage — Basis for Proportioning Tempel Haedong-Yonggung, Busan, KOR
 Haedong-Yonggung Temple, Busan, KOR

Jahr — Year 1991
Maße — Measurements 65 x 35 x 15 cm
Material — Material Bronze, Holz
 Bronze, wood

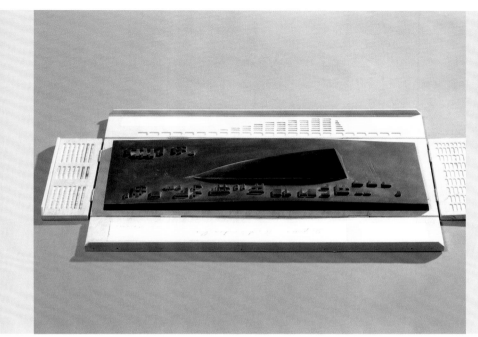

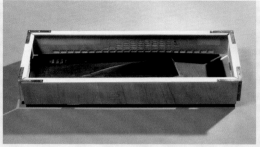

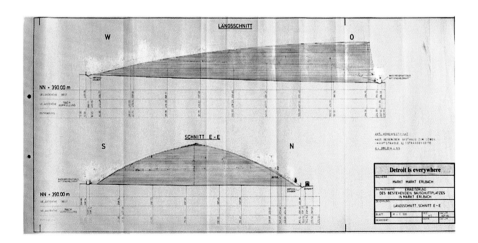

Proportionierungsgrundlage — Basis for Proportioning	Tempelanlage Cheongpyeong, Chuncheon, KOR
	Cheongpyeong Temple Complex, Chuncheon, KOR
Jahr — Year	1991
Maße — Measurements	62 x 38 x 13 cm
Material — Material	Bronze, Holz
	Bronze, wood

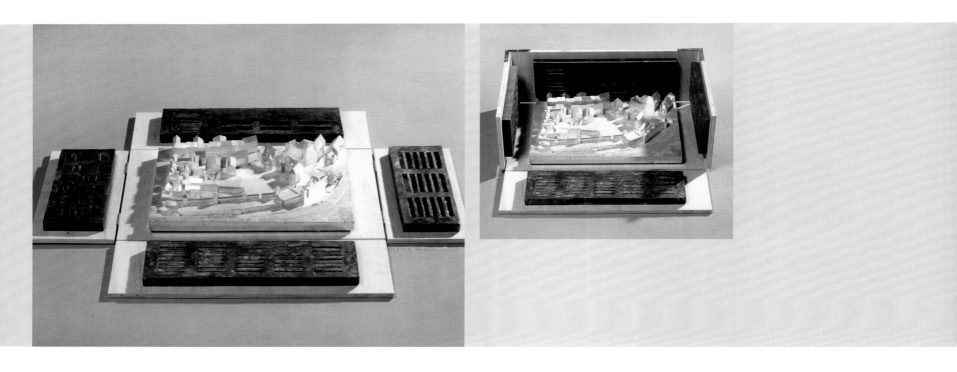

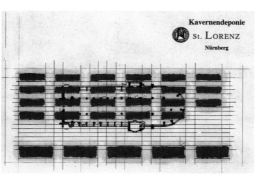
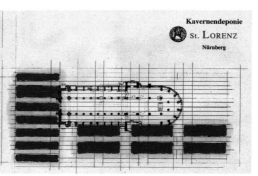

Proportionierungsgrundlage — Basis for Proportioning	St. Lorenz, Nürnberg, DEU
Jahr — Year	1989
Maße — Measurements	42 x 42 x 15 cm
Material — Material	Holz, Wachs, Blattgold
	Wood, wax, gold leaf

**Sondermülldeponie
Lorenzkirche**

Nürnberg 1 - Mitte -

Anlieferung: Mo. - Fr. 9 Uhr - 16 Uhr
 Sa. - So. 9 Uhr - 13 Uhr

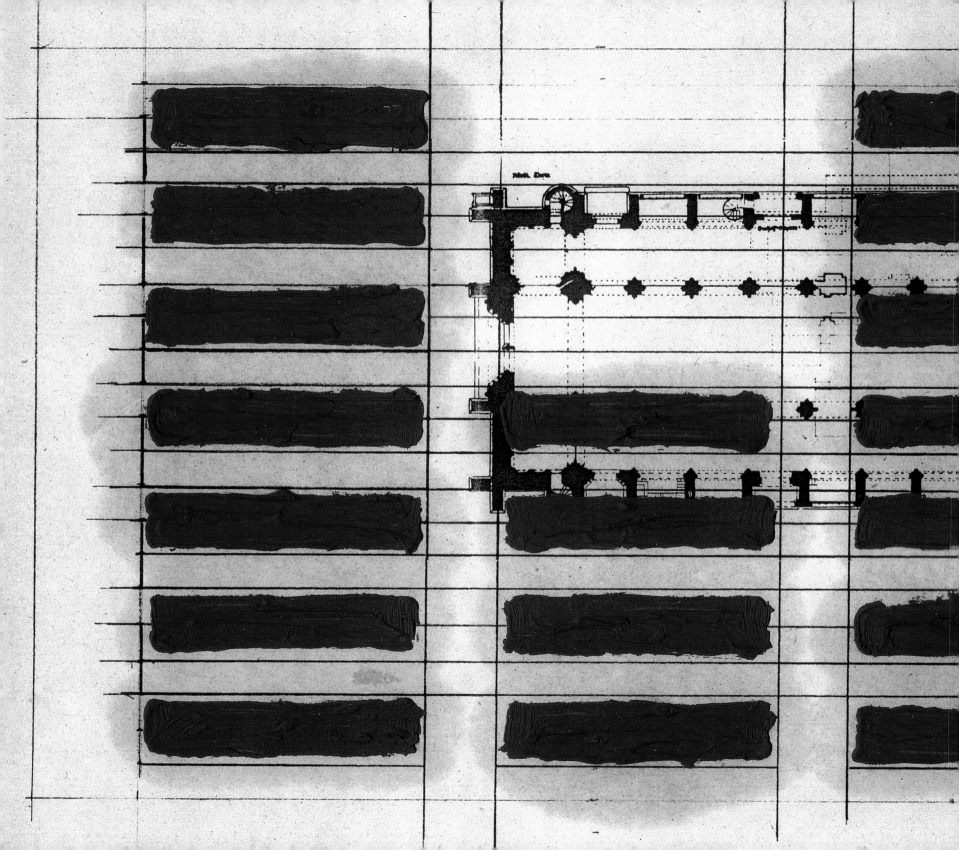

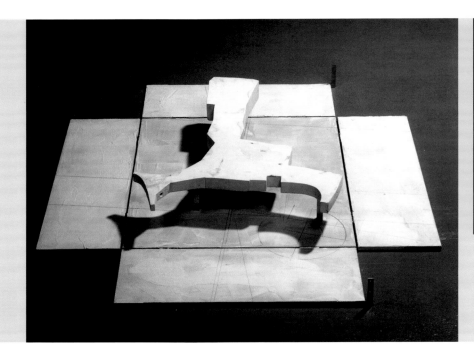
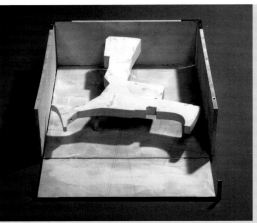

Proportionierungsgrundlage — Basis for Proportioning	Felsentempel Ramses II, Abu Simbel, EGY
	Ramses II Rock Temple, Abu Simbel, EGY

Jahr — Year	1991
Maße — Measurements	62 x 67 x 21 cm
Material — Material	Gips, Holz,Eisen
	Plaster, wood, iron

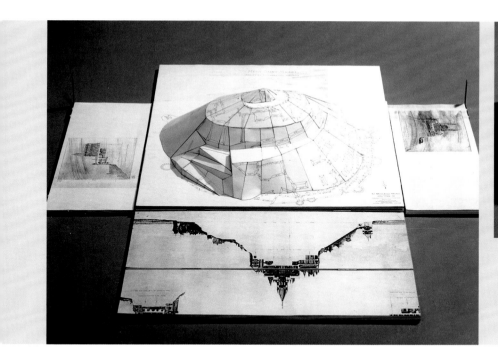

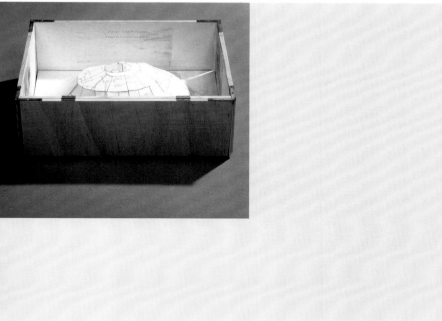

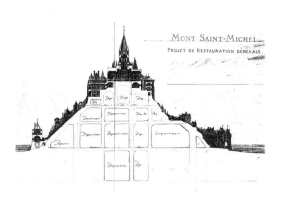

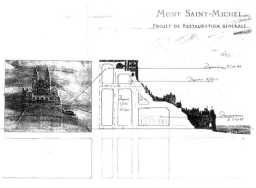

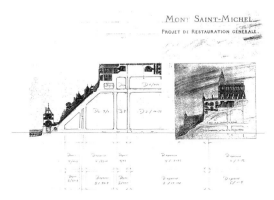

Proportionierungsgrundlage — Basis for Proportioning	Abteikirche Saint-Michel, Mont-Saint-Michel, FRA
	Abbey Church of Saint-Michel, Mont-Saint-Michel, FRA
Jahr — Year	1991
Maße — Measurements	72 x 58 x 32 cm
Material — Material	Gips, Holz, Pappe
	Plaster, wood, cardboard

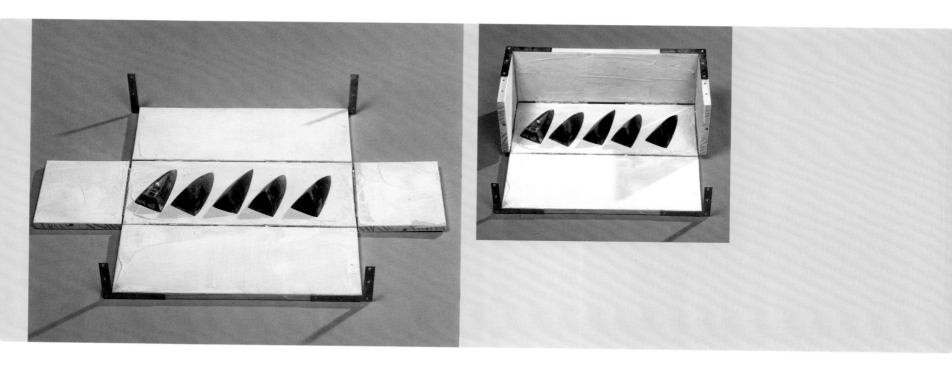

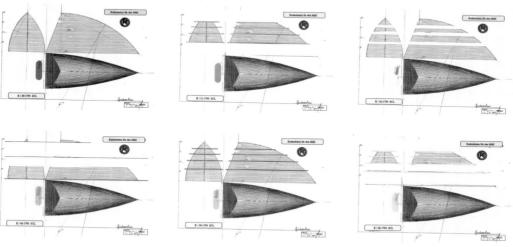

Proportionierungsgrundlage — Basis for Proportioning	Tempelstadt Uxmal, MEX
	Uxmal Temple City, MEX
Jahr — Year	1991
Maße — Measurements	36 x 17 x 15 cm
Material — Material	Gips, Holz, Eisen, Epoxidharz
	Plaster, wood, iron, epoxy resin

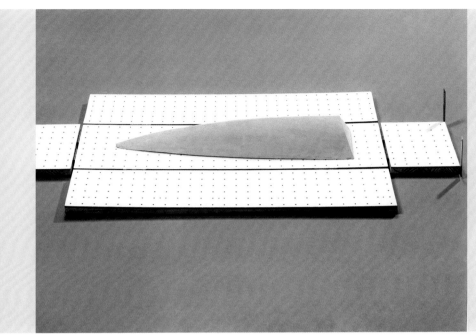
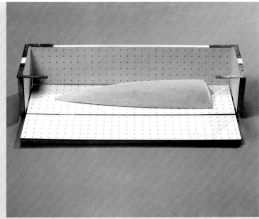

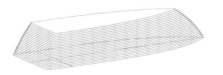

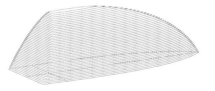

Proportionierungsgrundlage — *Basis for Proportioning*	Chrysler Building, New York, USA
Jahr — *Year*	1991
Maße — *Measurements*	54 x 22 x 15 cm
Material — *Material*	Gips, Holz, Eisen
	Plaster, wood, iron

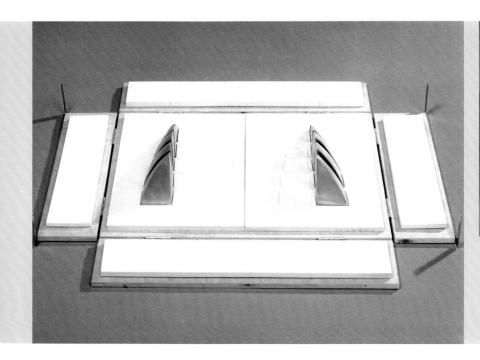

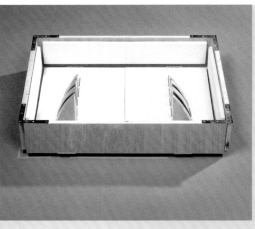

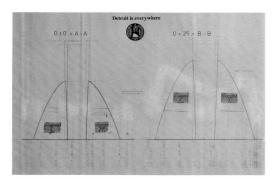

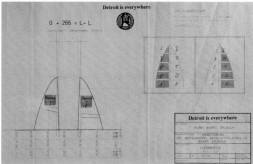

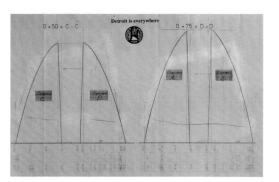

Proportionierungsgrundlage — Basis for Proportioning Sphinxtempel, Gizeh, EGY
Temple of the Sphinx, Giza, EGY

Jahr — Year 1993
Maße — Measurements 64 x 50 x 13 cm
Material — Material Aluminium, Gips, Holz
Aluminium, plaster, wood

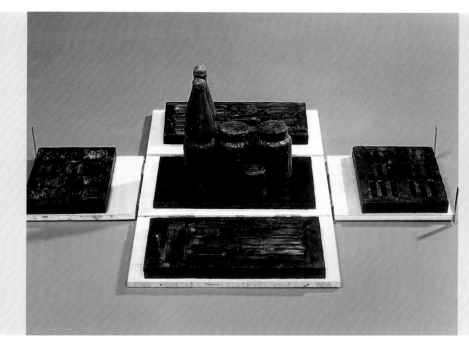

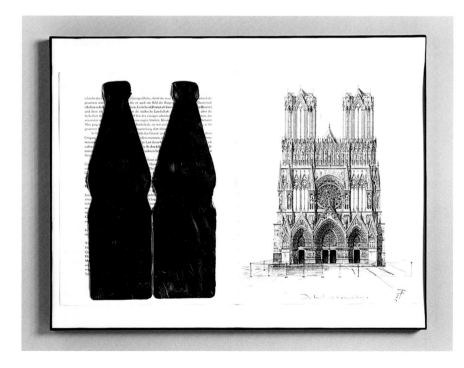

Proportionierungsgrundlage — Basis for Proportioning	Notre-Dame de Reims, FRA
Jahr — Year	1993
Maße — Measurements	54 x 56 x 18 cm
Material — Material	Gips, Holz, Eisen
	Plaster, wood, iron

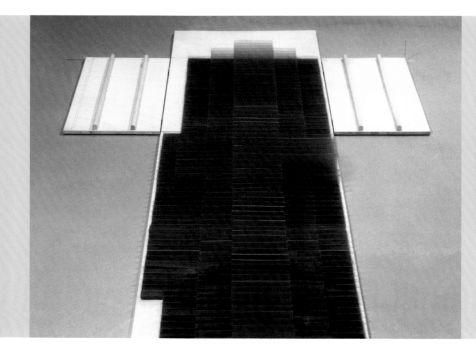

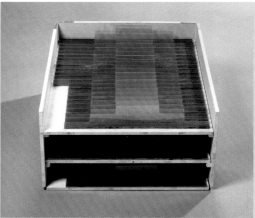

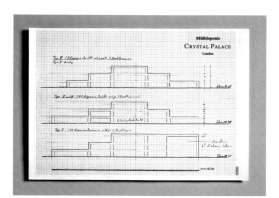

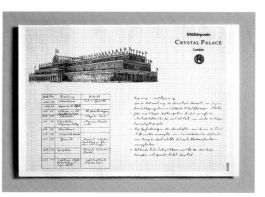

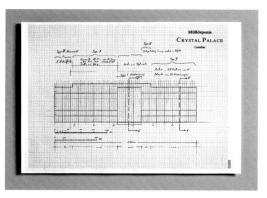

Proportionierungsgrundlage — Basis for Proportioning Crystal Palace, London, GBR

Jahr — Year 1993
Maße — Measurements 180 x 72 x 42 cm
Material — Material Gips, Holz, Plexiglas
Plaster, wood, acrylic glass

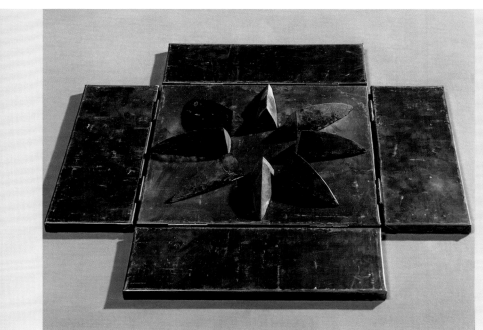
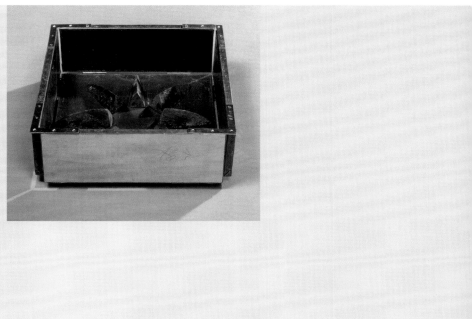

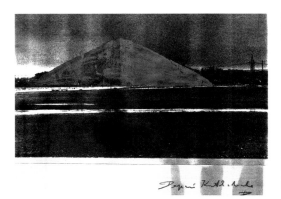
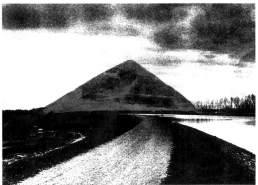

Proportionierungsgrundlage — Basis for Proportioning	Tempelanlage Cuicuilco, Mexico City, MEX
	Cuicuilco Temple Complex, Mexico City, MEX
Jahr — Year	1993
Maße — Measurements	42 x 42 x 15 cm
Material — Material	Blei, Holz, Blattgold
	Lead, wood, gold leaf

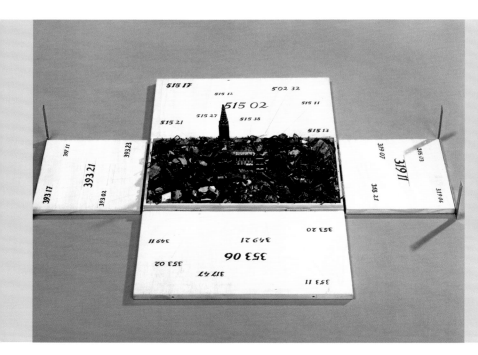

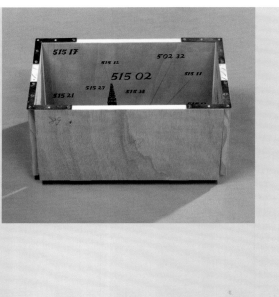

Decharge Cathédrale Notre-Dame de Strasbourg — Numerische Liste der eingelagerten Abfallstoffe

Proportionierungsgrundlage — *Basis for Proportioning*	Notre-Dame, Strasbourg, FRA
Jahr — *Year*	1993
Maße — *Measurements*	42 x 42 x 15 cm
Material — *Material*	Holz, Bronze, Schlacke
	Wood, bronze, slag

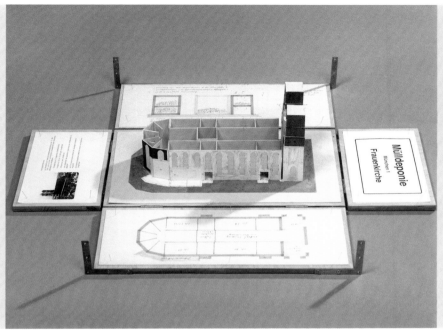

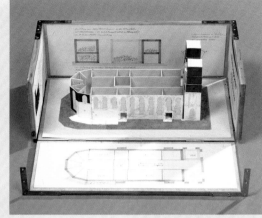

Nutzungsänderung:

Auf Beschluß der Stadtverordnetenversammlung vom 15. Mai 1995, wird im Dom von München (Frauenkirche) eine Hochsicherheitsdeponie eingebaut.

- Einlagerung in 72 separaten Stahlbetonsilos
- Einlagerung von ca. 20 000 cbm. Sondermüll
- Ablagerung nach Abfallarten
- die Möglichkeit der gezielten Rückholung der Abfallstoffe ist gegeben
- die Dichtungssysteme werden den jeweiligen Abfallarten angepaßt
- durchgehend begehbare Sohle mit Kontroll und Reperaturmöglichkeit

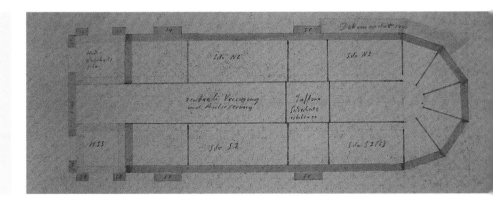

Proportionierungsgrundlage — Basis for Proportioning	Frauenkirche, München, DEU *Frauenkirche, Munich, DEU*
Jahr — Year	1993
Maße — Measurements	42 x 26 x 24 cm
Material — Material	Holz, Pappe *Wood, cardboard*

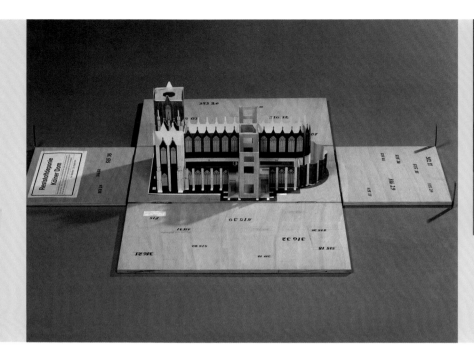

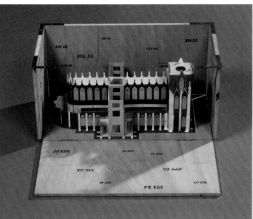

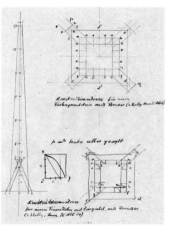

Proportionierungsgrundlage — Basis for Proportioning Hohe Domkirche St. Petrus, Köln, DEU
High Cathedral of St. Peter, Cologne, DEU

Jahr — Year 1993
Maße — Measurements 42 x 42 x 15 cm
Material — Material Holz, Pappe
Wood, cardboard

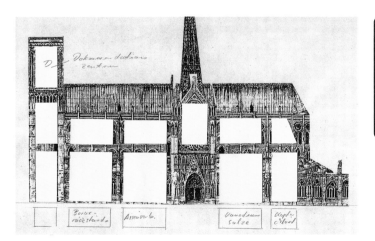

Decharge Cathedrale
Notre Dame

Ouvert: Lundi - Vendredi

9h -17h

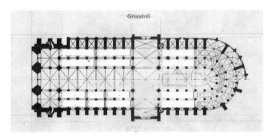

Proportionierungsgrundlage — Basis for Proportioning	Notre-Dame de Paris, FRA
Jahr — Year	1993
Maße — Measurements	32 x 16 x 19 cm
Material — Material	Holz, Pappe *Wood, cardboard*

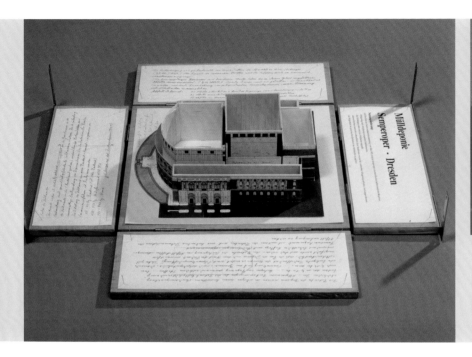

Reststoffdeponie Semper - Oper

Nutzungsänderung der Semper - Oper auf Beschluß der Stadtverordnetenversammlung vom November 1993. In den Räumen der Semper - Oper werden bis auf weiteres Reststoffe aus dem Stadtgebiet Dresden und seiner angrenzenden Gemeinden eingelagert

Proportionierungsgrundlage — Basis for Proportioning Semperoper, Dresden, DEU

Jahr — Year 1993
Maße — Measurements 42 x 42 x 15 cm
Material — Material Holz, Pappe
Wood, cardboard

ABFALL-SCHLÜSSEL	BEZEICHNUNG	HERKUNFT	WIEDERVERW.	CPB	HMV	SAV	HMD	SAD	UTD	SONSTIGES	TT-ABBAUEN	TT-ABBAUEN	BAUBEDÜRFT	
511 08	Kobalthaltiger Galvanikschlamm	Galvanikbetriebe und galvanotechnische Teilbetriebe				1			1		X	X	I	
511 11	Blei- oder zinnhaltiger Galvanikschlamm	Galvanikbetriebe und galvanotechnische Teilbetriebe				1			2		X	X	I	
511 12	Sonstige Galvanikschlämme	Galvanikbetriebe und galvanotechnische Teilbetriebe				1			1		X	X	I	
511 13	Sonstige Metallhydroxidschlämme	Chemische Industrie, Gewerbliche Wirtschaft, Industrieabwasserreinigung				1			1	Monodeponie	X	X	II	
513	Sonstige Oxide und Hydroxide													
513 01	Zinkoxid, -hydroxid	Zinkgewinnung und -verarbeitung, Chemische Industrie							1		X	X	I	
513 02	Zinnoxide	Zinnerzeugung und -verarbeitung					s				X	X	I	
513 04	Braunstein, Manganoxide	Herstellung von Batterien, Chemische Industrie							1		X	X	III	
513 05	Aluminiumoxid	Aluminiumerzeugung, -umschmelzwerke, Chemische Industrie					s				X	X	I	
513 06	Chrom-(III)-Oxid	Chemische Industrie							1		X	X	I	
513 07	Kupferoxid	Chemische Industrie, Metallerzeugung							1		X	X	I	
513 08	Aluminiumhydroxid	Oberflächenveredelung, Eloxieren					s				X	X	I	
513 09	Eisenhydroxid	Oberflächenbehandlung von Eisen und Stahl, Beizerei, Aranci					s						II	
513 10	Sonstige Metalloxide und Metallhydroxide ohne Eisen- und Aluminiumoxide und -hydroxide	Chemische Industrie, Gewerbliche Wirtschaft, Herstellung von Halbleitern							1	1	Monodeponie	X	X	II
515	Salze													
515 02	Hüttensalze	Gerberei, Rohfellverarbeitung, Schlachterei							2	1		X	X	I

ABFALL-SCHLÜSSEL	BEZEICHNUNG	HERKUNFT	WIEDERVERW.	CPB	HMV	SAV	HMD	SAD	UTD	SONSTIGES	TT-ABBAUEN	TT-ABBAUEN	BAUBEDÜRFT
552	Halogenierte organische Lösemittel und Lösemittelgemische, andere Flüssigkeiten mit halogenierten organischen Verbindungen												
552 01	1,2-Dichlorethan	Chemische Industrie, Gewerbliche Wirtschaft					1				X	X	I
552 02	Chlorbenzol	Chemische Industrie, Gewerbliche Wirtschaft					1				X	X	I
552 03	Trichlormethan (Chloroform)	Chemische Industrie, Gewerbliche Wirtschaft					1				X	X	I
552 05	Fluorchlorkohlenwasserstoffe, Kälte-, Treib- und Lösemittel	Chemische Industrie, Gewerbliche Wirtschaft					1				X	X	I
552 06	Dichlormethan	Chemische Industrie, Textilindustrie, Oberflächenbehandlung, Entlackung, Kunststoffverarbeitung					1				X	X	I
552 09	Tetrachlorethen (Per)	Chemische Industrie, Textilindustrie, Chemische Reinigung, Oberflächenbehandlung					1				X	X	I
552 11	Tetrachlormethan (Tetra)	Chemische Industrie, Laboratorien					1				X	X	I
552 12	Trichlorethane	Chemische Industrie, Textilindustrie, Oberflächenbehandlung					1				X	X	I
552 13	Trichlorethen (Tri)	Chemische Industrie, Textilindustrie, Chemische Reinigung, Oberflächenbehandlung					1				X	X	I
552 20	Lösemittelgemische, halogenierte organische Lösemittel enthaltend	Chemische Industrie, Gewerbliche Wirtschaft					1				X	X	I
552 23	Sonstige halogenierte organische Lösemittel	Chemische Industrie, Gewerbliche Wirtschaft					1				X	X	I
552 24	Lösemittel-Wassergemische, halogenierte organische Lösemittel enthaltend	Chemische Industrie, Chemische Reinigung					1				X	X	I

ABFALL-SCHLÜSSEL	BEZEICHNUNG	HERKUNFT	WIEDERVERW.	CPB	HMV	SAV	HMD	SAD	UTD	SONSTIGES	TT-ABBAUEN	TT-ABBAUEN	BAUBEDÜRFT	
353 24	Batterien, quecksilberhaltig	Herstellung von Batterien, Handel und Anwendung						2	1		X	X	I	
353 25	Trockenbatterien (Trockenzellen)	Herstellung von Batterien, Handel und Anwendung						1	2		X	X	I	
353 26	Quecksilber, quecksilberhaltige Rückstände, Quecksilberdampflampen, Leuchtstoffröhren	Herstellung, Handel und Anwendung, Metallurgie		1				2	1		X	X	I	
353 27	NE-Metallhältrückstände mit schädlichen Restinhalten	Gewerbliche Wirtschaft				1			1		X	X	I	
355	Metallschlämme													
355 01	Zinkschlamm	Zinkgewinnung und -verarbeitung, Verzinkerei, Druckerei, Herstellung von Klischees							1		X	X	I	
355 03	Bleischlamm	Bleigewinnung und -verarbeitung, Akkumulatoren							1		X	X	I	
355 04	Zinnschlamm	Zinngewinnung und -verarbeitung							1		X	X	I	
355 05	Anodenschlamm	Elektrolysen							1		X	X	I	
355 06	Sonstige Metallschlämme ohne Aluminium-, Eisen- und Magnesiumschlämme	Metallbearbeitung							1		X	X	I	
39	Andere Abfälle mineralischen Ursprungs sowie aus Veredlungsprodukten													
399	Sonstige Abfälle mineralischen Ursprungs sowie aus Veredlungsprodukten													
399 01	Jarositschlamm	NE-Metallerzeugung							1		Monodeponie	X	X	I
399 03	Steinsalzrückstände (Gisgart)	Chemische Industrie, Erzeugung von Chlor					2		1		Monodeponie	X	X	III
399 04	Querrissigungsmasse, Rohrtaub aus...	Kokereien, Gaswerke								1		X	X	I

ABFALL-SCHLÜSSEL	BEZEICHNUNG	HERKUNFT	WIEDERVERW.	CPB	HMV	SAV	HMD	SAD	UTD	SONSTIGES	TT-ABBAUEN	TT-ABBAUEN	BAUBEDÜRFT	
515 25	Bariumsalze	Herstellung von keramischen Erzeugnissen und Glas, Textilindustrie, Chemische Industrie, Härterei							1		X	X	I	
515 26	Calciumchlorid	Chemische Industrie					2	1			X	X	III	
515 27	Magnesiumchlorid	Chemische Industrie, Herstellung von Baustoffen, Baugewerbe					2	1			X	X	III	
515 28	Alkali- und Erdalkalisulfide	Chemische Industrie, Ledererzeugung					2	1			X	X	I	
515 29	Schwermetallsulfide	Chemische Industrie, Gewinnung von NE-Metallen					1	2			X	X	I	
515 30	Kupferchlorid	Chemische Industrie, Herstellung von Pflanzenbehandlungsmitteln, Elektrotechnik					2	1			X	X	I	
515 31	Aluminiumchloride, Aluminium-phosphatrückstände	Gerberei, Eloxalbetriebe					2	1			X	X	I	
515 32	Chlorkalk	Chemische Industrie, Entgiftung, Desinfektion		1			2	1			X	X	I	
515 33	Salze, cyanidhaltig	Chemische Industrie, Härterei					2	1			X	X	I	
515 40	Salze, nitrat- oder nitrithaltig	Chemische Industrie, Härterei					2	1			X	X	I	
515 34	Vanadiumsalze	Chemische Industrie, Metallgewinnung					2	1			X	X	I	
515 36	Abraumsalze	Bergbau							s		Monodeponie	X	X	I
515 38	Borsäurerückstände	Chemische Industrie, Herstellung von Glas und keramischen Erzeugnissen					2	1			X	X	I	
515 39	Arsenverbindungen	Chemische Industrie, Glas- und Keramikindustrie, NE-Metallherstellung					2	1			X	X	I	
515 41	Sonstige Salze, löslich	Chemische Industrie, Gewerbliche Wirtschaft					2	1			X	X	I	
515 42	Sonstige Salze, schwerlöslich	Chemische Industrie, Gewerbliche Wirtschaft					2	1			X	X	I	

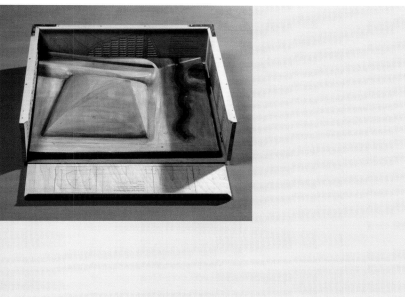

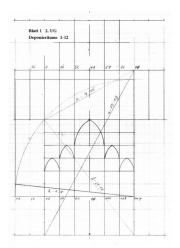
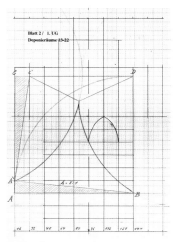
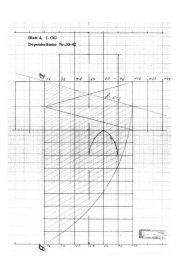

Proportionierungsgrundlage — Basis for Proportioning	Grossmünster, Zürich, CHE
Jahr — Year	2003
Maße — Measurements	58 x 58 x 17 cm
Material — Material	Gips, Holz
	Plaster, wood

Mülldeponie im Schloßgarten B

Wien.

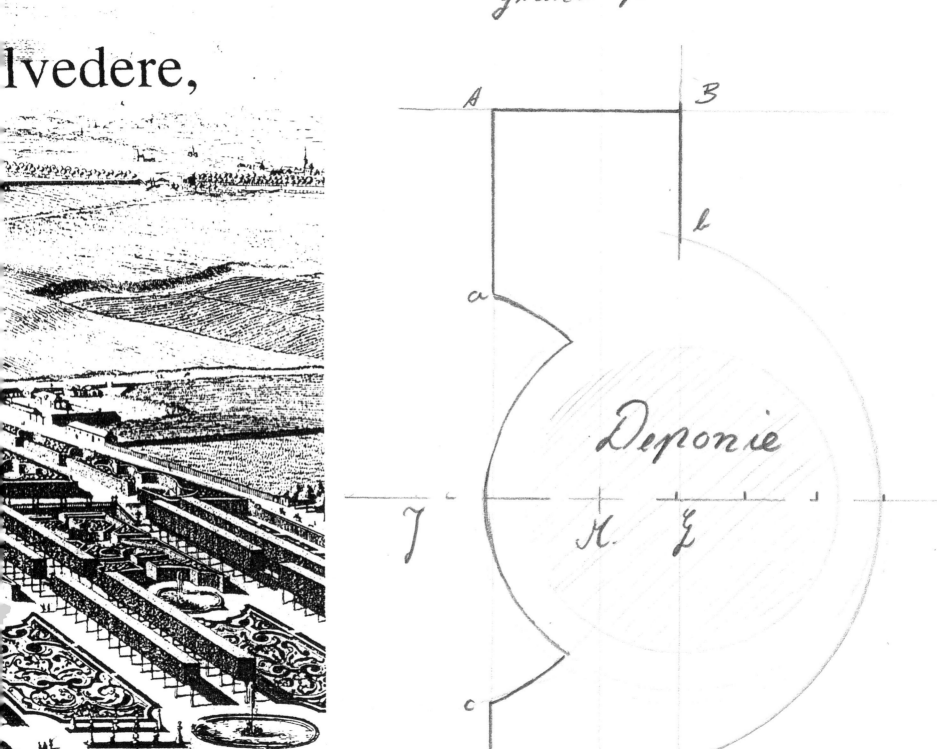

Grundriß

lvedere,

A B

b

a

Deponie

J K. L

c

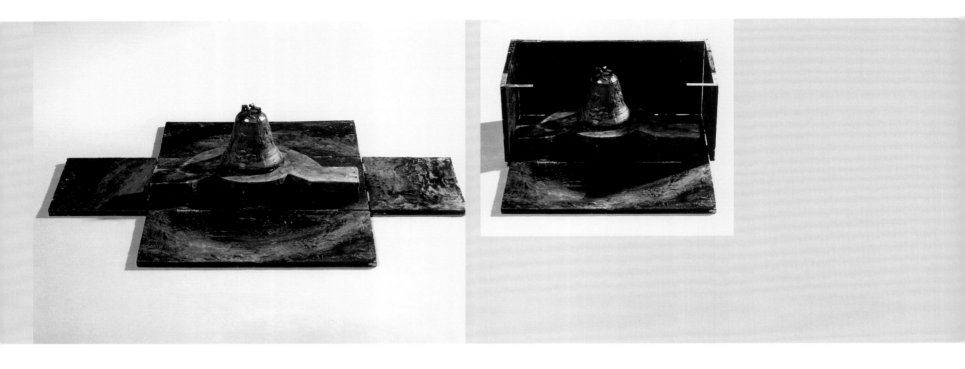

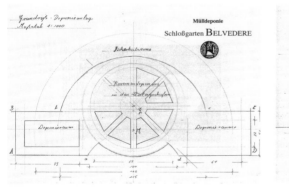

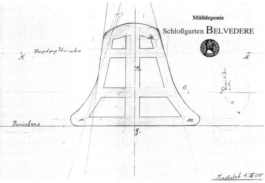

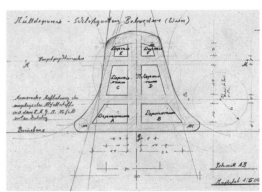

Proportionierungsgrundlage — *Basis for Proportioning*	Schlossgarten Belvedere, Wien, AUT
	Belvedere Palace Garden, Vienna, AUT
Jahr — *Year*	1993
Maße — *Measurements*	42 x 29 x 24 cm
Material — *Material*	Bienenwachs, Gips, Holz
	Beeswax, plaster, wood

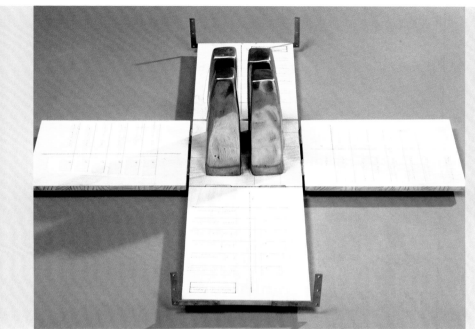

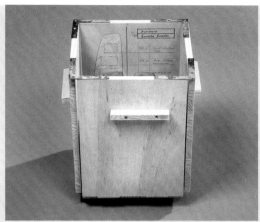

Proportionierungsgrundlage — *Basis for Proportioning*	Tempelanlage Angkor Wat, KHM
	Angkor Wat Temple Complex, KHM
Jahr — *Year*	1993
Maße — *Measurements*	24 x 24 x 38 cm
Material — *Material*	Aluminium, Holz
	Aluminium, wood

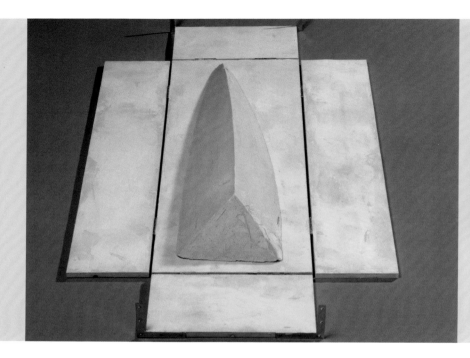
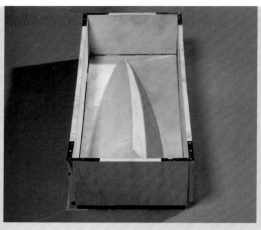

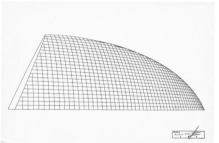
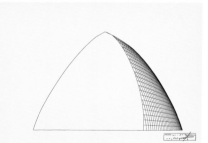
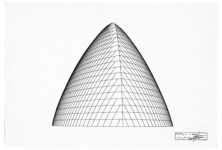
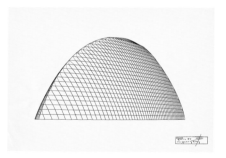

Proportionierungsgrundlage — Basis for Proportioning	Tempelanlage Honmyoji, Kumamoto, JPN
	Honmyoji Temple Complex, Kumamoto, JPN
Jahr — Year	1991
Maße — Measurements	52 x 32 x 17 cm
Material — Material	Gips, Holz, Eisen
	Plaster, wood, iron

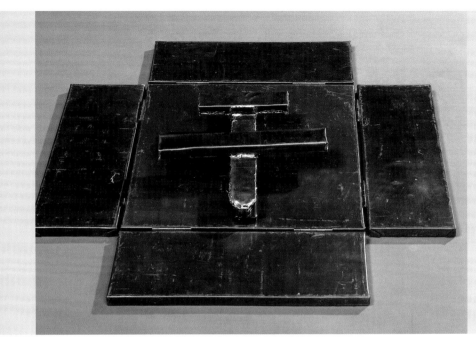

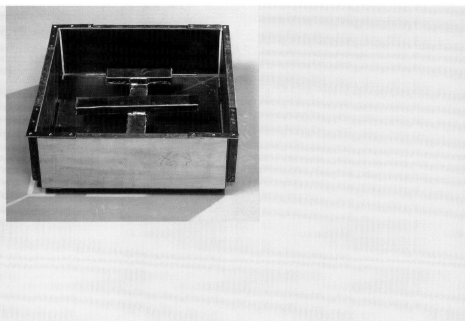

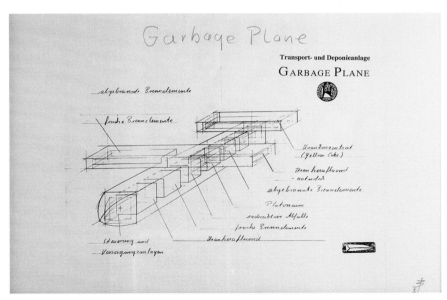

Jahr — Year	1993
Maße — Measurements	42 x 42 x 15 cm
Material — Material	Blei, Holz, Eisen
	Lead, wood, iron

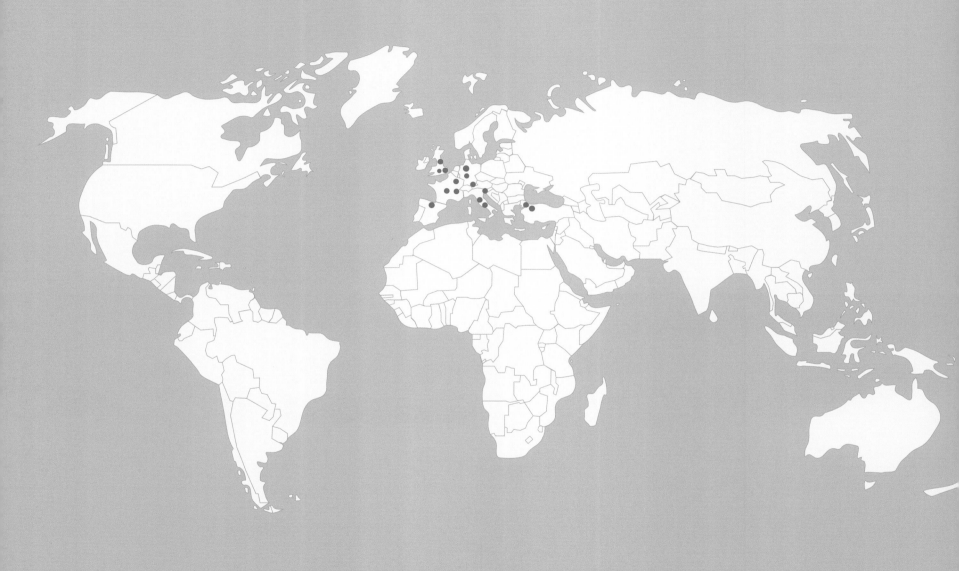

Kathedralen für den Müll
Cathedrals for Garbage

Müllarchitektur
Waste Architecture

Urban Mining Mülldeponien
Urban Mining Waste Dumps

Megadeponien
Mega-Dumbs

Runddeponien
Hazardous Waste Dumbs

Detroit is Everywhere
Detroit is Everywhere

Nuklear-Katastrophen
Nuclear Disasters

2.3

URBAN MINING MÜLLDEPONIEN
URBAN MINING WASTE DUMPS

Deponieanlagen zur Rohstoffrückgewinnung
nach dem Proportionsschema
gotischer Kathedralen

Waste dumps for raw material retrieval
based on the schemes of proportion behind
Gothic cathedrals

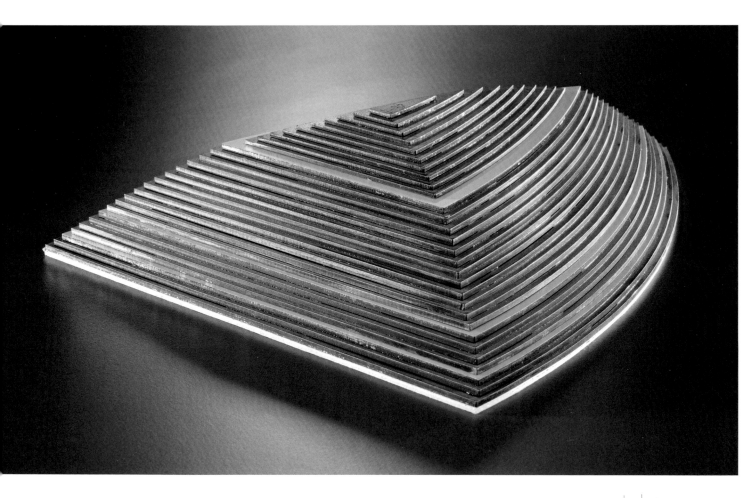

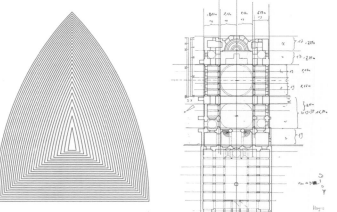

Proportionierungsgrundlage — Basis for Proportioning Hagia Irene, Istanbul, TUR

Jahr — Year 2003
Maße — Measurements 24 x 27 x 16 cm
Material — Material Eisen, Acryllack
Iron, acrylic lacquer

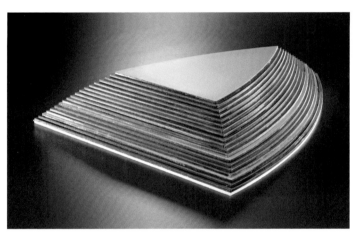

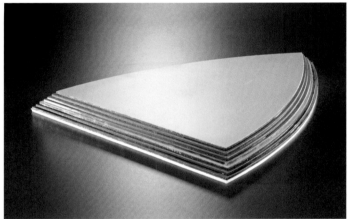

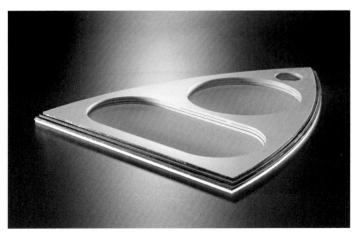

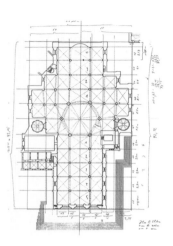

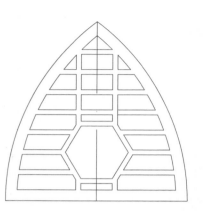

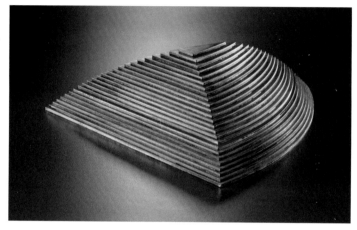

Proportionierungsgrundlage — Basis for Proportioning

Kathedrale Santa Maria Assunta, Siena, ITA
Cathedral of Santa Maria Assunta, Siena, ITA

Jahr — Year	2003
Maße — Measurements	21 x 26 x 17 cm
Material — Material	Eisen, Acryllack
	Iron, acrylic lacquer

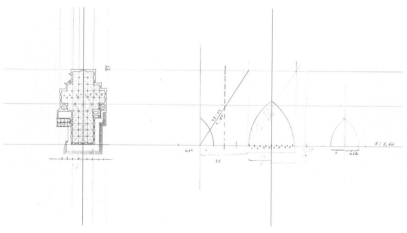

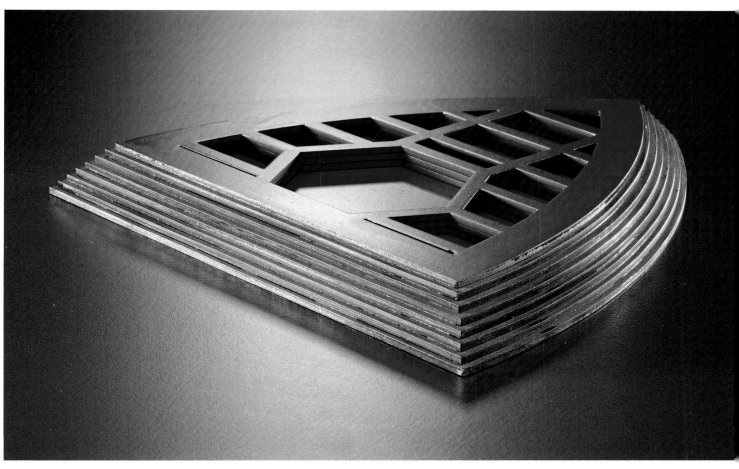

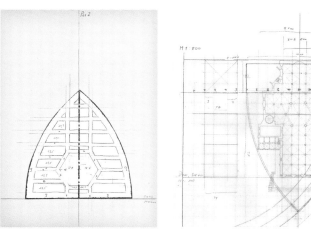

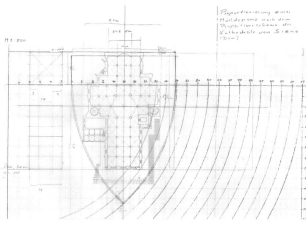

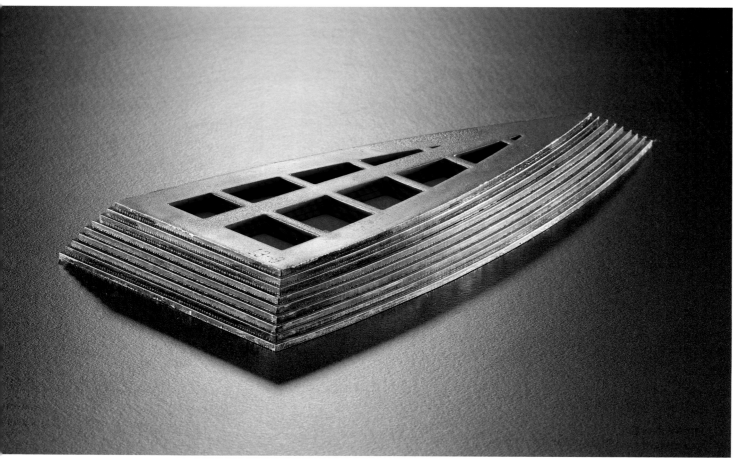

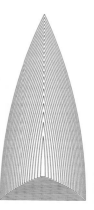
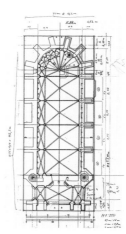
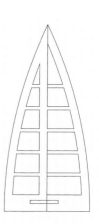

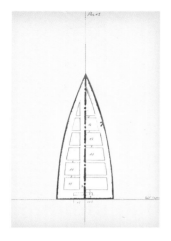

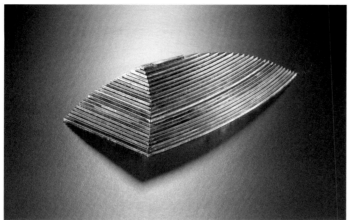

Proportionierungsgrundlage — Basis for Proportioning	Sainte-Chapelle, Paris, FRA
Jahr — Year	2003
Maße — Measurements	17 x 12 x 11 cm
Material — Material	Eisen, Acryllack
	Iron, acrylic lacquer

Proportionierungsgrundlage — Basis for Proportioning	Sainte-Chapelle, Paris, FRA
Jahr — Year	2003
Maße — Measurements	32 x 23 x 7 cm
Material — Material	Beton, Holz, Pappe
	Concrete, wood, cardboard

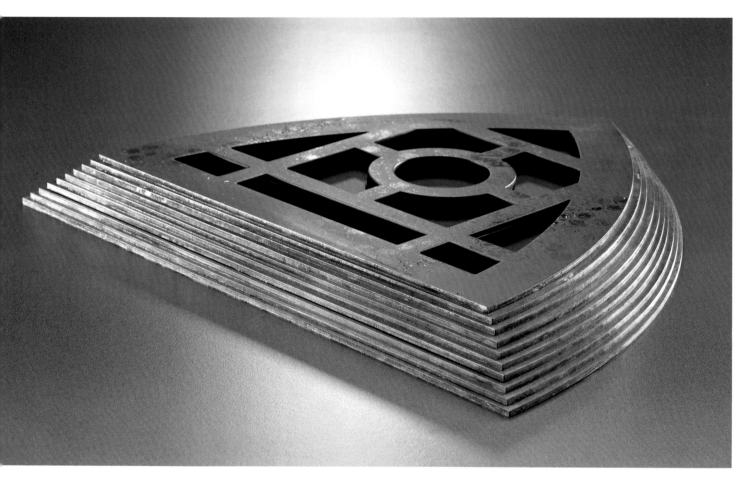

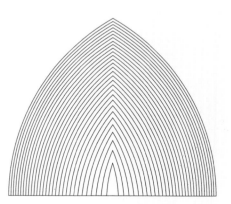
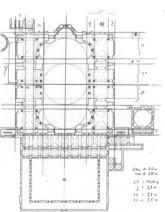

Proportionierungsgrundlage — Basis for Proportioning	Hagia Sophia, Istanbul, TUR
Jahr — Year	2003
Maße — Measurements	22 x 26 x 12 cm
Material — Material	Eisen, Acryllack
	Iron, acrylic lacquer

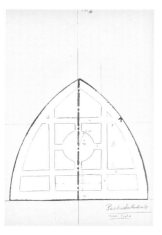

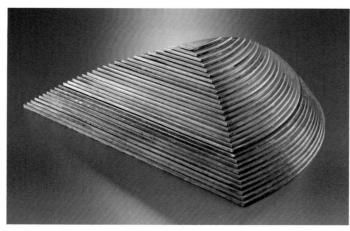

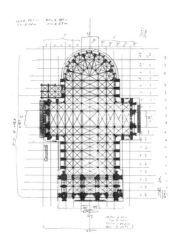

Proportionierungsgrundlage — *Basis for Proportioning*	Hohe Domkirche St. Petrus, Köln, DEU *Cologne High Cathedral St. Peter, Cologne, DEU*
Jahr — *Year*	2003
Maße — *Measurements*	22 x 26 x 12 cm
Material — *Material*	Eisen, Acryllack *Iron, acrylic lacquer*

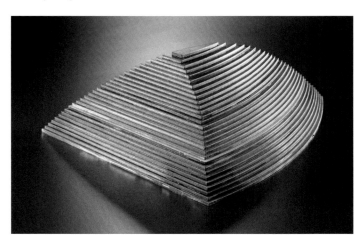
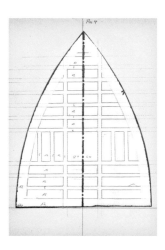

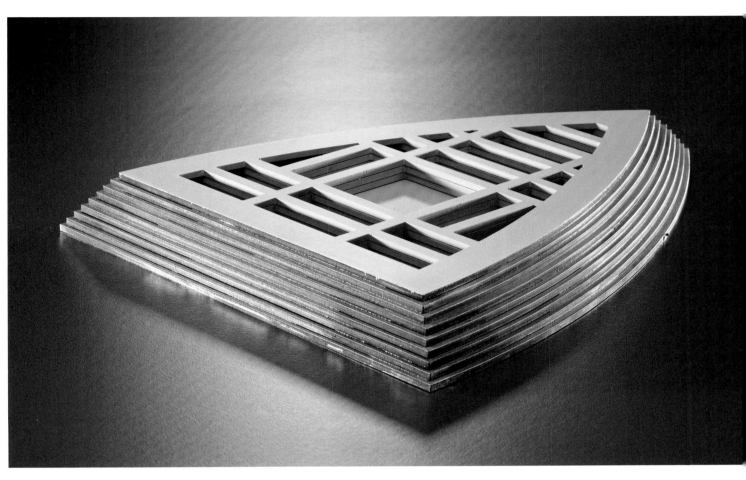

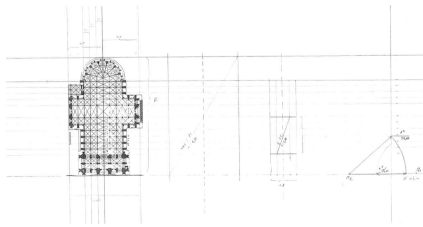

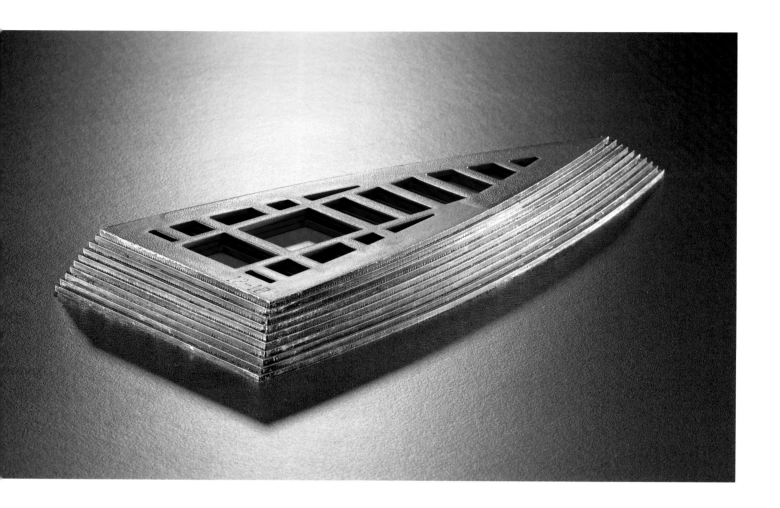

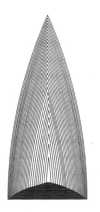 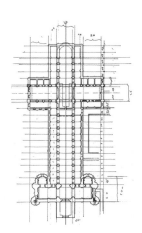 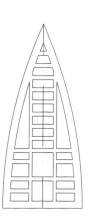

| *Proportionierungsgrundlage — Basis for Proportioning* | Kathedrale, Ely, GBR |
| | *Ely Cathedral, Ely, GBR* |

Jahr — Year	2003
Maße — Measurements	18 x 11 x 10 cm
Material — Material	Eisen, Acryllack
	Iron, acrylic lacquer

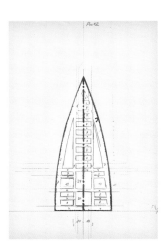 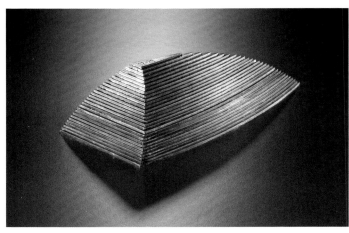

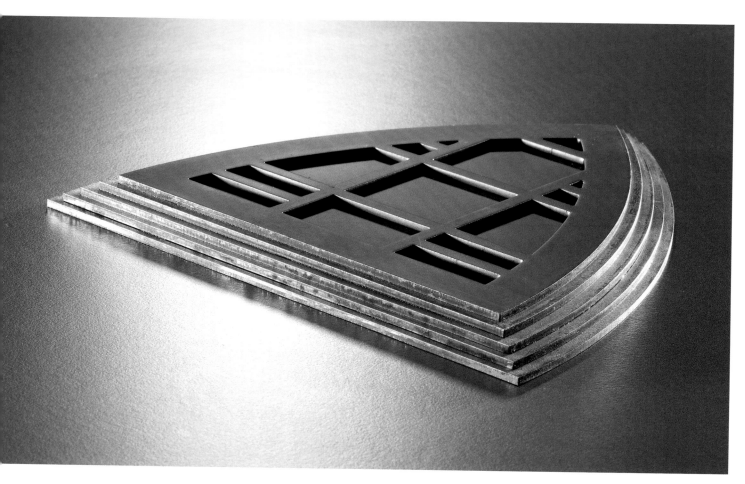

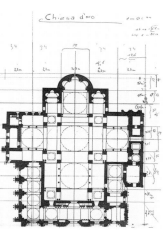

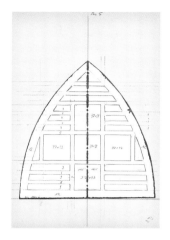 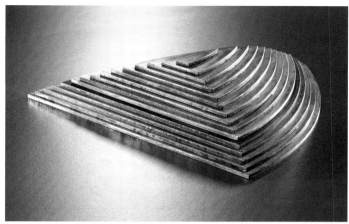 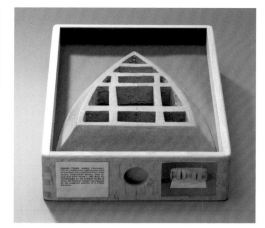

Proportionierungsgrundlage — Basis for Proportioning	Basilica di San Marco, Venedig, ITA
	Basilica di San Marco, Venice, ITA
Jahr — Year	2003
Maße — Measurements	24 x 27 x 16 cm
Material — Material	Eisen, Acryllack
	Iron, acrylic lacquer

Proportionierungsgrundlage — Basis for Proportioning	Basilica di San Marco, Venedig, ITA
	Basilica di San Marco, Venice, ITA
Jahr — Year	2003
Maße — Measurements	32 x 23 x 7 cm
Material — Material	Beton, Holz, Pappe
	Concrete, wood, cardboard

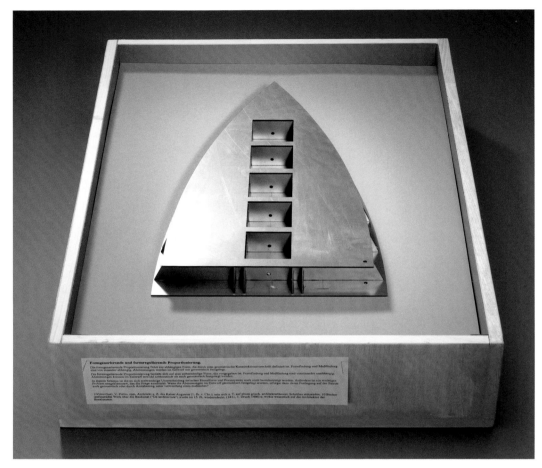

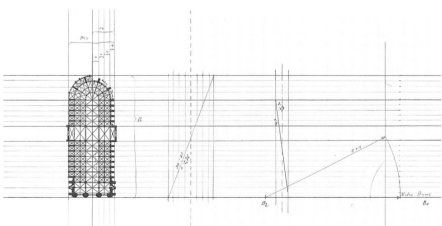

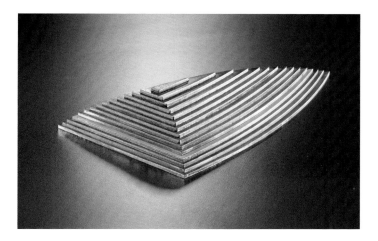

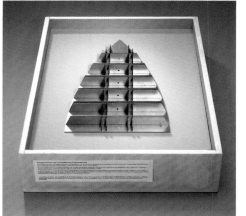

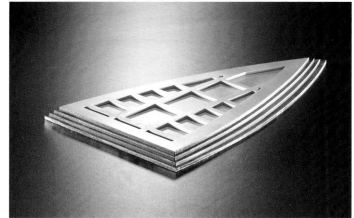

Proportionierungsgrundlage — Basis for Proportioning	Notre-Dame, Paris, FRA
Jahr — Year	2003
Maße — Measurements	26 x 12 x 9 cm
Material — Material	Eisen, Acryllack
	Iron, acrylic lacquer

Proportionierungsgrundlage — Basis for Proportioning	Notre-Dame, Paris, FRA
Jahr — Year	2003
Maße — Measurements	58 x 42 x 15 cm
Material — Material	Eisen, Holz Pappe
	Iron, wood, cardboard

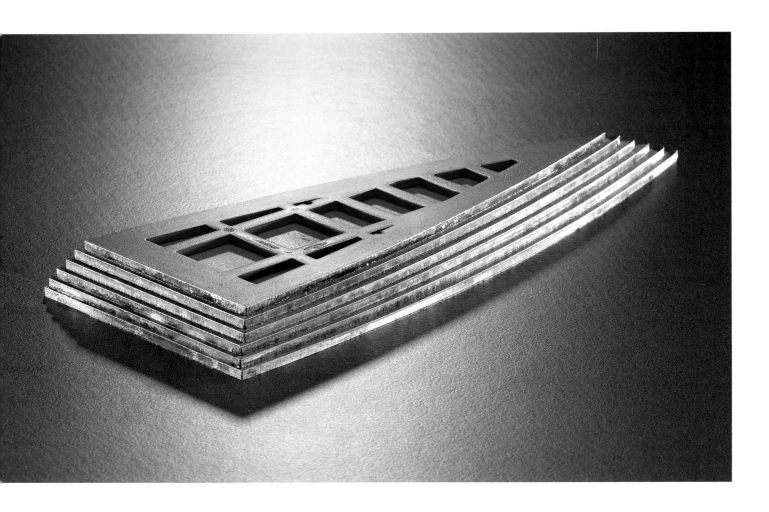

Proportionierungsgrundlage — *Basis for Proportioning* Klosterkirche Maria Laach, DEU
Abbey Church of Maria Laach, DEU

Jahr — *Year* 2003
Maße — *Measurements* 19 x 11 x 10 cm
Material — *Material* Eisen, Acryllack
Iron, acrylic lacquer

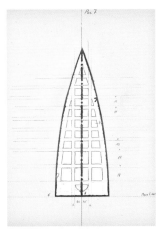

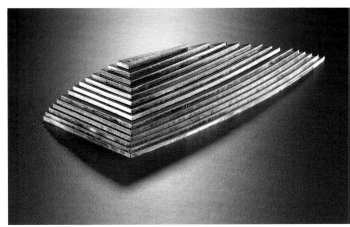

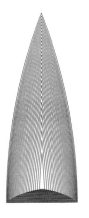

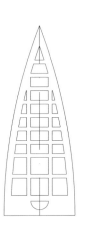

Proportionierungsgrundlage — Basis for Proportioning Kathedrale Santiago de Compostela, ESP
Cathedral of Santiago de Compostela, ESP

Jahr — Year 2003
Maße — Measurements 29 x 21 x 13 cm
Material — Material Eisen, Acryllack
Iron, acrylic lacquer

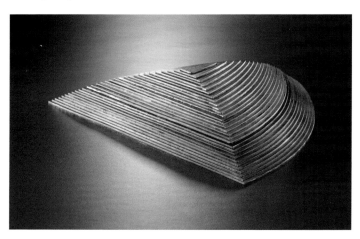 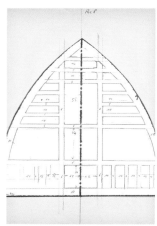

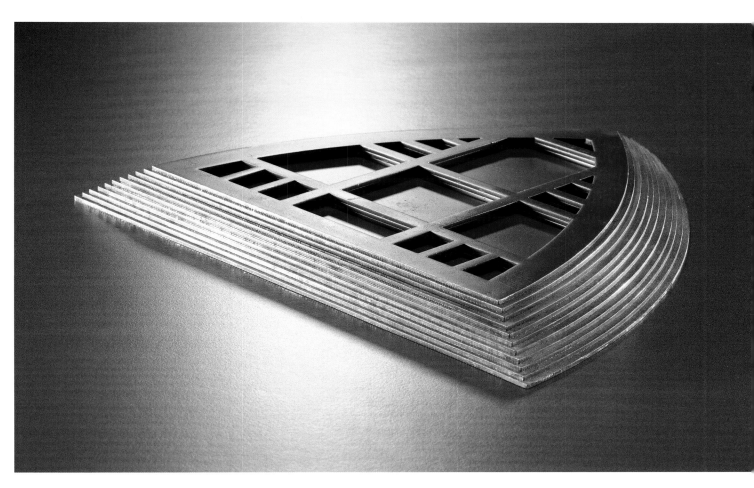

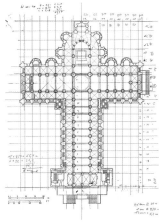

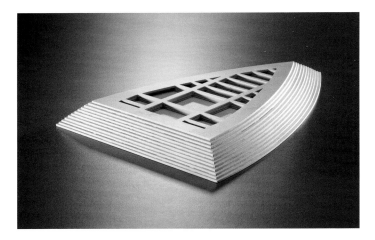

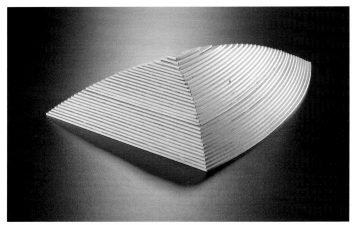

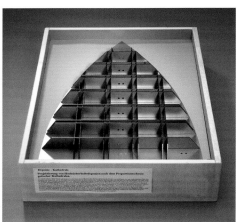

Proportionierungsgrundlage — Basis for Proportioning	Notre-Dame de Reims, FRA
Jahr — Year	2003
Maße — Measurements	19 x 29,5 x 14 cm
Material — Material	Eisen, Acryllack
	Iron, acrylic lacquer

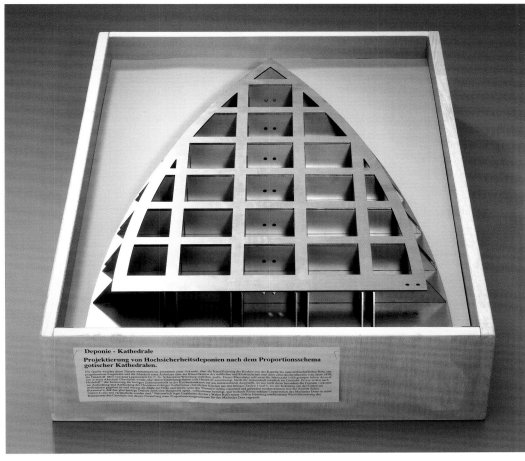

Proportionierungsgrundlage — Basis for Proportioning	Notre-Dame de Reims, FRA
Jahr — Year	2003
Maße — Measurements	58 x 42 x 15 cm
Material — Material	Eisen, Holz Pappe
	Iron, wood, cardboard

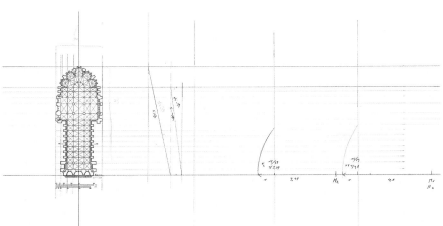

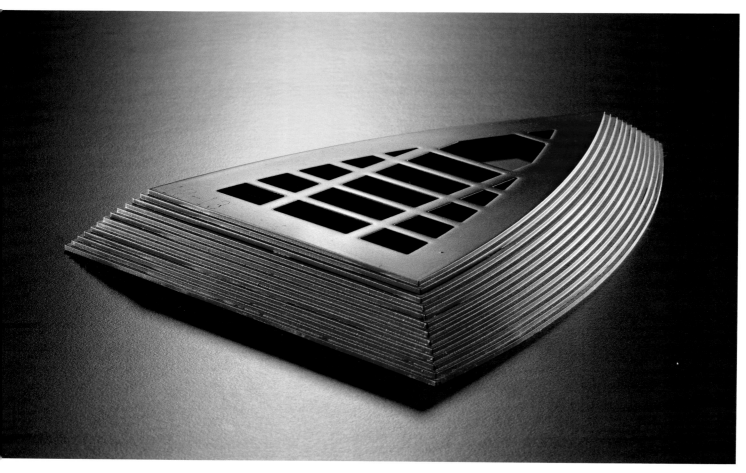

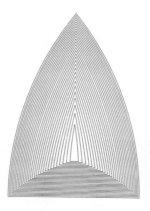

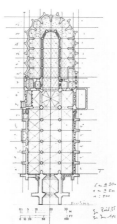

Proportionierungsgrundlage — *Basis for Proportioning* Münsterkirche, Freiburg, DEU
Freiburg Minster, Freiburg, DEU

Jahr — *Year* 2003
Maße — *Measurements* 24 x 18 x 13 cm
Material — *Material* Eisen, Acryllack
Iron, acrylic lacquer

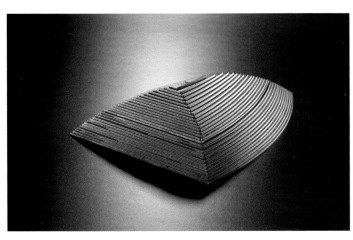

Proportionierungsgrundlage — Basis for Proportioning Westminster Abbey, London, GBR

Jahr — Year 2003
Maße — Measurements 32 x 23 x 7 cm
Material — Material Beton, Holz, Pappe
Concrete, wood, cardboard

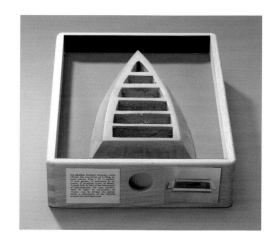

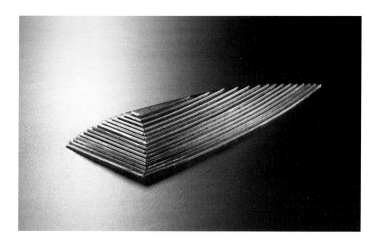

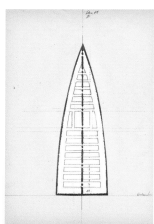

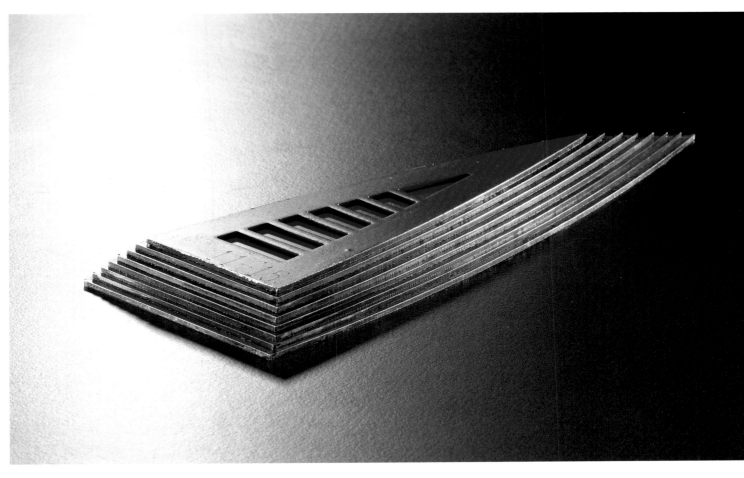

Proportionierungsgrundlage — *Basis for Proportioning* Westminster Abbey, London, GBR

Jahr — *Year* 2003
Maße — *Measurements* 18 x 11 x 7 cm
Material — *Material* Eisen, Acryllack
Iron, acrylic lacquer

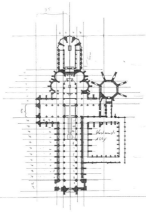

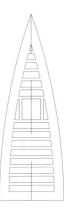

Proportionierungsgrundlage — *Basis for Proportioning* Basilica San Francesco, Assisi, ITA

Jahr — *Year* 2003
Maße — *Measurements* 32 x 23 x 7 cm
Material — *Material* Beton, Holz, Pappe
Concrete, wood, cardboard

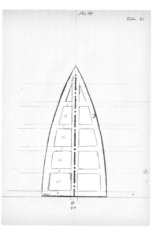

Proportionierungsgrundlage — *Basis for Proportioning* Basilica San Francesco, Assisi, ITA

Jahr — *Year* 2003
Maße — *Measurements* 19 x 11 x 9 cm
Material — *Material* Eisen, Acryllack
Iron, acrylic lacquer

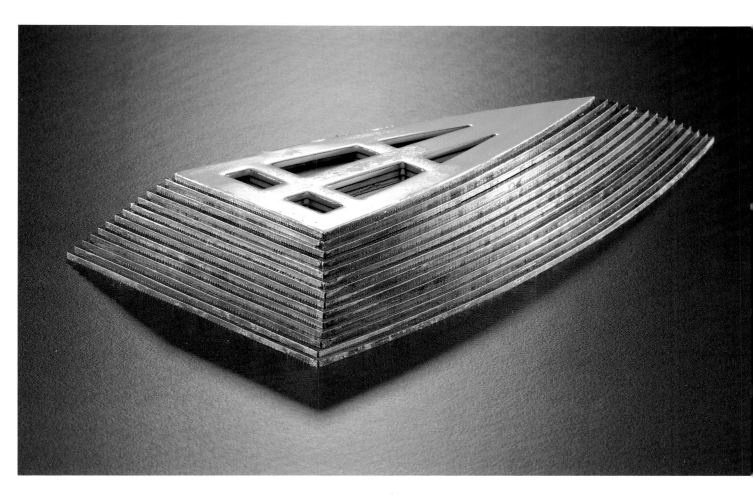

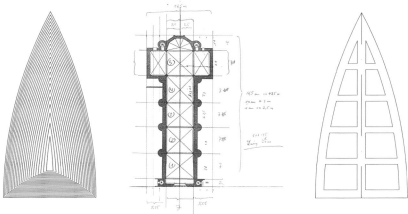

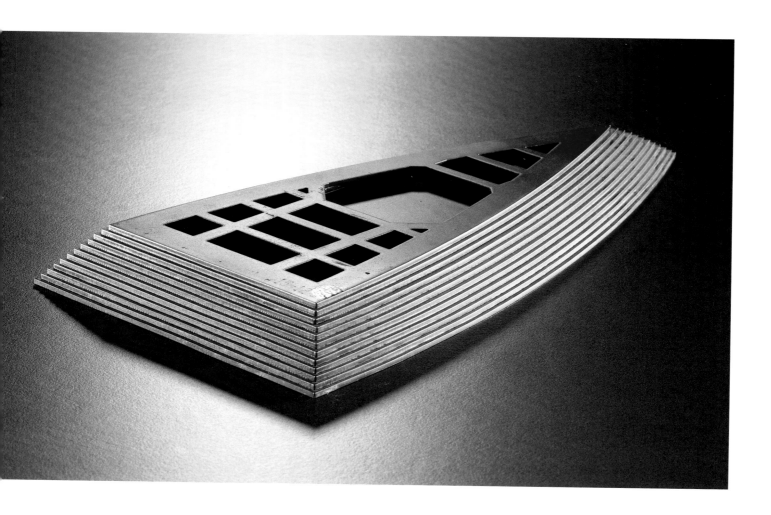

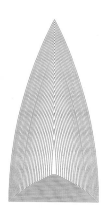

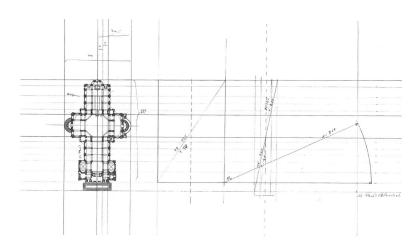

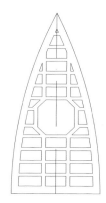

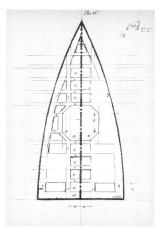

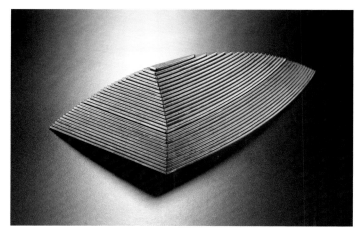

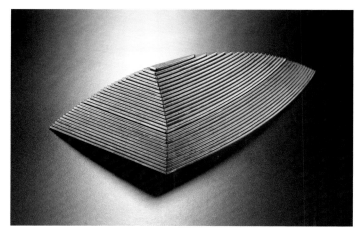

Proportionierungsgrundlage — Basis for Proportioning	St. Paul's Cathedral, London, GBR
Jahr — Year	2003
Maße — Measurements	24 x 13 x 11 cm
Material — Material	Eisen, Acryllack
	Iron, acrylic lacquer

Kathedralen für den Müll
Cathedrals for Garbage

Müllarchitektur
Waste Architecture

Urban Mining Mülldeponien
Urban Mining Waste Dumps

Megadeponien
Mega-Dumbs

Runddeponien
Hazardous Waste Dumbs

Detroit is Everywhere
Detroit is Everywhere

Nuklear-Katastrophen
Nuclear Disasters

2.4

MEGADEPONIEN
MEGA-DUMPS

Deponieanlagen für megaurbane Räume

Dumping facilities for mega-urban areas

KHU-2
13.000.000 t
Radioaktive Abfälle
Radioactive waste

SEK-1
75.000.000 t
Gefährlicher Sondermüll
Hazardous waste

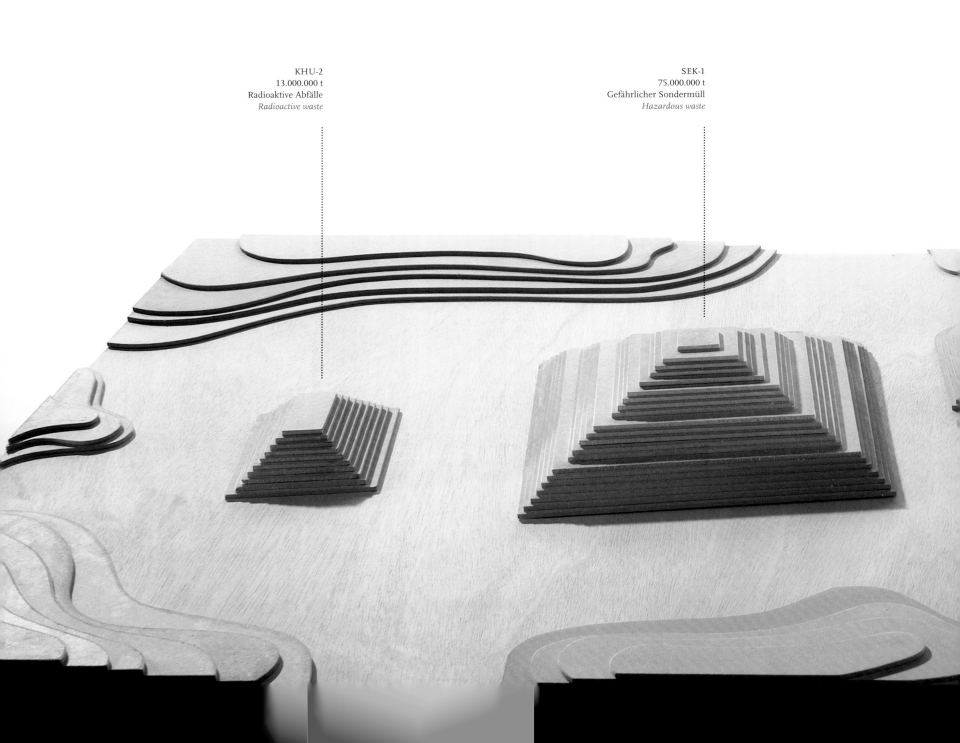

Einwohnerzahl — Population	19.000.000
Kapazität — Capacity	165.000.000 t
Grundfläche — Base area	64 ha
Jahr — Year	2007
Maße — Measurements	227 x 122 x 47 cm
Material — Material	Holz stabverleimt, MDF
	Wood, MDF panels

SEK-2
60.000.000 t
Haushaltsabfall
Domestic refuse

KHU-2
17.000.000 t
Haushaltsabfall
Domestic refuse

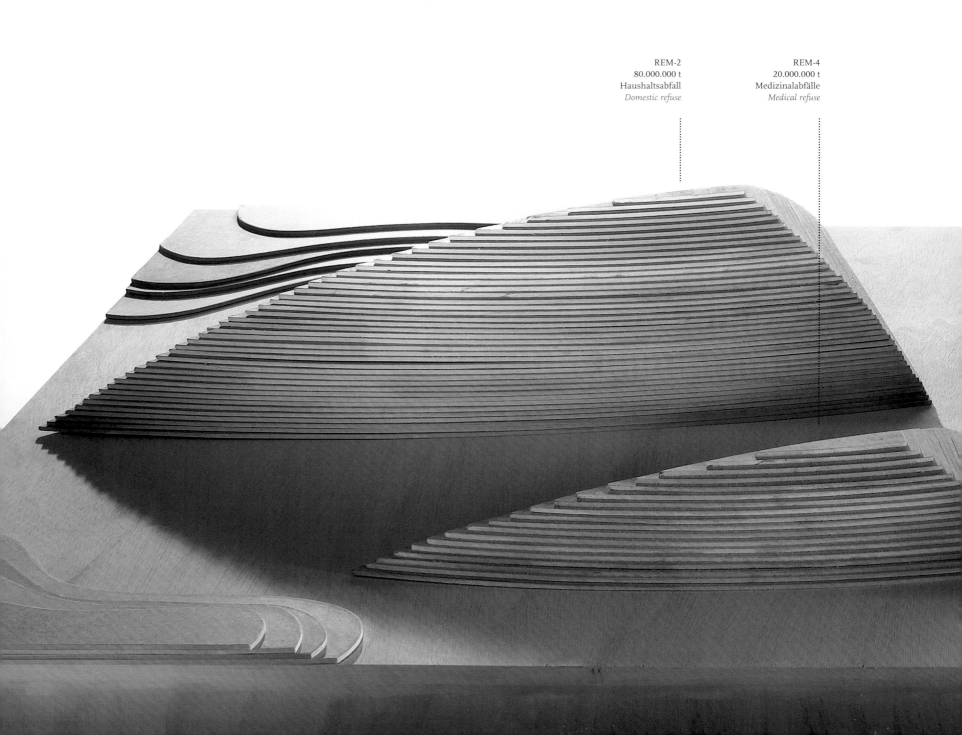

REM-2
80.000.000 t
Haushaltsabfall
Domestic refuse

REM-4
20.000.000 t
Medizinalabfälle
Medical refuse

Proportionierungsgrundlage — Basis for Proportioning Tempelanlage, Borobudur, IDN
 Temple Complex, Borobudur, IDN

Einwohnerzahl — Population 21.000.000
Kapazität — Capacity 205.000.000 t
Grundfläche — Base area 78 ha
Jahr — Year 2007
Maße — Measurements 227 x 122 x 52 cm
Material — Material Holz stabverleimt, MDF
 Wood, MDF panels

REM-4 REM-2
20.000.000 t 85.000.000 t
Toxische Abfälle Haushaltsabfall
Toxic waste *Domestic refuse*

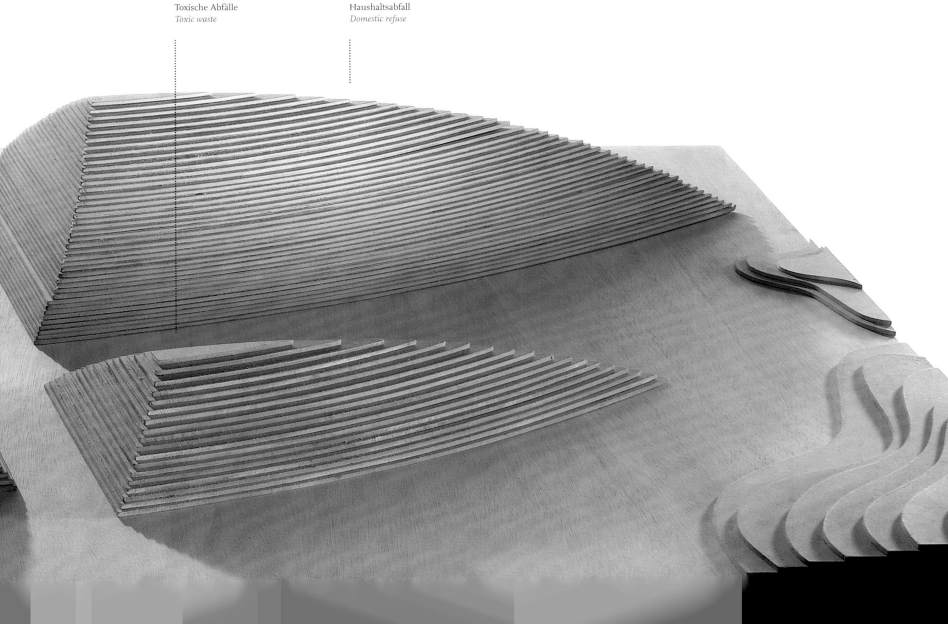

KHU-4
15.000.000 t
Medizinalabfälle
Medical refuse

SEK-4
8.000.000 t
Radioaktive Abfälle
Radioactive waste

RHA-2
75.000.000 t
Haushaltsabfall
Domestic refuse

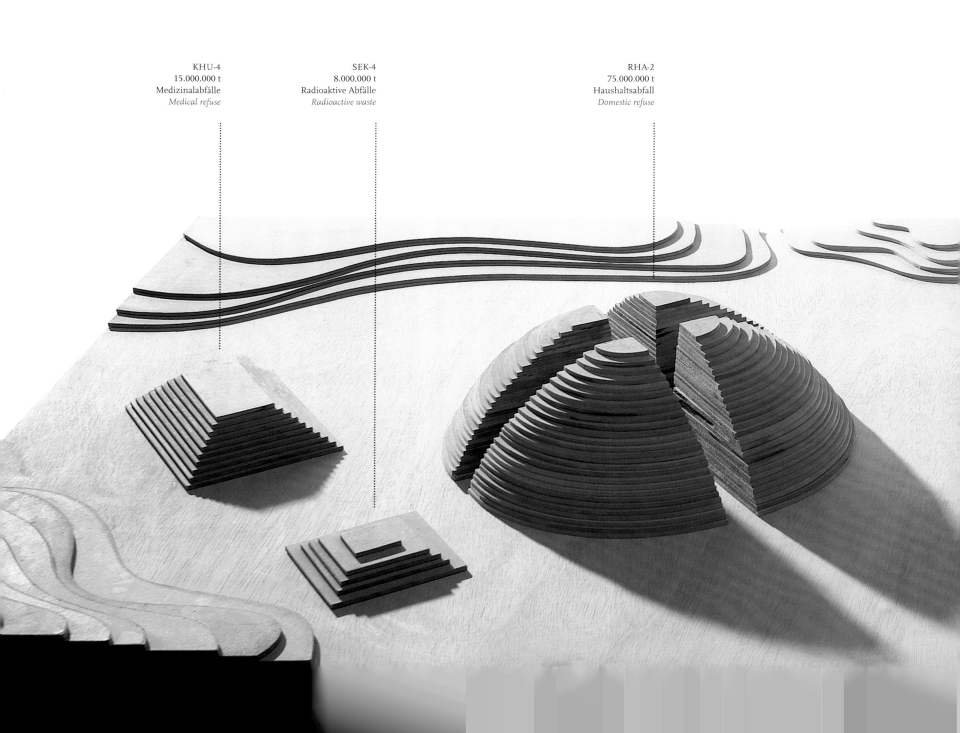

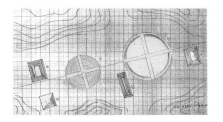

Proportionierungsgrundlage — Basis for Proportioning Dhakeshwari Tempel, Dhaka, BGD
Dhakeshwari Temple, Dhaka, BGD

Einwohnerzahl — Population 17.000.000
Kapazität — Capacity 210.000.000 t
Grundfläche — Base area 64 ha
Jahr — Year 2007
Maße — Measurements 227 x 122 x 44 cm
Material — Material Holz stabverleimt, MDF
Wood, MDF panels

KHU-2
9.000.000 t
Sondermüll
Special refuse

RAH-4
95.000.000 t
Industrieabfälle
Industrial waste

KHU-3
8.000.000 t
Toxische Abfälle
Toxic waste

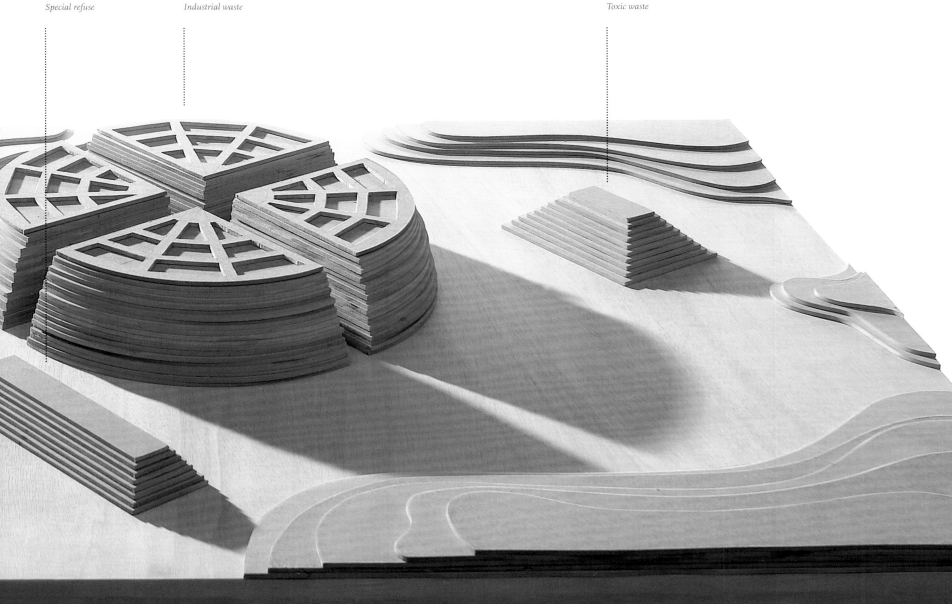

REM-2
50.000.000 t
Sondermüll
Special refuse

REM-4
60.000.000 t
Haushaltsabfall
Domestic refuse

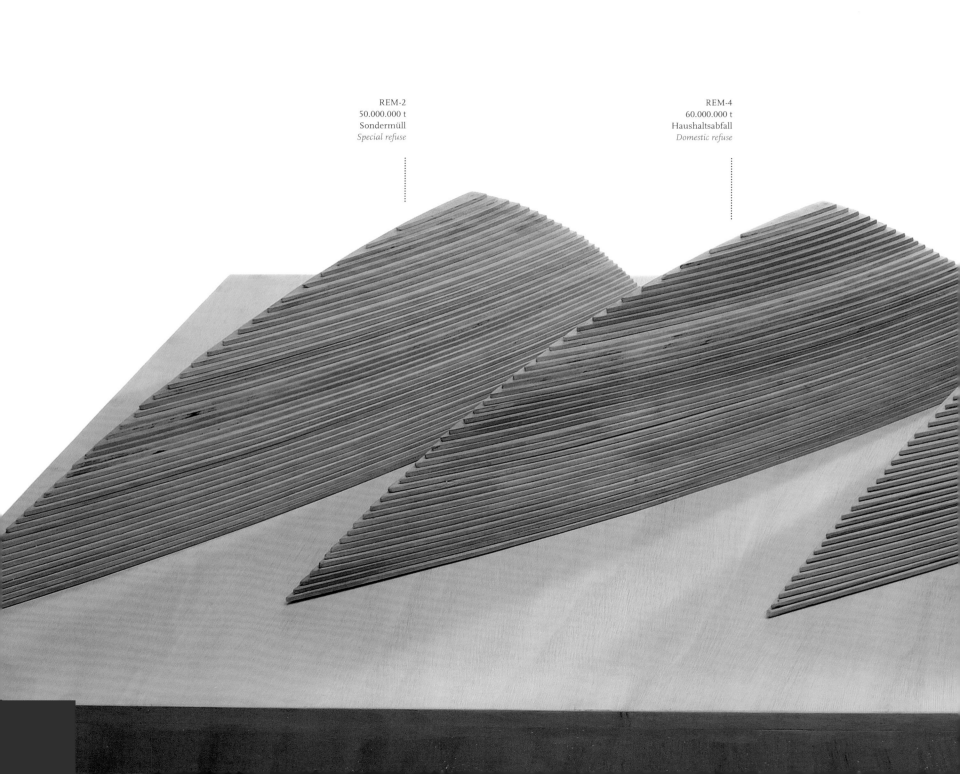

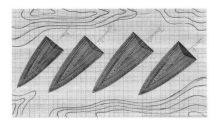

Proportionierungsgrundlage — Basis for Proportioning St. Paul's Cathedral, London, GBR

Einwohnerzahl — Population	16.000.000
Kapazität — Capacity	225.000.000 t
Grundfläche — Base area	70 ha
Jahr — Year	2007
Maße — Measurements	227 x 122 x 47 cm
Material — Material	Holz stabverleimt, MDF
	Wood, MDF panels

REM-2
55.000.000 t
Elektroschrott
Elctronic scrap

REM-2
60.000.000 t
Elektroschrott
Elctronic scrap

REM-2
45.000.000 t
Haushaltsabfall
Domestic refuse

REM-4
120.000.000 t
Industrieabfälle
Industrial waste

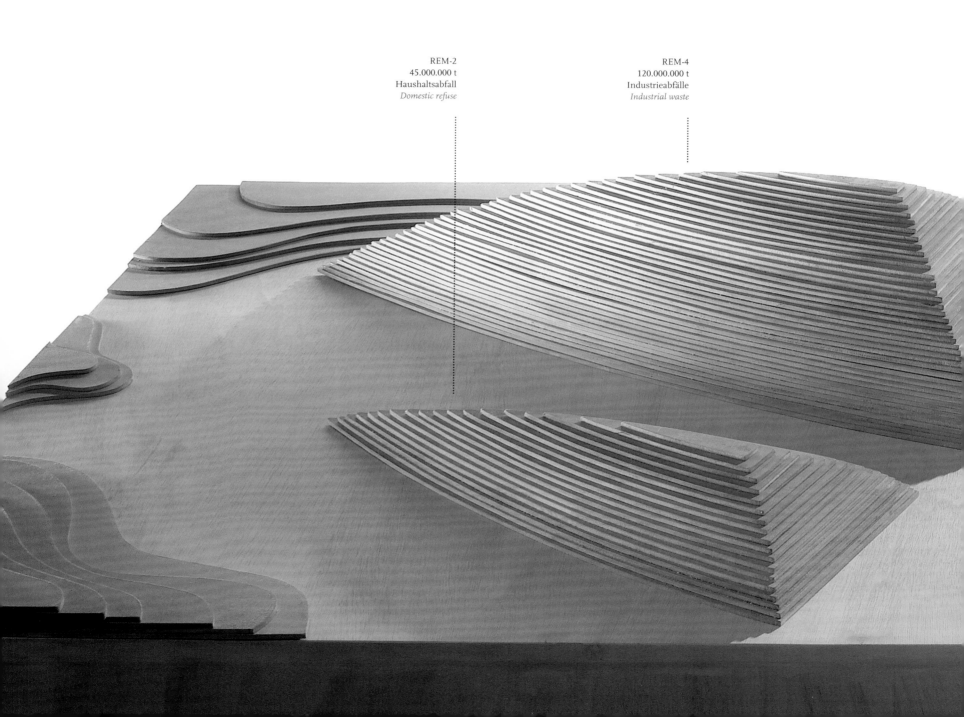

Proportionierungsgrundlage — Basis for Proportioning Tempelanlage, Teotihuacan, MEX
Temple Complex, Teotihuacan, MEX

Einwohnerzahl — Population 25.000.000
Kapazität — Capacity 240.000.000 t
Grundfläche — Base area 120 ha
Jahr — Year 2007
Maße — Measurements 227 x 122 x 53 cm
Material — Material Holz stabverleimt, MDF
Wood, MDF panels

SEK-1
60.000.000 t
Radioaktive Abfälle
Radioactive waste

KHU-4
15.000.000 t
Toxische Abfälle
Toxic waste

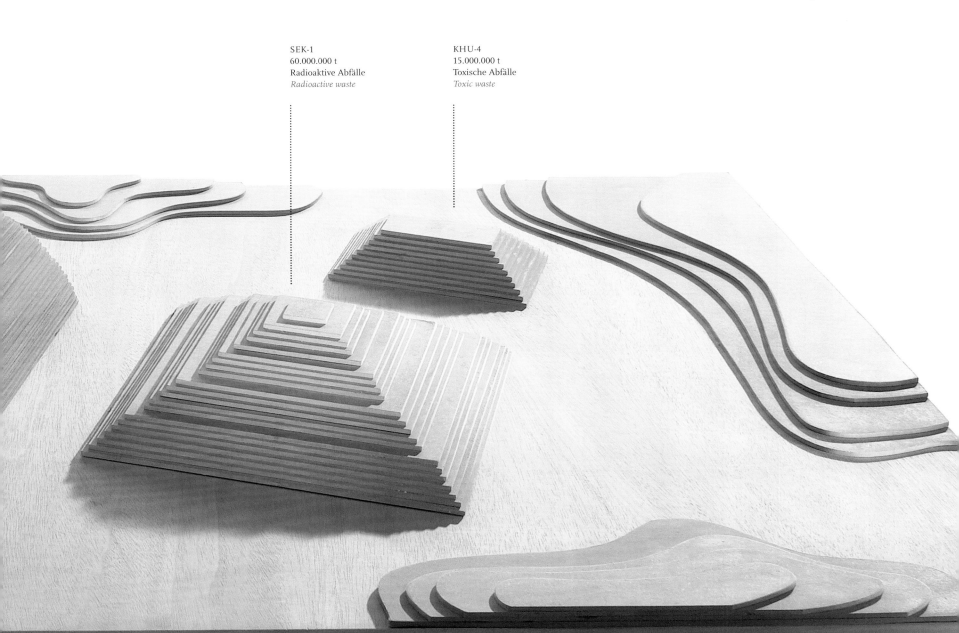

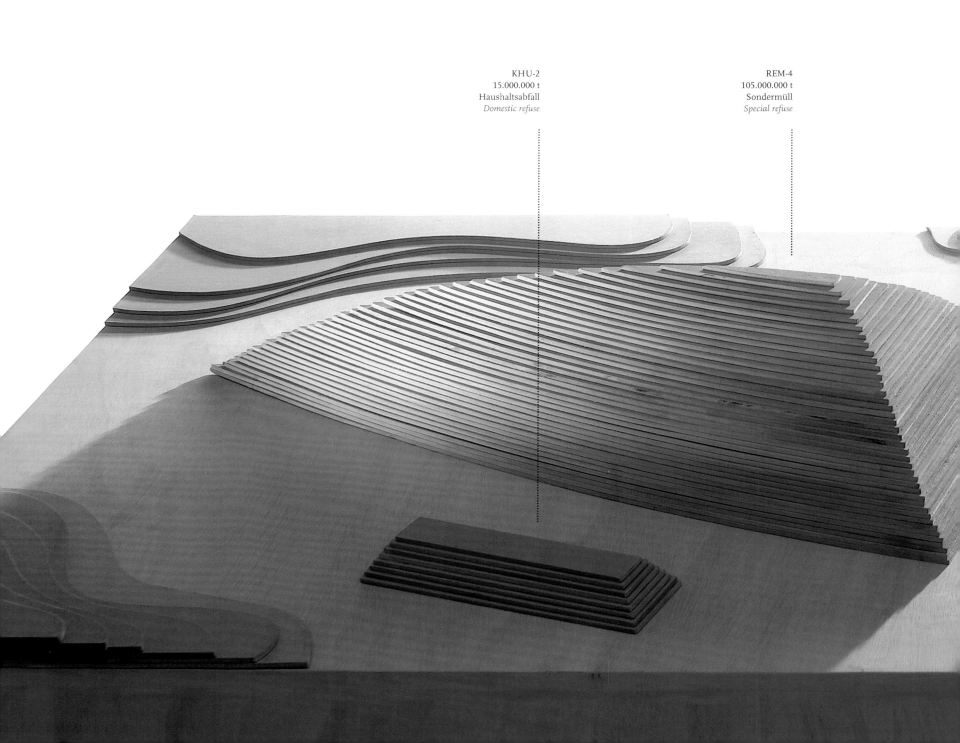

KHU-2
15.000.000 t
Haushaltsabfall
Domestic refuse

REM-4
105.000.000 t
Sondermüll
Special refuse

Proportionierungsgrundlage — *Basis for Proportioning* Hanuman Tempel, Mumbai, IND
Hanuman Temple, Mumbai, IND

Einwohnerzahl — *Population*	24.000.000
Kapazität — *Capacity*	185.000.000 t
Grundfläche — *Base area*	130 ha
Jahr — *Year*	2007
Maße — *Measurements*	227 x 122 x 44 cm
Material — *Material*	Holz stabverleimt, MDF
	Wood, MDF panels

RHA-2
95.000.000 t
Sondermüll
Special refuse

KHU-4
25.000.000 t
Medizinalabfälle
Medical refuse

SEK-4
10.000.000 t
Radioaktive Abfälle
Radioactive waste

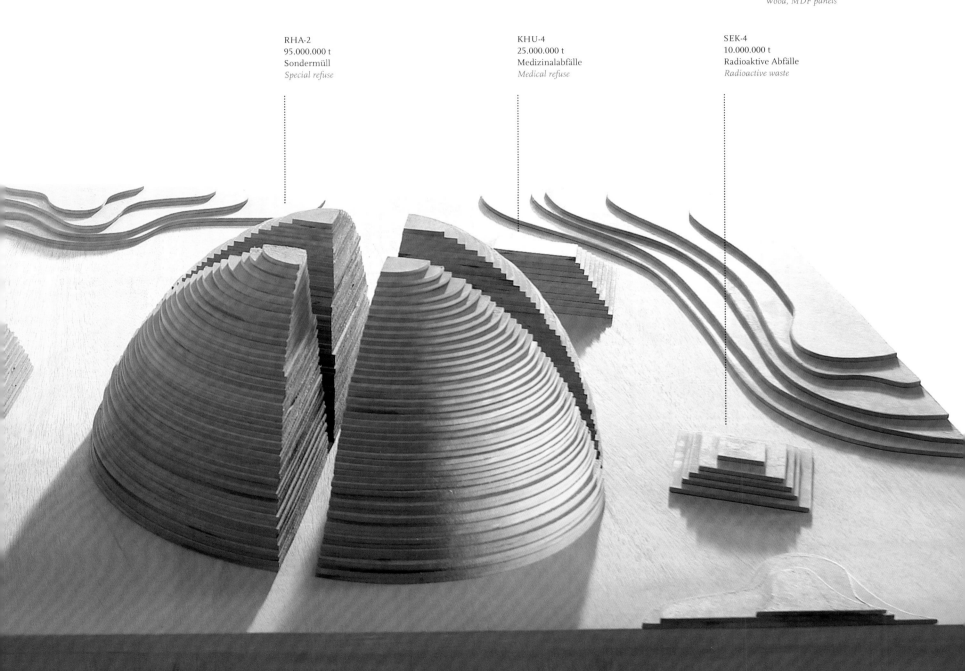

SKA-2
65.000.000 t
Elektroschrott
Electronic scrap

KHU-1
20.000.000 t
Elektroschrott
Electronic scrap

SKA-2
90.000.000 t
Industrieabfälle
Industrial waste

KHU-2
15.000.000 t
Medizinalabfälle
Medical refuse

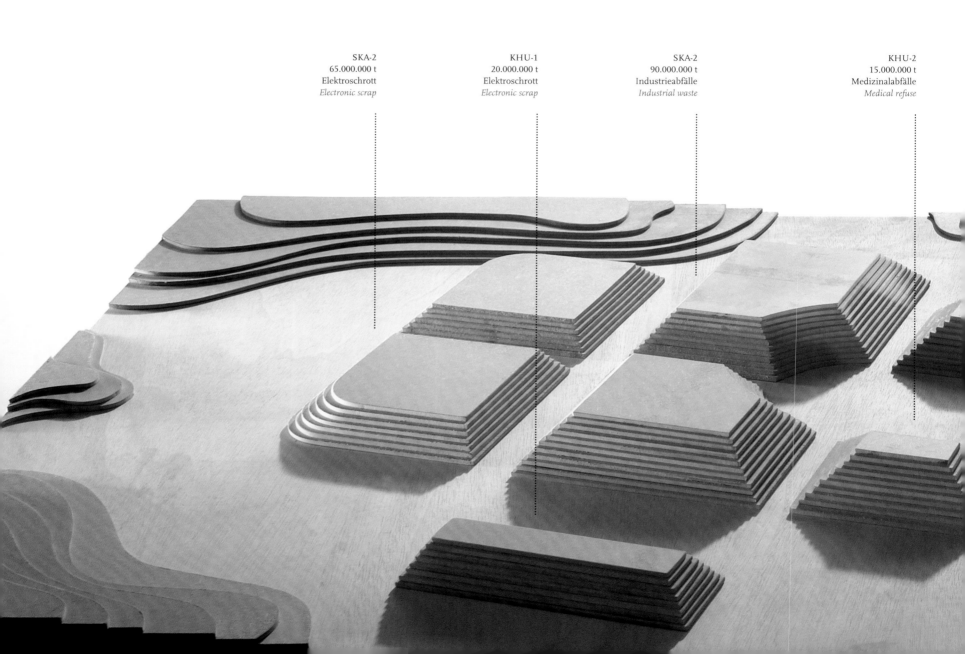

Proportionierungsgrundlage — *Basis for Proportioning* Tempel des Himmels, Beijing, CHN
Temple of Heaven, Beijing, CHN

Einwohnerzahl — *Population* 19.000.000
Kapazität — *Capacity* 285.000.000 t
Grundfläche — *Base area* 120 ha
Jahr — *Year* 2007
Maße — *Measurements* 227 x 122 x 39 cm
Material — *Material* Holz stabverleimt, MDF
Wood, MDF panels

KHU-2
15.000.000 t
Radioaktive Abfälle
Radioactive waste

SEK-1
35.000.000 t
Sondermüll
Special refuse

REM-2
35.000.000 t
Haushaltsabfall
Domestic refuse

SEK-4
10.000.000 t
Haushaltsabfall
Domestic refuse

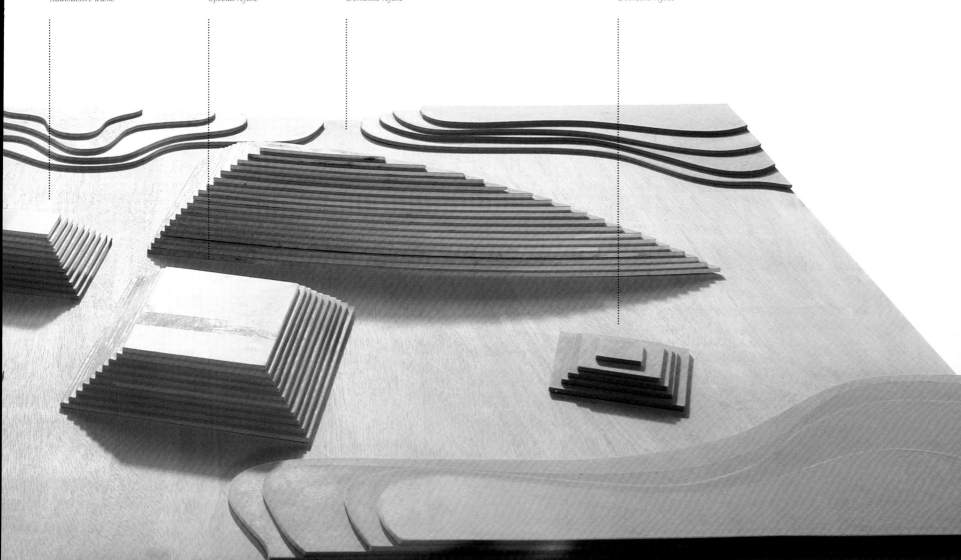

REM-2
50.000.000 t
Industrieabfälle
Industrial waste

REM-1
50.000.000 t
Industrieabfälle
Industrial waste

KHU-2
25.000.000 t
Toxische Abfälle
Toxic waste

SEK-2
35.000.000 t
Radioaktive Abfälle
Radioactive waste

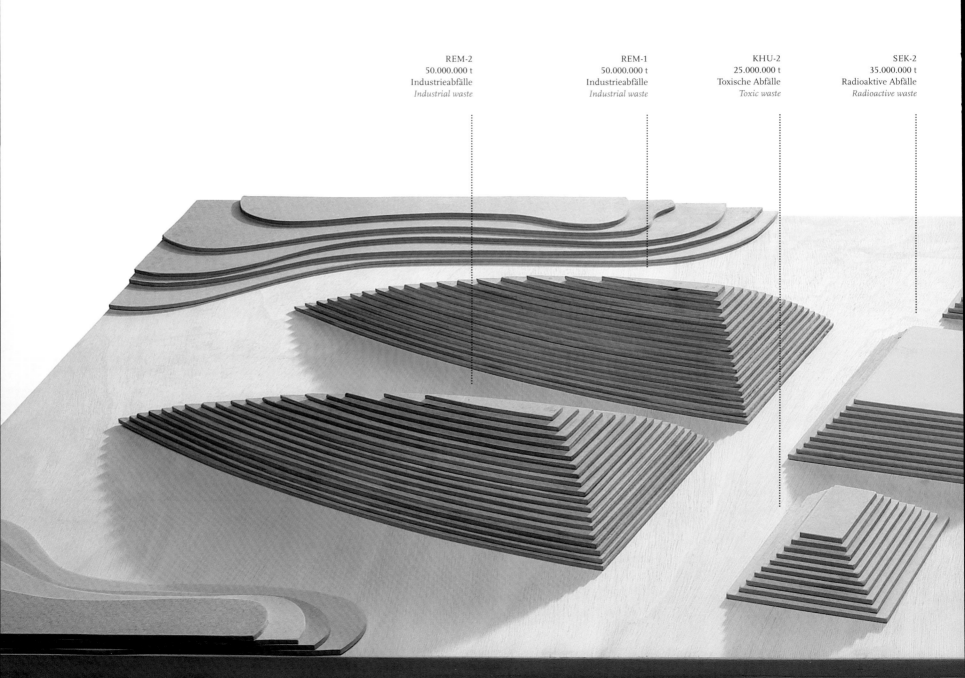

Proportionierungsgrundlage — *Basis for Proportioning* Bulgugsa Tempel, Seoul, KOR
Bulgugsa Temple, Seoul, KOR

Einwohnerzahl — *Population* 23.000.000
Kapazität — *Capacity* 285.000.000 t
Grundfläche — *Base area* 64 ha
Jahr — *Year* 2007
Maße — *Measurements* 227 x 122 x 47 cm
Material — *Material* Holz stabverleimt, MDF
Wood, MDF panels

KHU-2
25.000.000 t
Medizinalabfälle
Medical refuse

REM-4
50.000.000 t
Elektroschrott
Electronic scrap

REM-2
50.000.000 t
Haushaltsabfall
Domestic refuse

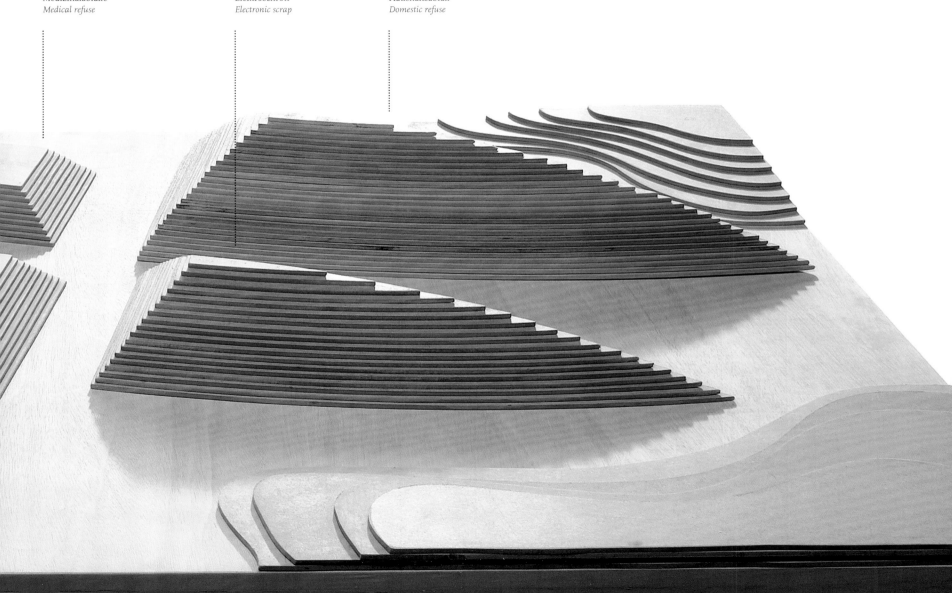

REM-2
65.000.000 t
Elektroschrott
Electronic scrap

REM-1
65.000.000 t
Industrieabfälle
Industrial waste

REM-2
85.000.000 t
Haushaltsabfall
Domestic refuse

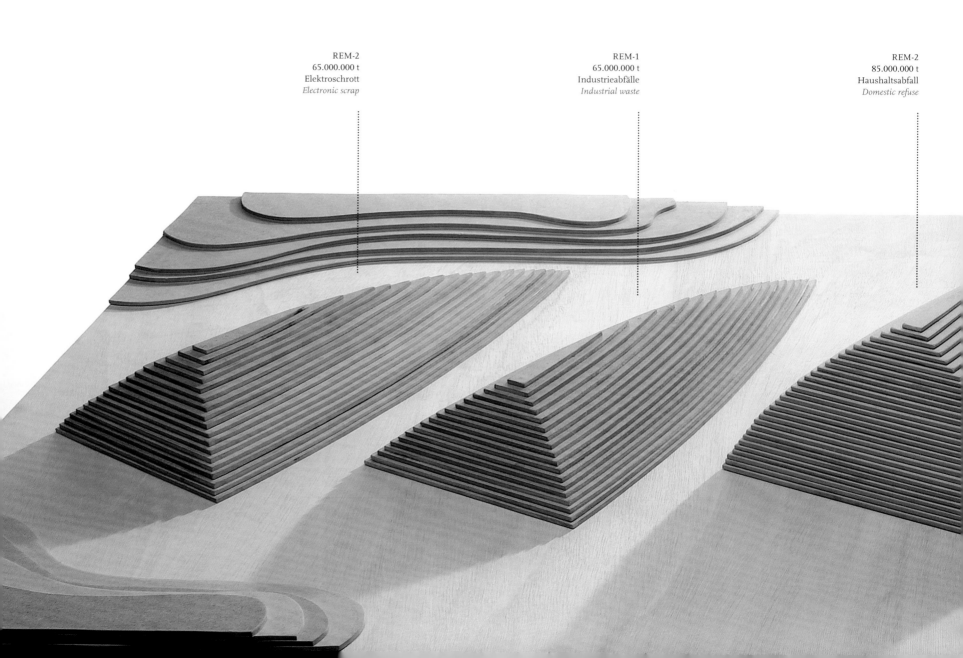

Proportionierungsgrundlage — Basis for Proportioning Catedral da Sé, BRA

Einwohnerzahl — Population	21.000.000
Kapazität — Capacity	290.000.000 t
Grundfläche — Base area	120 ha
Jahr — Year	2007
Maße — Measurements	227 x 122 x 57 cm
Material — Material	Holz stabverleimt, MDF
	Wood, MDF panels

REM-2
45.000.000 t
Industrieabfälle
Industrial waste

REM-4
30.000.000 t
Toxische Abfälle
Toxic waste

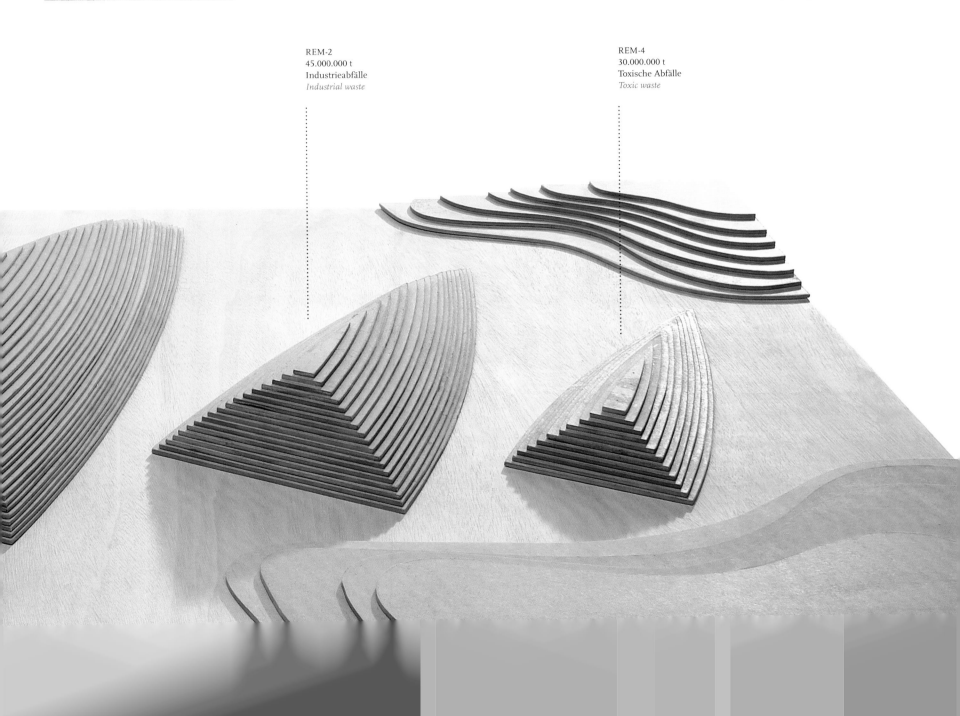

Kathedralen für den Müll
Cathedrals for Garbage

Müllarchitektur
Waste Architecture

Urban Mining Mülldeponien
Urban Mining Waste Dumps

Megadeponien
Mega-Dumbs

Runddeponien
Hazardous Waste Dumbs

Detroit is Everywhere
Detroit is Everywhere

Nuklear-Katastrophen
Nuclear Disasters

2.5

RUNDDEPONIEN
HAZARDOUS WASTE DUMPS

Hochsicherheitsdeponien für radioaktive Abfälle

High-security dumps for radioactive waste

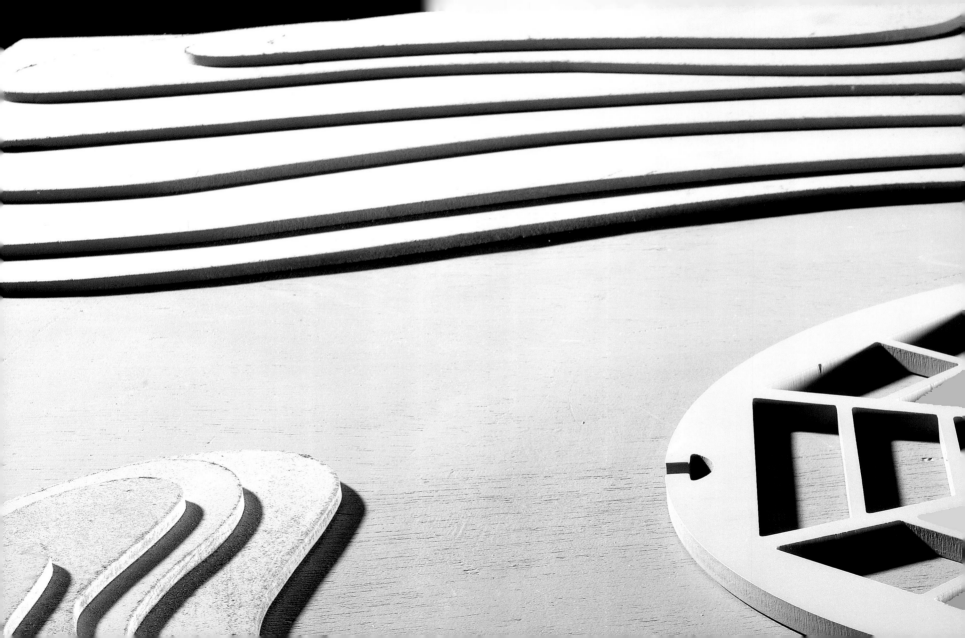

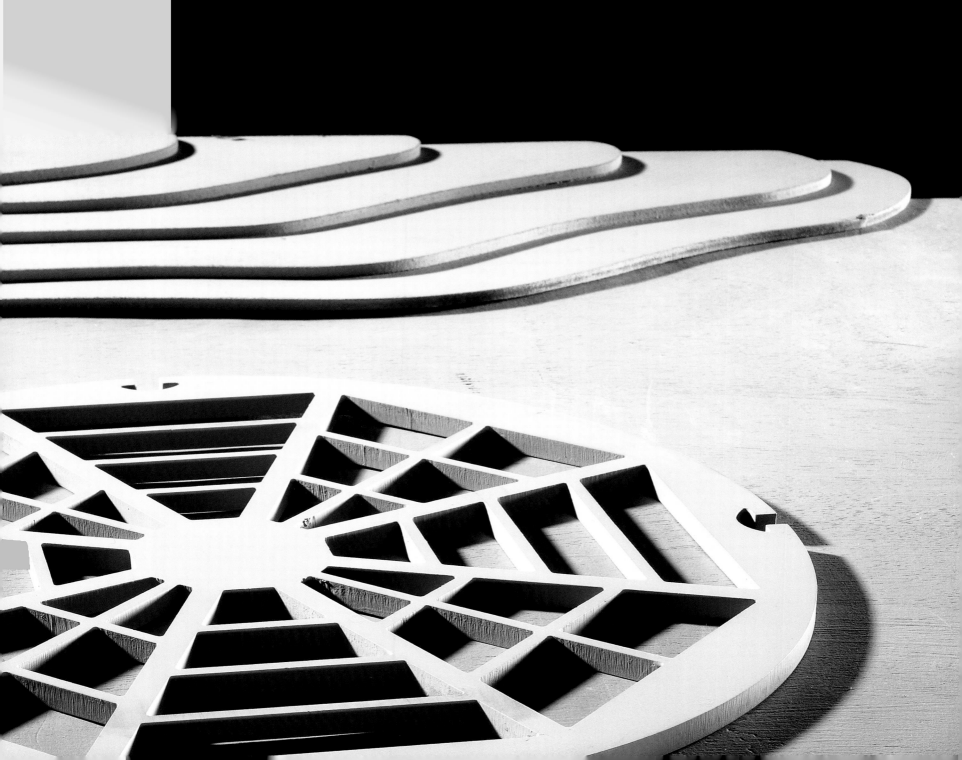

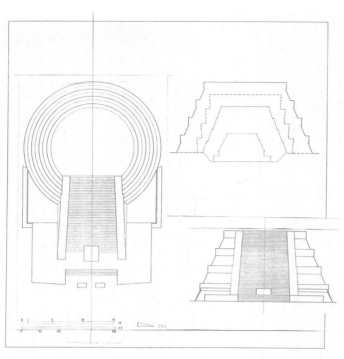

Pyramide circulaire de Calixtlahuaca, datant de l'époque aztèque (XIVᵉ et XVᵉ s.). Plan du dernier état, coupe montrant les superpositions successives et élévation du dernier état 1:300. A la fin du monde précolombien, on retrouve la forme circulaire qui existait à l'aube de la civilisation, à Cuicuilco, deux millénaires plus tôt. Cette pyramide est dédiée au dieu du Vent.

Calixtlahuaca, Rundpyramide, aztekische Zeit (14. u. 15. Jh.). Am Ende der präkolumbianischen Epoche taucht die Rundpyramide wieder auf, die es bereits 2000 Jahre früher in Cuicuilco gegeben hatte. Die Pyramide ist dem Windgott geweiht. Grundriß (letzter Zustand), Schnitt mit den verschiedenen Bauschichten, Aufriß (letzter Zustand) 1:300.

Circular pyramid, Calixtlahuaca, Aztec period (fourteenth and fifteenth centuries). Plan of the final state, section showing the successive superpositions, and elevation of the final state 1:300. At the end of the pre-Columbian period men rediscovered the circular form that had been used at Cuicuilco two millennia before. This pyramid is dedicated to the wind god.

419

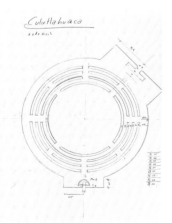

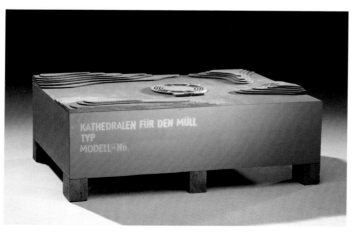

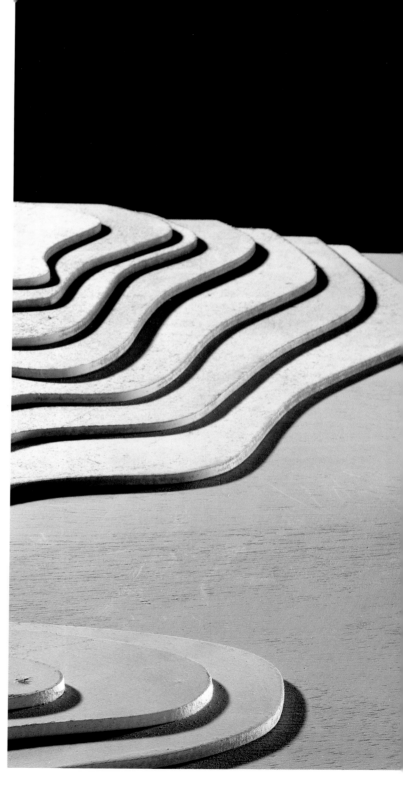

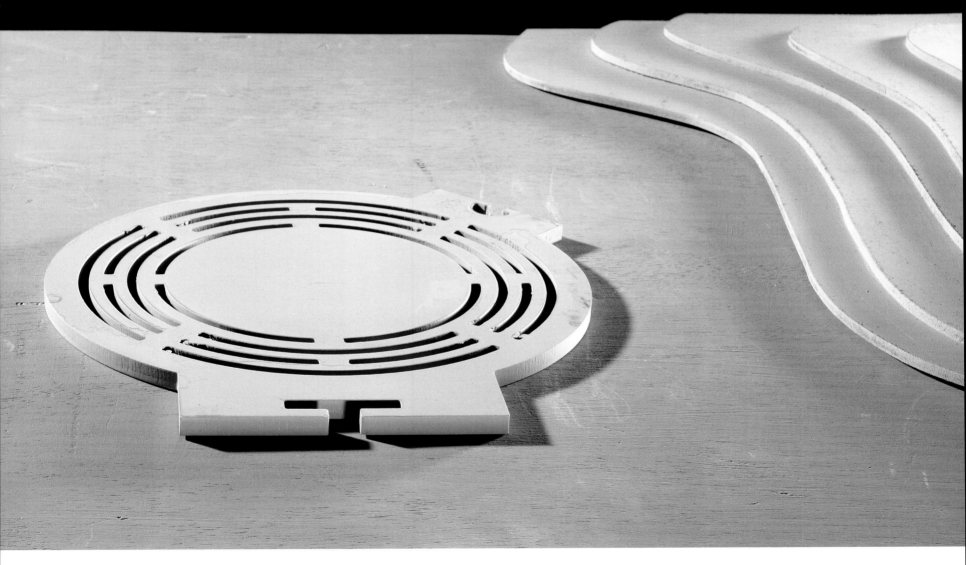

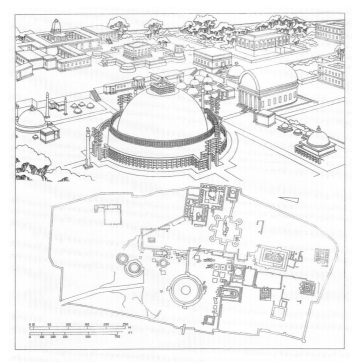

Monastère de Sanchi (Inde centrale), sanctuaire bouddhique fondé par le roi Ashoka (273–232 av.J.-C.) et construit entre le III^e siècle avant notre ère et le II^e s. de notre ère. Vue reconstituée et plan d'ensemble 1:5000. Au premier plan de la vue, le grand stupa, agrandi en 150 av.J.-C. et dont les torana furent édifiés en 25 av.J.-C.

Kloster Sanci (Zentralindien), zwischen dem 3.Jh. v.Chr. und dem 2.Jh. n.Chr. erbaut. Das buddhistische Heiligtum wurde von König Ashoka (273–232 v. Chr.) gestiftet. Im Vordergrund der große, 150 v.Chr. erweiterte Stupa mit den 25 v.Chr. erbauten Torana (Steintoren). Rekonstruktion der Anlage; Lageplan 1:5000.

Sanchi monastery (central India), a Buddhist shrine founded by King Ashoka (273–232 B.C.) and built between the third century B.C. and the second century A.D. Reconstructed view and overall plan 1:5000. In the foreground of the view is the Great Stupa, enlarged in 150 B.C. and with *toranas* (carved gateways) erected in 25 B.C.

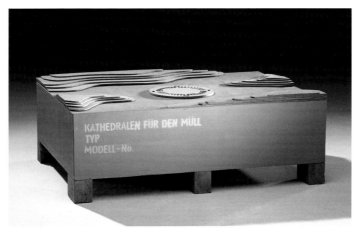

Proportionierungsgrundlage — Basis for Proportioning Großer Stupa, Sanchi, IND
Great Stupa, Sanchi, IND

Jahr — Year 2013
Maße — Measurements 120 x 85 x 52 cm
Material — Material Eisen, Holz
Iron, wood

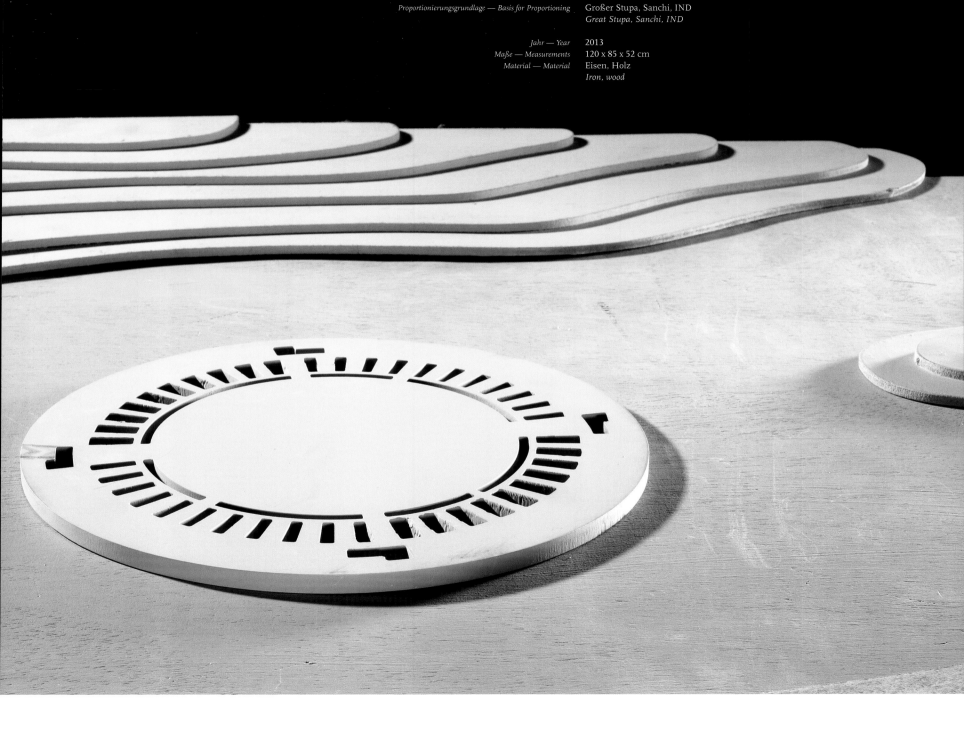

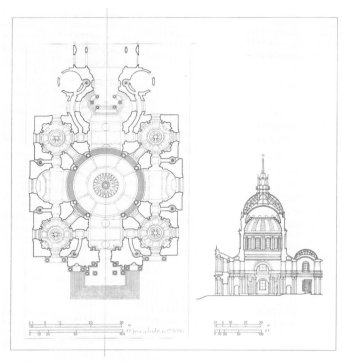

Eglise Saint-Louis-des-Invalides, Paris, édifiée par Jules Hardouin-Mansart, dont les premiers projets datent de 1676. Plan 1:600 et coupe longitudinale 1:1200. Disposition en croix grecque inscrite, avec coupole centrale dont le dôme interne culmine à 60 m. L'un des chefs-d'œuvre de l'architecture classique française.

Paris, Saint-Louis-des-Invalides (Invalidendom), erste Entwürfe 1676 von Jules Hardouin-Mansart. Ein griechisches Kreuz mit zentraler Kuppel bildet den Innenraum. Eines der Meisterwerke der klassischen französischen Architektur. Grundriß 1:600; Längsschnitt 1:1200.

St. Louis des Invalides, Paris, by Jules Hardouin-Mansart; the first plans date from 1676. Plan 1:600; longitudinal section 1:1200. Built on a Greek cross plan with a central dome rising to an interior height of 60 m., this is one of the masterpieces of the classical period of French architecture.

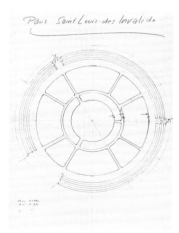

Paris Saint Louis-des Invalides

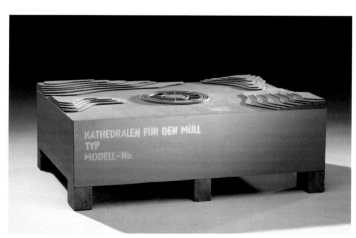

KATHEDRALEN FÜR DEN MÜLL
TYP
MODELL-No.

Proportionierungsgrundlage — Basis for Proportioning Saint-Louis des Invalides, Paris, FRA

Jahr — Year	2013
Maße — Measurements	120 x 85 x 52 cm
Material — Material	Eisen, Holz
	Iron, wood

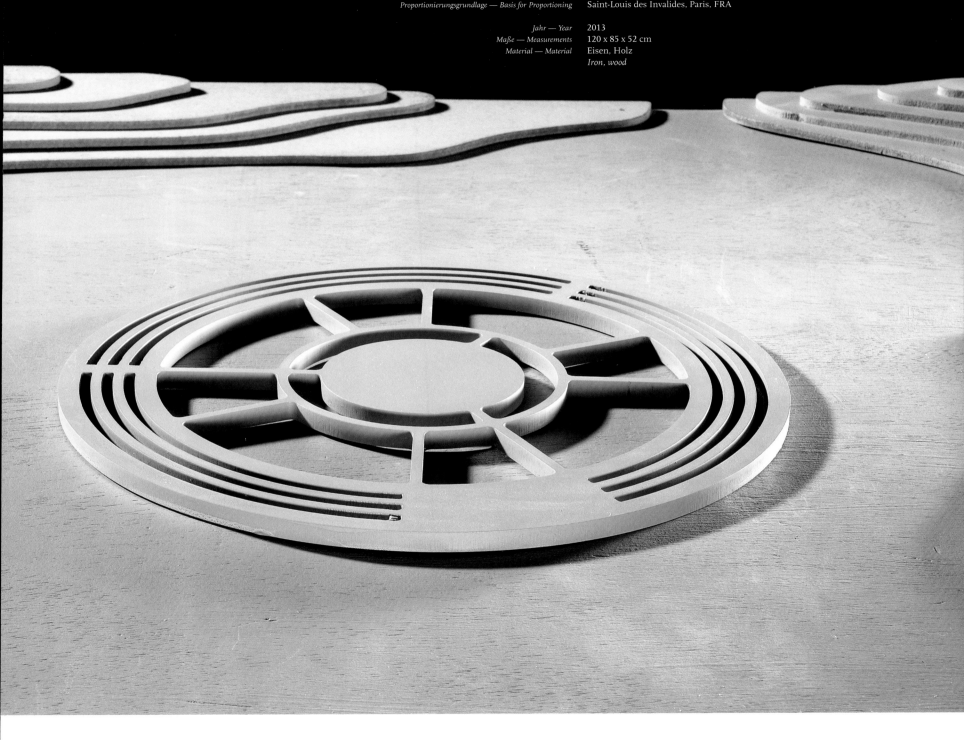

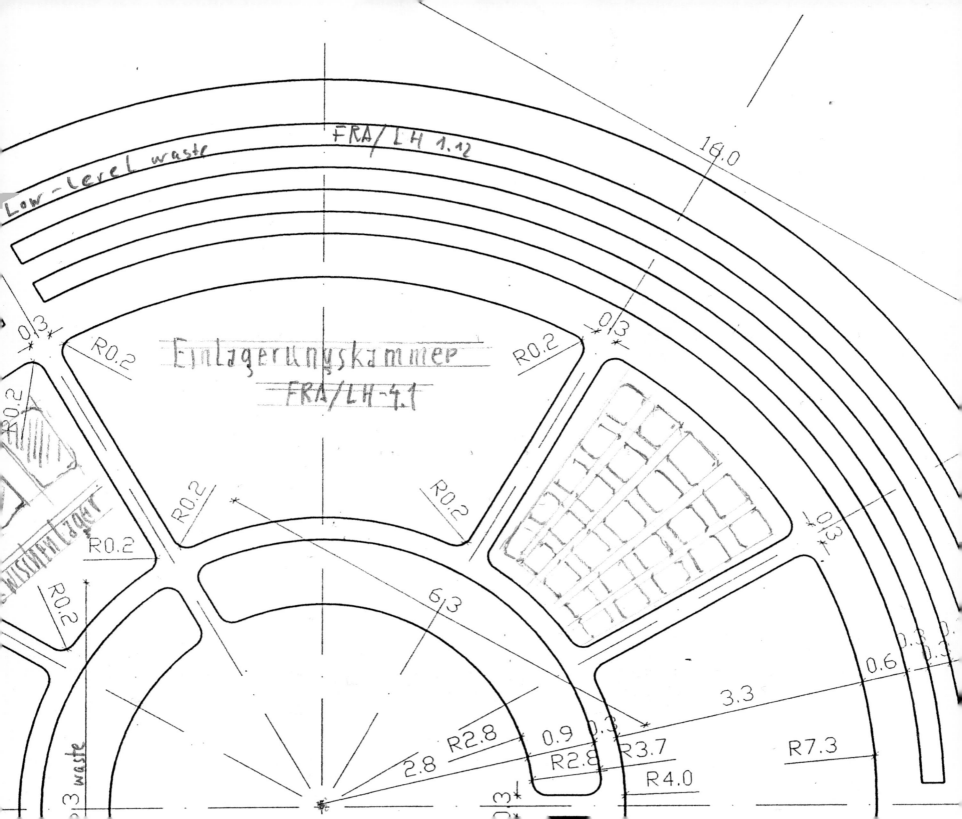

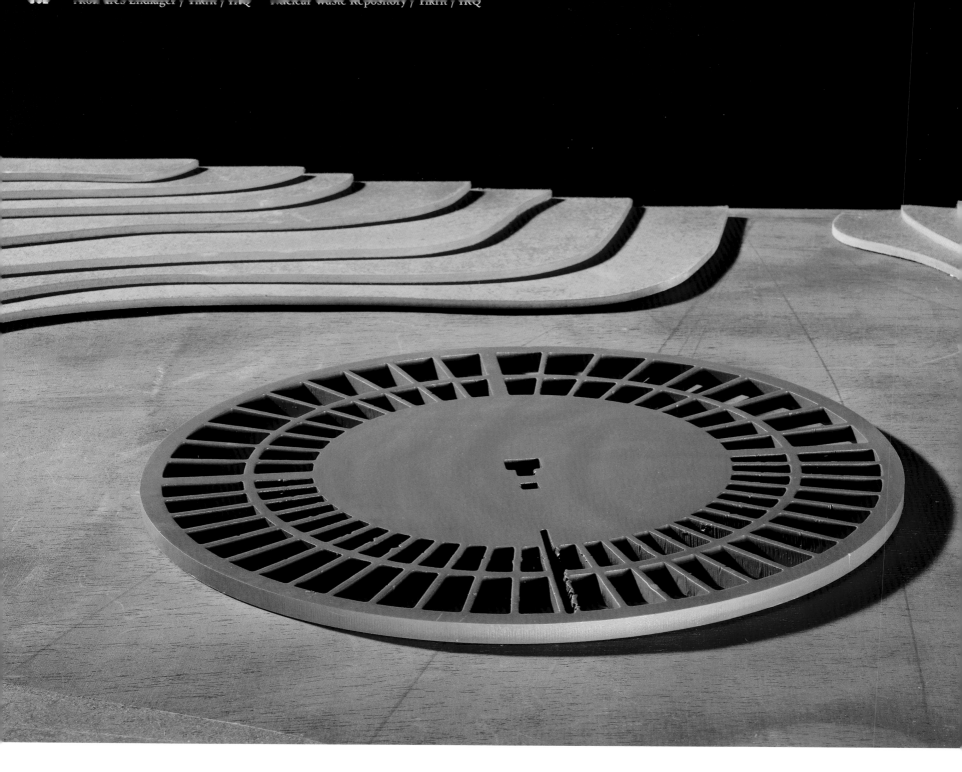

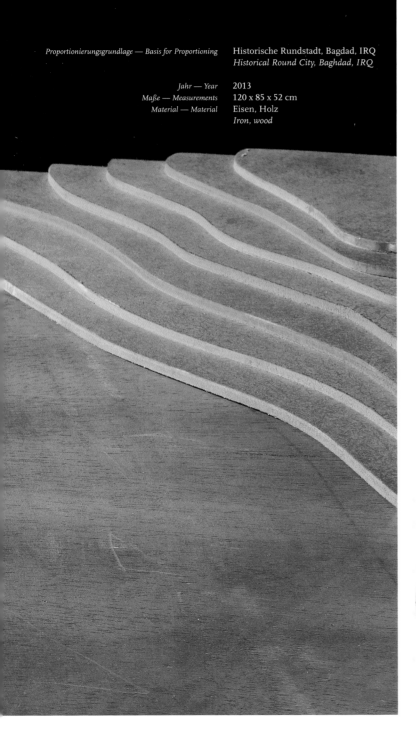

Proportionierungsgrundlage — Basis for Proportioning

Historische Rundstadt, Bagdad, IRQ
Historical Round City, Baghdad, IRQ

Jahr — Year	2013
Maße — Measurements	120 x 85 x 52 cm
Material — Material	Eisen, Holz
	Iron, wood

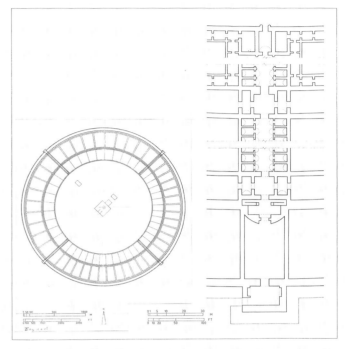

Ville Ronde de Bagdad (Irak), fondée par al-Mansur en 762. Plan 1:30000 et détail des portes et des murailles concentriques 1:1000. De bas en haut: l'une des quatre portes, avec chicane et pont, suivie d'un glacis conduisant à la seconde porte fortifiée; 54 arcades d'une rue marchande axiale, suivie d'une nouvelle porte, puis une trentaine d'arcades jusqu'à la dernière porte. Au centre, la mosquée et le palais.

Bagdad (Irak), die Rundstadt, 762 von el-Mansur gegründet. Im Zentrum Moschee und Palast. Stadtplan 1:30000; rechts: Detail eines der vier Zugänge mit den konzentrischen Stadtmauern 1:1000: von unten nach oben: äußerstes Tor mit Schikane und Brücke, dann Glacis, das zum zweiten befestigten Tor führt; 54 Arkaden einer Verkaufsstraße, drittes Tor, etwa 30 weitere Arkaden, innerstes Tor.

Round city of Baghdad (Iraq), founded by al-Mansur in 762. Plan 1:30,000 and detail of the gates and concentric walls 1:1000. From the bottom: one of the four gates, with zigzag and bridge, followed by a glacis leading up to the second fortified gate; 54 arches of an axial commercial street, followed by a new gate and a further thirty or so arches up to the last gate. Centre, the mosque and palace.

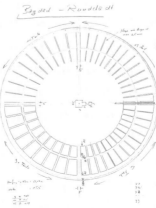

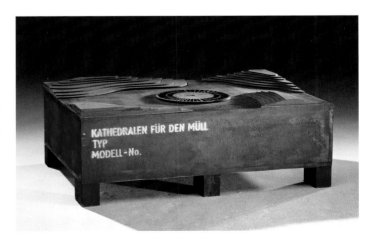

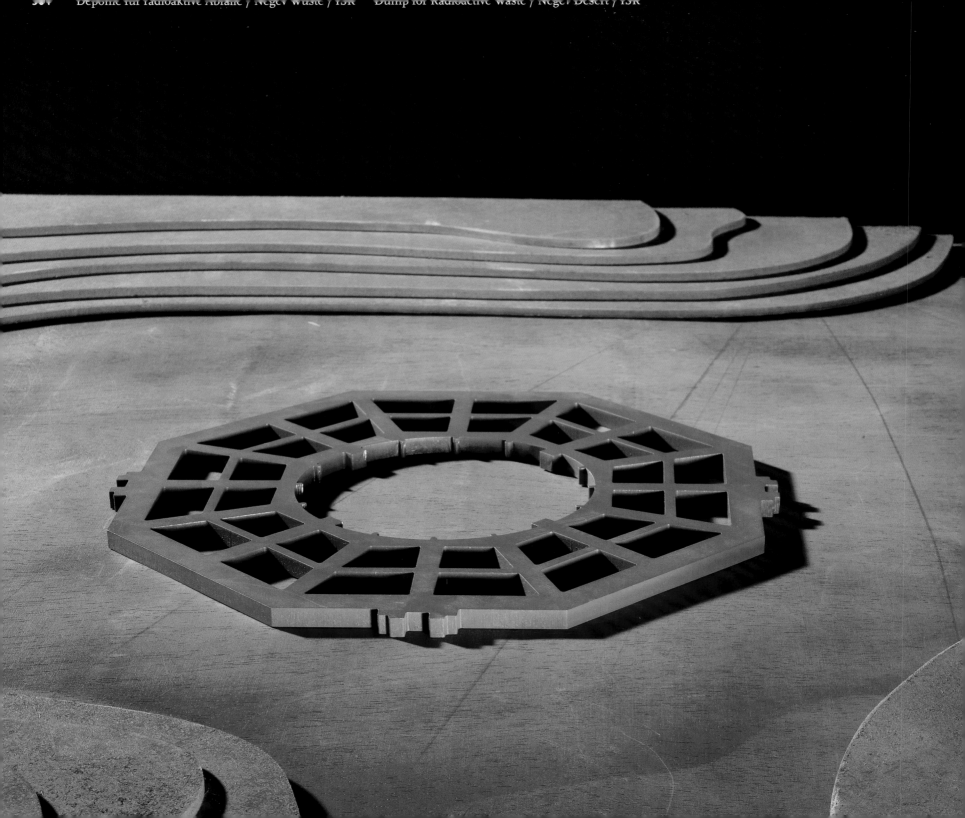

Proportionierungsgrundlage — Basis for Proportioning Felsendom, Jerusalem, ISR
Cathedral of the Rock, Jerusalem, ISR

Jahr — Year	2013
Maße — Measurements	120 x 85 x 52 cm
Material — Material	Eisen, Holz
	Iron, wood

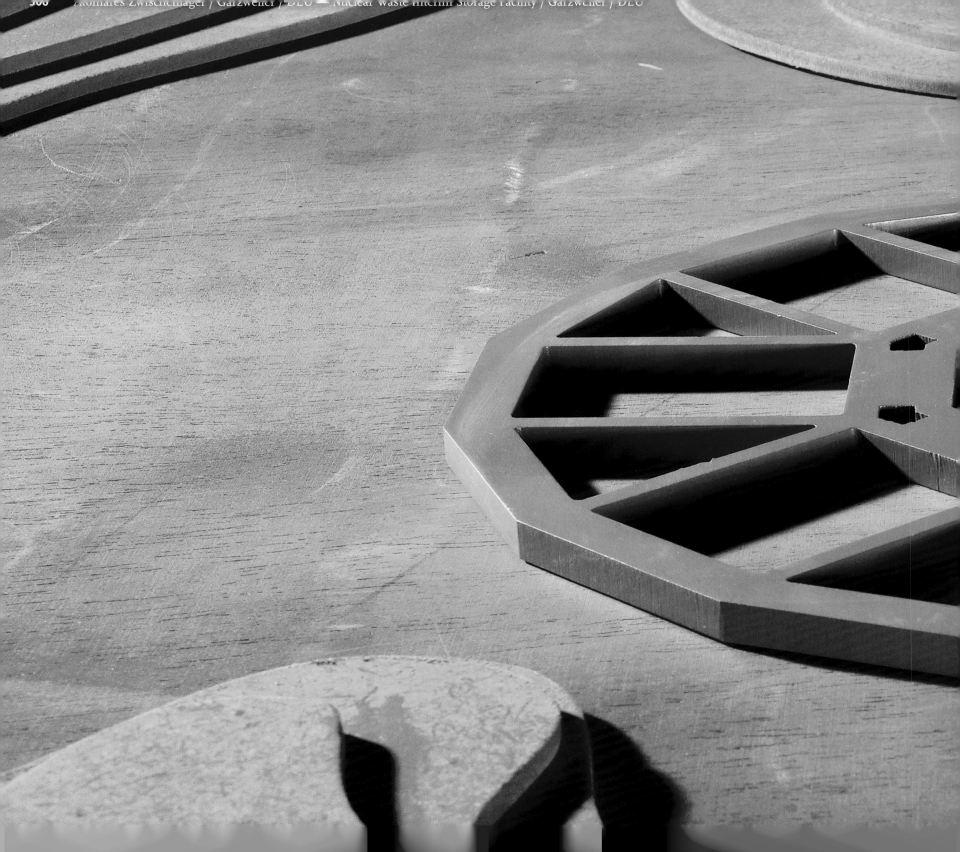

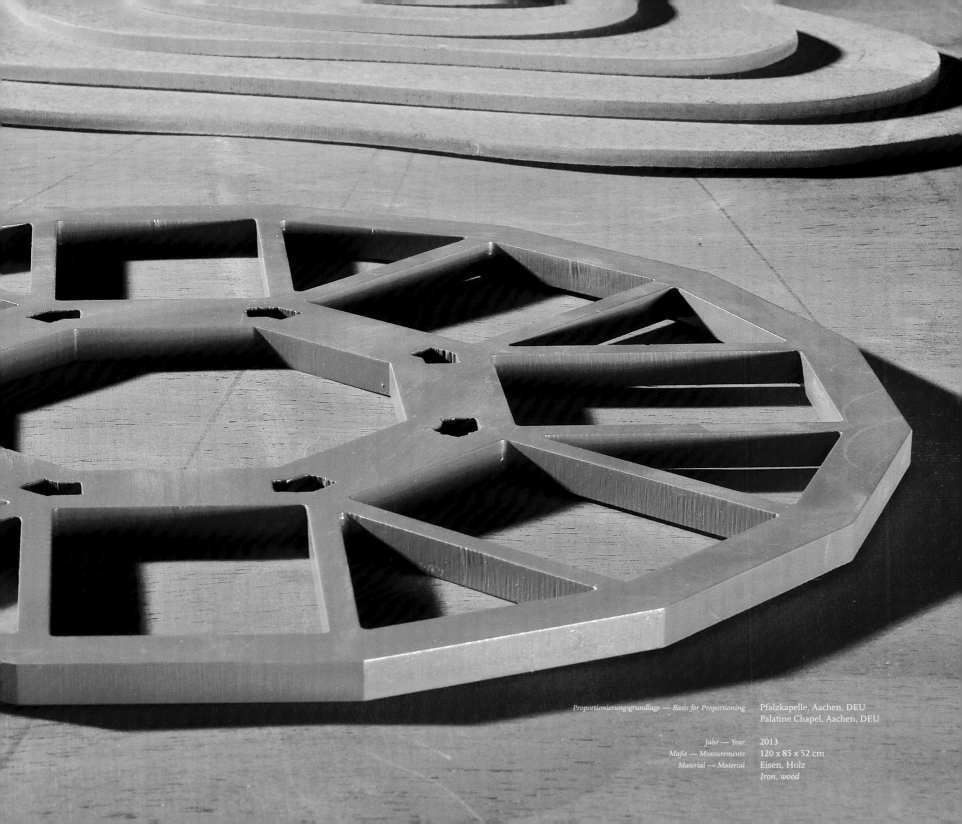

Proportionierungsgrundlage — Basis for Proportioning · Pfalzkapelle, Aachen, DEU
Palatine Chapel, Aachen, DEU

Jahr — Year	2013
Maße — Measurements	120 x 85 x 52 cm
Material — Material	Eisen, Holz
	Iron, wood

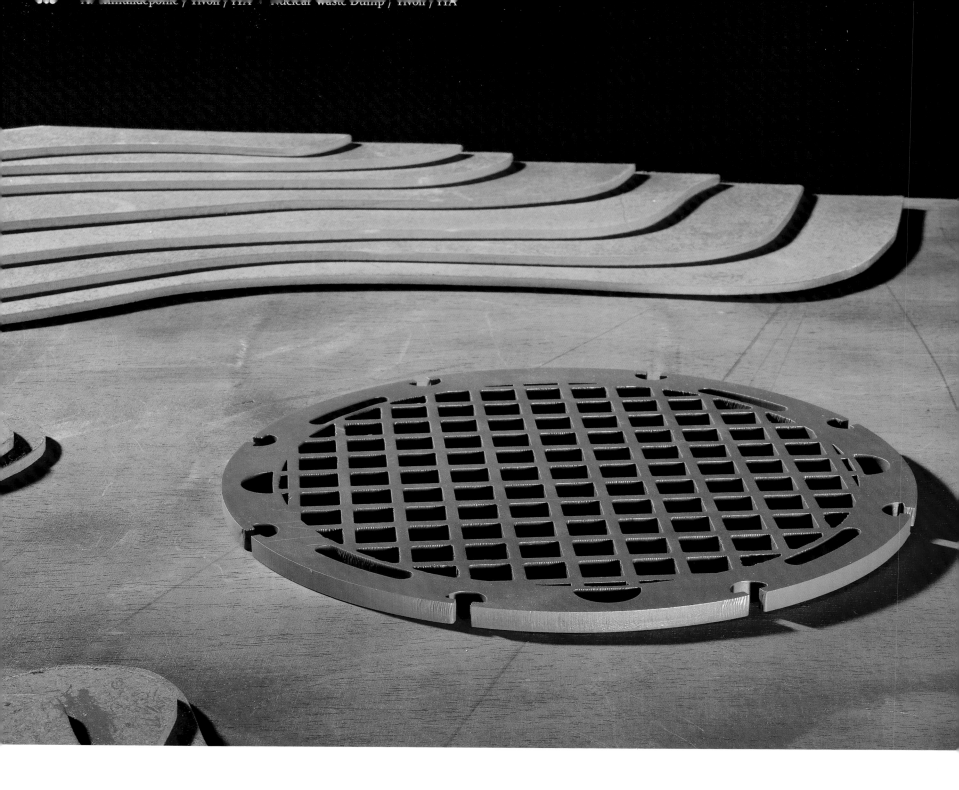

Proportionierungsgrundlage — Basis for Proportioning
Pantheon, Rom, ITA
Pantheon, Rome, ITA

Jahr — Year 2013
Maße — Measurements 120 x 85 x 52 cm
Material — Material Eisen, Holz
Iron, wood

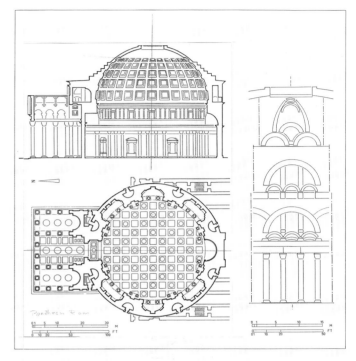

Panthéon, à Rome, construit sous le règne d'Hadrien, entre 120 et 123. Coupe longitudinale et plan 1:750, développement des structures de la coupole 1:400. La cella est une énorme rotonde de brique de 43,30 m de diamètre, surmontée d'une coupole à oculus culminant à une hauteur égale et construite, dans sa partie supérieure, en assises horizontales de tuf, sans contre-butement.

Rom, Pantheon, 120–123 n. Chr. (unter Hadrian). Die Cella ist ein Rundbau aus Ziegelmauerwerk mit einem Durchmesser von 43,30 m. Die Höhe bis zum Scheitel der Kuppel mit zentraler Lichtöffnung beträgt ebenfalls 43,30 m. Die Kuppel ist in ihrem oberen Teil aus horizontalen Tuffsteinlagen und ohne Widerlagersystem erbaut. Längsschnitt und Grundriß 1:750; System des Kuppelaufbaus 1:400.

Pantheon, Rome, built between A.D. 120 and 123, in the reign of Hadrian. Longitudinal section and plan 1:750; structural development of the dome 1:400. The cella is an enormous brick rotunda measuring 43.3 m. across, which is also the height of the oculus dome above it. It is constructed in the upper part of horizontal courses of tuff without buttressing.

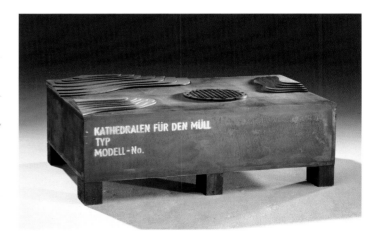

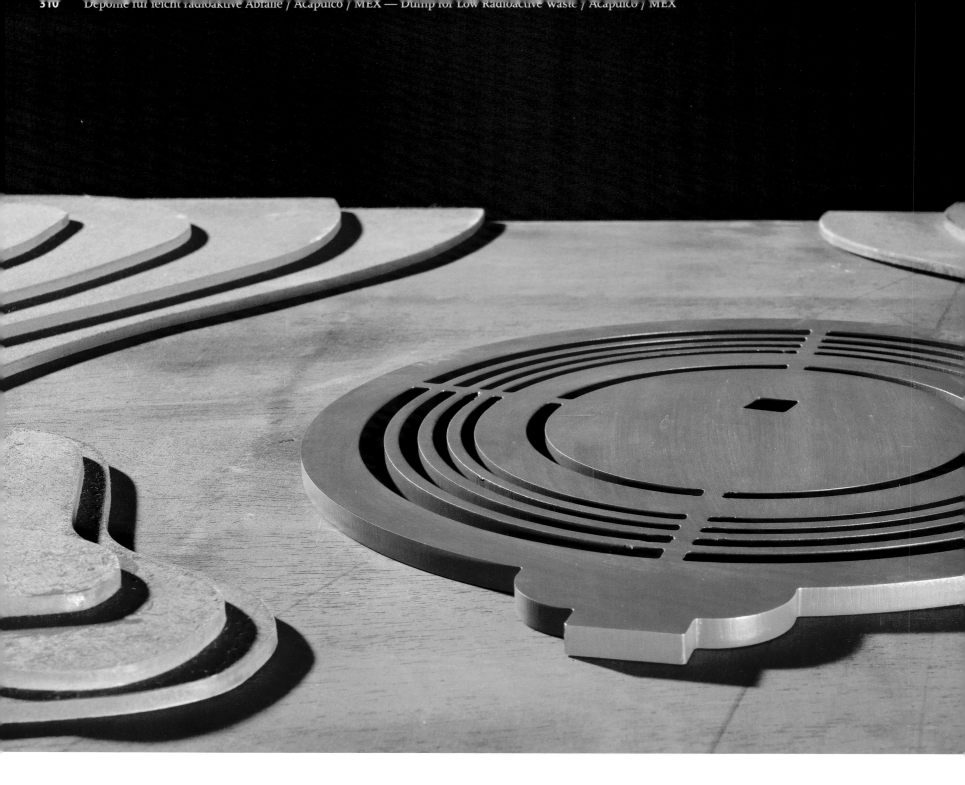

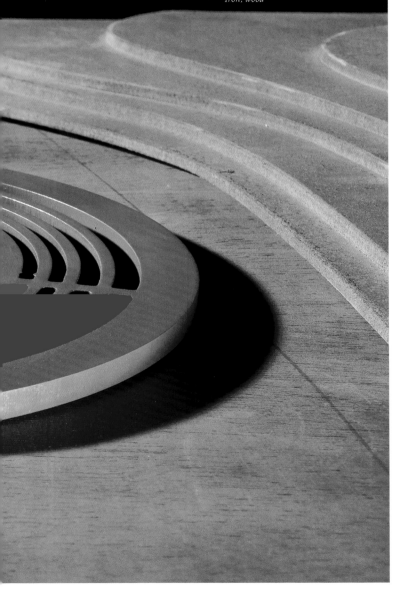

Cuicuilco Rundpyramide,
Mexico City, MEX
Cuicuilco Round Pyramide,
Mexico City, MEX

Jahr — Year	2013
Maße — Measurements	120 x 85 x 52 cm
Material — Material	Eisen, Holz
	Iron, wood

Pyramide circulaire de Cuicuilco, sur les Hauts Plateaux, près de Mexico, datant du Vᵉ s. avant notre ère. Elévation et plan 1:1500. Cette pyramide archaïque de 135 m de diamètre fut édifiée en deux temps, les deux degrés supérieurs remontant au IVᵉ siècle avant notre ère. Un sanctuaire en bois et chaume la couronnait. Elle fut recouverte par l'éruption de lave du volcan Xitlé.

Cuicuilco (bei Mexico City, Meseta Central), 5.Jh.v.Chr. Die Pyramide hat an der Basis einen Durchmesser von 135 m. Sie wurde in zwei Etappen errichtet: Die beiden oberen Stufen stammen erst aus dem 4.Jh.v.Chr. Auf der Plattform befand sich ein Heiligtum aus Holz und Flechtwerk. Die Pyramide wurde bei einem Ausbruch des Vulkans Xitle verschüttet. Aufriß und Grundriß 1:1500.

Circular pyramid, Cuicuilco (near Mexico City), fifth century B.C. Elevation and plan 1:1500. The pyramid measures 135 m. in diameter and was built in two stages, the two top steps having been added in the fourth century B.C. It was originally crowned by a wood-and-thatch shrine. An eruption of the volcano Xitle buried it in lava.

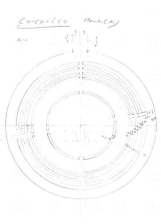

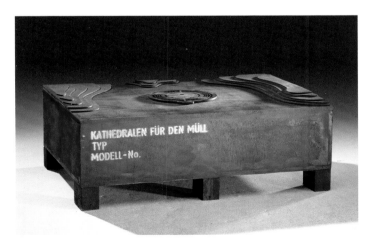

Kathedralen für den Müll
Cathedrals for Garbage

Müllarchitektur
Waste Architecture

Urban Mining Mülldeponien
Urban Mining Waste Dumps

Megadeponien
Mega-Dumbs

Runddeponien
Hazardous Waste Dumbs

Detroit is Everywhere
Detroit is Everywhere

Nuklear-Katastrophen
Nuclear Disasters

2.6

DETROIT IS EVERYWHERE

Mülldeponien in urbanen Zwischenräumen

Garbage dumps at the centre of urban areas

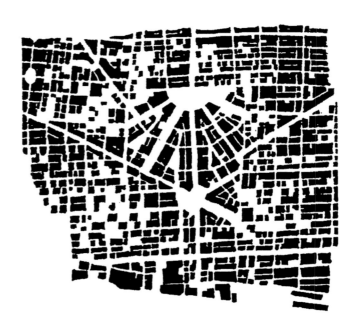

1916 1950

Mülldeponien in urbanen Zwischenräumen

Die Schwarzpläne von Detroit aus den Jahren 1916, 1950, 1994 und 2003 dokumentieren, wie sich das festgelegte und klar erkennbare Stadtgewebe auflöst, die Baublocks zerfasern, ihre Ränder aufbrechen und die Straßen leere Grundstücke erschließen. Inzwischen ist Detroit Downtown weniger dicht besiedelt als seine Umgebung. Das wirtschaftliche und gesellschaftliche Leben verlagert sich in Randgebiete und Vorstädte. Im Zentrum entstehen neue, großzügig angelegte Mülldeponien und Entsorgungsanlagen.

Garbage Dumps in Empty Urban Spaces

The as-built plans of Detroit from the years 1916, 1950, 1994 and 2003 document how the defined, clearly recognisable urban fabric is dissolving, the blocks of building fraying so that their edges break up and the streets enclose empty plots. These days, downtown Detroit is less densely populated than its surrounding areas. The city's economic and social life has moved to the periphery and suburbs. New, large-scale garbage dumps and disposal units are being developed in the centre.

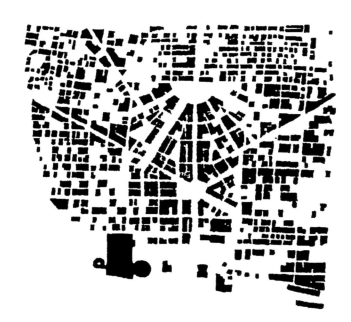

1994

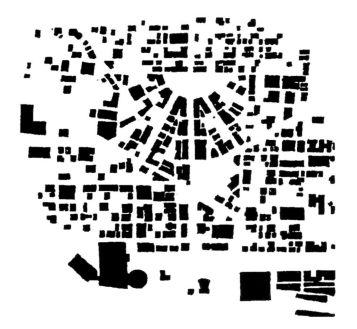

2003

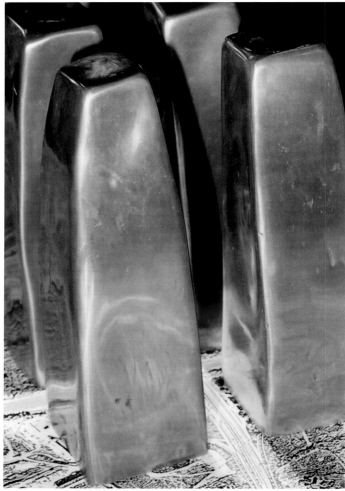

Standort — Location	Washington Blvd. / Grand River Ave., Detroit, USA
Deponietyp — Type of landfill	Kavernendeponie — *Cavern dump*
Jahr — Year	2004
Maße — Measurements	90 x 70 x 31 cm
Material — Material	Aluminium, Laserdruck
	Aluminium, laser print

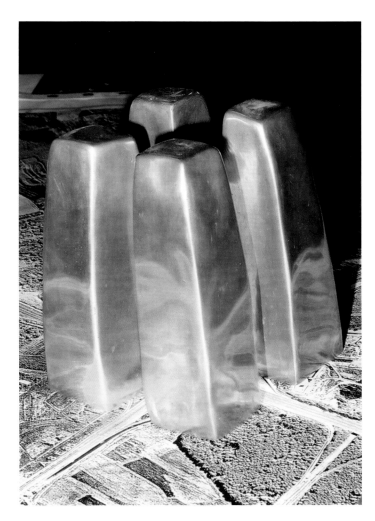
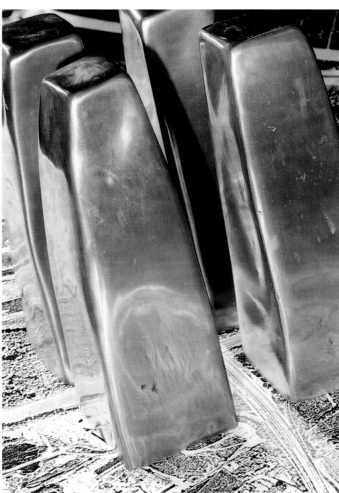

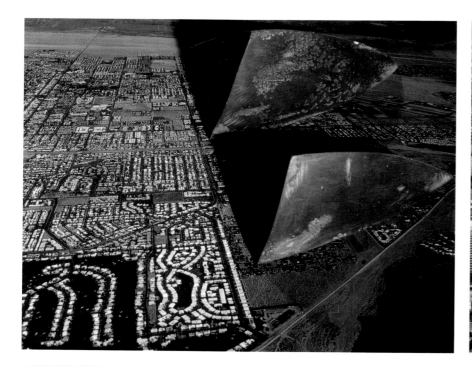

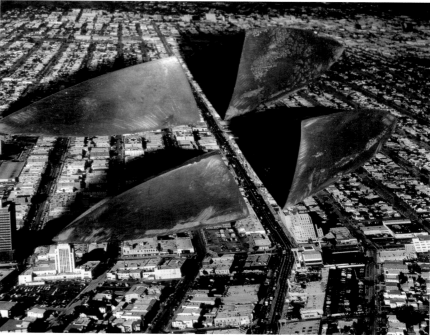

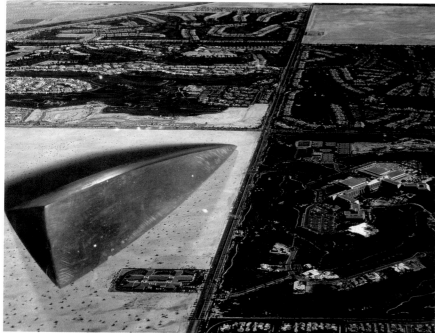

Standort — Location	Ventura Blvd. / Moorpark St., Los Angeles, USA
Deponietyp — Type of landfill	Haldendeponien — *Waste heap dump*
Jahr — Year	2004
Maße — Measurements	120 x 80 x 15 cm
Material — Material	Polyester, Beton, Fotodruck *Polyester, concrete, photo print*

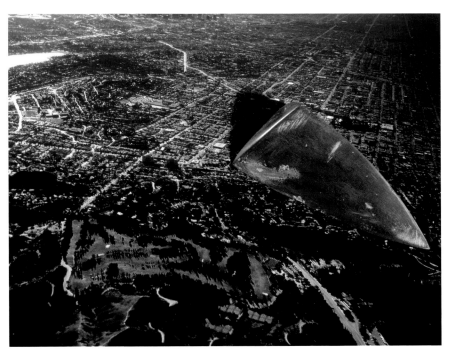
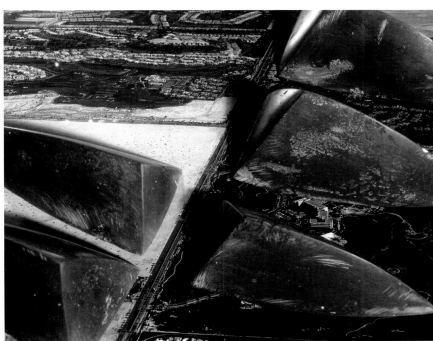
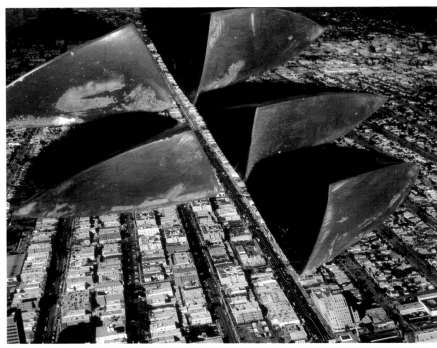
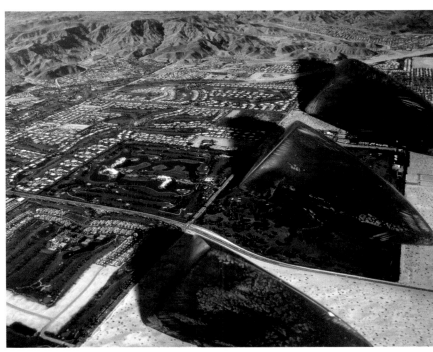

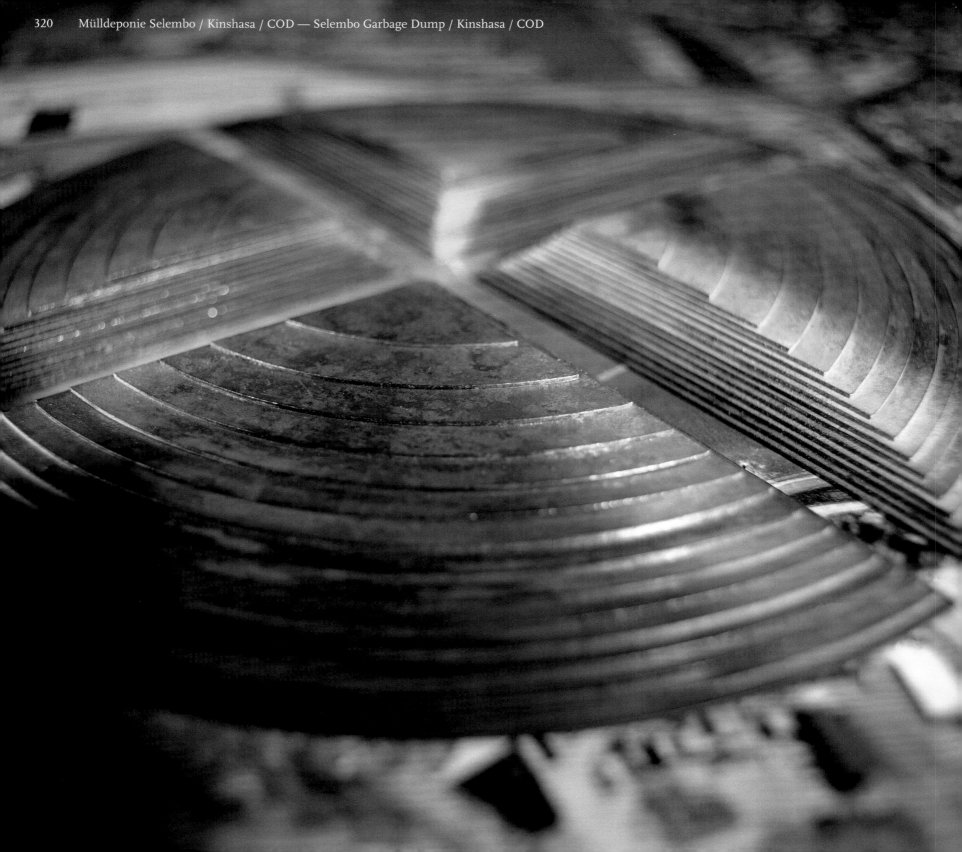

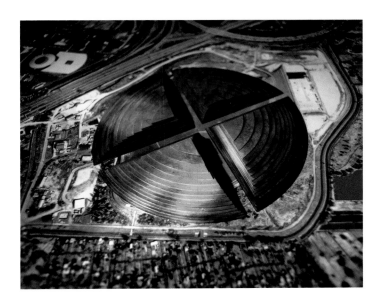

Standort — Location	Lubaki St. / Bayombe St., Kinshasa, COD
Deponietyp — Type of landfill	Verdichtungsdeponie — *Waste compaction dump*
Jahr — Year	2004
Maße — Measurements	90 x 80 x 15 cm
Material — Material	Eisenplatten, Laserdruck
	Iron plates, laser print

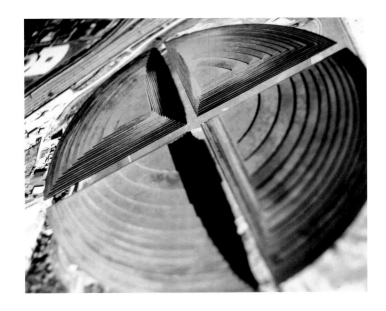

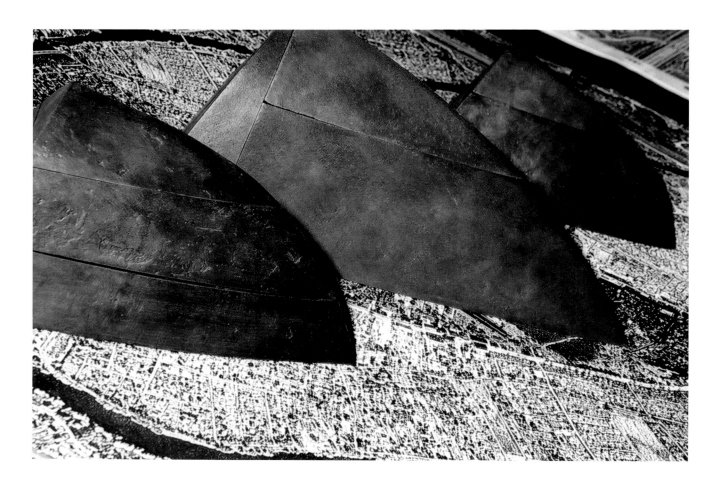

Standort — Location Igbosere Rd. / Cable St., Lagos, NGA

Deponietyp — Type of landfill Massenabfalldeponie — *Mass waste dump*
Jahr — Year 2004
Maße — Measurements 110 x 100 x 15 cm
Material — Material Epoxidharz, Fotodruck
Epoxy resin, photo print

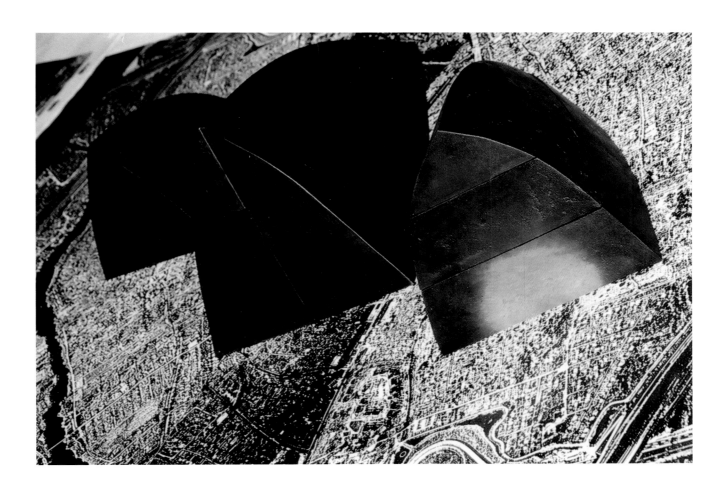

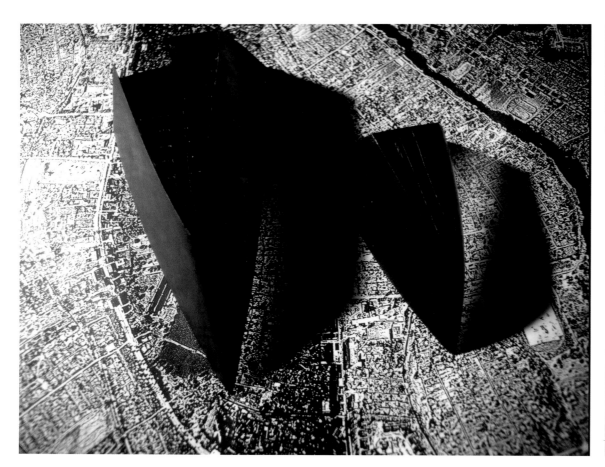
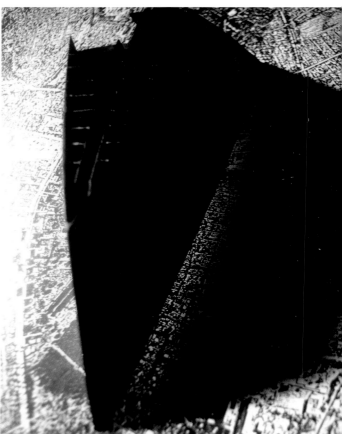

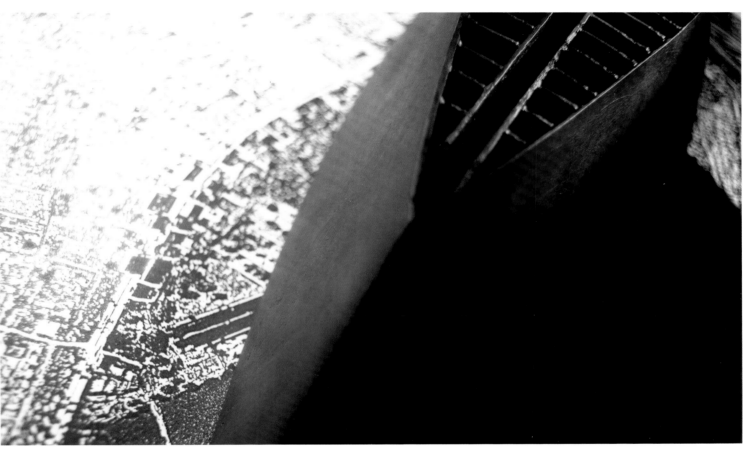

Standort — Location	Yeonan-Dong / Hang-Dong, Inchon, KOR
Deponietyp — Type of landfill	Massenabfalldeponie — *Mass waste dump*
Jahr — Year	2004
Maße — Measurements	120 x 110 x 21 cm
Material — Material	Bronze, Fotodruck
	Bronze, photo print

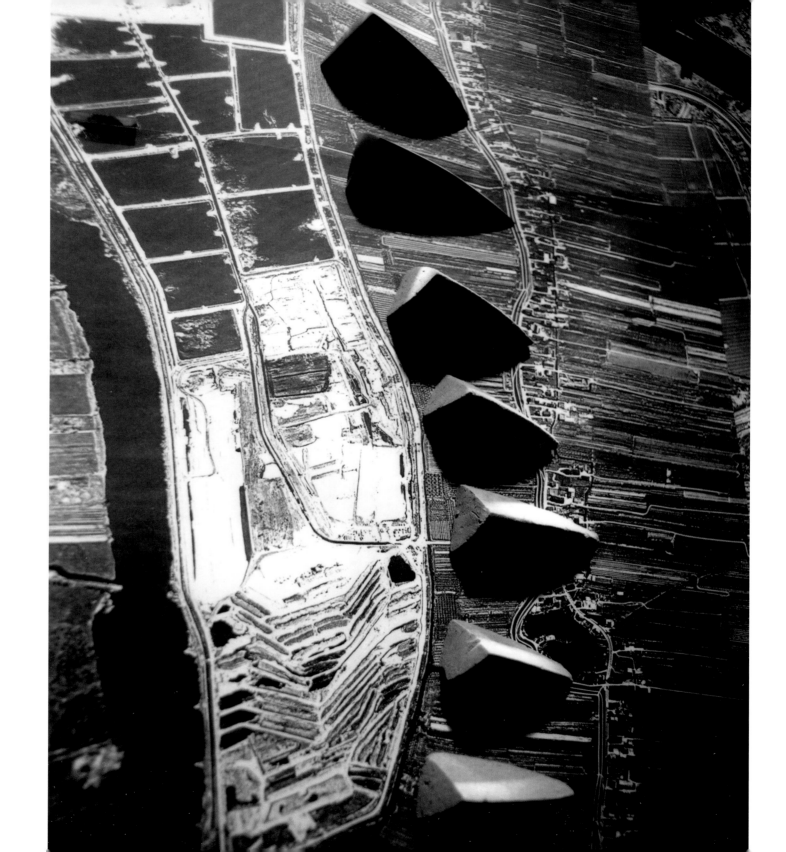

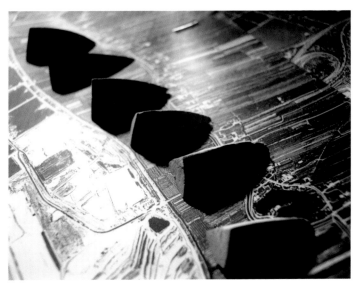

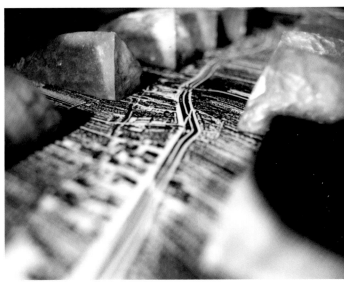

Standort — Location	An der Alten Süderelbe, Hamburg, DEU
Deponietyp — Type of landfill	Haldendeponie — *Waste heap dump*
Jahr — Year	2004
Maße — Measurements	70 x 80 x 15 cm
Material — Material	Epoxidharz, Fotodruck
	Epoxy resin, photo print

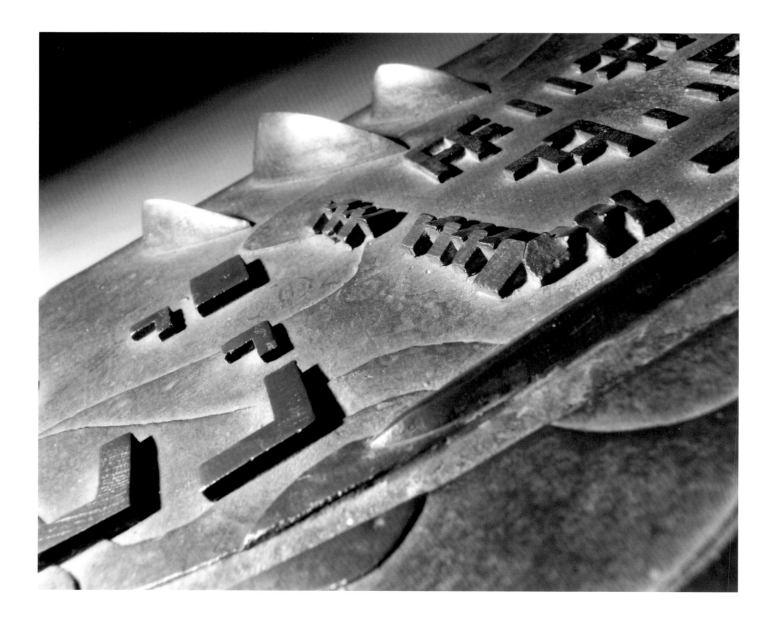

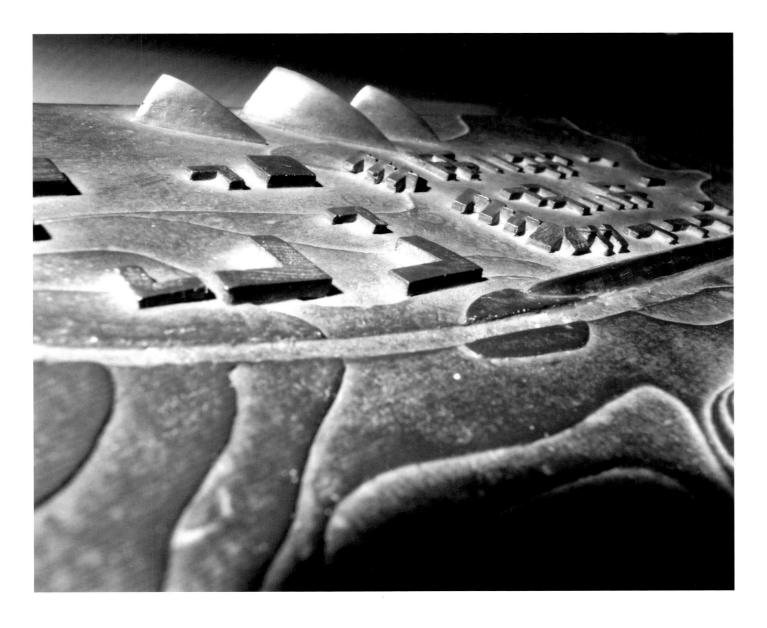

Standort — *Location*	Panfilovsky Prospekt, Moskau, RUS
	Panfilovsky Prospekt, Moscow, RUS
Deponietyp — *Type of landfill*	Sondermülldeponie — *Hazardous waste dump*
Jahr — *Year*	2004
Maße — *Measurements*	62 x 32 x 15 cm
Material — *Material*	Bronze, Fotodruck
	Bronze, photo print

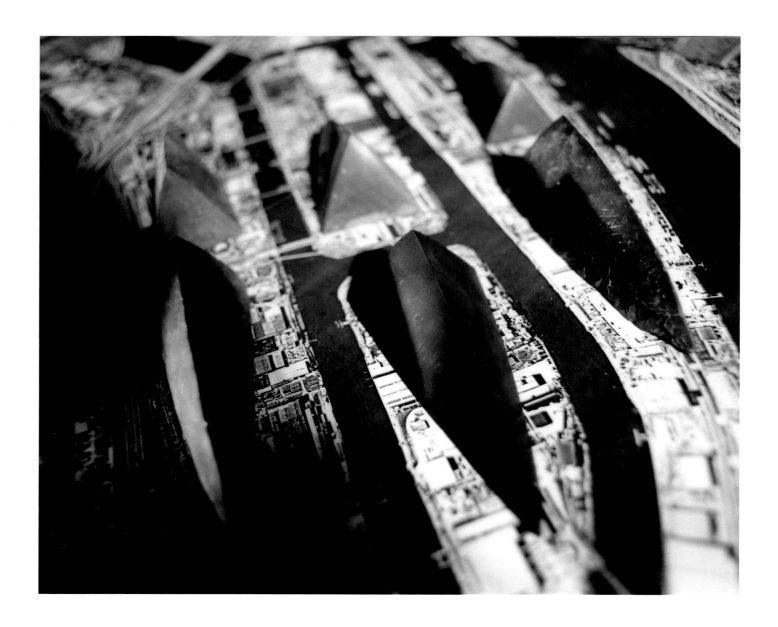

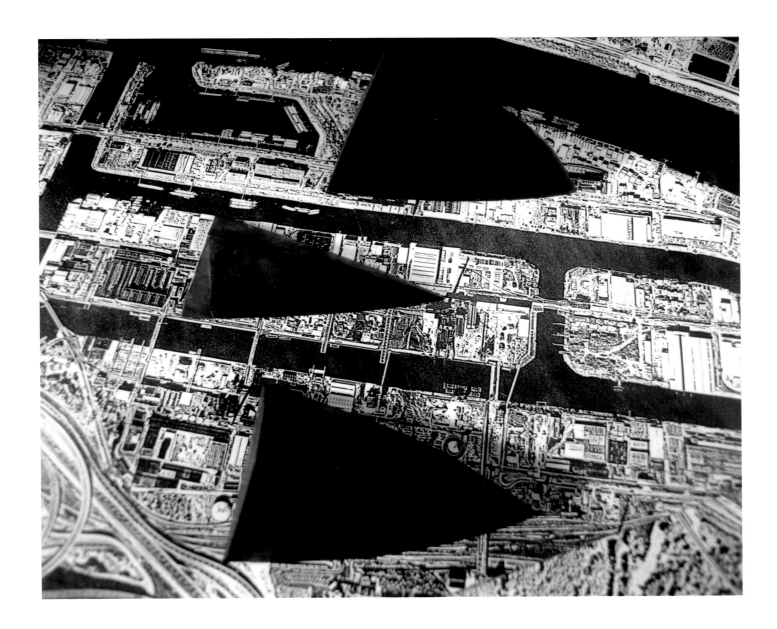

Standort — Location	Dongchuan Rd. / Jiping Rd., Shanghai, CHN
Deponietyp — Type of landfill	Sondermülldeponie — *Hazardous waste dump*
Jahr — Year	2004
Maße — Measurements	120 x 90 x 22 cm
Material — Material	Aluminium, Laserdruck *Aluminium, laser print*

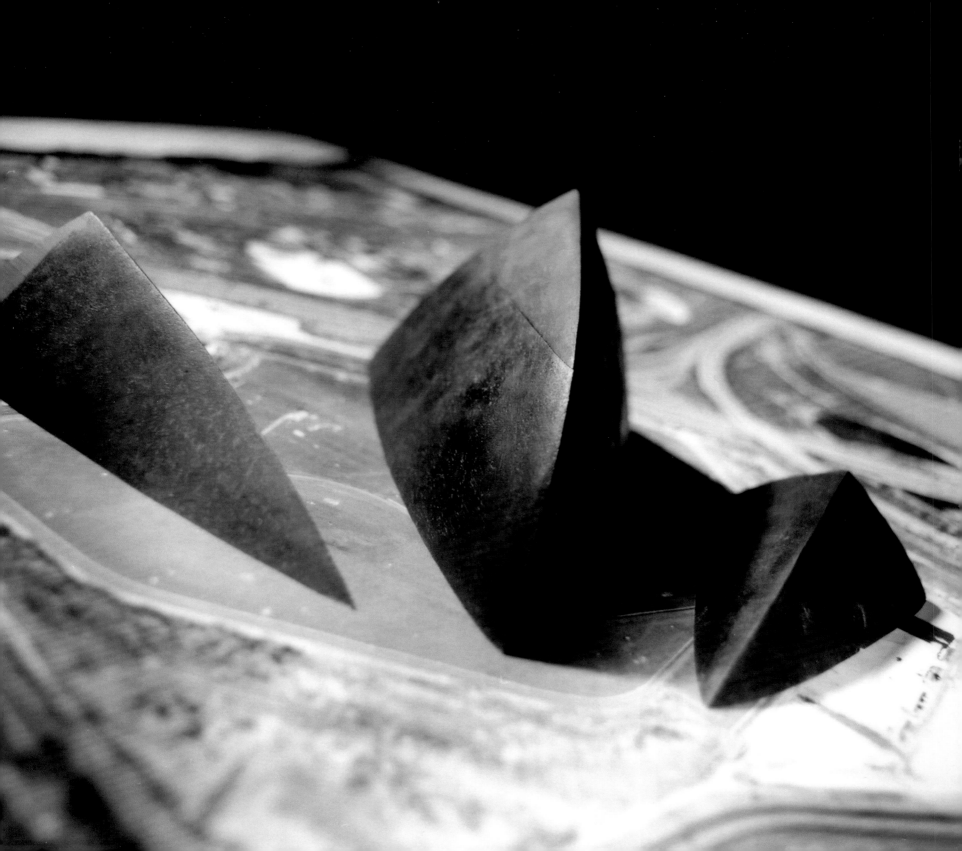

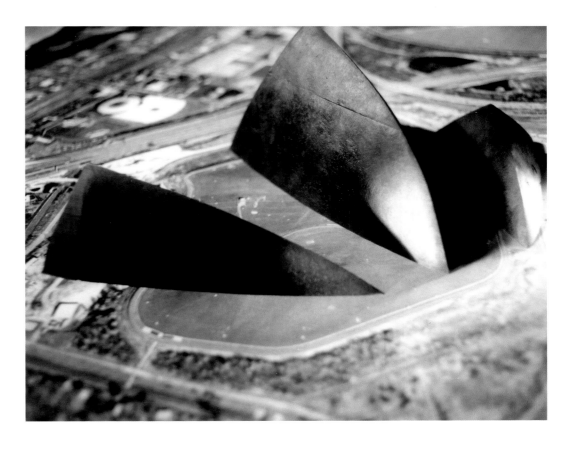

Standort — Location	Parka Central de Villa Nueva, Guatemala City, GTM
Deponietyp — Type of landfill	Sondermülldeponie — *Hazardous waste dump*
Jahr — Year	2004
Maße — Measurements	100 x 90 x 18 cm
Material — Material	Bronze, Laserdruck
	Bronze, laser print

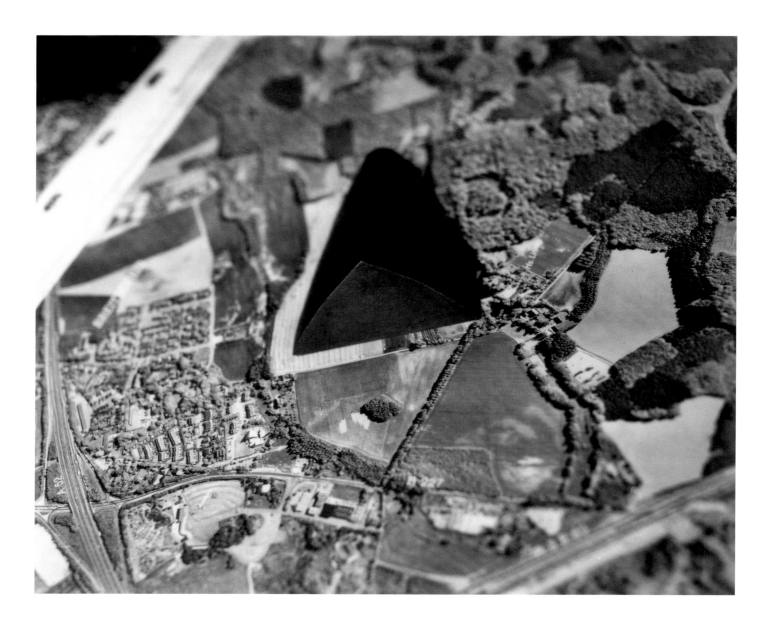

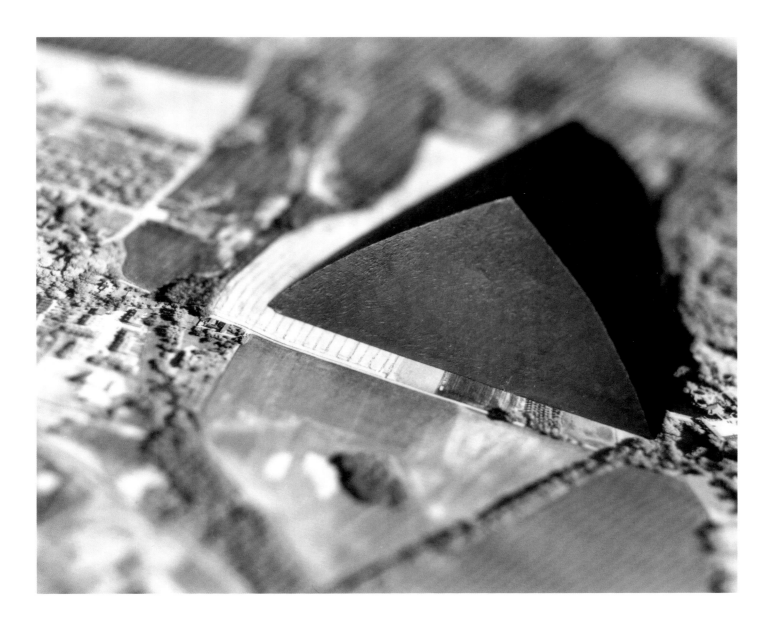

Standort — Location	Barham Park, London, GBR
Deponietyp — Type of landfill	Verdichtungsdeponie — *Waste compaction dump*
Jahr — Year	2004
Maße — Measurements	70 x 70 x 16 cm
Material — Material	Bronze, Laserdruck *Bronze, laser print*

<table>
<tr><td align="right">*Standort — Location*</td><td>Swami Vivekanand Rd., Mumbai, IND</td></tr>
<tr><td align="right">*Deponietyp — Type of landfill*</td><td>Massenabfalldeponie — *Mass waste dump*</td></tr>
<tr><td align="right">*Jahr — Year*</td><td>2004</td></tr>
<tr><td align="right">*Maße — Measurements*</td><td>90 x 120 x 19 cm</td></tr>
<tr><td align="right">*Material — Material*</td><td>Bronze, Fotodruck
Bronze, photo print</td></tr>
</table>

Standort — Location	Hickson Rd. / Kent St., Sydney, AUS
Deponietyp — Type of landfill	Haldendeponie — *Waste heap dump*
Jahr — Year	2004
Maße — Measurements	90 x 70 x 19 cm
Material — Material	Epoxidharz, Fotodruck
	Epoxy resin, photo print

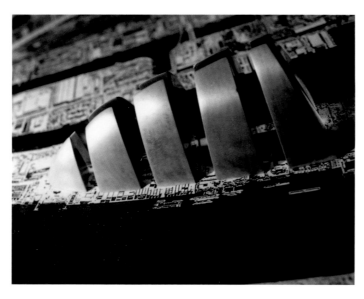
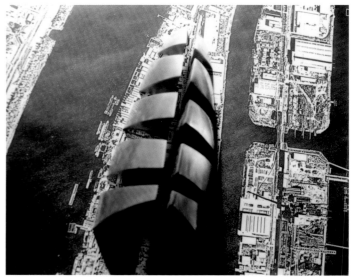

Standort — Location	Hickson Rd. / Kent St., Sydney, AUS
Deponietyp — Type of landfill	Haldendeponie — *Waste heap dump*
Jahr — Year	2004
Maße — Measurements	90 x 70 x 19 cm
Material — Material	Epoxidharz, Fotodruck
	Epoxy resin, photo print

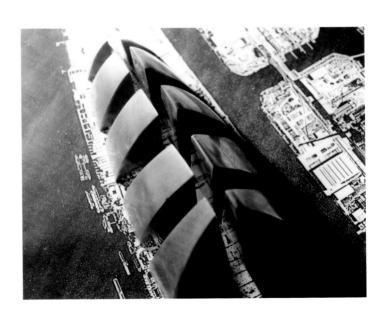

Kathedralen für den Müll
Cathedrals for Garbage

Müllarchitektur
Waste Architecture

Urban Mining Mülldeponien
Urban Mining Waste Dumps

Megadeponien
Mega-Dumbs

Runddeponien
Hazardous Waste Dumbs

Detroit is Everwhere
Detroit is Everywhere

Nuklear-Katastrophen
Nuclear Disasters

2.7

NUKLEAR-KATASTROPHEN
NUCLEAR DESASTERS

Sicherung und Markierung
nuklear verstrahlter Areale

Securing and marking areas exposed
to nuclear radiation

2.7/1
TSCHERNOBYL
SARKOPHAG

Am 26. April 1986 ereignete sich in Block Nr. 4 des Kernkraft-
werkes von Tschernobyl nahe der ukrainischen Stadt Prybjat
eine Nuklearkatastrophe. Dabei kam es zur Explosion des
Reaktors. Im November 1986 wurde ein Schutzmantel, der
Sarkophag-1, aus Stahlbeton errichtet. Da dieser Schutzmantel
brüchig geworden ist, wird zum dauerhaften Schutz vor hoch
radioaktiver Strahlung eine neue Hülle, der *Sarkophag-2*, gebaut.
Der *Sarkophag-2* hat die Form eines riesigen Stachels und ist
nach dem Proportionsschema der Sophienkathedrale von Kiew
aufgebaut. Er ist weithin sichtbar als Markierung und Kenn-
zeichnung der strahlenden Hinterlassenschaften der Reaktor-
katastrophe von 1986.

2.7/1 Chernobyl Sarcophagus
The Chernobyl nuclear catastrophe occurred on 26th April 1986
in Block No. 4 of the Chernobyl nuclear power station close to
the Ukrainian city of Pripyat. It culminated in the explosion of
the reactor. In November 1986 a protective casing was construct-
ed from reinforced concrete, *Sarcophagus-1*. As this protective
casing has become brittle, a new casing *Sarcophagus-2* is being
built to provide permanent protection from high radiation
levels. *Sarcophagus-2* takes the shape of a huge thorn and is con-
structed according to the scheme of proportions of St. Sophia's
Cathedral in Kiev. It is visible from far away as a marker and
identification of the radiating legacy of the 1986 reactor disaster.

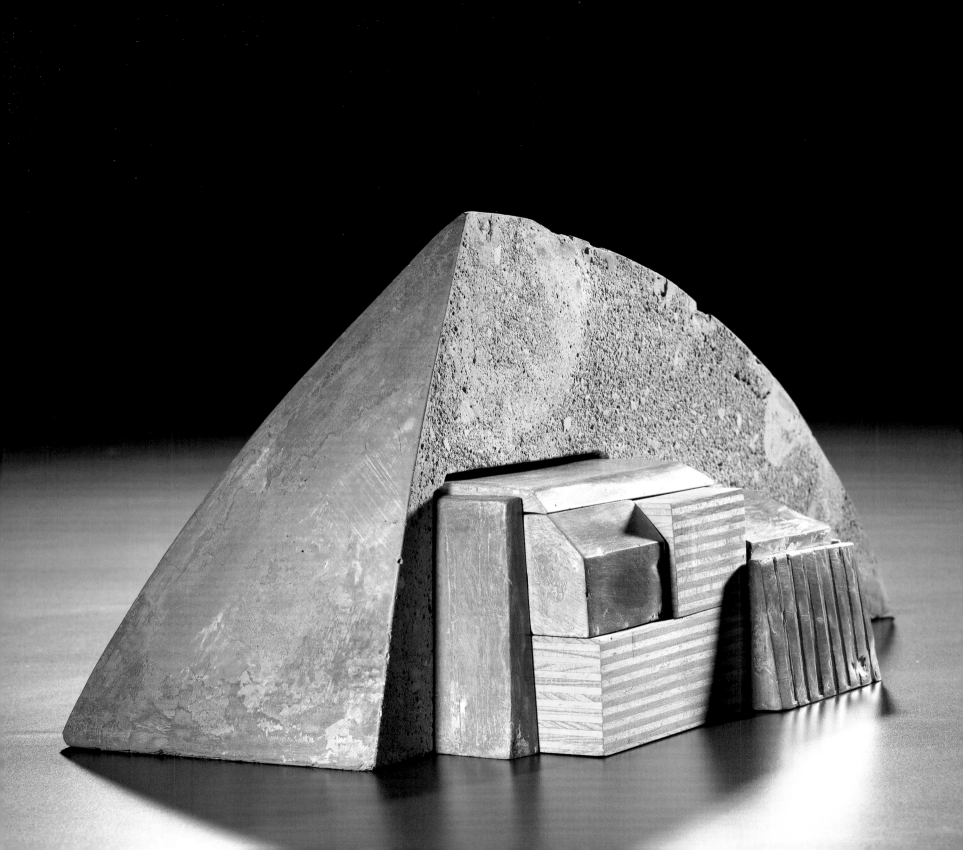

 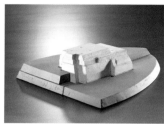 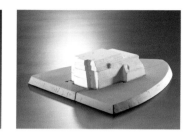 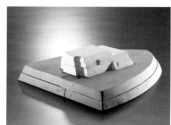 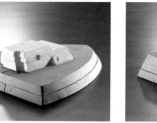

Sarkophag -2 — *Sarcophagus -2*

Proportionierungsgrundlage — Basis for Proportioning	Sophienkathedrale, Kiew, UKR *Cathedral of St. Sophia, Kiev, UKR*
Standort — Location	Oblast Kiew, UKR
Jahr — Year	2001
Maße — Measurements	39 x 33 x 27 cm
Material — Material	Holz, Gips, Pappe *Wood, plaster, cardboard*

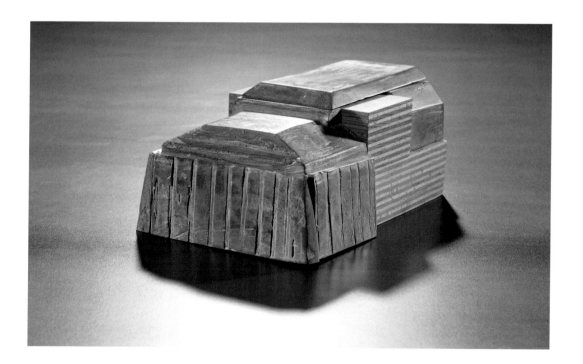

Sarkophag -1 – *Sarcophagus -1*

Standort — Location	Oblast Kiew, UKR
Jahr — Year	2001
Maße — Measurements	22 x 14 x 12 cm
Material — Material	Faserbeton, Eisen, Holz *Fibre concrete, iron, wood*

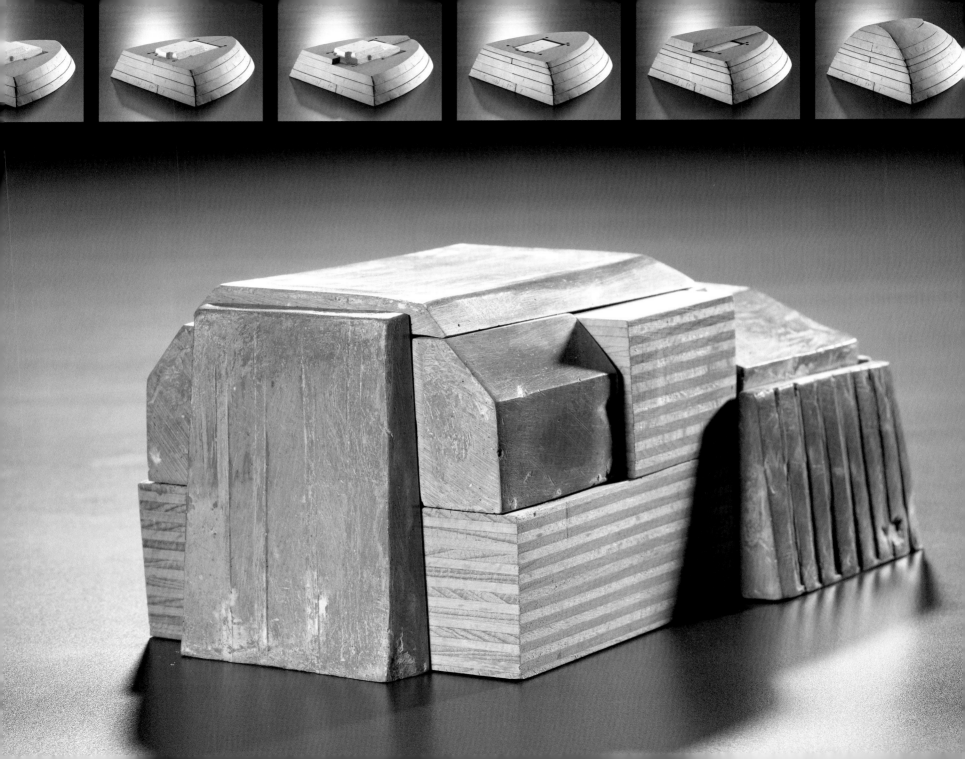

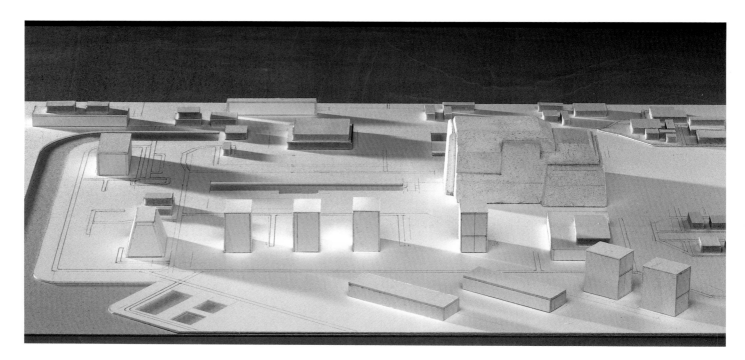

Todeszone — *Death zone*

Sophienkathedrale, Kiew, UKR
Cathedral of St. Sophia, Kiev, UKR
Oblast Kiew, Ukraine, UKR
2001
120 x 80 x 22 cm
Beton, Holz, Gips, Pappe
Concrete, wood, plaster, cardboard

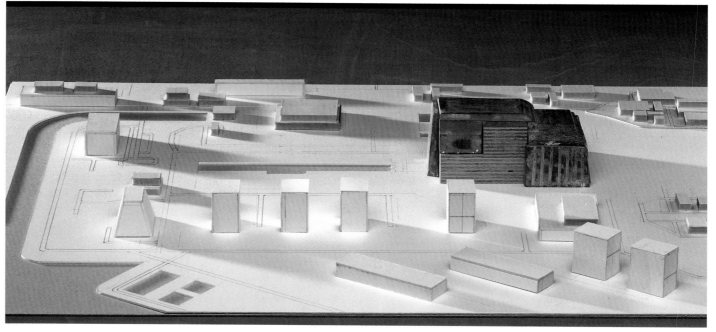

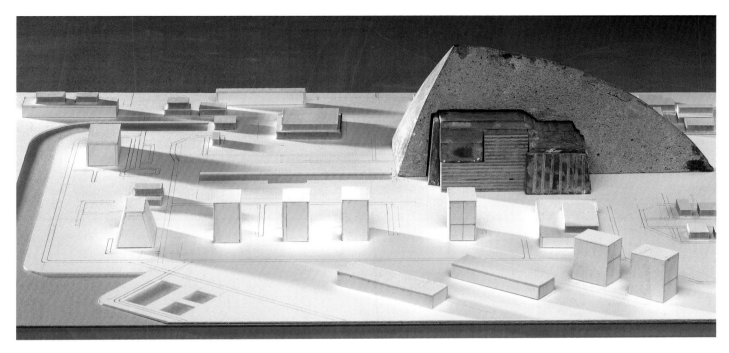

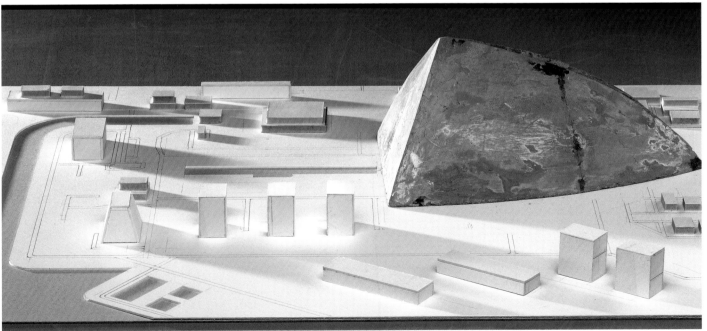

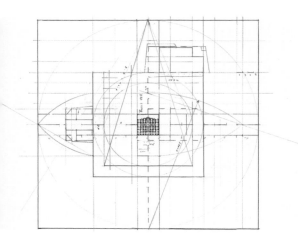
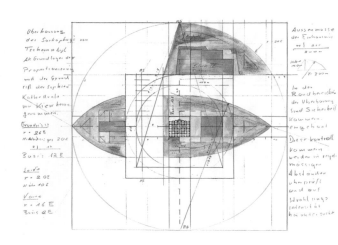
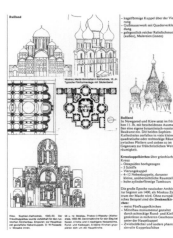

Sarkophag -2 — *Sarcophagus -2*

Proportionierungsgrundlage — Basis for Proportioning	Sophienkathedrale, Kiew, UKR *Cathedral of St. Sophia, Kiev, UKR*
Standort — Location	Oblast Kiew, Ukraine, UKR
Jahr — Year	2001
Maße — Measurements	120 x 80 x 22 cm
Material — Material	Verschiedene Materialien *Various materials*

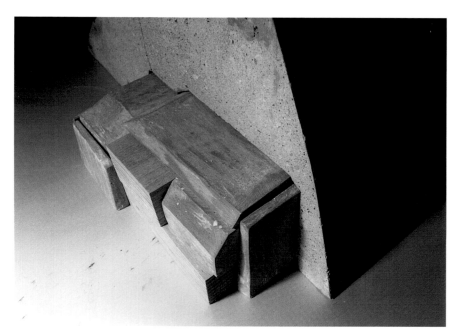
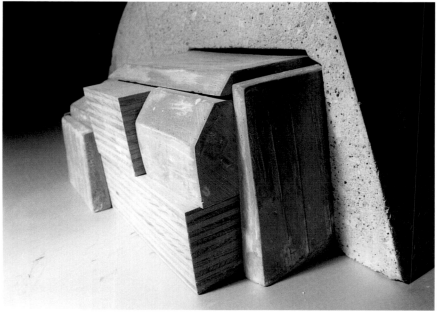

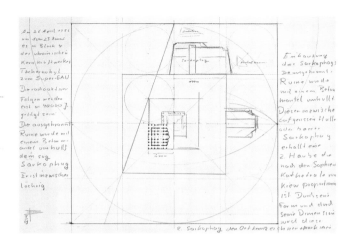
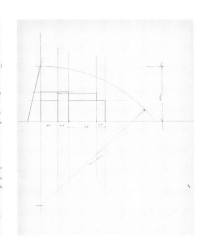
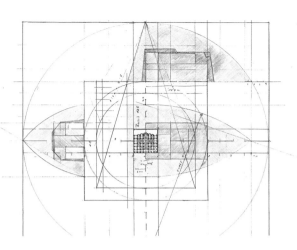

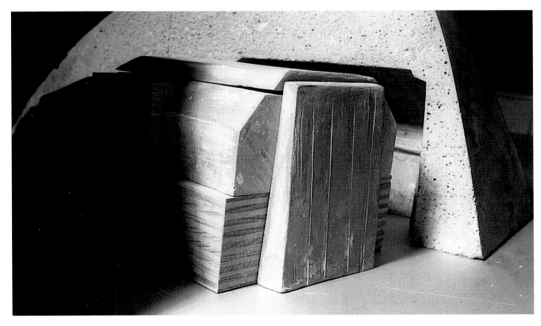

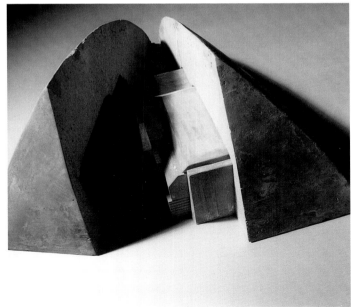

2.7/2
THREE MILE ISLAND NUKLEAR KOMPLEX

Das Kernkraftwerk Three Mile Island liegt auf der Insel Three Mile Island im Susquehanna River nahe der Stadt Harrisburg in Pennsylvania / USA. Am 28. März 1979 ereignete sich ein Kernschmelzunfall in Block Nr. 2. Nach dem Rückbau des Kernkraftwerkes soll auf der Insel ein nukleares Endlager entstehen. Als Proportionierungsgrundlage für die einzelnen Deponiekörper dient die Mastaba des Schepseskaf (Sakkara, Ägypten). Die Schutzbauten sind weithin sichtbar und halten Wache über das verstrahlte Erbe.

2.7/2 Three Mile Island Nuclear Complex
The Three Mile Island nuclear power station is situated on the island of the same name in the Susquehanna River in Pennsylvania, near Harrisburg in the USA. On 28th March 1979 a nuclear meltdown accident occurred in Block No. 2. After the deactivation of the nuclear power station, the proposal is to create a radioactive waste repository on the island. The pattern for the proportions of the individual storage units is the mastaba of King Shepseskaf (Sakkara, Egypt). The protective structures are visible from far away and stand like guardians over the earth contaminated with radiation.

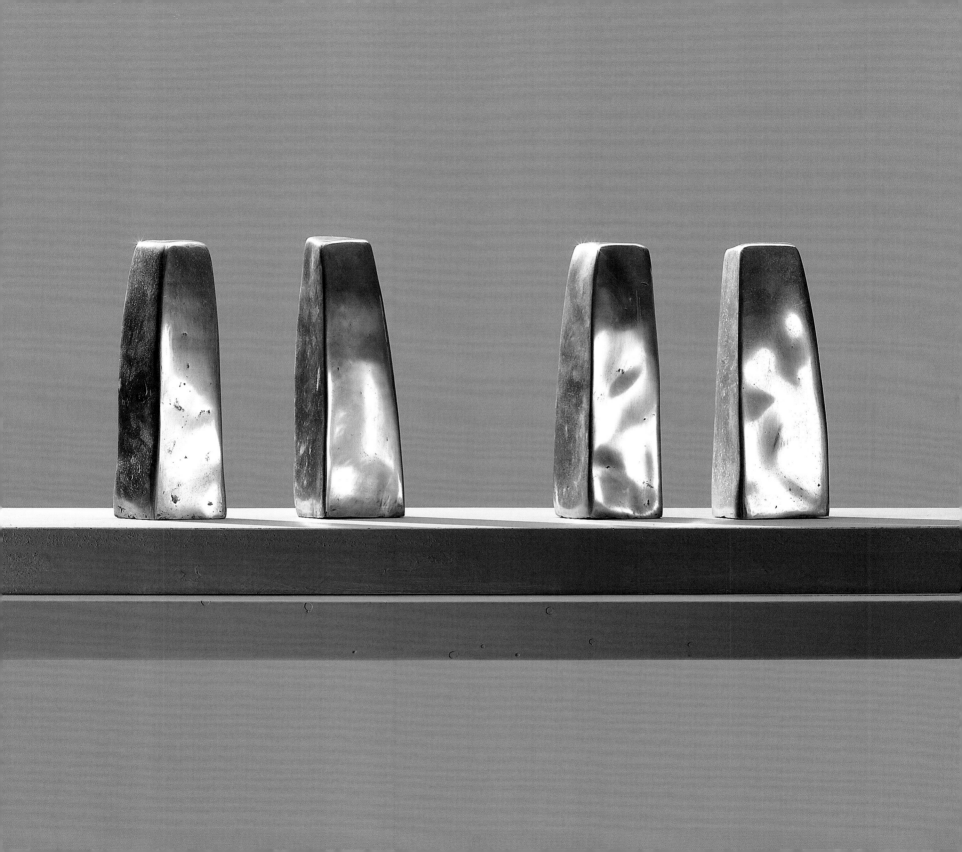

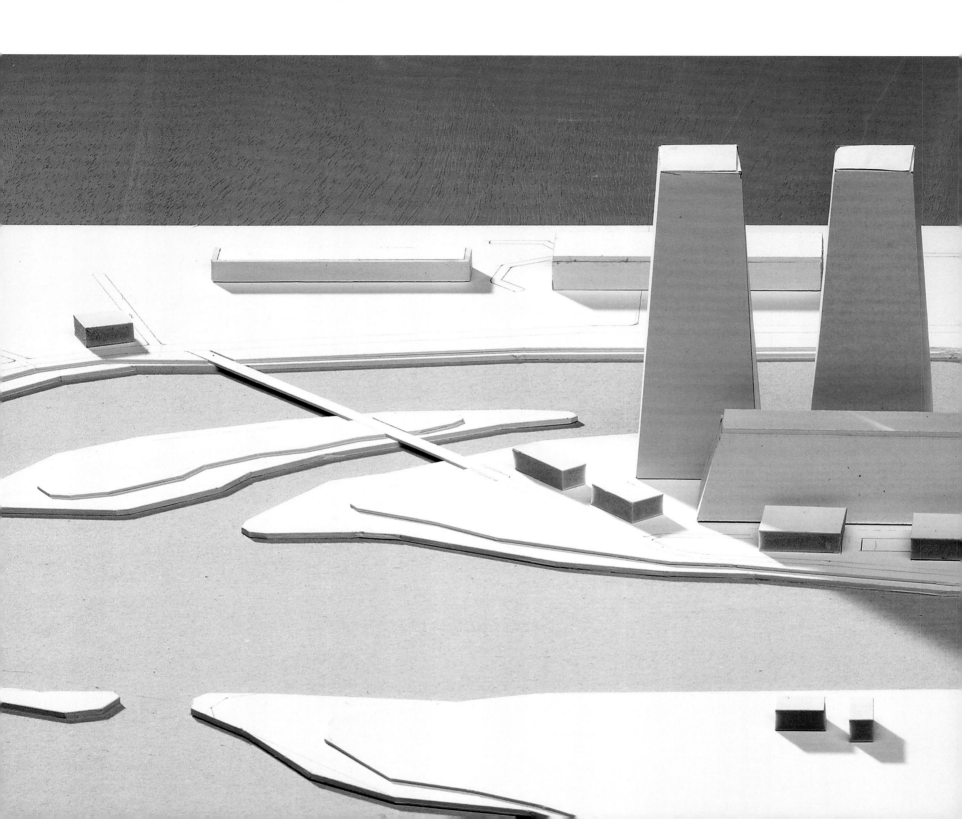

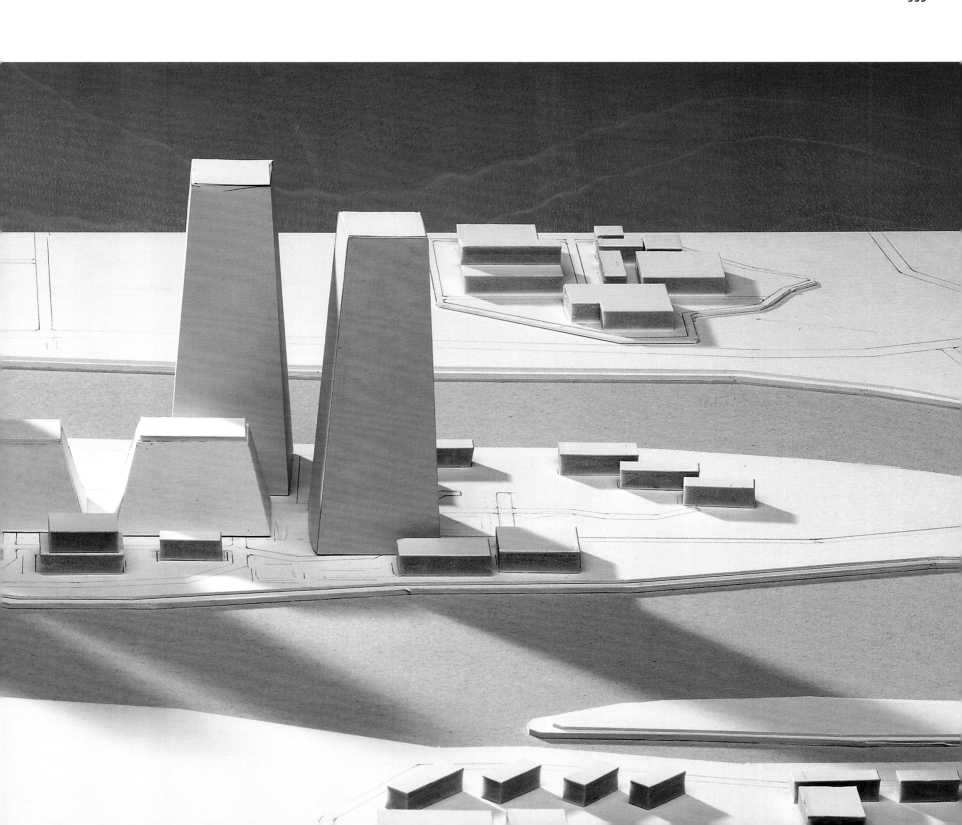

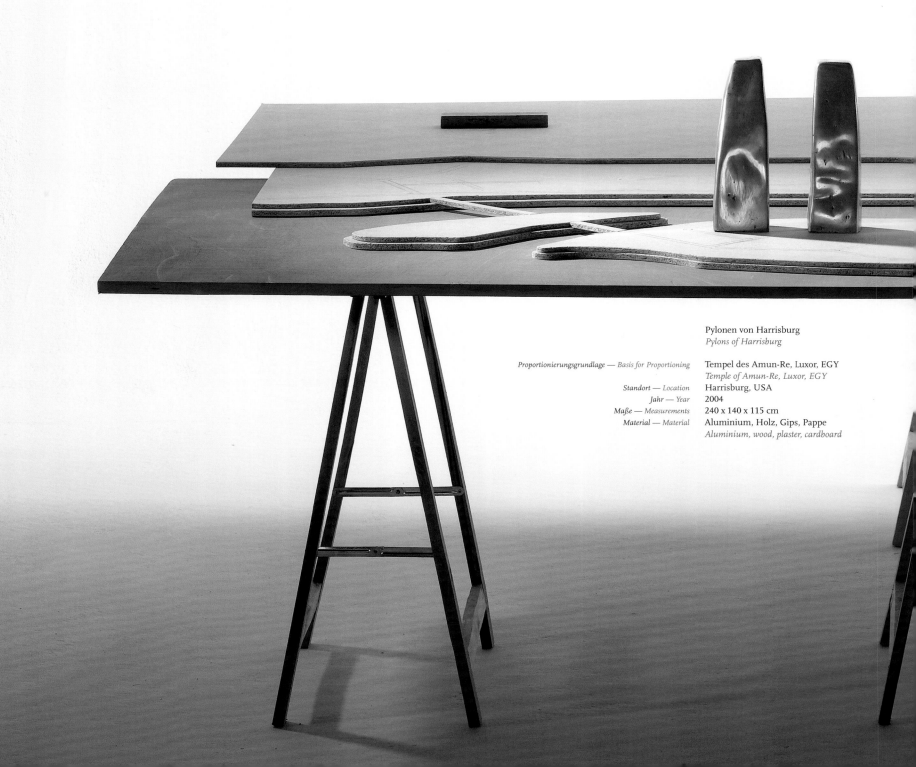

Pylonen von Harrisburg
Pylons of Harrisburg

Proportionierungsgrundlage — Basis for Proportioning	Tempel des Amun-Re, Luxor, EGY *Temple of Amun-Re, Luxor, EGY*
Standort — Location	Harrisburg, USA
Jahr — Year	2004
Maße — Measurements	240 x 140 x 115 cm
Material — Material	Aluminium, Holz, Gips, Pappe *Aluminium, wood, plaster, cardboard*

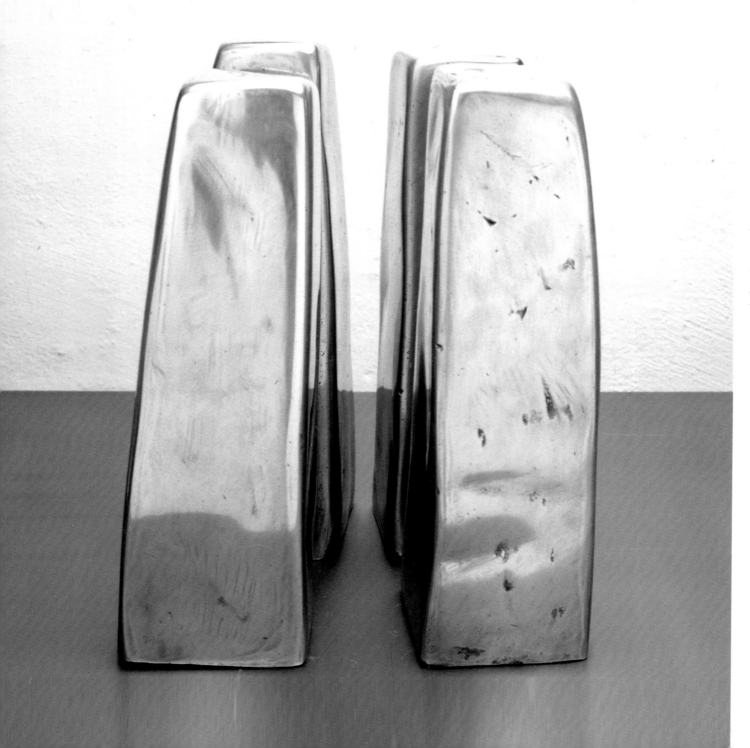

Pylonen von Harrisburg — *Pylons of Harrisburg*

Tempel des Amun-Re, Luxor, EGY
Temple of Amun-Re, Luxor, EGY
Harrisburg, USA
2004
11 x 11 x 32 cm, 4-teilig
Aluminium
Aluminium

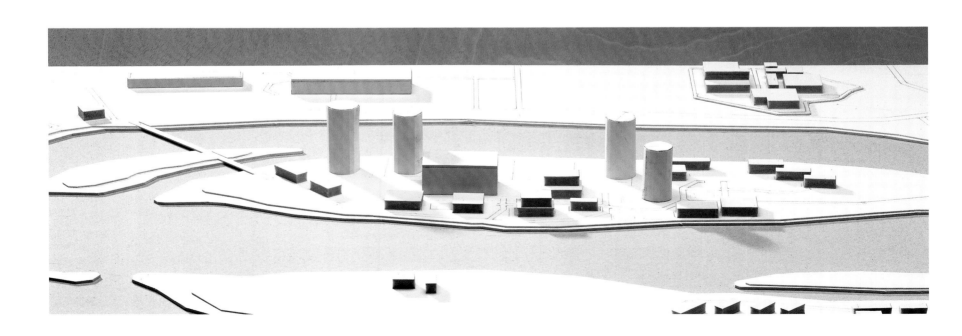

Nuklear Komplex Harrisburg — *Nuclear Complex Harrisburg*

Proportionierungsgrundlage — Basis for Proportioning Tempel des Amun-Re, Luxor, EGY
Temple of Amun-Re, Luxor, EGY

Standort — Location Harrisburg, USA
Jahr — Year 2004
Maße — Measurements 120 x 80 12 cm
Material — Material Holz, Gips, Pappe
Wood, plaster, cardboard

2.7/3
SELLAFIELD
NUKLEAR-KATHEDRALEN

Sellafield ist ein weltweit bekannter Nukllearkomplex an der Irischen See in Nordwestengland. Die Anlage wurde durch zahlreiche nukleare Störfälle und durch einen katastrophalen Brand im Jahr 1957 bekannt. Nach dem Rückbau des Kernkraftwerkes Calder und aller anderen sich auf dem Gelände befindlichen nuklearen Anlagen soll auf dem Areal ein Entsorgungspark für radioaktive Abfälle entstehen. Als Proportionierungsgrundlage für die einzelnen Deponiekörper dienen die Grundrisse verschiedener Kathedralen aus dem Vereinigten Königreich. Die *Atom-Kathedralen von Sellafield* wachen weithin sichtbar über die strahlenden Hinterlassenschaften einer nuklearen Ära.

2.7/3 Sellafield Nuclear Cathedrals
Sellafield is an internationally known nuclear complex beside the Irish Sea in North West England. The complex became famous following a catastrophic fire in 1957 and as the result of frequent nuclear incidents. After the closure of Calder nuclear power station and all other nuclear facilities on the site, the intention is to create a disposal park for radioactive waste here. The ground plans of various cathedrals in the United Kingdom form the basis for the individual storage units and their proportions. The *atomic cathedrals of Sellafield* watch, visible from afar, over the radiating remains of a nuclear era.

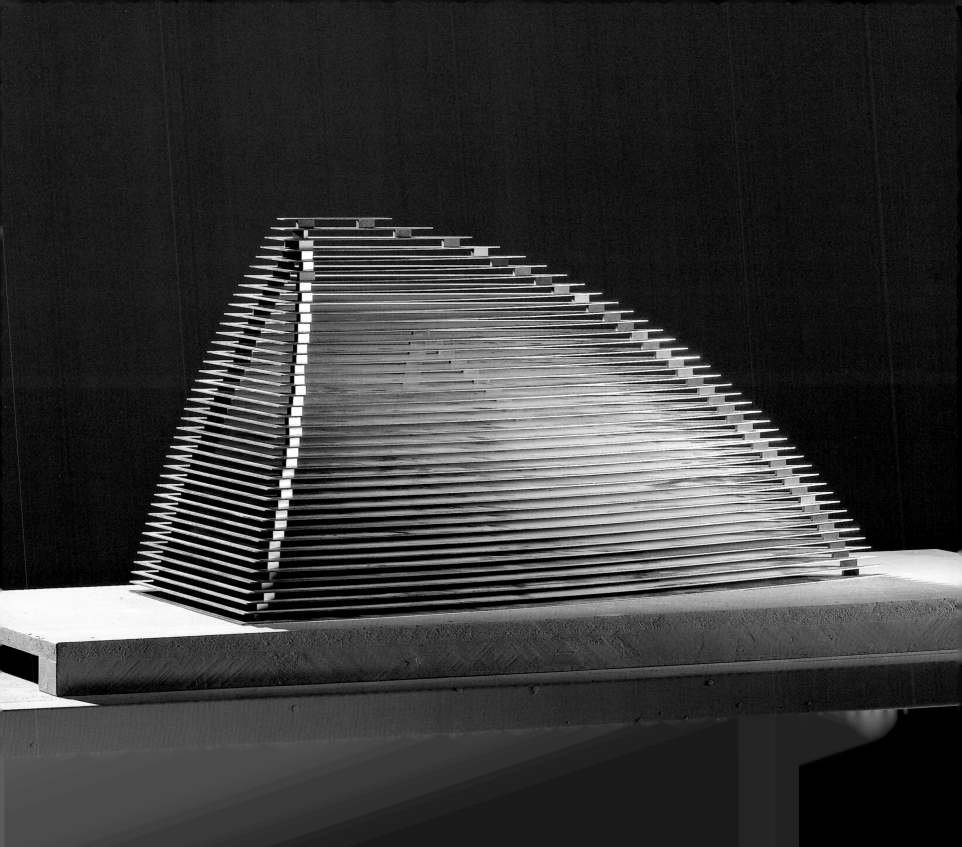

Die Kathedralen von Sellafield — *The cathedrals of Sellafield*

Standort — Location	Seascale, GBR
Jahr — Year	2004
Maße — Measurements	120 x 80 x 12 cm
Material — Material	Holz, Gips, Pappe
	Wood, plaster, cardboard

Sellafield Nuklear Komplex — *Sellafield nuclear complex*

Standort — Location	Seascale, GBR
Jahr — Year	2004
Maße — Measurements	120 x 80 x 12 cm
Material — Material	Holz, Gips, Pappe
	Wood, plaster, cardboard

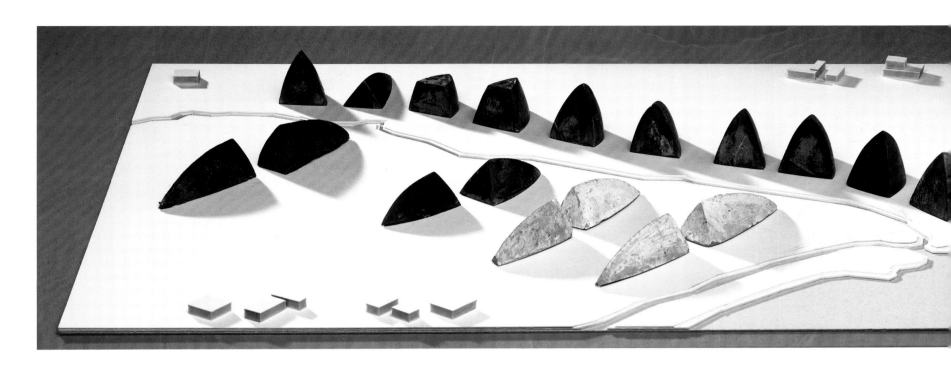

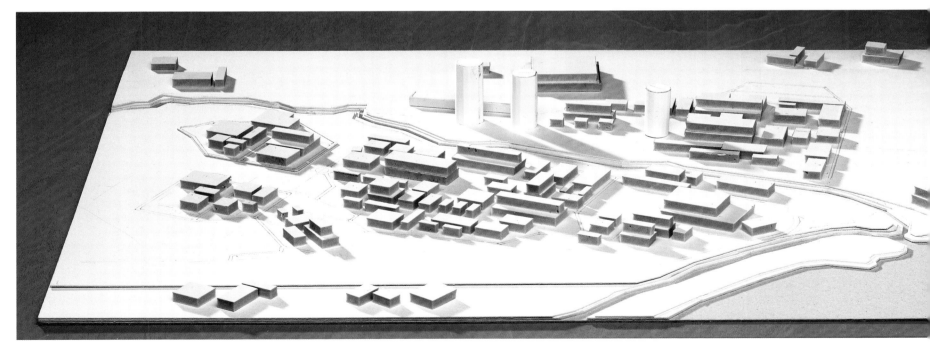

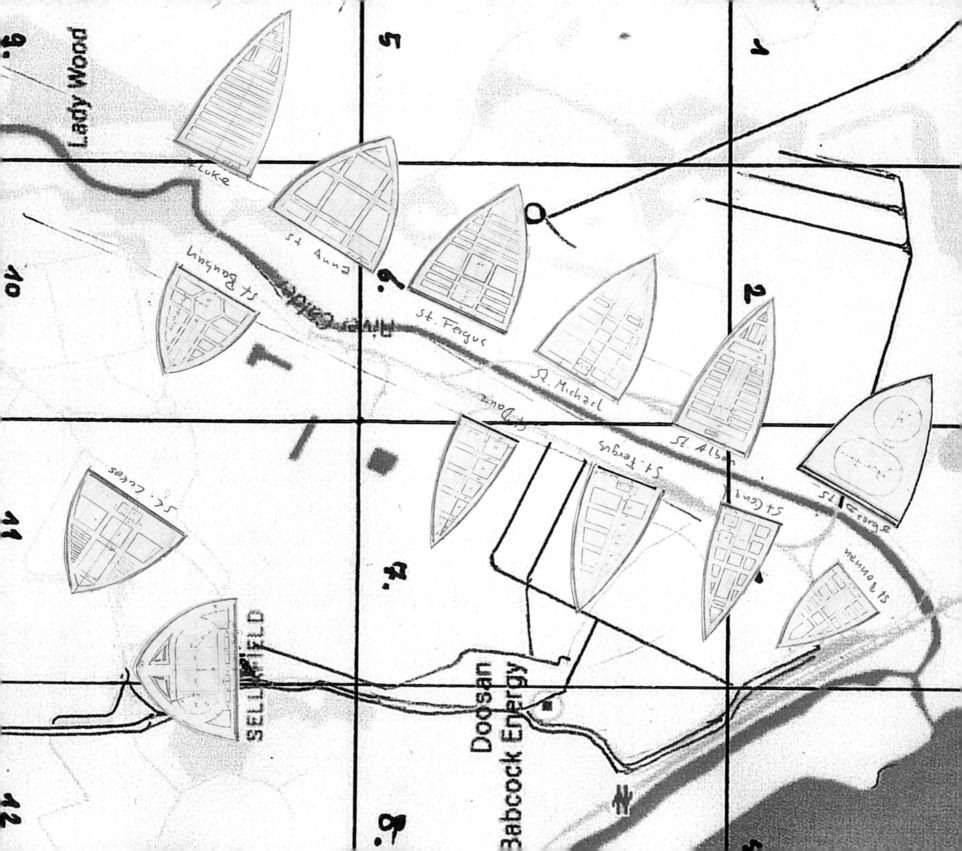

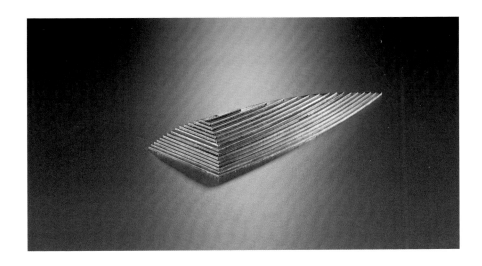

Die Kathedralen von Sellafield
The cathedrals of Sellafield

Standort — Location	Seascale, GBR
Jahr — Year	2004
Maße — Measurements	120 x 80 cm
Material — Material	Laserdruck, Pappe
	Laser print, cardboard

St. Alban Nukleardeponie
St. Alban nuclear waste dump

Volumen — Volume	2.500.000 t
Bautyp — Type	Nukleares Endlager
	Permanent nuclear repository
Jahr — Year	2011
Maße — Measures	23 x 11 x 7 cm
Material — Material	Eisen Acryllack
	Iron, acrylic lacquer

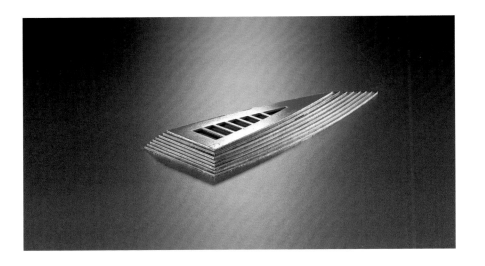

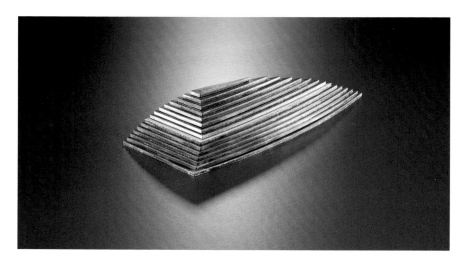

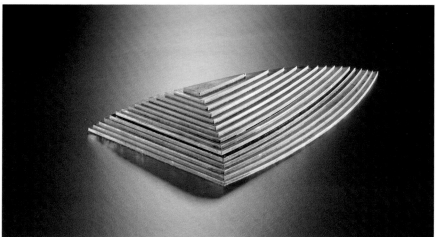

St. Donnan Nukleardeponie
St. Donnan nuclear waste dump

Volumen — *Volume*	4.500.000 t
Bautyp — *Type*	Nukleares Zwischenlager
	Intermediate nuclear repository
Jahr — *Year*	2011
Maße — *Measures*	24 x 8 x 6 cm
Material — *Material*	Eisen, Acryllack
	Iron, acrylic lacquer

St. Banbhan Nukleardeponie
St. Banbhan nuclear waste dump

Volumen — *Volume*	3.000.000 t
Bautyp — *Type*	Nukleares Endlager
	Permanent nuclear repository
Jahr — *Year*	2011
Maße — *Measures*	24 x 9 x 7 cm
Material — *Material*	Eisen, Acryllack
	Iron, acrylic lacquer

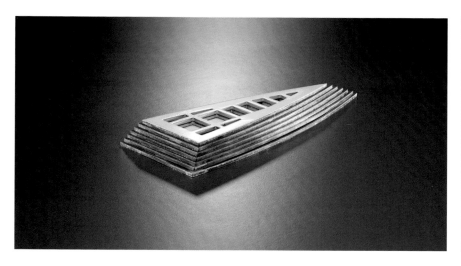

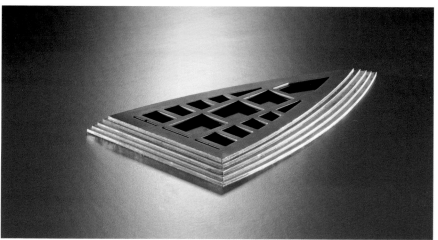

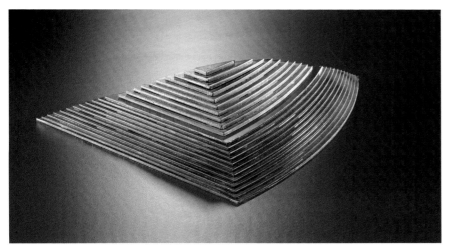

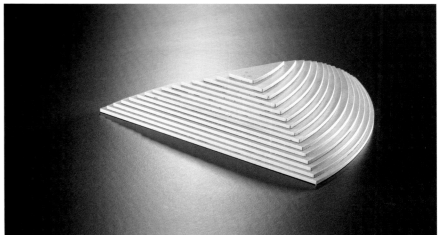

St. George Nukleardeponie
St. George nuclear waste dump

Volumen — Volume	6.000.000 t
Bautyp — Type	Nukleares Zwischenlager
	Intermediate nuclear repository
Jahr — Year	2011
Maße — Measures	27 x 13 x 11 cm
Material — Material	Eisen, Acryllack
	Iron, acrylic lacquer

St. Gilles Nukleardeponie
St. Gilles nuclear waste dump

Volumen — Volume	4.000.000 t
Bautyp — Type	Nukleares Endlager
	Permanent nuclear repository
Jahr — Year	2011
Maße — Measures	27 x 11 x 9 cm
Material — Material	Eisen, Acryllack
	Iron, acrylic lacquer

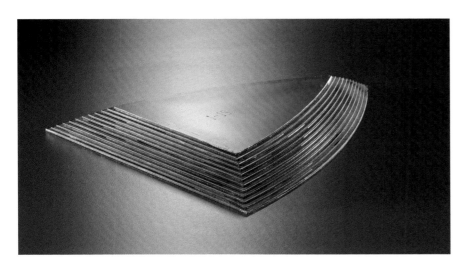

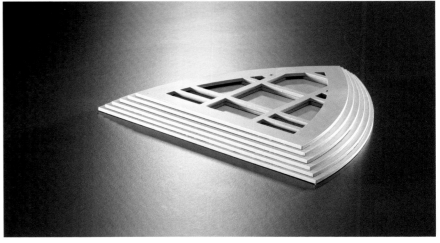

2.7/4
DIE WÄCHTER VON FUKUSHIMA

Am 11. März 2011 führte ein starkes Erdbeben und ein nachfolgender Tsunami in Japan zu einem Super-GAU im Kernkraftwerk Fukushima Daichi. In vier von sechs Reaktorblöcken kam es zu Explosionen und zur Kernschmelze und große Mengen an radioaktivem Material wurden freigesetzt.

Die beschädigten Reaktorblöcke sollen zum dauerhaften Schutz vor radioaktiver Strahlung in Form von überdimensionalen Wächter-Skulpturen nach den Proportionen des Isis-Tempels von Philae überbaut werden. Im Inneren der Wächter entstehen Deponieräume für radioaktiv verseuchtes Material. Durch die äußere Form und die Dimension werden die Wächter zu einem weithin sichtbaren Mahnmal der atomaren Gefahren.

2.7/4 The Guardians of Fukushima
On 11th March 2011 a powerful earthquake in Japan and the subsequent tsunami resulted in an unparalleled nuclear disaster in the Fukushima Daichi nuclear power station. Explosions and nuclear meltdown occurred in four of the six reactor blocks and large amounts of radioactive material were released.

To provide permanent protection from radiation, the damaged reactor blocks will be built over in the shape of oversized Guardian sculptures, based on the proportions of the Temple of Isis, Philae. Inside the Guardians storage units will be made for radioactively contaminated material. The outward shape and dimensions will make the Guardians into a monument to nuclear threat which is visible from a great distance.

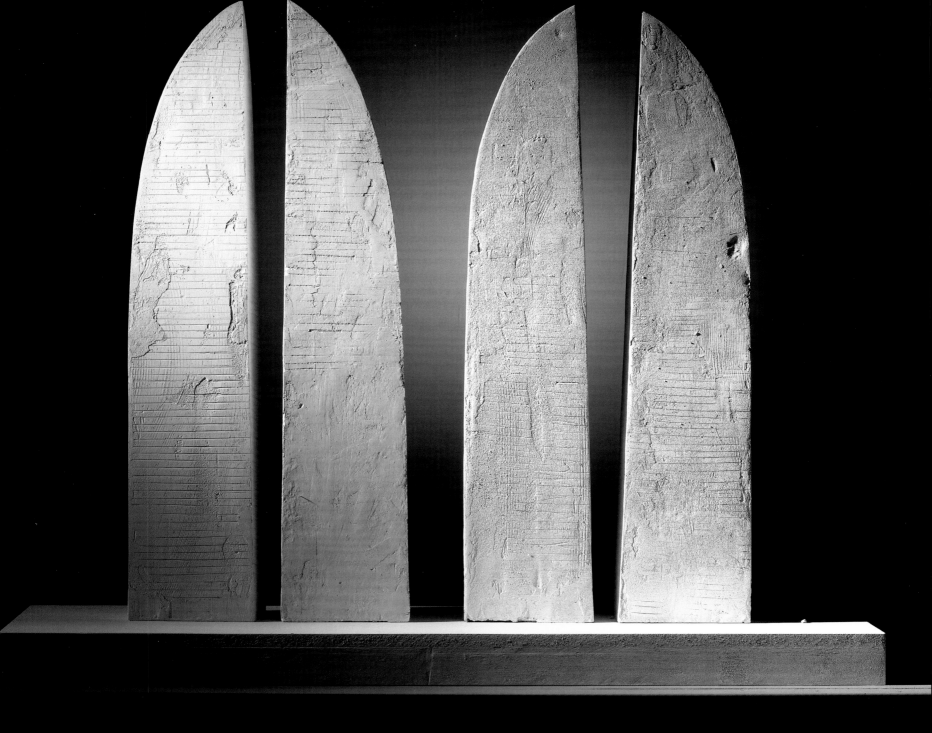

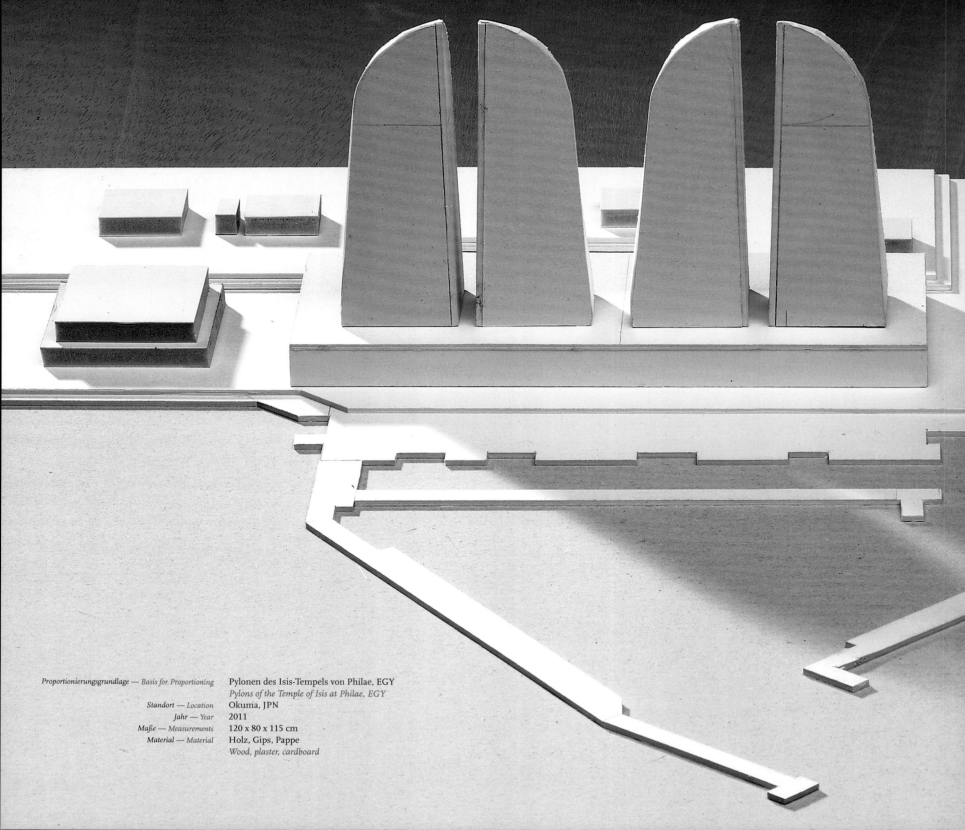

Proportionierungsgrundlage — Basis for Proportioning	Pylonen des Isis-Tempels von Philae, EGY
	Pylons of the Temple of Isis at Philae, EGY
Standort — Location	Okuma, JPN
Jahr — Year	2011
Maße — Measurements	120 x 80 x 115 cm
Material — Material	Holz, Gips, Pappe
	Wood, plaster, cardboard

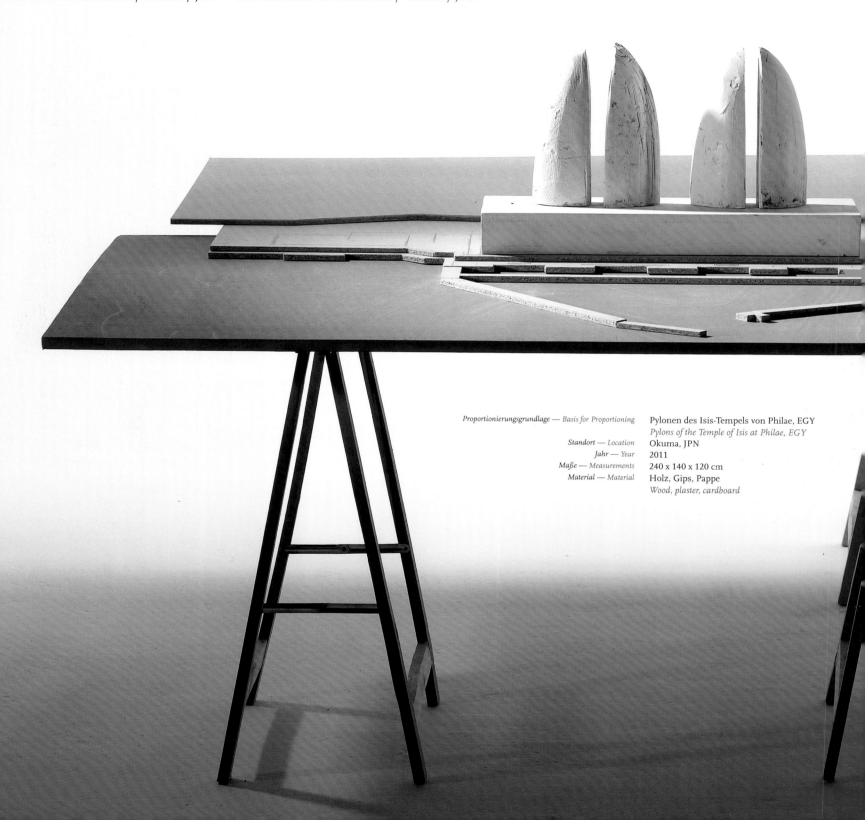

Proportionierungsgrundlage — Basis for Proportioning Pylonen des Isis-Tempels von Philae, EGY
Pylons of the Temple of Isis at Philae, EGY

Standort — Location Okuma, JPN

Jahr — Year 2011

Maße — Measurements 240 x 140 x 120 cm

Material — Material Holz, Gips, Pappe
Wood, plaster, cardboard

Proportionierungsgrundlage — Basis for Proportioning Pylonen des Isis-Tempels von Philae, EGY
Pylons of the Temple of Isis at Philae, EGY
Standort — Location Okuma, JPN
Jahr — Year 2011
Maße — Measurements 30 x 19 cm
Material — Material Laserdruck, Papier
Laser print, paper

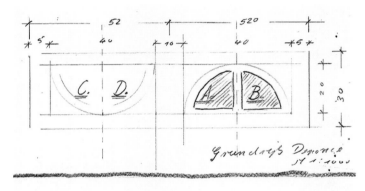

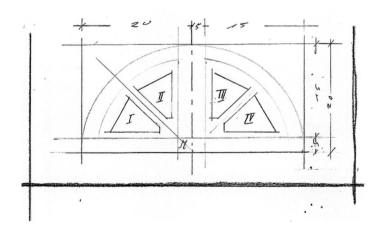

Proportionierungsgrundlage — Basis for Proportioning Pylonen des Isis-Tempels von Philae, EGY
Pylons of the Temple of Isis at Philae, EGY
Standort — Location Okuma, JPN
Jahr — Year 2011
Maße — Measurements 220 x 140 x 50 cm
Material — Material Styropor, Holz, Eisen
Styrofoam, wood, iron

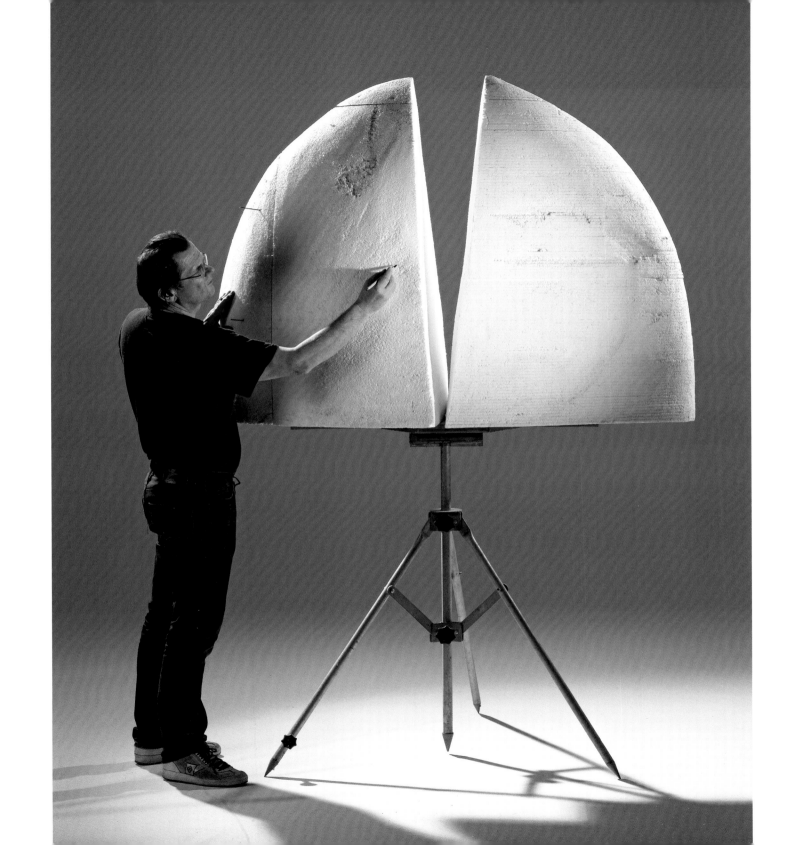

Proportionierungsgrundlage — Basis for Proportioning	Pylonen des Isis-Tempels von Philae, EGY
	Pylons of the Temple of Isis at Philae, EGY
Standort — Location	Okuma, JPN
Jahr — Year	2011
Maße — Measurements	40 x 15 cm
Material — Material	Laserdruck, Papier
	Laser print, paper

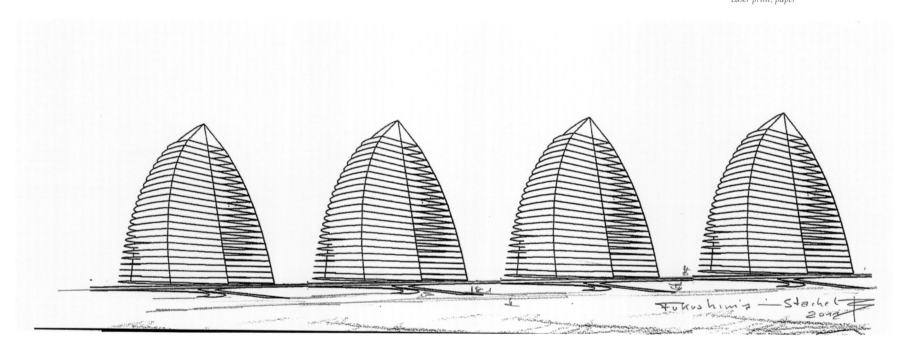

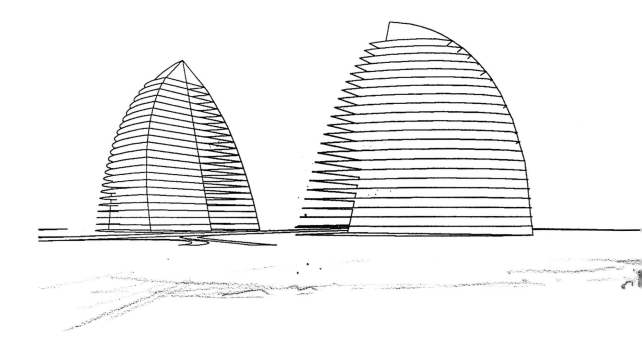

Geboren 1956 in Creglingen, DEU
1976–79 Lehre als Steinmetz und Holzbildhauer
1981–89 Studium an der Akademie der Bildenden Künste in Nürnberg, DEU
lebt und arbeitet in Nürnberg und Buch, DEU

http://winfried-baumann.de/

2016
KAPITAL HEIMAT, Projektraum Deutscher Künstlerbund, Berlin, DEU
KATHEDRALEN FÜR DEN MÜLL, Galerie Kunstraum Sterngasse, Nürnberg, DEU (S)
BLÜTEN IM VERBORGENEN, Han Gallery, Hawcheon, KOR (S)
DEEP SILENCE UND ANDERE HINTERLASSENSCHAFTEN, Halle für neue Kunst, Röttingen, DEU (S)

2015
TOUS POUR TOUS, Les Chiroux Centre Culturel Lüttich, BEL
PILGER UND ANDERE NOMADEN, Fränkisches Spitalmuseum Aub, DEU (S)
MINI SIZE ART, M.I.K.C Kunststation Delden, NLD
LOLA RENNT, Deutsches Nationaltheater Weimar, DEU
DER WEG DER KUNIGUNDE, Kunstprozession von Aub nach Bamberg, DEU
URBAN NOMADS STORE, Stadtraum Hildesheim, DEU (S)
EUROPEAN HOMELESS CUP 2015, Breitscheidplatz Berlin, DEU

2014
INSTANT HOUSING, PUBLIC NAPPING, Moskovskij Park Pobedy, St. Petersburg, RUS (S)
RELAXATION STATION, Contemporary Art Space, Hawcheon, KOR (S)
URBAN NOMADS WALL SPACE, Kunstdepot, Röttingen, DEU (S)
PREPPER, Galerie Kunstraum Sterngasse, Nürnberg, DEU (S)

Born 1956 in Creglingen, DEU
1976–79 Apprenticeship as a stonemason and sculptor in wood
1981–89 Study at the Academy of Fine Arts in Nuremberg, DEU
lives and works in Nuremberg and Buch, DEU

http://winfried-baumann.de/

2016
KAPITAL HEIMAT, Projektraum Deutscher Künstlerbund, Berlin DEU
KATHEDRALEN FÜR DEN MÜLL, Galerie Kunstraum Sterngasse, Nuremberg, DEU (S)
BLÜTEN IM VERBORGENEN, Han Gallery, Hawcheon, KOR (S)
DEEP SILENCE UND ANDERE HINTERLASSENSCHAFTEN, Halle für neue Kunst, Röttingen, DEU (S)

2015
TOUS POUR TOUS, Les Chiroux Centre Culturel Liège, BEL
PILGER UND ANDERE NOMADEN, Fränkisches Spitalmuseum Aub, DEU (S)
MINI SIZE ART, M.I.K.C Kunststation Delden, NLD
LOLA RENNT, Deutsches Nationaltheater Weimar, DEU
DER WEG DER KUNIGUNDE, art procession from Aub to Bamberg, DEU
URBAN NOMADS STORE, Stadtraum Hildesheim, DEU (S)
EUROPEAN HOMELESS CUP 2015, Breitscheidplatz Berlin, DEU

2014
INSTANT HOUSING, PUBLIC NAPPING, Moskovskij Park Pobedy, St. Petersburg, RUS (S)
RELAXATION STATION, Contemporary Art Space, Hawcheon, KOR (S)
URBAN NOMADS WALL SPACE, Kunstdepot, Röttingen, DEU (S)
PREPPER, Galerie Kunstraum Sterngasse, Nuremberg, DEU (S)

TOPF UND DECKEL, Museum Villa Zandes, Bergisch Gladbach, DEU
UN EXPOSITION CONCUE ET REALISEE, New Gallery, Vancouver, CAN
BIENVENUE DANS L'UNIVERSE ARTISTIQUE, Grunt Gallery, Vancouver, CAN
REST ART WORKE, Alte Kraftwerkshalle, Krakau, POL

2013
INSTANT HOUSING – STRASSE FÜR ALLE, Corso Umberto, Turin, ITA (S)
MEIN RECHT DRAUSSEN AUF DER STRASSE, Toskanische Säulenhalle, Zeughaus, Augsburg, DEU (S)
KUNST TROTZ(T) ARMUT, documenta-Halle, Kassel, DEU

2012
GRENZLINIEN, Ausstellungshalle Goethe-Universität Frankfurt, DEU
5 JAHRE, 5 WOCHEN, 5 SINNE, INSTANT COOKING, Arp Museum, Bahnhof Rolandseck, DEU
GRENZRAUM, Projekt-Display Frankfurter Kunstverein, DEU (S)
30 KÜNSTLER / 30 RÄUME, Galerie Kunstraum Sterngasse, Institut für moderne Kunst Nürnberg, Kunsthalle Nürnberg, Kunstverein Nürnberg – Albrecht Dürer Gesellschaft und Neues Museum – Staatliches Museum für Kunst und Design in Nürnberg, DEU

2011
I LOVE ALDI, DIE ALDISIERUNG DER KUNST, (Kunstautomat Sterngasse in Zusammenarbeit mit Anna Bien), Wilhem-Hack-Museum, Ludwigshafen, DEU
NEW HOME, Perron 1, Galerie voor installaties, M.I.K.C., Delden, NLD
ATSA 10 ANS D'URGENCE @ MERCIER, Maison de la culture de Côte-des-Neiges, Montreal, CAN
ARMUT – PERSPEKTIVEN IN KUNST UND GESELLSCHAFT, Stadtmuseum Simeonstift, Trier, und Museum der Brotkultur, Ulm, DEU
URBAN NOMADS DRESSCODE, Galerie Kunstraum Sterngasse, Nürnberg, DEU (S)
KUNST TROTZ(T) ARMUT, Städtische Galerie Rosenheim, DEU

2010
LA BIENNALE INTERNATIONAL DESIGN, Saint-Étienne, FRA
ÉTAT D'URGENCE, ATSA – ACTION TERRORISTE SOCIALMENT ACCEPTABLE, Montreal, CAN
ÜBER GRENZEN, Kultursommer Rheinland-Pfalz, Mainz, DEU
METRO, Galerie Kunstraum Sterngasse, Nürnberg, DEU (S)
CAGEMAN, Kaspar Hauser Festival, Kunsthaus Reitbahn, Ansbach, DEU (S)
INSTANT HOUSING „STRASSENKREUZER", Galerie Kunstraum Sterngasse, Nürnberg, DEU (S)

2009
CITÉ DU DESIGN, L'OBJET DU DESIGN, Saint-Étienne, FRA
ESTUAIRE, BIENNALE FOR CONTEMPORARY ART, Nantes/St. Nazaire, FRA
KAAILAND ZUID, ANTWERPEN OPEN VZW, Antwerpen, BEL
PUBLIC DESIGN FESTIVAL MILANO, Esterni und Goethe Institut Mailand, ITA (S)
KUNST TROTZ(T) ARMUT, Diakonie Bayern, Kirche St. Lorenz, Nürnberg, DEU
MY PRIVATE LAND 2, Galerie Kunstraum Sterngasse, Nürnberg, DEU

2008
URBAN NOMADS, Municipal Art Museum, Hawchon, KOR (S)
INSTANT HOUSING – zum 40. Jubiläum der Wohnungsnotfallhilfe des Caritasverbandes für Stuttgart e.V., Kunstmuseum Stuttgart, DEU (S)
DAS GELÄNDE, Kunsthalle Nürnberg, DEU
CAGEMAN, Galerie Kunstraum Sterngasse, Nürnberg, DEU (S)

2007
FUSSBAD FÜR ALLE – BEIM GASTSPIEL 2007 DES KULTURRING C, Galerie Atelier Mona Burger, Fürth, DEU (S)

TOPF UND DECKEL, Museum Villa Zandes, Bergisch Gladbach, DEU
UN EXPOSITION CONCUE ET REALISEE, New Gallery, Vancouver, CAN
BIENVENUE DANS L'UNIVERSE ARTISTIQUE, Grunt Gallery, Vancouver, CAN
REST ART WORKE, Alte Kraftwerkshalle, Krakau, POL

2013
INSTANT HOUSING – STRASSE FÜR ALLE, Corso Umberto, Turin, ITA (S)
MEIN RECHT DRAUSSEN AUF DER STRASSE, Toskanische Säulenhalle, Zeughaus, Augsburg, DEU
KUNST TROTZ(T) ARMUT, documenta-Halle in Kassel, DEU

2012
GRENZLINIEN, exhibition hall, Goethe University Frankfurt, DEU
5 JAHRE, 5 WOCHEN, 5 SINNE, INSTANT COOKING, Arp Museum, Bahnhof Rolandseck, DEU
GRENZRAUM, project display, Frankfurter Kunstverein, DEU (S)
30 KÜNSTLER / 30 RÄUME, Galerie Kunstraum Sterngasse, Institut für moderne Kunst Nürnberg, Kunsthalle Nürnberg, Kunstverein Nürnberg – Albrecht Dürer Gesellschaft and Neues Museum – Staatliches Museum für Kunst und Design in Nürnberg, DEU

2011
I LOVE ALDI, DIE ALDISIERUNG DER KUNST, (Kunstautomat Sterngasse in collaboration with Anna Bien), Wilhem-Hack-Museum, Ludwigshafen, DEU
NEW HOME, Perron 1, Galerie voor installaties, M.I.K.C., Delden, NLD
ATSA 10 ANS D'URGENCE @ MERCIER, Maison de la culture de Côte-des-Neiges, Montreal, CAN
ARMUT – PERSPEKTIVEN IN KUNST UND GESELLSCHAFT, Stadtmuseum Simeonstift, Trier, and Museum der Brotkultur, Ulm, DEU
URBAN NOMADS DRESSCODE, Galerie Kunstraum Sterngasse, Nuremberg, DEU (S)
KUNST TROTZ(T) ARMUT, Städtische Galerie Rosenheim, DEU

2010
LA BIENNALE INTERNATIONAL DESIGN SAINT ÉTIENNE, FRA
ÉTAT D'URGENCE, ATSA – ACTION TERRORISTE SOCIALMENT ACCEPTABLE, MONTREAL, CAN
ÜBER GRENZEN, Kultursommer Rheinland-Pfalz, Mainz, DEU
METRO, Galerie Kunstraum Sterngasse, Nuremberg, DEU (S)
CAGEMAN, Kaspar Hauser Festival, Kunsthaus Reitbahn, Ansbach, DEU (S)
INSTANT HOUSING "STRASSENKREUZER", Galerie Kunstraum Sterngasse, Nuremberg, DEU (S)

2009
CITÉ DU DESIGN, L'OBJET DU DESIGN, Saint Étienne, FRA
ESTUAIRE, BIENNALE FOR CONTEMPORARY ART, Nantes/St. Nazaire, FRA
KAAILAND ZUID, ANTWERPEN OPEN VZW, Antwerp, BEL
PUBLIC DESIGN FESTIVAL MILANO, Esterni and Goethe Institute Milan, ITA (S)
KUNST TROTZ(T) ARMUT, Diakonie Bayern, Church of St. Lorenz, Nuremberg, DEU
MY PRIVATE LAND 2, Galerie Kunstraum Sterngasse, Nuremberg, DEU

2008
URBAN NOMADS, Municipal Art Museum, Hawchon, KOR (S)
INSTANT HOUSING – To mark the 40th anniversary of Wohnungsnotfallhilfe des Caritasverbandes für Stuttgart e.V., Kunstmuseum Stuttgart, DEU (S)
DAS GELÄNDE, Kunsthalle Nürnberg, DEU
CAGEMAN, Galerie Kunstraum Sterngasse, Nuremberg, DEU (S)

2007
FUSSBAD FÜR ALLE – GASTSPIEL 2007 DES KULTURRING C, Galerie Atelier Mona Burger, Fürth, DEU (S)

KATASTROPHEN II – DER KUNSTVEREIN GRAZ, REGENSBURG SCHLÄGT ZURÜCK, Galerie Bernsteinzimmer Nürnberg, DEU
INSTANT COOKING, Städtische Galerie Bietigheim-Bissingen, DEU (S)
DAS MODELL ALS MATRIX & METAPHER, Kunsthaus Nürnberg, DEU
HOME STORIES, Zwischen Dokumentation und Fiktion, Stadtgalerie Kiel und Städtische Galerie Wolfsburg, DEU
INSTANT HOUSING „GURKENFLIEGER", Designmai 2007, Berlin, DEU
INSTANT HOUSING, Galerie Kunstraum Sterngasse Nürnberg, DEU (S)

2006
AUF DER STRASSE NICHT ALLEIN, NACHT DER WOHNUNGSLOSENHILFE, Bahnhof Zoo, Berlin, DEU (S)
25 JAHRE „FRISCH GESTRICHEN", Galerie Kunstraum Sterngasse Nürnberg, DEU
KATASTROPHEN I, Kunstverein GRAZ, Regensburg, DEU
FERNWÄRME – DAS REISEBÜRO DER BESONDEREN ART, 2. KUNSTHORTEN 2006, Dortmund, DEU
TOD, eckstein – das haus der evang.-luth. Kirche, Nürnberg, DEU
ENTRY 2006 – WIE WERDEN WIR MORGEN LEBEN?, PLATTFORM DESIGNCITY, stadt.bau.raum, Gelsenkirchen, DEU
HOME STORIES, ZWISCHEN DOKUMENTATION UND FIKTION, Städtische Galerie Bietigheim-Bissingen, DEU
DORMART, Internationales Kunstprojekt zum Thema „Schlaf", Depot Dortmund, DE
DESIGN>CITY, Designmai 06, Berlin, DEU
VOM SORGENKIND ZUM WUNDERGREIS – BAZON BROCKS LUSTMARSCH DURCHS THEORIE-GELÄNDE, Schirn Kunsthalle Frankfurt, DEU

2005
SHOTS ON BRAVE NEW WORLDS, Designfilmpool, Berlin, DEU
FUSSBAD FÜR ALLE, BLAUE NACHT 2005, Galerie Kunstraum Sterngasse Nürnberg, DEU (S)
„JUNG + DEUTSCH", Art Front Gallery und Goethe Institut Tokio, JPN
NACHSOMMER 2005, Kulturforum Ernst-Sachs-Bad, Schweinfurt, DE
PFLEGEKUNST, Stadthaus Ulm, DEU
INSTANT HOUSING H-3, Galerie Kunstraum Sterngasse Nürnberg, DEU (S)
INSTANT HOUSING, Berliner Kunstsalon in der ARENA, Berlin, DEU

2004
INSTANT HELP, Kulturhaus Skopje – Mazedonien, MK, und Galerie Kunstraum Sterngasse, Nürnberg, DEU (S)
ARENAPROJEKT – LEERSTAND UND FUSSBAD FÜR ALLE, Stadtraum Aub, DEU (S)
INSTANT HOUSING SW02-04, Städtische Sammlungen Schweinfurt, DEU (S)
PAARLAUF HAMBURG – NÜRNBERG, Kunsthaus Hamburg, DEU
XTREME HOUSES, Halle 14, Leipziger Baumwollspinnerei, Leipzig, DEU
LICHT FELD 4, Gundelfinger Feld, Basel, CHE
XTREME HOUSES, lothringer13, Städtische Kunsthalle München, DEU

2003
INSTANT HELP, Galerie Kunstraum Sterngasse, Nürnberg, DEU (S)
INSTANT HOUSING UND INSTANT HELP, MIGRATION, STEIRISCHER HERBST 2003, Graz, AUT (S)
INSTANT HOUSING VERSUCHSANORDNUNG, Zugspitze, DEU (S)
GESICHTER DES SÜDENS, Karl-Bröger Platz, Nürnberg, DEU (S)
LICHT FELD 3, Gundelfinger Feld, Basel, CHE
PAARLAUF, HAMBURG – NÜRNBERG, Kunsthaus Nürnberg, DEU

2002
BESIEDLUNG F13 PROJEKT, INSTANT HOUSING MIT DEM STRASSENMAGAZIN AUGUSTIN, Wien, AUT (S)
NO HOME – INSTANT HOUSING MIT DEM OBDACHLOSENMAGAZIN SURPRISE, Zürich, CHE (S)

KATASTROPHEN II – DER KUNSTVEREIN GRAZ, REGENSBURG SCHLÄGT ZURÜCK, Galerie Bernsteinzimmer Nuremberg, DEU
INSTANT COOKING, Städtische Galerie Bietigheim-Bissingen, DEU (S)
DAS MODELL ALS MATRIX & METAPHER, Kunsthaus Nürnberg, DEU
HOME STORIES, ZWISCHEN DOKUMENTATION UND FIKTION, Stadtgalerie Kiel and Städtische Galerie Wolfsburg, DEU
INSTANT HOUSING "GURKENFLIEGER", Designmai 2007, Berlin, DEU
INSTANT HOUSING, Galerie Kunstraum Sterngasse, Nuremberg, DEU (S)

2006
AUF DER STRASSE NICHT ALLEIN, NACHT DER WOHNUNGSLOSENHILFE, Bahnhof Zoo, Berlin, DEU (S)
25 JAHRE "FRISCH GESTRICHEN", Galerie Kunstraum Sterngasse, Nuremberg, DEU
KATASTROPHEN I, Kunstverein GRAZ, Regensburg, DEU
FERNWÄRME – DAS REISEBÜRO DER BESONDEREN ART, 2. kunsthorten 2006, Dortmund, DEU
TOD, eckstein – das haus der evang.-luth. Kirche, Nuremberg, DEU
ENTRY 2006 – WIE WERDEN WIR MORGEN LEBEN?, Plattform DESIGNCITY, stadt.bau.raum, Gelsenkirchen, DEU
HOME STORIES, ZWISCHEN DOKUMENTATION UND FIKTION, Städtische Galerie Bietigheim-Bissingen, DEU
DORMART, International art-project for sleeping, Depot Dortmund, DE
DESIGN>CITY, DESIGNMAI 06, Berlin, DEU
VOM SORGENKIND ZUM WUNDERGREIS – BAZON BROCKS LUSTMARSCH DURCHS THEORIE-GELÄNDE, Schirn Kunsthalle Frankfurt, DEU

2005
SHOTS ON BRAVE NEW WORLDS, Designfilmpool, Berlin, DEU
FUSSBAD FÜR ALLE, BLAUE NACHT 2005, Galerie Kunstraum Sterngasse, Nuremberg, DEU (S)
"JUNG + DEUTSCH", Art Front Gallery and Goethe Institute Tokyo, JPN
NACHSOMMER 2005, Kulturforum Ernst-Sachs-Bad, Schweinfurt, DEU
PFLEGEKUNST, Stadthaus Ulm, DEU
INSTANT HOUSING H-3, Galerie Kunstraum Sterngasse, Nuremberg, DEU (S)
INSTANT HOUSING, Berliner Kunstsalon in ARENA, Berlin, DEU

2004
INSTANT HELP, Kulturhaus Skopje – Mazedonien MK and Galerie Kunstraum Sterngasse, Nuremberg, DEU (S)
ARENAPROJEKT – LEERSTAND UND FUSSBAD FÜR ALLE, in the streets of Aub (S)
INSTANT HOUSING SW02-04, Städtische Sammlungen Schweinfurt (S)
PAARLAUF HAMBURG – NÜRNBERG, Kunsthaus Hamburg, DEU
XTREME HOUSES, Halle 14, Leipziger Baumwollspinnerei, Leipzig, DEU
LICHT FELD 4, Gundelfinger Feld, Basel, CHE
XTREME HOUSES, lothringer13, Städtische Kunsthalle, Munich, DEU

2003
INSTANT HELP, Galerie Kunstraum Sterngasse, Nuremberg, DEU (S)
INSTANT HOUSING UND INSTANT HELP, MIGRATION, STEIRISCHER HERBST 2003, Graz, AUT (S)
INSTANT HOUSING VERSUCHSANORDNUNG, Zugspitze, DEU (S)
GESICHTER DES SÜDENS, Karl-Bröger Platz, Nuremberg, DEU (S)
LICHT FELD 3, Gundelfinger Feld, Basel, CHE
PAARLAUF HAMBURG – NÜRNBERG, Kunsthaus Nürnberg, DEU

2002
BESIEDLUNG F13 PROJEKT, INSTANT HOUSING WITH THE STREET MAGAZINE AUGUSTIN, Vienna, AUT (S)
NO HOME – INSTANT HOUSING WITH THE MAGAZINE FOR THE HOMELESS SURPRISE, Zurich, CHE (S)

DACH ÜBER DEM KOPF – INSTANT HOUSING MIT DEM OBDACHLOSENMAGAZIN SURPRISE, Basel, CHE (S)
INSTANT HOUSING – DIE STRASSE IST FÜR ALLE DA, fiftyfifty Galerie, Düsseldorf, DEU (S)
INSTANT HOUSING MIT DEM STRASSENMAGAZIN TAGESSATZ, Karlsplatz, Kassel, DEU (S)
INSTANT HOUSING, KUNSTAKTION MIT DER OBDACHLOSENZEITUNG TAGESSATZ, Göttingen, DEU (S)
INSTANT HOUSING, KUNSTAKTION MIT DEM STRASSENMAGAZIN NOTAUSGANG, Jena, DEU (S)
INSTANT COOKING, BLAUE NACHT, Galerie Kunstraum Sterngasse, Nürnberg, DEU (S)
20 JAHRE FRISCH GESTRICHEN, Galerie Kunstraum Sterngasse, Nürnberg, DEU
STAND DER DINGE 1, KREIS Galerie, Nürnberg, DEU
LICHTFELD N2, BMF-Museum, Bayerische Metallwarenfabrik GmbH, Nürnberg, DEU
INSTANT MEMORIALS, CONSUMENTART, Nürnberg, DEU
AUF DER SPUR DES HASEN – 500 JAHRE DÜRER HASE, Ehrenhalle des Rathauses, Nürnberg, DEU

2001
INSTANT HOUSING CAMP, KUNSTAKTION MIT DEN STRASSENMAGAZINEN FLATZ UND BISS, Karlsplatz, München, DEU (S)
INSTANT HOUSING WBF-240, Showroom der Galerie Lindig in Paludetto, Nürnberg, DEU (S)
WIR HABEN MUTIGE HERZEN, INSTANT MEMORIALS, Galerie in der Pfahlstraße, Eichstätt, DEU (S)
INSIDE AND OUT, TEIL 2, Blindeninstitut Rückersdorf, DEU (mit Anna Bien)

2000
ZEITWEISEN – KUNST IN DER LORENZKIRCHE, St. Lorenz, Nürnberg, DEU

1999
INSTANT MEMORIALS, Hospitalhof Stuttgart, DEU (S)
ERNTEDANK – KÜNSTLERDANK MIT BAZON BROCK, Künstlerverein Malkasten, Düsseldorf, DE
SEOUL – DIALOG – HAMBURG, Total Museum of Contemporary Art, Seoul, KOR

1998
INSIDE AND OUT, Kumamoto Prefectural Museum of Art, Kumamoto, JPN (mit Anna Bien)
50 JAHRE KÜNSTLERGRUPPE DER KREIS, Kunsthalle Nürnberg, DEU

1997
MONUMENTS, Galerie ars videndi, Pfaffenhofen, DEU (S)
SEOUL – DIALOG – HAMBURG, Kampnagel, Hamburg, DEU

1996
KUNSTRAUM KIRCHE, Landeskirchliches Museum Friedenskirche, Ludwigsburg, DEU

1995
MOSTY, Výstavni síň Mánes, Prag, CZE
FORMAT XL, KÜNSTLERGRUPPE DER KREIS, Kunsthaus Nürnberg, DEU
50 JAHRE FRIEDEN, St. Lorenz, Nürnberg, DEU

1994
DER KREIS IN STEIN, Schloss Faber-Castell, Stein, DEU

1993
STUMMER FRÜHLING, Kunsthaus Nürnberg, DEU (S)
ATLANTIKWALL, KUNST IM AUTOHAUS PILLENSTEIN, Fürth, DEU (S)
FRISCH GESTRICHEN, Kunstverein Kohlenhof, Nürnberg, DEU
KUNSTRAUMFRANKEN, Kunsthalle Nürnberg, DEU

DACH ÜBER DEM KOPF – INSTANT HOUSING WITH THE MAGAZINE FOR THE HOMELESS SURPRISE, Basel, CHE (S)
INSTANT HOUSING – DIE STRASSE IST FÜR ALLE DA, fiftyfifty Galerie, Düsseldorf, DEU (S)
INSTANT HOUSING WITH THE STREET MAGAZINE TAGESSATZ, Karlsplatz, Kassel, DEU (S)
INSTANT HOUSING, ART ACTION WITH THE NEWSPAPER FOR THE HOMELESS TAGESSATZ, Göttingen, DEU (S)
INSTANT HOUSING, ART ACTION WITH THE STREET MAGAZINE NOTAUSGANG, Jena, DEU (S)
INSTANT COOKING, BLAUE NACHT, Galerie Kunstraum Sterngasse, Nuremberg, DEU (S)
20 JAHRE FRISCH GESTRICHEN, Galerie Kunstraum Sterngasse, Nuremberg, DEU
STAND DER DINGE 1, KREIS Galerie, Nuremberg, DEU
LICHTFELD N2, BMF-Museum, Bayerische Metallwarenfabrik GmbH, Nuremberg, DEU
INSTANT MEMORIALS, ConsumentART, Nuremberg, DEU
AUF DER SPUR DES HASEN – 500 JAHRE DÜRER HASE, Hall of Honour in the Town Hall, Nuremberg, DEU

2001
INSTANT HOUSING CAMP, ART ACTION WITH THE STREET MAGAZINES FLATZ AND BISS, Karlsplatz, Munich, DEU (S)
INSTANT HOUSING WBF 240, showroom of Galerie Lindig in Paludetto, Nuremberg, DEU (S)
WIR HABEN MUTIGE HERZEN, INSTANT MEMORIALS, Galerie in der Pfahlstraße, Eichstätt, DEU (S)
INSIDE AND OUT, Part 2, Institute for the Blind, Rückersdorf, DEU (with Anna Bien)

2000
ZEITWEISEN – KUNST IN DER LORENZKIRCHE, Church of St. Lorenz, Nuremberg, DEU

1999
INSTANT MEMORIALS, Hospitalhof Stuttgart, DEU (S)
ERNTEDANK – KÜNSTLERDANK MIT BAZON BROCK, Künstlerverein Malkasten, Düsseldorf, DEU
SEOUL – DIALOG – HAMBURG, Total Museum of Contemporary Art, Seoul, KOR

1998
INSIDE AND OUT, Kumamoto Prefectural Museum of Art, Kumamoto, JPN (with Anna Bien)
50 JAHRE KÜNSTLERGRUPPE DER KREIS, Kunsthalle Nürnberg, DEU

1997
MONUMENTS, Galerie ars videndi, Pfaffenhofen, DEU (S)
SEOUL – DIALOGUE – HAMBURG, Kampnagel, Hamburg, DEU

1996
KUNSTRAUM KIRCHE, Landeskirchliches Museum Friedenskirche, Ludwigsburg, DEU

1995
MOSTY, Výstavni síň Mánes, Prague, CZE
FORMAT XL, KÜNSTLERGRUPPE DER KREIS, Kunsthaus Nürnberg, DEU
50 JAHRE FRIEDEN, St. Lorenz, Nuremberg, DEU

1994
DER KREIS IN STEIN, Schloss Faber-Castell, Stein, DEU

1993
STUMMER FRÜHLING, Kunsthaus Nürnberg, DEU (S)
ATLANTIKWALL, KUNST IM AUTOHAUS PILLENSTEIN, Fürth, DEU (S)
FRISCH GESTRICHEN, Kunstverein Kohlenhof, Nuremberg, DEU
KUNSTRAUMFRANKEN, Kunsthalle Nürnberg, DEU

1992
VERSTÄNDIGUNG IM BIENENSTAAT, Produzentengalerie Karg e. V., Oldenburg, DEU (S)
FRISCH GESTRICHEN, Kunstkreis JURA, Historisches Reitstadel, Neumarkt, DEU
FREMD, Werkschule Oldenburg, DEU
10 JAHRE „FRISCH GESTRICHEN", Galerie Näke, Nürnberg, DEU
HORNSCHUCHPROMENADE – KUNST IN FÜRTH 92, Kulturring C, Stadtraum Fürth, DEU
POSITIONEN + TENDENZEN – JUNGE KUNST IN FRANKEN, Schloss Faber-Castell, Stein, DEU

1991
OFF ROAD KALLIGOS, Galerie Näke, Nürnberg, DEU (S)
ZWANZIG SOCKEL, Kulturring C, Stadthalle Fürth, DEU
5 X KISTE UND 1X KASTEN, Kunstverein Kohlenhof, Nürnberg, DEU
WODKA KAKAO FÜR KNUT, Galerie Näke, Nürnberg, DEU

1990
ZEHNVORZWEITAUSEND, Künstlergruppe Der Kreis, Hauptmarkt, Nürnberg, DEU

1989
DEBÜTANTENPREIS DES FREISTAATES BAYERN, Kunstverein Kohlenhof, Nürnberg, DEU (S)
GOLDBREULER UND ANDERE FLIEGER, Galerie Näke, Nürnberg, DEU (S)
FRISCH: GRUPPE FRISCH GESTRICHEN, Kunsthaus Nürnberg, DEU

1988
NEW YORK WATERFRONT, Municipal Art Society of New York, USA
UNTER OFFENEM HIMMEL, Galerie Näke, Katharinenkloster, Nürnberg, DEU

1987
INTERNATIONAL GROUP ART WORK, GRUPPE FRISCH GESTRICHEN, Gesamthochschule Kassel, DEU
KREIS IM FLUSS, AKTION AUF DER PEGNITZ MIT DER KÜNSTLERGRUPPE DER KREIS, Nürnberg, DEU
SWESCHI (FRISCH), Kabelmetallfabrik, Nürnberg, DEU (mit Karl Veitz, Fred Ziegler, Roland M. Beck und Michael Reiter)
UNTER OFFENEM HIMMEL, Galerie Näke, Katharinenkloster, Nürnberg, DEU

1986
GROSSE KUNSTAUSSTELLUNG MÜNCHEN, Haus der Kunst, München, DEU

1985
BILD BOTSCHAFT BILD, Deutsche Gesellschaft für christliche Kunst, München, DEU
EINZELZELLE – AMNESTY INTERNATIONAL, St. Sebald, Nürnberg, DEU

(S) = Einzelausstellung

1992
VERSTÄNDIGUNG IM BIENENSTAAT, Produzentengalerie Karg e. V., Oldenburg, DEU (S)
FRISCH GESTRICHEN, Kunstkreis JURA, Historisches Reitstadel, Neumarkt, DEU
FREMD, Werkschule Oldenburg, DEU
10 JAHRE "FRISCH GESTRICHEN", Galerie Näke, Nuremberg, DEU
HORNSCHUCHPROMENADE – KUNST IN FÜRTH 92, Kulturring C, in the streets of Fürth, DEU
POSITIONEN + TENDENZEN – JUNGE KUNST IN FRANKEN, Schloss Faber-Castell, Stein, DEU

1991
OFF ROAD KALLIGOS, Galerie Näke, Nuremberg, DEU (S)
ZWANZIG SOCKEL, Kulturring C, Stadthalle Fürth, DEU
5 X KISTE UND 1X KASTEN, Kunstverein Kohlenhof, Nuremberg, DEU
WODKA KAKAO FÜR KNUT, Galerie Näke, Nuremberg, DEU

1990
ZEHNVORZWEITAUSEND, KÜNSTLERGRUPPE DER KREIS, Hauptmarkt, Nuremberg, DEU

1989
DEBÜTANTENPREIS DES FREISTAATES BAYERN, Kunstverein Kohlenhof, Nuremberg, DEU (S)
GOLDBREULER UND ANDERE FLIEGER, Galerie Näke, Nuremberg, DEU (S)
FRISCH: GRUPPE FRISCH GESTRICHEN, Kunsthaus Nürnberg, DEU

1988
NEW YORK WATERFRONT, Municipal Art Society of New York, USA
UNTER OFFENEM HIMMEL, Galerie Näke, Katharinenkloster, Nuremberg, DEU

1987
INTERNATIONAL GROUP ART WORK, GRUPPE FRISCH GESTRICHEN, Gesamthochschule Kassel, DEU
KREIS IM FLUSS, ACTION ON THE PEGNITZ WITH KÜNSTLERGRUPPE DER KREIS, Nuremberg, DEU
SWESCHI (FRISCH), Kabelmetallfabrik, Nuremberg, DEU (with Karl Veitz, Fred Ziegler, Roland M. Beck, Michael Reiter)
UNTER OFFENEM HIMMEL, Galerie Näke, Katharinenkloster, Nuremberg, DEU

1986
GROSSE KUNSTAUSSTELLUNG MÜNCHEN, Haus der Kunst, Munich, DEU

1985
BILD BOTSCHAFT BILD, Deutsche Gesellschaft für christliche Kunst, Munich, DEU
EINZELZELLE – AMNESTY INTERNATIONAL, Church of St. Sebald, Nuremberg, DEU

(S) = Solo exhibition

Dank / Credits

Anna Bien, Wolfgang Geiß, Karl Schwarz und Birgit Suk

Gefördert durch / Sponsored by

B&P Premium Werke München
Integral Kulturstiftung Maxhütte Haidhof
STS, Regensburg

Impressum / Colophon

Erschienen im / Published by:
Hirmer Verlag GmbH
Nymphenburger Straße 84
80636 München / Munich
Deutschland / Germany

Herausgeber / Editor: Institut für moderne Kunst Nürnberg

Autoren / Authors: Prof. Bazon Brock, Barbara Rothe, Dr. Harriet Zilch

Übersetzung / Translation: Lucinda Rennison

Lektorat / Copy-editing: Anke Schlecht

Deutsches Korrektorat / German proofreading: Alexander Langkals

Englisches Korrektorat / English proofreading: Jane Michael

Bildnachweis / Photo credits: Winfried Baumann (S./pp. 48–53 / 70–73 / 84–85 /
118–123 / 129–130), Song Yup Bien (S./pp. 42–45), Elmar Hahn (S./pp. 22–41 /
144–169 / 184–185 / 190 / 240–311 / 345–378), Jürgen Musolf (S./pp. 46–47 /
127–128 / 188 / 191–201 / 215), Brigitta Maria Lankowitz (S./pp. 176–181 / 316–341),
Norbert Zeitler (S./pp. 54–69 / 74–81 / 109–117 / 136–137 / 204–237)

Gestaltung und Satz / Layout and typesetting: Wolfgang Gillitzer, Nürnberg

Hirmer Projektmanagement / Hirmer project management: Rainer Arnold

Lithografie / Lithography: Repromayer Medienproduktion, Reutlingen

Druck und Bindung / Printing and binding: Printer Trento

Papier / Paper: GardaMatt Art

Printed in Italy

Bibliografische Information der Deutschen Nationalbibliothek
Die Deutsche Nationalbibliothek verzeichnet diese Publikation in der Deutschen
Nationalbibliografie; detaillierte bibliografische Daten sind im Internet über
http://www.dnb.de abrufbar.

Bibliographic information published by the Deutsche Nationalbibliothek
The Deutsche Nationalbibliothek lists this publication in the Deutsche Nationalbiblio-
grafie; detailed bibliographic data is available on the Internet at http://www.dnb.de.

ISBN 978-3-7774-2613-6

www.hirmerverlag.de
www.hirmerpublishers.com